University of California Press gratefully acknowledges the generous contributions to this book provided by the Jewish Studies Endowment Fund of the University of California Press Foundation, which is supported by a major gift from the S. Mark Taper Foundation, and by the Art Endowment Fund of the University of California Press Foundation, which is supported by a major gift from the Ahmanson Foundation.

The Judah L. Magnes Museum gratefully acknowledges the support of the Taube Foundation for Jewish Life and Culture.

MAYER KIRSHENBLATT BARBARA KIRSHENBLATT-GIMBLETT

They Called Me Mayer July

PAINTED MEMORIES OF A JEWISH CHILDHOOD IN POLAND BEFORE THE HOLOCAUST

University of California Press
Berkeley Los Angeles London

Judah L. Magnes Museum
Berkeley

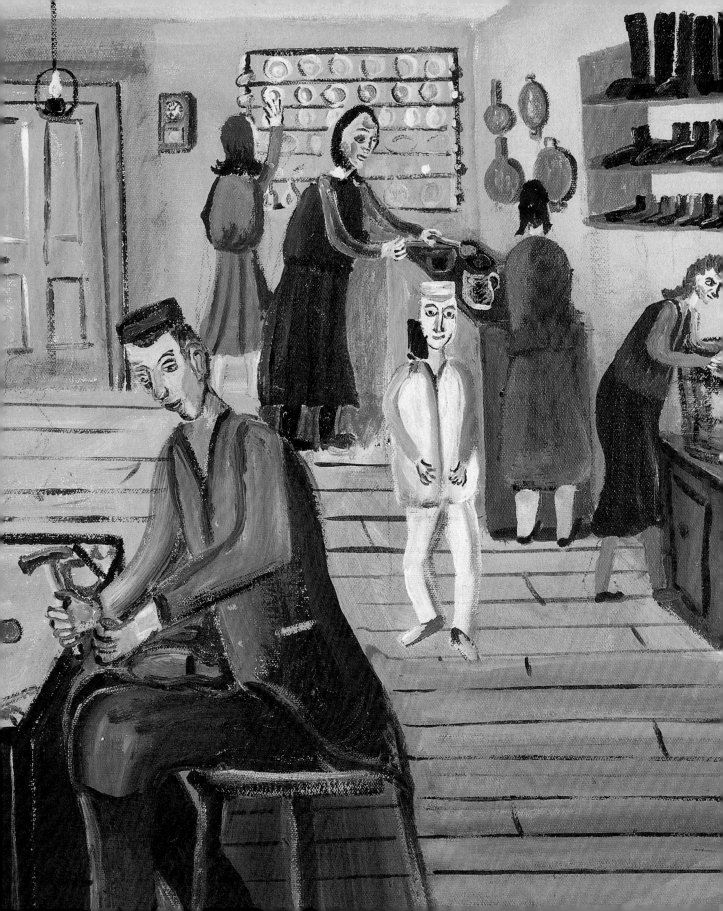

TO THE PEOPLE OF APT

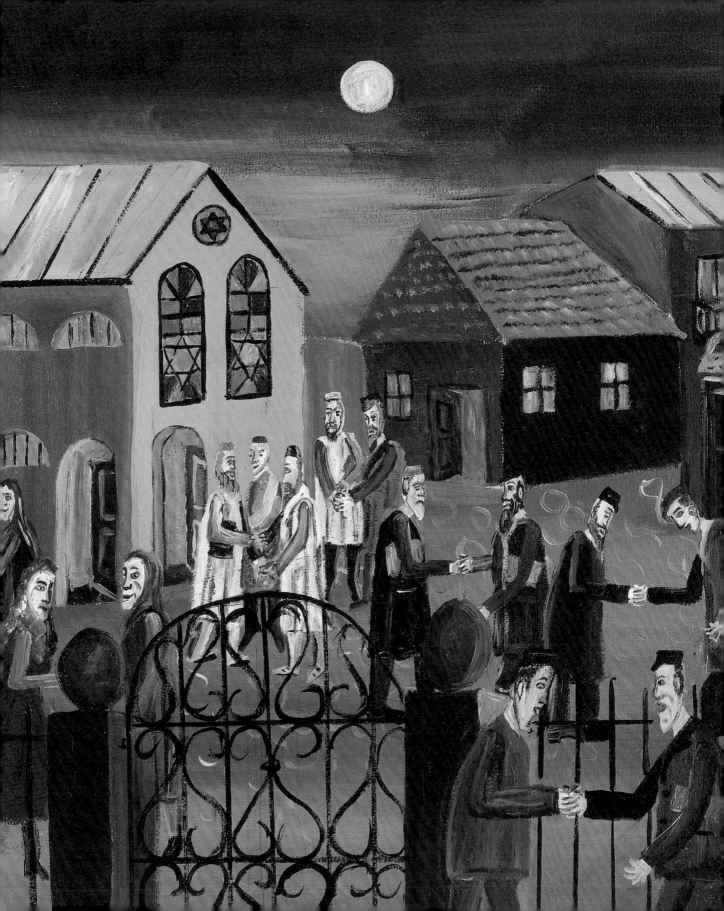

CONTENTS

OPATÓW / APT

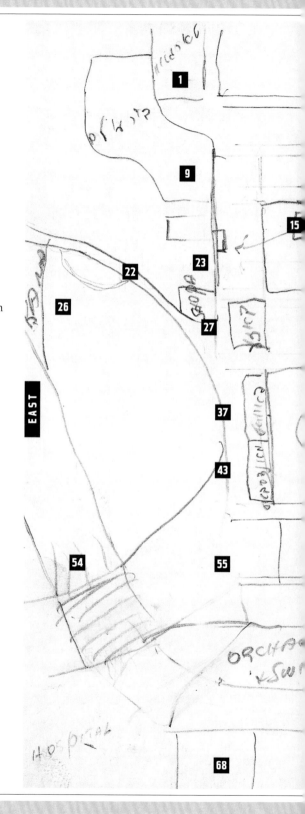

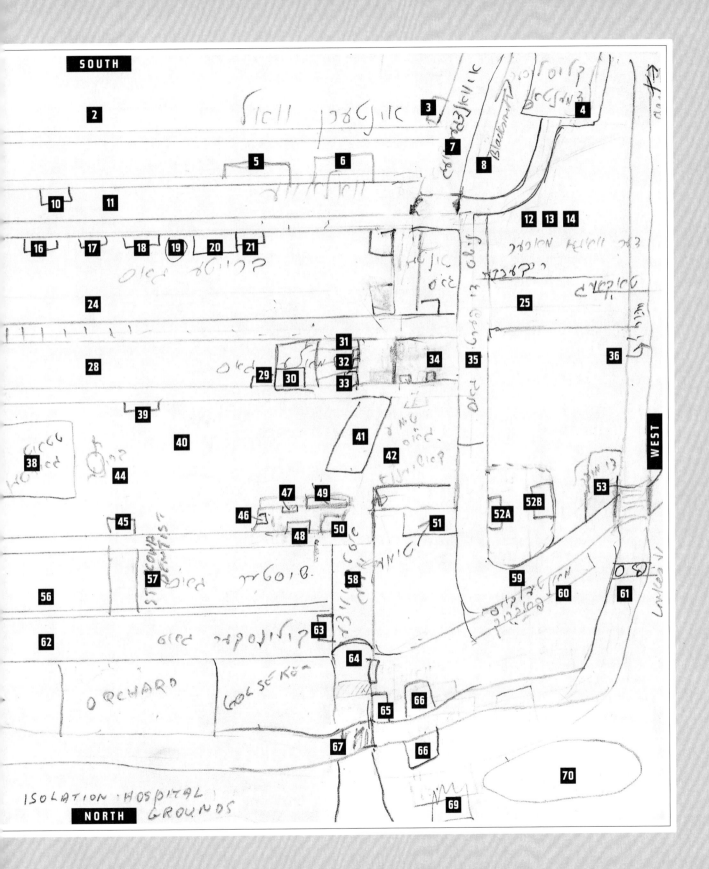

STOREHOUSE OF MEMORIES

I was named after my great-grandfather Mayer Makhl Gutmacher. Everybody in town had a nickname. Mine was Mayer *tamez*, Mayer July, because July was the hottest month of the year. Mayer *tamez* means Crazy Mayer. People get excited when it is hot, and I was an excitable kid. I was always on the go. I was very smart and very hyperactive. Of course, they wouldn't call me Mayer *tamez* to my face. They were afraid to do that. There were a bunch of Mayers. So to tell them apart, each had a nickname. Which Mayer do you want? Mayer *tamez*? Mayer *treyger*, Mayer the Porter? Or Mayer *droybe*, Mayer the Goose Carcass?

I was just different, odd, to say the least, and still am to my contemporaries. I was small, I was picked on, and I didn't take any crap. If anyone started up with me, I grabbed whatever was handy, a stick, a stone. People would say, "Stay away from Mayer *tamez*, *meshigener* Mayer, Crazy Mayer." Once I was a bit older, I stopped wearing a hat, which was pretty rebellious, because a Jewish male is supposed to cover his head. I spent quite a bit of time by myself doing whatever I was interested in. I used to fool around on the meadows, catch tiny sunfish in the creek, and almost derailed a train. Khamele Wajnberg and I were the only ones to play in the carp pond in a punt. I would cover miles running with my hoop around the whole perimeter of the town in the evening after school.

What little free time I had was precious. My school day was eight or nine hours long, six days a week. Even Saturdays and Jewish holidays were not completely free. We got two months of vacation from public school but only two weeks off from *khayder*, the Jewish religious school. I finished the seven grades of public school and attended *khayder* until I was about fourteen. I failed one grade of public school because I played hooky. I was too busy watching everything that was going on in town. I would spend hours observing the blacksmith and the tinsmith, the ropemaker and the cooper, the mills and the carp ponds, and the town square on market day, when all the peasants came to town.

I was always an avid reader. My fondness for reading helped me learn English when I came to Canada in 1934. But books don't give you the kind of details that I remember—where people would go to the toilet or how we would wash. However much I learned in school or from books, it is my fate that almost everything in my life I had to learn by myself, including how to paint.

I started painting in 1990, when I was seventy-three years old, at the urging of my daughter and my wife. They kept cracking the whip. My daughter would say, "My daddy can do anything." She is a folklorist, an anthropologist, and she would beg me:

"Would you please, please paint what you remember?"

"What do you mean paint?"

"Paint, just go ahead, Daddy, and paint. I know you can do it. Please do it."

So, on my fiftieth wedding anniversary, when she came to see me in Toronto, I had painted my mother's kitchen in Apt, which was known as Opatów in Polish. By then my wife had been urging me for ten years to paint. My daughter's husband is an artist, and he kept buying me art supplies.

In 1981, we were in Boca Raton, Florida, for the winter. We were staying in Century Village, a huge complex, which was mostly for seniors. There were lots of activities: movies, lectures, swimming, and stamp collecting. I was bored, so I wandered into an art class. There were about ten or twelve people and an instructor. She put a few things on the table, and we would draw. I drew a lot of green peppers. I call this my green pepper period. A few years later, my wife signed me up for a painting class, a life drawing class, at our local JCC, Jewish Community Center, where we did aerobics four times a week. She said, "It's paid for, whether or not you attend." So, I went, but I didn't last long because the model moved so quickly from pose to pose, I couldn't finish the drawing. My daughter told me to forget about the classes and paint from memory. The teacher also encouraged me to work on my own.

At the same time, in the steam room at the gym or in a corner of the health club, I'd get together with my buddies. Most of the people there are Holocaust survivors. Within five or ten minutes of any conversation, whether the topic was politics, women, this or that, we would be back in the concentration camps, on the march, in the railroad cars, in the bush with the partisans. It was as if there were no life before the war, so overshadowed had their memories become by the pain they suffered. I lost many members of my family in the Holocaust, but God spared me from living through that horror myself. He also blessed me with a wonderful memory.

I consider myself a storehouse of memories. My project is to paint prewar life in a small Jewish town in Poland. That's what really interests me. The way I paint is important, of course, but the most important thing is to get a subject. I have to get a subject. I think about it. I remember. It just comes to me. The subjects I decide to paint are those that have a story

to tell. I draw mainly from my memory. I also paint stories I heard from my Apt friends or read in the Apt chronicles, the memorial book for my town. Regrettably, I have very little imagination. I don't dream or, if I do, the dream is nothing I can paint. I can only paint what I lived through. I can only paint what is in my memory and in my head.

I paint these scenes as I remember them as a child. That's the reason why, in my early paintings, the rooms are so huge and I am so small. What I am trying to do, basically, is not to glorify myself but to portray life as it was. I hope it gives you some idea what life was like. We were living in very crowded conditions—we had two rooms—and we were considered middle class. I don't really remember any illustrated books or pictures on the wall at home. I don't remember ever going to a museum or seeing the great masters. But I did have a good art teacher in public school, and he took us to the church to draw the windows, doors, and carvings from the outside. I also saw the painted interior of the synagogue.

The first painting that I did was of my mother's kitchen. I used this theme because my daughter asked me. She wanted to know what my mother's kitchen looked like in the Old Coun-

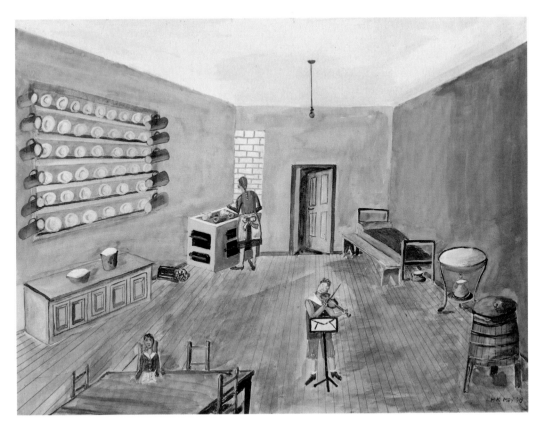

Kitchen

try. I kept telling her over the years what things were like. After doing the kitchen, I painted other scenes from inside my house and then I painted what happened outside my house with other people. I never intended to get into this full-time. When I saw the picture I did, I saw I could do better, so I immediately painted another one, the same thing. It was a little better. I have painted several themes many times—the synagogue interior, Simchas Torah, the Purim play, scenes in the *besmedresh*, or house of study, Passover at my paternal grandfather's in Drildz, and the wedding. I wanted to improve on these subjects, and I did improve.

When I am about to start a new painting, I think about it. I lie down and daydream about it. Memories keep flooding in and I just keep going. I sometimes have a hard time getting started. I'm afraid. I can't sleep at night. Every so often, I go down to my painting room and have a look. Did I do it right? Did I do it wrong? But once I start, I can't stop. I just wonder what's going to be next. How will it turn out? I think to myself, "Can I do this better?" I hesitate to rub out something that I've done. If I do away with it, will I be able to do it again? Once I've finished a painting, I bring it up to the living room, lean it on the couch, and look at it for a while. Once I'm finished with it, I'm done. Then I forget about it and wonder what I'm going to do next.

At first, I would just go directly to the canvas and lay out the painting with a charcoal pencil. As I painted, I covered the charcoal. I used the charcoal drawing as a guide so that I knew where to put everything. Today, I make drawings on paper and then I go to the canvas. I do not outline everything on the canvas. I paint the background. Then I add the streets and the figures. Sometimes I have to paint over and over again on the same canvas to get it right.

The paintings I make today are a lot different from when I started fifteen years ago. First and foremost, I do not thin out the paint as much as I used to. The colors are more powerful. I use more primary colors. I also use a lot of earth colors—raw sienna, burnt sienna, raw umber, burnt umber. I also try to avoid painting flat. I try to give my pictures more depth and perspective. I put more distance between people in the front and people in the back. I make the ones in the front bigger and the ones in the back smaller. The faces are more detailed. There is more contrast. Basically, I am most comfortable with a canvas that is twenty-four inches by thirty-six inches, although I have painted on larger and smaller canvasses. In 1998, I tried lithography for the first time.

To this day, I am not happy with what I do. When I see what other people do, I feel humbled. Maybe I should have gone for art lessons. But I got a lot of encouragement, so I didn't

get discouraged and I liked the recognition. No matter what I did, I tried to be good at it. When I came to Canada, I worked in a coat factory for about six months. I was seventeen. So I said immediately that, if I am going to be a tailor, I will go to school and I will learn to be a designer. I went to night school and I still know how to take measurements for women's pants. That career came to an end when I fell asleep and ran my finger under the needle of the sewing machine. I had been up late with my friends. Then I became a house painter. Again I immediately tried to improve myself. I went to night school. I was already married. I rushed to school three or four times a week with a bicycle. Sometimes I didn't even change my clothes. They taught me how to mix colors and wood grain. I am a very proficient grainer. I can imitate any kind of wood. I can take that white door and make it look like chestnut, walnut, oak, mahogany, as you wish.

This is how I came to paint Jewish life in Apt, which was known as Opatów in Polish. I should explain that I don't differentiate very much between Jewish and non-Jewish life. I had a few friends who were not Jewish, although they were not my very closest friends. When we met, we had a good time. We would chit-chat, walk around for a couple of hours, and discuss different things, from politics to schoolwork. These friends were not anti-Semitic or hateful. I used to play music with a Christian boy, but that's where it ended because he belonged to one side of town and I belonged to the other side. That said, more than two-thirds of the population of Apt was Jewish: in 1921, there were 5,462 Jews and 2,365 Christians. We considered Apt a Jewish town: a Jew could live out his whole life in the Jewish community, and many never went beyond the town's boundaries.

The places I remember exist no more. They are only in my head, and if I die they will disappear with me. I paint these scenes as I remember them as a little boy looking through the window.

In this painting, I am wearing the unofficial uniform for boys from non-Orthodox homes who attended the Polish public school. Only the hat was compulsory. It was four-cornered with a patent-leather peak. Religious Jews didn't want to wear those hats because the seams on the top of the hat formed a cross. They wore the Jewish hat, a peaked cap, and long dark coat. We wore a navy blue jacket, gray plus fours, and a white shirt with a Słowacki collar. The plus fours were wide enough to look like a skirt. When we stood in a row, it looked like the whole line was wearing one great skirt. The wide collar was named after Juliusz Słowacki, a nineteenth-century Polish national poet who wore that kind of collar. He was a contemporary of Adam Mickiewicz, whose poetry I had to memorize at school. Sporty

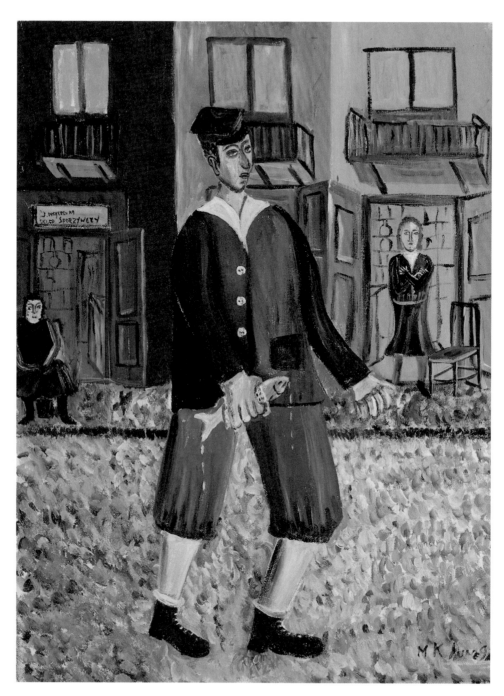

*Boy with
Herring*

fellows like me had red ski boots with brass eyes and wide yellow shoelaces. My red ski boots were my favorite shoes. They were *sportowe*, sporty, but they were not made in Apt. We wore two pairs of white socks: knee socks and a second pair that folded over the shoe like a collar. We looked pretty smart with those nice shoes and knee high socks.

You can see me coming home with a herring. Mother sent me to my grandmother's store to buy a herring. They did not wrap herring in paper, because paper was in short supply, and even newspaper was precious. One newspaper would be shared among several families, rather than each family buying their own. The shopkeeper wrapped a little piece of newspaper around the middle of the herring, just big enough for my hand to hold it. Brine would drip from the head and tail of the herring. On the way home, I would lick the drops of brine.

Herring was an important part of the diet. A woman could make a whole banquet from a herring. When purchasing a herring, you always asked for a male. After washing the herring and opening it up, Mother would remove the milt, or *milekh*, a long sack of semen. She would open the milt and scrape the semen away from the membrane, which she threw away. To the semen, the *zumekhts*, she added minced onion and a little vinegar and sugar to taste to make a sauce, a *zuze*—it was called a *kratsborsht*, or scratch borsht, because the milt had been scraped. Everyone got a little piece of herring, a small piece of bread to dip in the *kratsborsht*, and maybe also a boiled potato. That was supper.

In Canada, the head of a herring or other fish is discarded. In the Old Country, it was considered a delicacy. It was reserved for the head of the family. Sometimes the head was thrown onto the hot coals of the stove and roasted. Then you ate the head and sucked out every tiny little bone. A few boiled potatoes, bread, and a piece of the herring made an excellent meal for a poor family. My mother had to be a gourmet cook to make a herring into a meal for the whole family. One herring would feed a family of four or five. Many people did not even have that and went to bed hungry.

This is also the outfit that I brought to Canada in February 1934. I awoke to a very cold morning on my first day in Toronto—it was the second-coldest winter on record—and went out in these clothes to explore the city. As I walked along Spadina Avenue and College Street, people looked at me like I had arrived from the moon! A fire truck came rushing by. I thought to myself, "How big could a city be?" and started running after the truck. A mile down the road I gave up. Toronto was definitely bigger than Apt.

You can see me in many of the paintings. I am wearing this outfit and observing what is going on.

PART ONE

My Town

Apt may not have been a major moment on the Polish map, but it was an important town on the Jewish map. Apt was known as a rabbinic town. It was the home of many famous rabbis, including Reb Mayerl and Reb Yeshiye Heshl, a great Hasidic sage. Although Reb Yeshiye Heshl did not stay long in Apt, he was known as the *Apter rebe*.

Reb Mayerl had a great reputation as a religious scholar and a holy man. He had many admirers. One of the most important dates in the life of our town was the anniversary of the demise of Reb Mayerl in 1723. I read in the memorial book for my town how people would come to Apt from near and far to visit his grave. They would pray, recite the psalms, light candles, and leave *kvitlekh*, written petitions, on his grave. They hoped that he would intervene with the Almighty on their behalf. People would request a groom for an unmarried daughter, a male child, a cure for an ailment, or economic success.

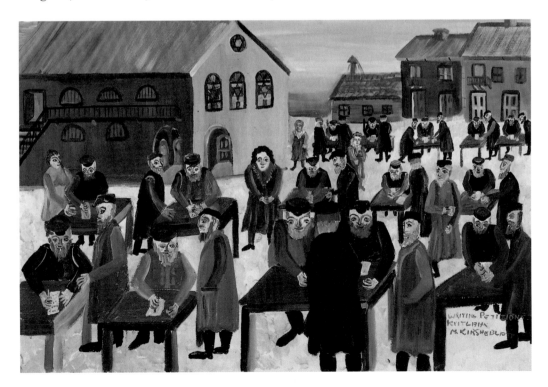

Writing Petitions on the Anniversary of Reb Mayerl's Death

For the note to be effective, it had to be written in the Holy Tongue. Although most Jews could read the prayer book in Hebrew-Aramaic, many did not know how to write in the sacred language. Anyone who could write Hebrew would trundle out a table and chair and set up shop along *di yidishe gas*, which means the Jewish Street, all the way from the synagogue to the Jewish cemetery. In the two centuries since Reb Mayerl's death, the town had developed a whole new industry—*shraybn kvitlekh* (writing petitions). For a few pennies, the town's teachers and their students would write a petition. They had a very busy day.

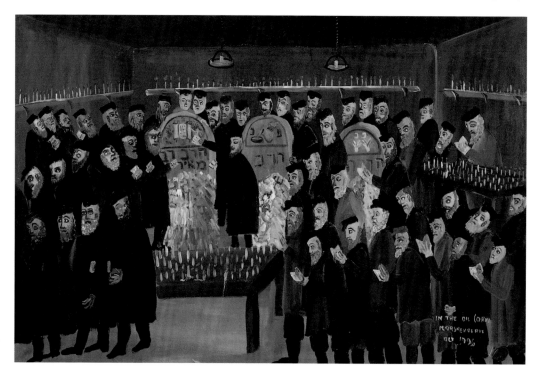

In the Oyel at the Grave of Reb Mayerl

With petitions in hand, the followers of Reb Mayerl would go to the cemetery. There was much coming and going from the *oyel*, a little hut in the cemetery that housed the graves of holy persons. The literal meaning of the word *oyel* (Yiddish) or *ohel* (Hebrew) is tent. Only the holiest men were honored in this way. There were graves for three holy men in the *oyel*—Reb Mayerl, Reb Yekele, and Reb Shmilekhl. Hundreds of people crowded the path to and from Reb Mayerl's grave. They had to run a gauntlet. Beggars lined up along each side of the path and pulled at the corners of the *kapotes*, the long black coats or caftans, of all those who passed. They vied for their attention and implored them for a few pennies. This was before my time.

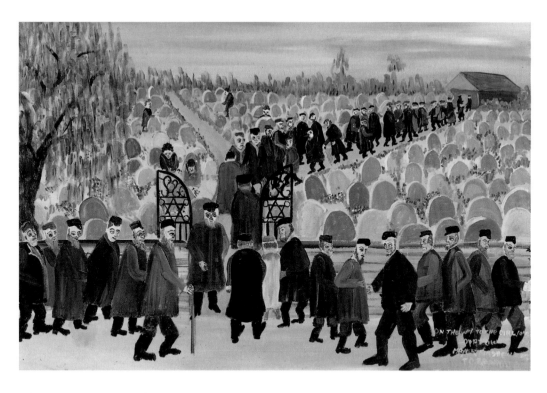

The memorial book for Apt recounts how another holy rabbi helped the town during a cholera epidemic in 1892. Every few days someone died. In a community of about six thousand, that was a calamity. Prominent citizens went to the holy rabbi, imploring him to say a few prayers to the Almighty. Maybe the epidemic would subside. The rabbi thoughtfully replied, "Let's try a wedding in the Jewish cemetery. Perhaps the dearly departed will intervene with the Holy One to help." It is considered a great *mitsve*, or good deed, to help the poor to marry. All that was needed was a bride and groom.

The matchmakers got busy. In town there was a young bachelor who was supported by the community. His job was to clean the communal bath. Each week he drained the water and replaced it with a fresh supply. He also kept the fire going in the *mikve* so that the water would always be hot. He lived in the *hegdesh*, a room where the burial society kept the implements for cleaning the dead. On being approached, the young man gladly accepted.

Now a bride was needed. There was in town a young lady, an orphan. In Yiddish, it is enough to have lost one parent to be an orphan. This woman had lost both parents. She was what is called a *kalekhdike yesoyme*, a round orphan, because she had absolutely no relatives. In

exchange for a place to sleep on top of the oven, her daily bread, and a few cast-off clothes, she did the housework for a well-to-do family. She received no wages. On being approached, she also gladly agreed.

A proclamation was issued in the synagogue, the houses of study, and the Jewish schools that a black wedding, a *shvartse khasene,* would be held in the cemetery at a designated time. Everyone was to attend. On the appointed day, the whole town, including people from the surrounding villages, streamed into the cemetery. They gathered near the *oyel.* The sexton brought a wedding canopy. The bride wore a donated wedding dress. The rabbi conducted the ceremony. Many people shed a tear on this solemn occasion.

The community donated gifts and food. A table was set up with a small barrel of vodka, glasses, and large joints of roasted mutton. Everyone wished each other a long life. When the assembly was already a little tipsy, Yankl Krakowski, the *badkhn,* a master of ceremonies, stood on a stool and announced that the time had come to call out the wedding gifts. See-ing as this poor couple had no home, the appeal went out for cash donations. Everyone

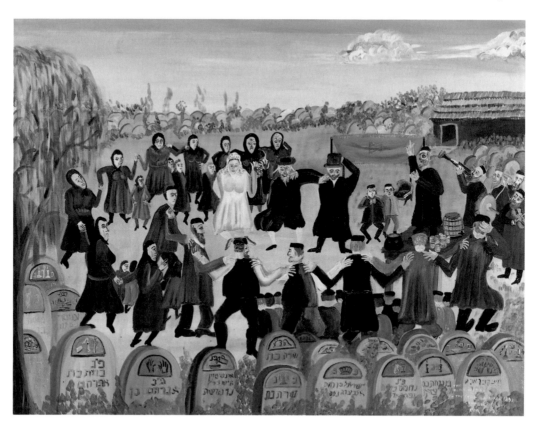

The Black Wedding in the Cemetery, ca. 1892

reached into his or her pocket, and in a short time the iron pot was full of money. When it became too heavy to hold, Yankl set the pot down on the table. He regaled the company with jokes and songs. The band struck up a lively tune, and everyone—men, women, and children—danced. Reb Tsvi Hirsh, who officiated at the wedding, stepped into the large circle of dancers. Small in stature, head held high, his eyes looking toward the sky, his beard and sidelocks flying, Reb Tsvi Hirsh began to dance. He invited the newlyweds to join him in the obligatory *mitsve-tants*. The merriment continued late into the night. Sure enough, the cholera epidemic subsided in a few days.

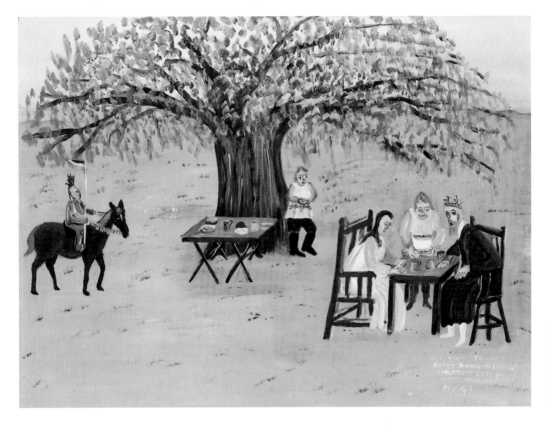

King Kazimierz the Great Entertaining His Jewish Girlfriend, Esterka

We knew from other stories we heard that Jews had been in Poland for a very long time. According to legend, Kazimierz Wielki, King Kazimierz the Great, had a Jewish girlfriend. Her name was Ester, but she was known affectionately as Esterka in Polish and Esterke in Yiddish. She was sort of parallel to Ester of Purim fame. She was also, it was said, instrumental in the king's inviting Jews to Poland to promote commerce. That would have been about seven hundred years ago. King Kazimierz was said to have entertained Ester under a great oak tree. In this painting, two peasants serve the royal pair, while a knight in armor

keeps watch. This enormous tree, which was supposed to date back about nine hundred years, had branches so long and heavy that they had to be supported so as not to break off and accelerate the demise of the tree. I was told that the tree was in Kazimierz, or Kuzmer in Yiddish, which is the Jewish quarter on the outskirts of Kraków. When I was a young boy, I was told that the great oak tree was still there. That tree was a national monument.

Apt was an old city. Long ago, Apt and the neighboring villages belonged to the church and then to various Polish noble families. Jews settled in Apt in the 1500s. In the old days, the Jews in Apt and its environs formed one community. There were five approaches to Apt: from Sandomierz to the east, Iwaniska to the south, Łagów to the west, Ożarów to the northeast, and Ostrowiec to the north. Three of those approaches crossed the Opatówka River, which ran along three sides of the town. The river flowed from the west.

Sandomierz (Tsozmir in Yiddish) was an ancient town on the Vistula River. It was famous for its *kolegiata* (collegiate church), where to this day you can see an eighteenth-century painting that shows Jews murdering a Christian child. Innocent Jews in Sandomierz and elsewhere were actually tried and convicted of ritual murder because of such blood libels; it was believed that they used the blood of Christian children to make their matzos. Iwaniska (Ivansk in Yiddish) was a much smaller town than Apt. They used to joke that when the *Ivansker maydn*, Ivansk maidens, were sent out at night to close the wooden shutters, they

Town Panorama

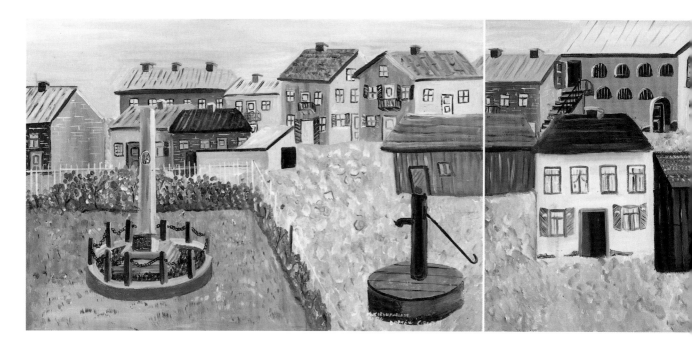

did not return until the next morning. The people from Ivansk were also called *Ivansker maysim*, Ivansk corpses. No one knows why. One of my mother's sisters married a man from Planta, a village outside of Ivansk. He worked for a sawmill there. He estimated how much lumber could be cut from a stand of trees. Łagów (Lagev in Yiddish), a very small town, also depended on the lumber industry. I passed through Lagev only once, when I departed for Canada. People from Lagev were called *Lagever feyrd-ganuvim*, Lagev horse thieves. In actuality, they were horse traders. Ożarów (Ozherov in Yiddish) was also a small town. I passed through there when I went to a camp for training Zionist leaders in Ruda-Opalin, not far from Chełm. People from Ozherov were nicknamed *Ozherover kozes*, Ozherov goats. And, of course, people from Apt had their nickname too, such as *Apter shlokhes*, Apt slobs—*shlokhes* means unkempt, sloppy. They also had the nickname Apter *flakes*, from the Polish word for tripe (*flaczki*)—*flake* in Yiddish means bad mouth—because people from Apt were known as gossips, though I doubt that Apt was any worse than other places. To add insult to injury, a relative from a small town near Łódź told me that when beggars knocked on doors in his hometown, people said they were probably from Apt. This was just friendly rivalry between towns.

The two bridges along *Lagever veyg* and *Ozherover veyg* crossed the Opatówka River. A third bridge, the only toll bridge, ran along *Ostrovtser veyg,* the road from Ostrovtse to Apt. Mr.

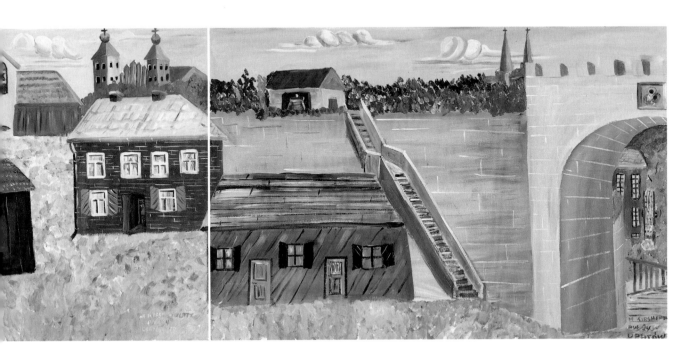

Goldseker collected the tolls at this bridge as part of his concession from the government to build roads. He had a few daughters, the youngest was Laye—we called her Lalush. I liked her. We went to school together. She was very nice, a charmer, but she was not very social. She didn't belong to our Zionist organization or bother with the other guys. I think her family was rather protective of her. They were quite well-to-do: they had an estate, a big house and a big yard, right next to the river. They also had stables and a cow.

Ostrovtse, a larger city about eleven miles north of Apt, was known in Polish then as Ostrowiec nad Kamienną, because the city is located on the Kamienna River, and today as Ostrowiec Świętokrzyski, to indicate the province in which it is now found. It had a big steel foundry and railroad, which made it the shipping hub of the region. The busiest entrance to Apt was along this road, across the toll bridge, and through *Ostrovtser brame* (Ostrowiec Gate); the official name of this gate in Polish was Brama Warszawska, because it was on the road leading through Ostrowiec to Warsaw, which was 118 miles away. At the top of this old portal, which was almost all that remained of the ancient town walls, was a picture of the Black Madonna and Child, *Matka Boska Częstochowska*. In about 1933, just before I left Apt for Canada, the city prohibited buses and trucks from entering the city through the ancient gate for fear they would damage this treasured edifice. They diverted traffic, except for horse-drawn wagons, to the western entrance to the town so that traffic had to enter from *Lagever veyg*.

When I envision a map of Apt, south is at the top and north is at the bottom. This is how the map of the town is oriented in the memorial book for Apt as well as in an 1841 view that appears on the cover of a book, in Polish, about the seven-hundred-year history of Opatów. It is customary to envision the town from the point of view of someone entering the northern portal, *Ostrovtser brame* (at the bottom right of the map) and looking at the southern panorama of the city (at the top of the map). From this perspective, the church was on a hill to the right, the town square ran west to east in the middle, and the great masonry synagogue was in the center of the map, just behind the town square. That's how I painted the town panorama, from right (west) to left (east): as if you were entering from the *Ostrovtser brame*, at the far right of the painting, and walking east past the church and synagogue to the far end of the town square, where the *powiat*, the district seat, and public garden were located. The city hall was not in the center of town, but on *Tsozmirer veyg*.

Upon entering through the *Ostrovtser brame*, you would see steps leading up to an enormous bell that was used mostly for Easter processions, funerals, and fire alarms. The spires of the Bernardine monastery and its Baroque church can be seen in the distance. The build-

ing with stained glass windows is the synagogue. The most prominent structures in our town were the church, the monastery, and the synagogue. Our synagogue was renowned throughout Poland for its architecture and beautiful interior paintings. The Jewish communal buildings were constructed long before my time. They were ancient, hundreds and hundreds of years old.

The synagogue was located on the Jewish Street, also known as Broad Street, which ran parallel to the town square and connected the west and east sides of town. The street leading from the Jewish Street to the town square ran right to the bottom of the park at the eastern end of the town square. This street was called ulica Ogrodowa, or Garden Street. The town square was also the marketplace. After World War I, the marketplace was named Plac Wilsona in honor of President Woodrow Wilson, who played such an important role in the establishment of an independent Poland.

Most towns in Poland were built according to this plan. The best buildings in town were around the town square. Most of the buildings on the square were masonry, and the shops were exclusive. There were apartments above the shops. A few wooden structures could be found on the south side. Many marketplaces were built so that one side was higher than the

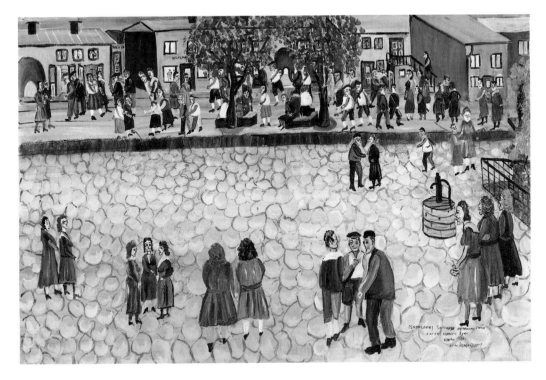

Saturday Afternoon Stroll on the Town Square

other. I saw this in Drildz (Iłża in Polish), the town where my father was born, and in Ostrovtse. In Apt, the south side of the marketplace was high and the north side was low. The north side was the more exclusive side. That's where the nicest houses and shops were located. We used to stroll back and forth on the north side for hours on end on Saturdays and holidays. This was the place to see and to be seen. If you had a nice new dress, you showed it off there. There was a saying that what you put in your stomach no one could see, but what you put on your back everybody could see.

At home, things were extremely congested. You didn't get any privacy, so at any opportunity you left the house. You went out and met your friends and walked up and down, up and down, on the sidewalk there along the town square. I must have covered a million miles up and down. We would rest on two red sandstone blocks, about three feet long, under the shade of two chestnut trees, outside Buchiński's restaurant, which was in the middle of the north side of the square. When the gypsies came to town, they performed inside Buchiński's. I

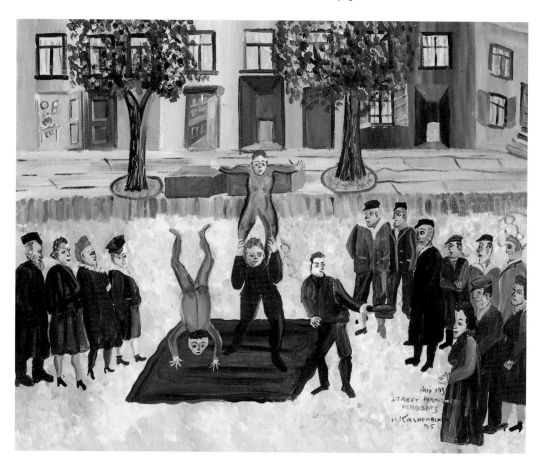

*Acrobats
Outside
Buchiński's
Restaurant*

sometimes saw street performers outside Buchiński's. When acrobats came to town, they spread a blanket on the cobblestones and did their tricks. Sometimes they set up in the big area in front of our house.

Our house was not far from the *Ostrovtser brame* and near the church. An organ-grinder would perform at the intersection of our street, ulica Kościelna (Church Street), and the street leading to the ancient city gate. He was a big hit. The organ-grinder had a parrot and a basket of fortunes. For ten *groshn* (pennies) he would bring a little basket close to the parrot, and the parrot would obediently pick out a fortune for you. There wasn't much money around, so he performed near our place, around the marketplace, in the courtyard of Mandelbaum, the richest man in town, and outside Buchiński's.

Fayvl Bulwa, the watchmaker, had his shop on the north side of the square. He prayed at the *lokal,* the meeting room of the General Zionist Organization, which is where my father

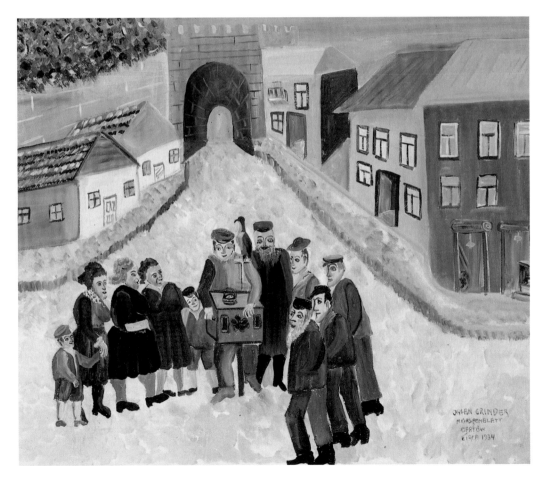

Organ-Grinder

took us. This man had a phobia. He was terribly frightened of cats. You can't imagine. Simchas Torah, when everybody was feeling good—they were a little tipsy—a guy in the *lokal* went "Meow" and Bulwa would jump up on the table or cower in a corner. He was terrified. He would jump out of his skin. Once they brought in a sack full of cats and let them loose. The guy went absolutely berserk. This was a ritual every Simchas Torah. Why the guy bothered coming in to *davn*, to pray, on Simchas Torah, I don't know. But that was the ritual every year.

On the south side of the main square was the hat store that belonged to the parents of my friend Harshl Watman. They stocked school hats and regular sports caps with a peak, sort of like a newsboy cap—it was called *litsipet*—which they manufactured themselves, and hard hats and fedoras, which they imported from larger cities. To the best of my recollection, they also imported the *yidish hitl* (Jewish cap), or *gules-hitl* (diaspora cap), as this hat was also known.

Erlich was the only photographer in town. His studio was also located on the south side of the main square, but closer to the garden. I was friends with Erlich's son, a nice boy. When they moved away, Goldman bought the studio. It was like a greenhouse, with a glass ceil-

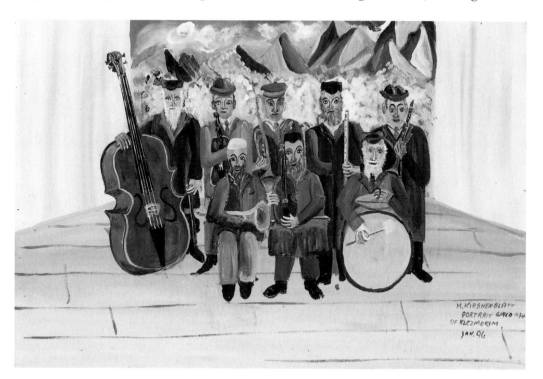

Portrait of Klezmurim in Photographer's Studio

ing and a glass wall. You had to draw the curtain to keep out the light. He didn't need flash because there was so much natural light. He also had a very nice foyer. When you came in, he would straighten you all out. He had backdrops and props and boxes and chairs. You stood in front of the backdrop. The photographs were made not on film but on glass plates. After they were developed, he showed you the proofs, you picked what you wanted, and he would touch up the photograph himself. I watched him touch it up. He scraped out a little bit here and put a bit there. He also took our school group photographs. I recently learned that, in the 1920s, he made studio portraits of town characters; he also took snapshots of them on the street. They include some of the ones I painted, such as Bashe Rayzl, one of the town crazies. I had no idea he was doing that at the time. He sent these photographs to New York, where they were published in the rotogravure section of the Yiddish daily *Forverts*.

We had our pictures taken on several occasions. The first one that I remember was when I was six years old. Yosl was not yet born, so just the three of us—Vadye, Harshl, and I— were in the picture. When my grandmother or my uncles came from Drildz, we would have pictures taken. We had a big photograph album with a red velvet cover. When my father was in Canada, we used to send him photographs.

Layzer Mandelbaum, the richest citizen in our town, had a beautiful house in Apt and a residence in Warsaw. His house in Apt was the biggest residential building in the city; it was right next to the county seat office on the eastern end of the town square. A man who advertised himself as the human fly—*ludzka mucha* in Polish—would climb the corner of Mandelbaum's building. The large cornerstones that projected from the masonry provided him with hand- and footholds. Once he got to the top, he fastened a projecting pole to the roof, somehow, and did some acrobatic tricks. He descended in the same way.

I loved watching the fiddle players, singers, and cellists perform in Mandelbaum's courtyard. There were many tenants in his building and, this being one of the best in town, the performers expected to collect more money there. People living in the apartments overlooking the courtyard opened their windows and leaned out. They watched the performers, wrapped a few coins in a bit of cloth, and threw them down to the performers. I was always eager to help out by collecting the money that fell to the ground. Naturally there was always a lot of action there.

Mandelbaum made his money from two factories on the edge of town. His big soap factory was famous throughout Poland for its Elephant Soap, a big bar of laundry soap, *mydło ze słoniem*, whose trademark was the elephant. It was a long bar, one and a half inches thick,

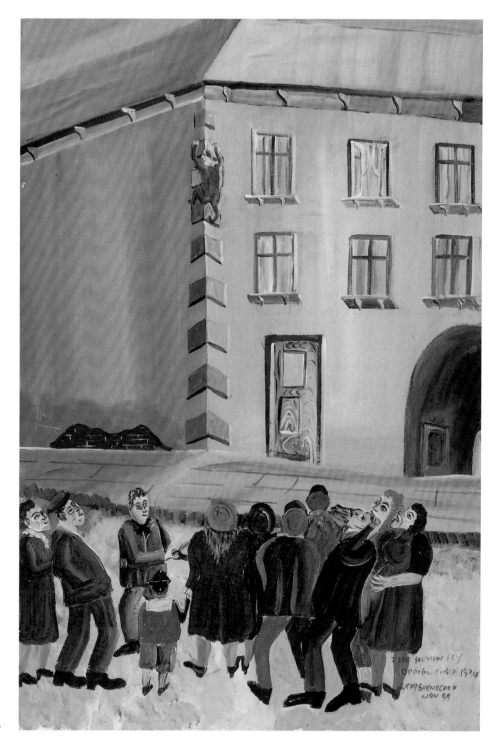

The Human Fly

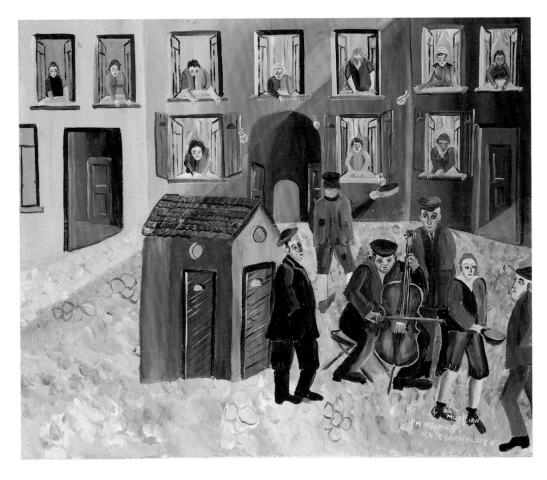

Cellist in Mandelbaum's Courtyard

twelve inches long, and two and a half inches wide. It was divided into several sections, on each of which was impressed the image of either an elephant or the brand name, *Kantorja Sp. Akc. Opatów*. The factory also made other kinds of soap as well as candles. It employed a total of about twenty-five people. The soap factory was located on *Lagever veyg*, on the edge of town, along the Opatówka River. It was kitty-corner to Rozenberg's power mill.

Mandelbaum's other factory, an *olejarnia*, which extracted oil from various kinds of seeds, was located on ulica Kilińskiego. This factory only operated in the fall, after the harvest. Mainly it extracted oil from *rzepak* (rapeseed) and from sunflower seeds. After the oil had been extracted, the fiber would come out in round cakes about twelve inches in diameter and two or three inches thick. Farmers fed those cakes to their livestock, which gave a healthy shine to their coats, especially the horses.

Elephant Soap: Kantorja Sp. Akc. Opatów

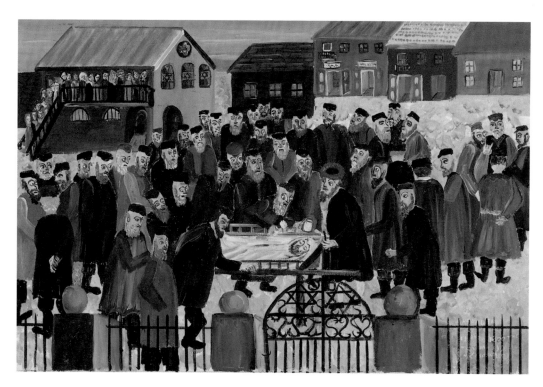

Shaving the Corpse

The Mandelbaums were completely assimilated. I don't remember them ever coming to synagogue. If they did, it would have been once a year for Kol Nidre on the Day of Atonement, the holiest day of the year. They were neither the first nor the only assimilated Jews in town. A story is told in the Apt memorial book about a rich man in Apt who abandoned most of his religion. One day the famous rabbis in the city called all the Jewish barbers together and made them swear a solemn oath not to shave the beards of any Jews. So the man asked a Gentile barber to shave off his beard and sidelocks. The rabbi often berated this man, warning him of what might befall him for this transgression. The man went around clean-shaven in a top hat and fashionable clothes rather than in the traditional Jewish cap and long coat. He only attended the synagogue once a year, for Kol Nidre. One day he got sick. He was bedridden for several months. During that time, his beard grew back. He finally passed away. When the rabbi learned of his death, he decreed that, before the body could be interred, the beard had to come off. This man had to appear in front of the Lord looking just the way he did when he was alive—without a beard. The rabbi ordered the body brought to the synagogue courtyard and the man's face lathered and shaved. So it was done. They shaved the corpse. This incident took place before my time. I read about it in the memorial book for my town.

On the ground floor of Mandelbaum's building was Słupowski's printing shop. Słupowski was the nephew of our Jewish landlady. He did all the printing for the town. Słupowski printed the Polish death notices. They consisted of a white sheet of paper with a black border, a little cross in a circle, and the name of the deceased, his or her address, date of death, and funeral information. These notices were posted around town so people would know where to pay their respects. The corpse was dressed up and laid out in the house. Jews did not post such death notices. Słupowski also printed announcements for the theater, movies, and events. These announcements were posted on round kiosks.

No newspapers were printed in Apt. The papers came from Warsaw. My family did not bother with Polish newspapers. We read the Jewish newspapers, in Yiddish. Yiddish reached a larger readership, since not all Jews were proficient in Polish. (My generation was the first to attend compulsory Polish public school.) There were also some Hebrew publications. Three families would share one newspaper. I loved to read the newspaper at the table while I was eating. But my father would not allow this. He would say, "You cannot read at the table because you'll stain the paper with food and this paper has to go to the neighbors."

We shared subscriptions to *Moment* and *Haynt* with Kalmen Rozenfeld, who lived in our courtyard, and with Laybl Zylberberg, who lived a few doors away. Zylberberg was in friendly competition with my father because he also sold leather. Zylberberg survived the concentration camps and returned to Apt after the war. People told him, "Remove yourself or you're going to get killed." He said, "My children and I agreed that whoever survives the war will meet in Apt. Tomorrow morning I'm leaving." That night he was shot by Poles who were afraid he might want his property back. The next morning Osa (nickname for Yosl) Zinger arrived in town. People told him the story. Osa found a door, put the body on the door, hired a wagon, took the body to the cemetery, and buried it. I heard this story from Osa when he arrived in Canada.

Mandelbaum's house faced the fenced park at the eastern end of the main square. This park was closed to the public except when there was a patriotic event. In the center of the park was a memorial to the fallen heroes of World War I. The memorial was in the city garden, which took up almost half of the town square. Jews never entered the garden. As a matter of fact, I don't recall seeing anyone in the garden, though others say that Christians, especially those who were better off, did visit the garden and sit on the benches. I painted people in the garden to make it livelier. The park was well maintained, with clipped grass, beautiful flowers, shrubs, trees, and narrow paths. A friend of mine from Apt who went through

the Holocaust and came to the United States in 1948 told me that the town later put two deer in the garden. It was like a little zoo. When I visited recently, I saw people in the garden. The fence was gone.

Outside the original fence was a well. It was not used very much, because the water was not as cold and as fresh as the water from Harshl *kishke*'s well. (Harshl *kishke*'s real name was Harshl Orlan. *Kishke* is the Yiddish word for intestine, or gut, and refers also to a delicacy, stuffed derma, which is made by filling a cow's intestine with flour, fat, and spices and roasting it. Why they called him Harshl the Stuffed Intestine, I have no idea.) The best water in town came from his well. It was always cold and pristine. It was a pleasure to drink. Harshl *kishke*'s well was going day in and day out, except Saturdays, for eight hours a day, without ever running out. It was a very deep well and supplied half the town with drinking water. If that well was too busy, there was the city well, on the marketplace. You didn't have to pay for water from the city well, but it was not as deep and, as I said, the water was not as cold or as tasty as that from Harshl *kishke*'s well. For laundry, we used water from the city well, and for daily cooking and drinking, we used the water from Harshl *kishke*'s well.

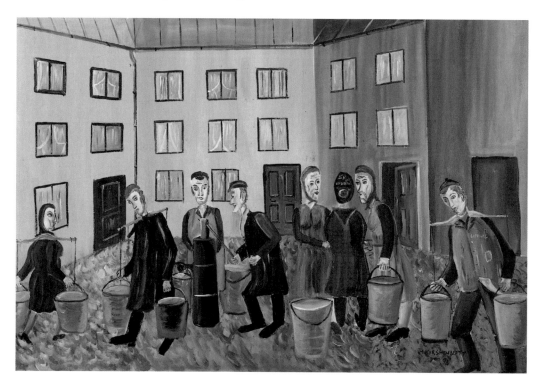

Water-Carriers at Harshl Kishke's Well

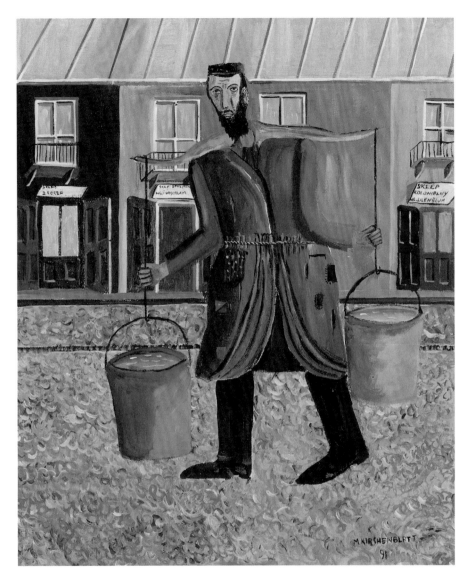

Water-Carrier

Harshl *kishke*'s well was a gathering place. Most of the professional water-carriers would congregate here and draw their water for delivery to the houses. They must have paid him some sort of fee. Just to keep the pump in repair cost money. Women came there to draw their own water and save the few pennies they would have paid a professional water-carrier to bring it to their homes. Once there, they took the opportunity to gossip a little. Right next door was the outhouse. It was built out of concrete. Apparently it did not contaminate the water, because from that water, so far as I know, nobody ever got sick. Even the prostitutes used to frequent Harshl *kishke*'s well in search of customers.

The water-carrier, the *vaser-treyger,* was one step above a beggar. What did he have around his waist? A rope to hold his things and a red kerchief sticking out of his pocket. He had the corners of his coat tucked under his belt so they didn't get in his way as he walked. Carrying water was a very difficult job. There was one man, a Pole by the name of Ludwik, who was very tall, a six-footer. He had the local tinsmith make him special buckets that were extra large. All the other water-carriers, no matter how short they were, also had to get big buckets in order to compete with him. When smaller men carried such big buckets, they dragged them on the ground. It was extremely difficult for them to manage. There was one guy, Duvid *vaser-treyger* (David the Water-Carrier), who was so small that he had to shorten the ropes from the yoke to the pails. Even so, his buckets almost touched the ground. A water-carrier would make ten *groshn* for a load of water. Those buckets probably weighed at least forty pounds each. There must be four gallons of water there, and every imperial gallon weighs about ten pounds. The water-carrier in my painting is hauling about eighty pounds in those two buckets.

As the town receded from the main square, the wooden houses on the back streets became poorer and poorer. On the east side of town was the *Yordn* (Jordan), a slum of attached row houses, leaning and dilapidated. This area was called the Jordan because, before it was paved, it was always wet and muddy, like the Jordan River.

Not far from the *Yordn* was the *hegdesh,* a room in a low wooden house *oybn di gas* (at the top of Broad Street), not far from the Jewish cemetery, at the eastern end of town. The *hegdesh* was where the burial society stored their implements. Itinerant beggars slept there in the summer. The *hegdesh* was unheated, so they would sleep in the *besmedresh* (house of study) in the winter; Lower *besmedresh* had a big brick oven and benches around it where the beggars could lie down and keep warm. At its western end, Broad Street narrowed into *Klezmurim-gesl* (Musicians Street). Two families of musicians lived on this street; other musicians lived elsewhere in town.

On the southern outskirts of town was Yarmye's Hotel, named for its owner, Yarmye Zajfman—*Yarmye* is the Yiddish version of *Yirmeyahu,* the Hebrew name for the biblical prophet Jeremiah. This huge building, which surrounded a courtyard on three sides, was a rabbit warren of tiny rooms on two stories. It was so dilapidated it was more like a shanty-town. Hundreds of people lived there. Poor people lived there permanently. It was some "hotel." It was more like a zoo. People there kept goats and chickens. If you had a goat, you had a little bit of milk, from the chicken a few eggs. Yarmye's was not in the heart of town but on the road to Ivansk. Just five or six hundred yards from the town square was already

countryside. During the day, the goats used to go around foraging. Goats eat anything. But people would not leave their animals outside at night because they would be stolen. So they brought the animals into their rooms. The boards were dried out and twisted, and the wind and snow blew in through the cracks between the boards. There wasn't even newspaper or cardboard to seal the cracks. How they survived the winter is beyond me. Perhaps the animals helped keep them warm.

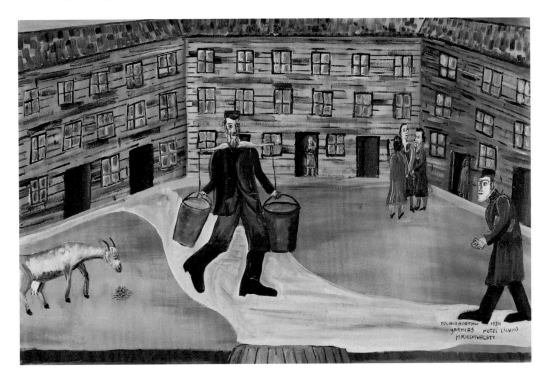

Yarmye's Hotel

How did I get to go inside Yarmye's Hotel? When I was about fifteen years old, there was a census. That would have been 1931, and I was in my last year of school. Mr. Koziarski, the public school teacher who taught me Polish poetry and literature, was one of several people in the town who went around collecting census information. Because I was such an avid reader and my Polish was flawless, he picked me to accompany him to translate from Yiddish to Polish. Imagine Jews living in the town for hundreds of years who could not speak Polish. Some of them had a very limited vocabulary, maybe a hundred words, just enough to deal with the Polish farmer when he came to buy something from their establishment. The majority of the town citizens were Jewish, and they could live out their life in the Jewish milieu without needing to learn Polish. Most of the Jewish population never left the town.

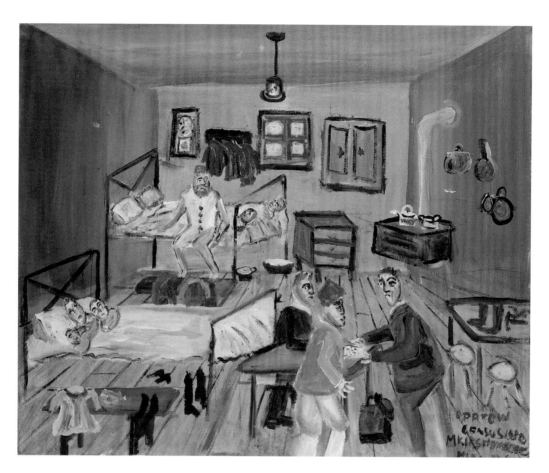

Taking the Census at Yarmye's

We started out at eight o'clock in the morning. A lot of the people at Yarmye's Hotel were still asleep. The overcrowding was unimaginable. They lived eight to ten people in a room. The mother slept with two children at the foot of her bed and two alongside her, the father the same. Some slept on the table, some under the table. How the father ever found an opportunity to make children is beyond me, though at the time the thought never dawned on me. There was a tiny cast-iron stove with two burners for cooking. We spent two days there.

There were many Zajfmans in town besides Yarmye, and several of them were in the liquor business, both wholesale and retail. One had a *rozlewnia*, a bottling works, for beer. Another, Moyshe Zajfman, owned a bar in town just opposite my father's leather store. The bar was on the southwest corner of *Shmule gas* (Narrow Street, or ulica Wąska in Polish), and *Ivansker veyg*. My father's store was on the southeast corner. Zajfman employed a deaf man who was very nice and very strong. When a beer delivery arrived, the deaf man hauled the

kegs down to the cellar, where I think they bottled the beer themselves. Zajfman catered to the local non-Jews, especially on Wednesdays, when the peasants came to market. Whores would stand around in front of Zajfman's bar and solicit the peasants. Jews did not generally frequent bars. Zajfman's was closed on Saturdays and Sundays, but on Saturday after Havdala and on Sunday, a few Jews would sneak in. They would sit around, have a few beers, and socialize. The law against doing business on Sunday made life very difficult for Jews because they had to close their businesses two days a week—on Saturday, the Jewish Sabbath, and on Sunday, the Christian Sabbath.

Uma (short for Avrum) Grinsztajn was one of my best friends. My mother told me that Uma's father once met Zajfman on the street on the Jewish Sabbath and begged him, "*Reb Moyshe, git mir a gmiles-kheysed tseyn zlotes,*" which means, "Mr. Moses, give me an interest-free loan, ten zlotys." Zajfman answered, "Are you crazy? What makes you think I would carry money on the Sabbath?" Uma's father responded, "So, open the bar and give me a bottle of beer," to which Zajfman replied, "You're out of your mind. I am not going to open the store on Saturday." Uma's father then retorted, "So, if you cannot give me a loan or a bottle of beer, carry me on your back for a little while." Uma's father was disabled. One of his arms was withered. He made his living, meager as it was, as a *badkhn*, performing as master of ceremonies and jester at weddings.

There was a fourth Zajfman family. They lived in Szmelcman's building, at the northeast corner of Broad Street and *Ivansker veyg*. My father's leather shop was also in that building, but at the opposite corner. Szmelcman's building was a block long, extending from Broad Street to Narrow Street, along the east side of *Ivansker veyg*, if I remember correctly. Although he was well-to-do, Pinkhes Zajfman, his wife, and one child lived modestly in two small rooms. His nickname was *dzhobes*, from *dzioby*, which means pockmarks in Polish. The Zajfmans were unable to conceive a child, so they took in a little boy, Moyshele Kajzer, whom they raised as their own son. Jews never adopted children in the Old Country. We took in foster children, usually poor relatives, and treated them as our own. In Polish this was called *wychowaniec*, which means a child that is raised by someone else. Although such children were raised as if the foster parents were their real parents, the children never lost contact with their relatives and never changed their names. Moyshele was a nice little boy. He wore a *yidish hitl*. The Purim play that I painted is in their house.

The holiday of Purim commemorates the steadfast faith and miraculous survival of a Jewish community in Persia. To celebrate, we used to dress up in makeshift costumes and homemade masks. I just put on a white sheet and smeared my face with charcoal or with soot

from the lamp chimney. We went from house to house singing a ditty to a familiar tune—
"*Hant iz pirim, morgn iz os, git mir a groshn in varft mikh aros*" (Today is Purim, tomorrow
it is over, give me a penny and throw me out)—and collecting candies and pennies.

A highlight of the holiday was the Purim play. The most popular plays were *Mordecai and
Esther*, which told the story of Purim; *Mekhires-yoysef*, which was about the sale of Joseph
by his brothers (this play always drew a few tears); and, above all, *The Kraków Wedding*
(*Krakowskie Wesele* in Polish), which is the subject of this painting. The troupe would re-
hearse for months in advance. Most of the performers were laborers and artisans. They wore
homemade costumes, the styles going back to the eighteenth century. The female charac-
ters are wearing the traditional costume of the Kraków region. If the women look mascu-
line, it is because men are playing the female parts. In the Jewish tradition, a woman would
not perform this sort of thing. Those playing male roles are wearing shako hats, which were
inspired by the hats that soldiers wore during the Napoleonic wars to make them look taller
and more intimidating. The hats were decorated with braid and tassels. *The Kraków Wed-
ding* was the only Purim play that required instrumental music.

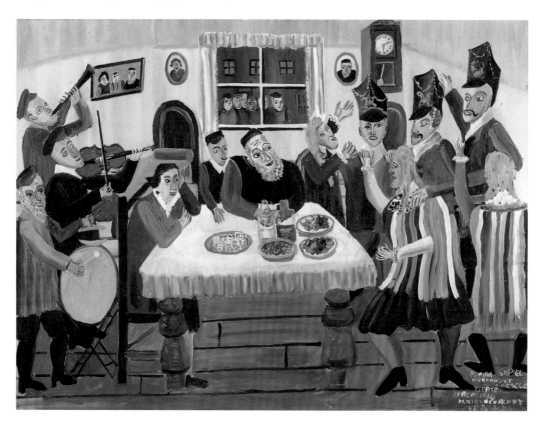

*Purim Play:
"The Kraków
Wedding"*

The Purim players would perform for five or six families in an evening. They did not visit every house, only those of prominent citizens. These were command performances in the homes of people who could afford to reward the players. They wouldn't come to my house. We loved to follow the Purim players from place to place. In my painting, you can see us standing outside Pinkhes Zajfman's home and watching the Purim play through the window. We weren't allowed inside. The place was too small and crowded. On the table you can see bottles of vodka and wine, candles, a few candies, and some little nibbles. There are only a few holidays in the Jewish tradition where you're obligated to get tipsy. Purim is one of them. Simchas Torah is another. By the end of the evening and after a few drinks, the Purim players would go home happy.

There were not many such rich families in a small Polish city like ours. If you were a well-to-do religious Jew and an important citizen in the community, you would commission a Torah scroll from a scribe. As befitted a man of his wealth and piety, Pinkhes Zajfman commissioned a Torah scroll, which took about three years to complete. The scribe was very devout. He knew the Pentateuch by heart. Every morning, before commencing to write, he was obliged to purify himself at the *mikve,* the ritual bath, where he would completely immerse himself seven times. When the scroll was completed, a procession of townspeople carried it with great joy to the synagogue, where they deposited it in the Holy Ark. The musicians played and people danced and sang along the way. This was known as *firn a sayfer-toyre* (Sefer Torah procession). Afterward, Zajfman hosted a celebration with drinks and refreshments.

Jews generally lived in town, although some Jews also lived on the outskirts. Most Jewish dwellings were one room or two at most, although some Jews owned land and buildings. We rented two rooms in town. Few people could afford to build their own houses. I remember one man, Khaskl Luzers, who built a house on the north side of Broad Street, not far from the synagogue. Khaskl Luzers had a *kolonyal-gesheft,* literally a colonial store, where he sold imported delicacies. He lived above the store. For Khaskl's house, they dug a very deep foundation to reach virgin soil so the house would not settle. The hole was so deep that, to build the foundation, they just dropped rocks into it, poured in mortar, dropped in more rocks, and poured in more mortar. The hole was very, very deep. There was a basement, but it was only about eight feet high. Khaskl Luzers built a nice brick house there.

I saw mortar being made every time there was construction going on in Apt. The first step in making mortar was to prepare the lime at the building site. Several weeks before they were ready to start construction, the workers dug a pit about five feet deep, six feet long,

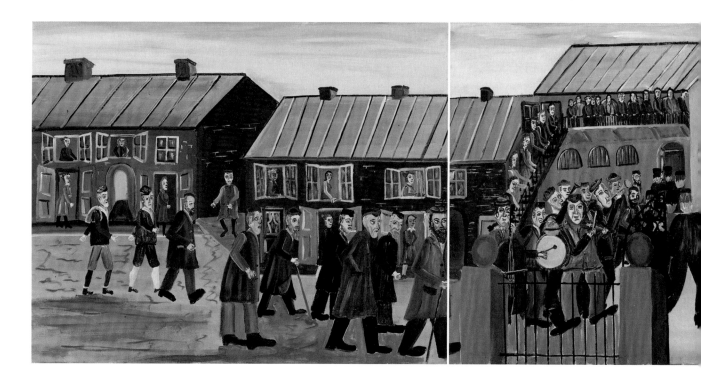

Sefer Torah Procession

and four feet wide, depending on how much lime they needed. They placed a wooden trough next to the pit. The trough was about the same dimensions as the pit, only shallower, about fifteen inches deep, with a twelve-inch sliding barrier at one end. Wagons would bring the quicklime in big huge lumps. A man who knew how to handle this dangerous material would mix the lime with water in the wooden trough. The lime would start to boil and steam. Using a tool like a hoe, but wider, he would agitate the mass constantly to dissolve all the lime. The material was quite loose. Then, he would open the sliding barrier at the end of the wooden trough and release the lime into the pit. He would repeat the process until the hole was full. They covered the hole containing lime with boards so people would not fall in. The lime would sit for a week or so to reach the consistency of soft butter, at which point the lime would not burn your skin. They would lift out the lime with shovels when it was like jelly and put it back into the wooden trough. To make mortar, they added water, sand, and other materials to the lime.

Powdered quicklime was also used as a disinfectant. In the spring, the gutters were full of dirty stinky water. The city did not remove snow in the winter. All winter long, the farmers came to market, and the urine from their horses would not flow away. It sunk into the snow. The manure stuck to the ice. It was difficult to clean the streets. When spring came,

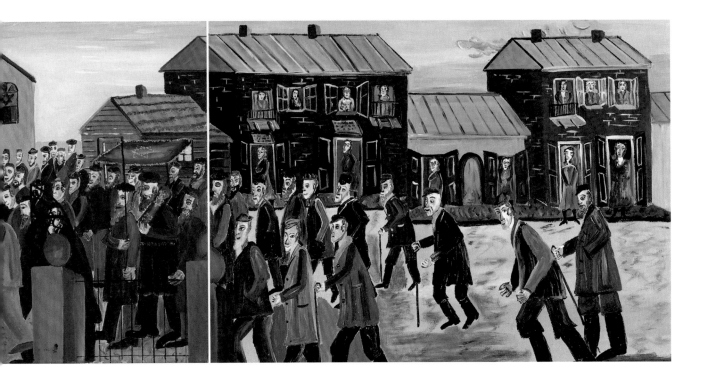

to make the snow melt more quickly, the city sent men with picks and steel bars that were sharpened at one end to break up the compacted snow and ice. It was as thick as eight inches. There were no sewers, although the gutters were interconnected so everything flowed into the river anyway. In the gutters and where there were depressions and the stinky water had gathered, men would spread powdered quicklime with a shovel. This was to cut down on the smell and the bugs.

Two people sold lime in Apt. One was the woman whose husband was so devout that he whitewashed the decorated walls of Upper *besmedresh* so the men would not be distracted during prayer. The other was Yankl *kvapus* and his wife. That was not their real name. It was their nickname. They had no children. They sold lime, as well as starch and bluing for laundry, and herring. Don't ask me why this combination; people would do anything to get by. Yankl's wife was a big, tall woman. She wore many skirts, one on top of the other. What I remember best about her is the way she shook hands with everyone on the eve of Yom Kippur, the Day of Atonement, in front of the synagogue. This is a time of contrition. It was customary to apologize, ask forgiveness for any offenses committed during the previous twelve months, and shake hands. Crying, she would blow her nose in her hands before shaking hands.

Most of the houses on Broad Street were brick, but the odd one was made of wood. I saw how two wooden houses were built: one was on Old Rampart Street, and the other was in the courtyard of my grandfather's house on Broad Street. In that courtyard, the brother of Świderska, the town prostitute, built his one-room wooden abode, abutting the courtyard outhouse. To build their one-room house, they made the walls with vertical two-by-fours to which they nailed wide horizontal boards. To those boards, they nailed long strips of wood in a herringbone design, leaving about a two-inch space between them. Those long strips had been fashioned by splitting wood into lengths that were about 30 inches by 2 inches by 2 inches. Then they applied clay.

Just south of town, on the west side of *Ivansker veyg*, opposite Yarmye's Hotel, was yellow clay that was very sticky. This clay was exposed when they cut through a hill to make *Ivansker veyg* a long time ago. You could see a bluff of yellow clay about fifteen feet high under about three feet of the best topsoil. They would bring this clay to the building site, where they would mix it with water in a rectangular box about three feet by five feet. Women worked the clay with their feet until it was the consistency of butter. Then they picked up the clay with their hands and smeared it roughly into the spaces between the strips of wood that made the herringbone design. They pressed little pieces of stone and brick into the soft clay. They covered the entire surface with a heavy layer of clay, smoothing it out with their hands. After the clay was almost dry, they took a wet rag and wiped the surface to smooth it out some more, although it remained a little bumpy. When the clay was dry, they whitewashed it. If you had money, you would apply a couple of rows of tiles or nail eight-inch-wide boards to the bottom of the wall so the rain and snow would not wash the clay away. If the base of the wall washed away, it was easily repaired with clay. When the sun dried the surface, it became almost as hard as unfired brick. The interior walls were made the same way.

As for the other trades associated with making a house, there was one glazier in town. His name was Laybish Yukl. His business was in his house on *Klezmurim-gesl*, which was a continuation of Broad Street, where it narrowed. He was also the bookbinder; I once took a book to him to be bound. Because he handled paper and made paste, people assumed he could hang wallpaper, too. Wallpaper was so rare and expensive that when Mordkhe Wajcblum, my mother's cousin, brought wallpaper back from Warsaw, he asked the bookbinder to hang it. He managed somehow to do the job.

As far as metal fittings were concerned, one man—I think his name was Lubliner—made hinges for doors. His place was on *Shevske gas* (Shoemaker Street). We knew his family,

though I did not have much to do with them. He made hinges out of steel oil drums. To this day, I wonder how, with the little technology that he had, he managed to take the steel drums apart, straighten them out, and make the hinges. He tumbled the hinges in two revolving drums in the yard outside his workshop: one was filled with sand for cleaning the hinges; the other was filled with pieces of leather for polishing them. He probably made these drums himself specifically for the purpose of tumbling the hinges. These drums ran on an electric motor, but before there was electricity he actually turned the drums by hand.

The non-Jews did not have their own neighborhood. They were scattered through the town. The better-off ones rented brick houses. Others lived on the outskirts of town, where they had more land. Where *Ozherover veyg* intersected with the Opatówka River, you could see old-fashioned houses with thatched roofs. Polish people lived there in one or two rooms. Being on the edge of town, these houses had a little land around them, a garden, a few chickens, and maybe a goat. They had an outhouse. In summer, the gardens were full of flowers and vegetables.

Farmers who lived in the countryside or in a nearby village were better off than many Poles in town because they had their own well, an outhouse, and a couple of cows. Not only could a farmer feed himself, but he could also sell the milk and the butter and cheese he made. Nonetheless, things were very difficult.

Most towns were built near a body of water, and Apt was no exception. Flowing along the western, northern, and eastern sides of town was the Opatówka River. We had our favorite spots. We swam in the *kanye*, a deep pool in a bend of the river near the bridge along *Tsoʒmirer veyg*. We slithered down the *shliʒhe*, a wooden slide under the bridge along *Oʒherover veyg*. Because of erosion, there was a steep drop in the riverbed at that point. To prevent further erosion, they covered the slope with wooden planks. A gentle waterfall flowed over the planks, which were overgrown with algae and very slippery. We used to slide down the planks into the deep pool that formed at the bottom of the slope.

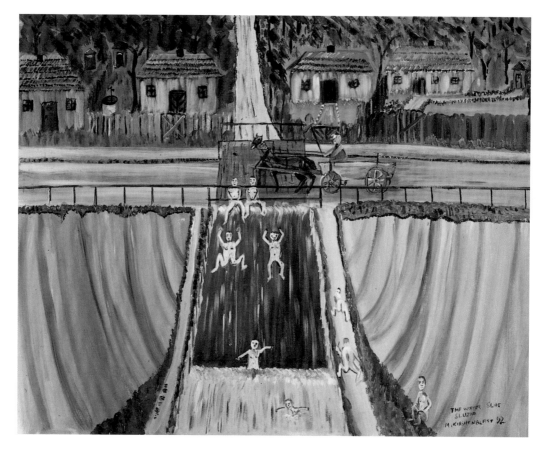

*The
Water Slide*

The riverbanks were very deep and steep. We used to take *Takhl-gesl* (Little River Street) from the center of town to the western stretch of the river and watch the women rinse the laundry in the shallow water. The river was so shallow in some areas that you could walk across it on stepping-stones. *Takhl-gesl* was a wide, unpaved street. The cooper, the wood-turner, and the wainwright, the man who built wagons, worked on this street. On nice days, I could see the cooper working outside. He made butter churns, buckets, some large pitchers, and, of course, barrels. He also did repairs.

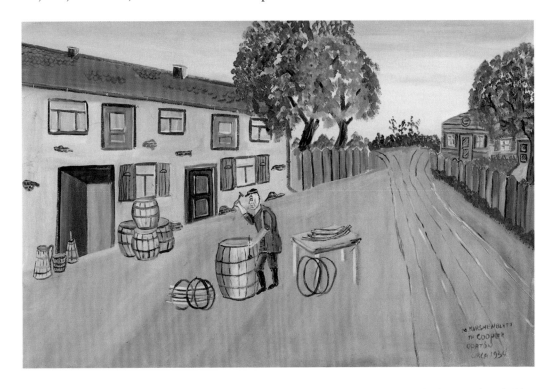

The Cooper on Little River Street

Altogether there were three, possibly four, mills in town. The river, which was also fed by springs, provided enough water to turn the wheel of Goldman's water mill, which was located just north of the bridge along *Ostrovtser veyg*. Alongside the river, next to this mill, were two ponds where they raised carp in the summer and harvested ice in the winter. We used to catch minnows at the entrances to those millponds.

The biggest mill was Srulke Rozenberg's power mill, which was located on the river just south of the bridge along *Lagever veyg*. Rozenberg and Goldman were business partners. I'm told that a Goldman in-law helped to develop and modernize the power mill. I used to be friends with Goldman's son Khaskl. They had a bathtub installed in a tiny room in the

power mill and diverted water that cooled the engines to fill the bath. The water was not very hot, but pleasant. We used to bathe there, which was very nice. Others say there was a third mill, owned by the Goldbergs, near the cemetery, but I do not remember it.

What I do recall is that a Polish farmer owned a windmill (*wiatrak* in Polish). It was on a windy hill on *Ivansker veyg* about half a mile out of town. Because the big mills could not be bothered grinding small amounts of grain, my maternal grandfather, Sruel, would carry a sack of grain to the windmill, which produced a coarse gray flour. Grandfather would take this flour to Yosl Tsalel Volfs, who baked *shtopers*, delicious flat cakes sprinkled with sugar. The full name of Yosl Tsalel Volfs, which translates as Yosl, son of Tsalel Volf, was Yosl Wakswaser. He made the best cheesecake in town. I especially liked his bread, which was round, yeasty, and topped with a crisp red crust, which he slashed. It must have been a sourdough. It was delicious. Each baker made his product differently. Yosl Tsalel Volfs's *shtritslekh*, blueberry buns, were extraordinary: lots of blueberries, thin dough, full of juice. When you ate them the juice ran down your chin. His store was on Broad Street, directly opposite the synagogue.

There were many bakers in town, most if not all of them Jewish, as far as I know, and each one had its specialties and clientele. First was the bakery opposite Yosl Tsalel Volfs's, which was in a basement. Grandfather used to take pumpkin seeds there to be roasted. Second was Gelman's bakery, which was just below Moyre Simkhe's *khayder*. The school was upstairs, and Gelman's bakery was next door downstairs. Gelman's son was in *khayder* with us, and my friend Uma befriended him. Uma was always promoting someone for something; Gelman's father baked pastries, so Uma promoted him for pastries. The boy was eager to chum around with us because a lot of boys envied us four musketeers—me, Fromek Wajcblum, Uma Grinsztajn, and Maylekh Katz—or, as we were called in Polish, *czterej muszkieterowie*. We boys spoke Polish among ourselves and Yiddish with our parents. Maylekh's nickname was *ketsl* (kitten), or Maylekh *ketsl*, because Katz means cat. Since there were two Maylekh Katzes in town, he was also known as *der klayner* Maylekh (Little Maylekh) to distinguish him from his first cousin *der groyser* Maylekh (Big Maylekh). Ketsl and Uma survived Auschwitz; Fromek was in the Polish cavalry and died in action. We four were best friends.

Third was Marmurek's bakery, which operated twenty-four hours a day and attracted people who lived in the market area. This bakery was so famous that it even appeared on a map: Saul Marmurek, who survived the Holocaust and came to Toronto, remembers that a German soldier came into their bakery and showed him that their bakery was marked on his map. Marmurek told me that his family baked a variety of savory rolls, sweet rolls, and breads.

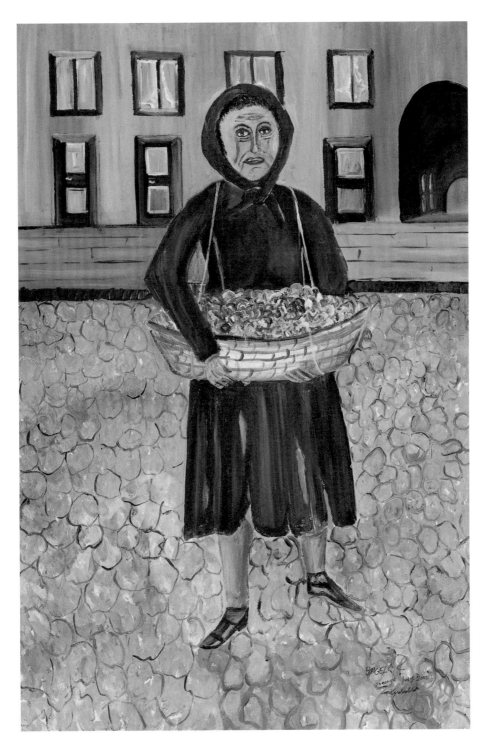

The
Bagel-Seller

The rolls included *mantove ʒeml*, a kind of panini, made with wheat flour and yeast. A *platsek* (*placek* in Polish) was a flat bread made from dark wheat flour. Sweet rolls included *shtrits-lekh* and *shtopers*, which were very inexpensive. *Shtopers* were made with a cheap, dark wheat flour from which the best part had been largely removed; they were also known as *poplonkes* in Yiddish and *poplonki* in Polish. They were small, round, and flat, with little indentations on top so they would not balloon when they rose, and they were sprinkled with a little sugar and baked in a wood-fired oven like you bake pizza. Marmurek's bakery made both sour-dough and yeast breads. Sourdough breads included *gebatlt broyt*, made with about 55 per-cent rye flour, and *raʒeve broyt*, a dark coarse bread made from about 95 percent rye flour. *Raʒeve broyt* was the real dark farmer's bread. It really moved the bowels. Yeast breads in-cluded *vaytsn broyt*, a round wheat bread, also called *droʒhdʒhove broyt* (*drożdże* means yeast in Polish).

The fourth was a baker in our neighborhood. I don't remember his name. He was so thin, he was a veritable twig. I never knew how that man managed to work. His specialty was hallahs, buns, and, above all, bagels. He baked delicious bagels, which were just like the *ob-warʒanki* still sold on the streets of Kraków today. The bagels were made of two thin coils, which he twisted, bringing the ends together to form a ring. He would put the bagels on a stick, several at a time, and drop them into boiling water. When they floated, he would lift them out with the stick, let them drain, and place them on a peel. Before setting them di-rectly on the floor of the oven, he would sprinkle them with poppy seeds and salt. We waited for him to take the bagels out of the oven so we could take them home hot. He was the baker who baked our challahs for us and kept our Sabbath breakfast and dinner hot in his oven. A fifth bakery, which was nicknamed the *Kuter-beker*, Tomcat Baker, was known for a spe-cial *kiml*, or caraway, bread. Bagels were also sold on the street. I remember a woman who walked around selling bagels from a basket that she carried on Wednesday, when there were lots of people in town for market day.

There were also several bakeries that made matzo for Passover. Ester Lustman's mother had such a bakery on *Ivansker veyg* in the basement of her house. All year long, she sold her baked goods from a shop on the main market square. When it came time to make matzo, she cleaned out the bakery to get rid of all traces of leaven. The way they made matzo was like this. One man did the kneading and portioned out the balls of dough. Six women diligently rolled the dough on a board. One lady did the perforations, and a man at the oven baked the matzo. The whole process, from adding water to the flour to taking the matzo out of the oven, had to be completed in eighteen minutes or less, according to religious law.

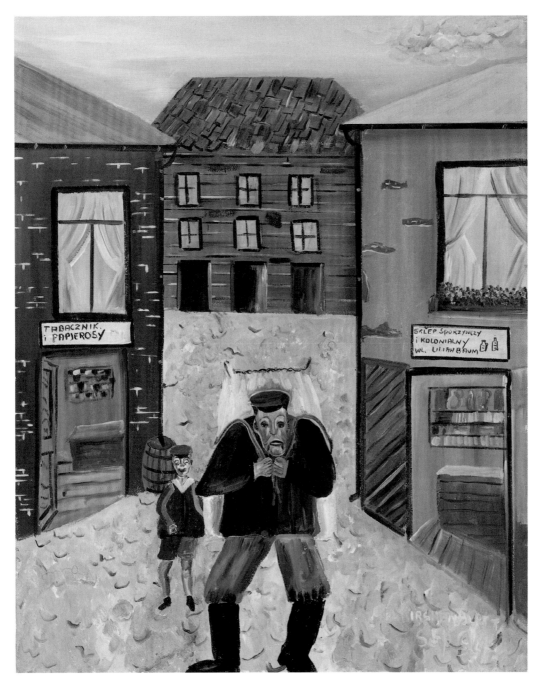

Laybl Tule,
the Flour-Porter

The bakers got most of their flour from Rozenberg, whose power mill was the main mill in town. Rozenberg, the only one to mill on a large scale, supplied flour to the whole town as well as to outlying areas. Most of the grain came from Heynekh Langer, the biggest grain merchant in the city. Langer and Rozenberg were rich men. Langer lived on *Tsozmirer veyg* and was one of the select few who had a telephone in his house. Most everyone else had to call from the post office, which was not very often in any case. Tall and bearded, Langer was Orthodox. Rozenberg was the only person in town that I know of who owned a grand piano. His daughter, Alte, used to take piano lessons from the church organist. My mother was very friendly with his wife. They were both active in the Zionist organization and helped establish the Tarbut *shule*, a Zionist school that not only taught modern Hebrew but also used Hebrew as the language of instruction for many subjects.

Rozenberg employed several people, among them Laybl *tule*, who had an unwritten agreement with Rozenberg that he would be the only porter to haul flour from Rozenberg's power mill to the bakeries and stores in town. It was a very difficult job. A sack of flour must have weighed over two hundred pounds. Laybl *tule* would hang out around the power mill, waiting for the next delivery. My mother told me that, when I was a little boy, I attached myself to that guy and followed him around wherever he went. If my mother were looking for me, she would ask, "Did you see Laybl *tule?*" People would say, "Yes, he is over there." Then she knew where to find me. My mother didn't like me wandering all over the place. I was three or four years old. So she said to me, "You know what his name is? His name is Laybulu *tululu.*" So when I followed him around I would call out, "Laybulu *tululu*, Laybulu *tululu.*" He did not like that, so he would chase me away. After two or three times, I finally took the hint and left him alone. I never followed him around again. Laybl *tule* was also a champion domino player. He used to play with another champion, *der blinder* Yosl, Blind Yosl, the brother of my maternal grandfather, which made him my granduncle.

The Goldman family had been in the milling business for generations. Goldman's water mill on *Ostrovtser veyg* was a small operation. It worked partly on water and partly on power. It was located on the west side of the bridge, where *Ostrovtser veyg* crossed the river. There must have been a steep drop in the river at this point in order for the water to flow over the big waterwheel and make it turn.

On either side of the river, next to the mill, were two carp ponds. I believe that Goldman owned those ponds, too. They fed the fish the by-products of the flour mill. They controlled the water level of the millponds and kept the water fresh and circulating by means of two wooden barriers, about two feet wide and as deep as the millpond. They would raise and

lower these barriers to allow water from the river to flow in or out of the pond. The two openings to the millpond were covered with wire screens so the fish could not escape. To catch the fish, they drained the millpond by closing the intake and opening the outflow to release the water into the river. Workers would enter the drained millpond with wicker baskets and collect the carp flopping on the mud. To refill the millpond, they would reverse the process, closing the outflow and opening the intake. Near the screen of the intake gate were millions of minnows. My friend Khamele Wajnberg took a sieve that they used in the mill—the sieve was made with horsehair—and we caught minnows with it.

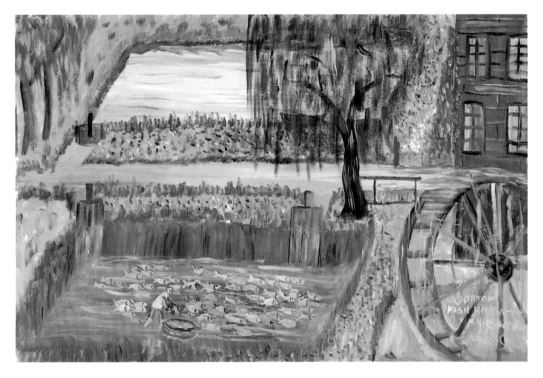

Carp Ponds

There was also a punt that we used to row on the millpond. We spent wonderful hours there, dreaming about sailors and pirates; I knew about pirates because I was reading a lot. These millponds were also where they cut blocks of ice during the winter. Men would use saws to cut the ice. They hauled the ice away on a wagon and stored it in sawdust in a barn until summer, when they would sell it to candy stores, ice cream shops, and drinking places. Where they stored the ice was called the *lapus*. I didn't see this but was told about it many years later by the people who sold ice to my father. This is where my father got ice for his little candy store before I was born. Later, the ice came from somewhere else.

Khamele's father owned a little grocery store on the ground level of the mill building, which faced *Ostrovtser veyg*. He was located just past the toll bridge on the way into town, so peasants coming to market on Wednesdays might stop off to buy something from him. Otherwise, local people would not bother to go beyond the city gate for groceries. His main income was from the eggs that he preserved in the basement of his home, which adjoined the city gate, a short distance from the mill. He was ideally placed because the farmers would pass his house on their way to the marketplace, and Wajnberg could have first crack at buying their eggs. In the basement of his house was a huge pool of water in which he dissolved quicklime. All summer, he bought eggs and immersed them in that limewater to preserve them. The lime in the water was not enough to make the solution jell but just enough to preserve the eggs. The solution stayed liquid. In the winter, when there were no eggs, he shipped preserved eggs to Warsaw, Łódź, and other large centers. We did not eat stored eggs. We ate only fresh eggs. I think the stored eggs were used for baking. Eggs were hard to come by in the winter because chickens did not lay then. In the summer, when the hens were laying, they would keep the roosters away from the chickens so they could not fertilize the eggs, because Jews would not eat an egg with a *blitstrop* (fleck of blood), indicating that it was fertile.

I used to chum around with Khamele and his sister Ester. Every time I went to see Ester, she was a different person. She always acted out the characters of the latest book she was reading. One day she was Anna Karenina, another day she was the heroine of *War and Peace* or *Les Misérables*. I was a handsome young lad with blond hair and blue eyes. You wouldn't believe it, but I had beautiful curly hair. The parents of some of my girlfriends objected to their daughters going out with me because I didn't wear a hat. So we were already a bit assimilated. Ester's father didn't like me because one day he saw me bareheaded on the street. So he discouraged Ester from seeing me. Whenever I wanted to see her, I had to make sure that he was not home. He always came home for lunch. Even from the street I could hear him slurping his soup. One day while I was visiting, he came home unexpectedly. We heard him coming up the stairs. Ester pushed me out to the balcony. They lived right next to the ancient city gate along *Ostrovtser veyg* and were neighbors with the Trojsters, who were harnessmakers. After about five minutes out there, it suddenly started pouring and I got soaked. We were more careful after that.

The Jewish Street was synonymous with the Jewish neighborhood, although Jews lived throughout Apt. It was the main street in the Jewish part of town. This street was known by three names: the Jewish Street, Broad Street, and Berek Joselewicz Street. It was called the Jewish Street, *di yidishe gas,* because it was the center of Jewish life. The synagogue and two of the *bes-medrushim* (houses of study) were on this street. It was called Broad Street—*di brayte gas* in Yiddish and ulica Szeroka in Polish—because it was the widest street in town. With stores on both sides, it was the most commercial street besides the marketplace. This street was renamed ulica Berka Joselewicza in Polish and *di gas fin Berek Yoselevitsh* in Yiddish for the Polish Jewish hero who founded a Jewish cavalry regiment and fought with Tadeusz Kociuszko for Polish independence in the 1794 uprising against the Russian occupation. Kociuszko had distinguished himself as an army engineer during the American Revolution of 1776 and returned to Poland to fight for its independence. Although ulica Berka Joselewicza was the street's official Polish name, it was seldom used. The best part of the Jewish Street was at the upper end. People who lived there did not associate with those who lived at the lower end.

The synagogue—it was called *di hoykhe shil,* the high synagogue—was never used during the week but only on Friday evenings, Saturdays, and holidays. It was huge and unheated. In the winter, it was bitterly cold inside, and there were barely enough people to make a minyan, a prayer quorum of ten men. Usually, services took place in the *besmedresh, shtibl* (Hasidic house of prayer), or *lokal* (meeting hall) of one of the Zionist organizations. Everyone went to these places for morning and evening prayers. They only came to the synagogue on the Sabbath and holidays. In better weather on a Saturday morning, there was a crowd at the synagogue, many more people than I show in my painting.

The synagogue, to my eyes as a youngster, was an imposing edifice. When the synagogue was built, about five hundred years ago, Jews were not permitted to build the synagogue higher than the church, lest the synagogue dominate the church. A sunken floor thus gave the synagogue interior extra height. To enter the men's section, the main sanctuary, one had to descend about four steps. The floor was made of large stone slabs.

There were two doors: one to the main synagogue, and, to its left, one to the women's section on the ground floor. An outdoor staircase led to the second floor of the women's section, which had a dirt floor. I believe that the floor of the women's section was made by pounding earth between the thick beams. There were semicircular windows along the walls of the women's section. In places of prayer on one story, there were wooden floors and a *mekhitse*, a partition, beyond which the women sat.

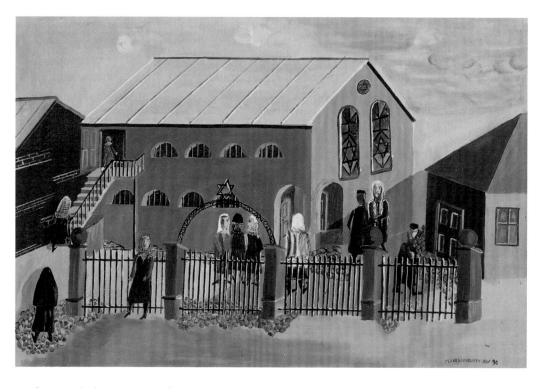

Synagogue Exterior

In the vestibule was a big *fas*, a wooden water barrel. Men would wash their hands when returning to the synagogue after they had gone out to urinate. There was also a towel, a loop of cloth about five feet long hanging from a dowel. It was black from being used by everyone.

Alongside the outdoor staircase leading to the women's section was a wooden shed that was attached to the outer west wall of the synagogue. This shed, the *pulish*, was where they tossed all the old prayer books; inside the synagogue there was another *pulish* for worn-out Torah scrolls. When sacred texts could no longer be used, they had to be disposed of properly— either burned or buried in the cemetery. In other words, you could not use the pages of a prayer book for toilet paper. The house to the right of the synagogue was the *besmedresh*. Traditionally, there is always a *besmedresh* near a synagogue.

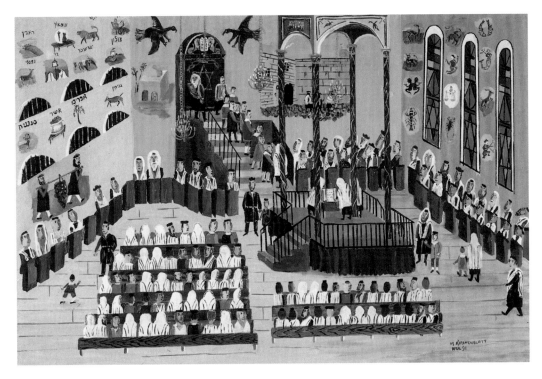

Synagogue Interior

My painting shows a Saturday morning inside the synagogue, a time of many comings and goings. The synagogue was constructed entirely of masonry, except for the benches and lecterns, the Holy Ark, and other pieces of furniture. A distinctive feature of this type of synagogue was the central platform holding the reader's desk (*bime*). This is where the public reading from the Torah scroll took place. The ceiling vaults converged at the four points of an impressive architectural canopy covering the *bime*.

In the middle of the east wall, facing Jerusalem, was the Holy Ark (*urn-koydesh*) containing the sacred Torah scrolls. In front of the Ark was the *ner-tumid*, the eternal light. Two eagles painted on the wall, one on each side of the Ark, made a big impression on me as a child. They were so huge, with their long talons and their wings outspread, as if they were about to land. The eagles and carved lions rampant on top of the Ark are symbols. As it is said in *Pirke uves*, Wisdom of the Fathers, "Be bold as a leopard, light as an eagle, swift as a deer, and strong as a lion to carry out the will of your Father in Heaven." To the left of the Holy Ark was a painting of Rachel's Tomb. To the right was a picture of the Western Wall. That is where the rabbi sat. Prominent citizens sat along the eastern wall. The decorations were beautiful.

About ten steps led up to the Ark. The choir stood on the steps. I am among them in the painting. The choir was made up almost entirely of boys. They sang soprano and alto. We had one or two men in the bass section. The man in white is the *khazn,* the cantor. He stood below. He would lead the service and conduct the choir at the same time. During the fall, before the holidays, the *khazn* would go around to the Jewish schools and find boys for the choir. He would make them sing a scale to determine if they had a good voice and an ear for music. He used a tuning whistle to sound the note of A, if I remember correctly. I was picked. I sang in the choir from the age of nine or ten until I finished *khayder* at the age of fourteen. We would go to his house for rehearsals twice a week. Just before the High Holidays, there could be rehearsals every day. That was the only time of the year that we performed. He gave us about a zloty, a silver zloty, like a silver dollar, for our efforts. That's what all the *meshoyrerim,* the choirboys, got. He didn't have very much money. They didn't pay him very much. For us it was very nice to get a zloty. The *khazn* had not been blessed with sons, only daughters. They lived in one big room on *Tsozmirer veyg.*

On the north wall were the barred windows of the women's section. Women were required to sit separately so as not to distract the men from prayer. On that wall were the coats of arms of the twelve tribes. Below them were the two spies sent by Joshua to scout out the land. They brought back a big bunch of grapes to show how fertile the land was. The entrance to the sanctuary was from the northwest corner. On the south wall were stained glass windows and signs of the zodiac. There were also stained glass windows on the west wall.

Just as we were leaving for Canada in 1934, the community imported a painter, Professor Perec Willenberg, from Częstochowa, to redecorate the interior. About ten years ago in Israel, I met his son, Sam (Shmuel), the only Apt Jew to survive Treblinka. Sam was not originally from Apt but was forced to move there in 1940. He told me that the war broke out before his father had a chance to finish. Sam also told me that his father saved himself and made a living during the war by painting the Holy Mother and Jesus Christ and selling the pictures in front of churches. He pretended to be deaf so he would not have to speak, because if he spoke people could tell from his accent he was Jewish. He would follow pilgrimages to holy sites in Poland like Częstochowa and paint holy pictures for the local population. Sam told me that after the war he went back to Warsaw and, as he descended into the basement of a building, he looked up and saw, on the slanted underside of the stairway above his head, a picture of the Virgin Mary that his father had painted. His father had signed it. Turns out that Sam's mother had converted to Judaism from Russian Orthodoxy.

On the Days of Awe, a pall of sadness would descend on the town. These were the most important days of the year. On these days God would give out His sentence for the coming year, and your fate would be sealed for the next twelve months. During the entire month before Yom Kippur, the men would go to say *slikhes*, penitential prayers, to ask for forgiveness.

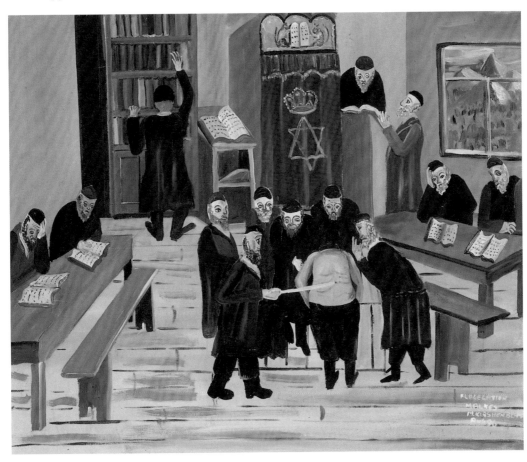

Malkes: Flagellation

It was customary among some pious Jews, a few hours before sundown, to subject themselves to flogging as a sign of contrition. This was called *malkes*. The Christians were not the only ones to use flagellation. The Jews did, too, and some Orthodox Jews still do to this day. It is written in the Talmud that, during the afternoon, a few hours before Yom Kippur eve, one should receive thirty-nine strokes, although six is an acceptable amount. If a man were ill, three strokes or none at all was all right. The flogger, the *shmayser*, was paid a small amount by his victim. A counter was standing by to keep track of the strokes in case the flogger got too enthusiastic.

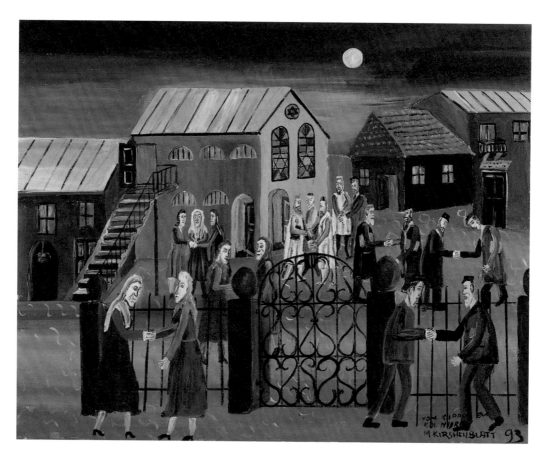

*Yom Kippur
Eve*

On the fateful evening of Erev Yom Kippur, people would gather outside, on the street or in the courtyard, and shake hands. If you were angry with anyone, you made up. You wished each other health, prosperity, and long life. This was a time of forgiveness. Then everyone packed into the synagogue. The weather was usually mild because Yom Kippur falls in the early autumn. Inside the synagogue, there was a heaviness in the air. The place was lit with tapers and lamps. Everybody was standing shoulder to shoulder. The smell of their freshly oiled boots mixed with the scent of burning candles. Everybody was bloated from gorging themselves on the last meal before the twenty-four-hour fast.

It is on Erev Yom Kippur, just before reciting the awesome Kol Nidre, that the preferred seats and the honors, the *aliyes*, such as getting called up to the Torah and reciting the *mafter*, the Haftorah, are auctioned off. The first *aliye* goes to a Kohen, the second to a Levite, and then the third one is auctioned off.

The eve of Yom Kippur was also the only evening service when we wore prayer shawls. The rest of the year, whether daily, the Sabbath, or holidays, we wore prayer shawls only at morning services. At the point in the Erev Yom Kippur service when the Kohanim, the priests, were to bless the congregation, they paraded to the dais in front of the Holy Ark. We youngsters would wait with great anticipation for the coming event. Everybody had to cover their faces with their prayer shawls. They were not supposed to look at the raised hands of the priests while they performed the blessing ritual (*dikhenen*) because the glory of God (the *shkhine*) would rest on their outstretched hands, which they held in a special way, with a space between the third and fourth fingers and thumbs touching. We were warned that, if we looked, we would become blind. Of course, I looked. Notwithstanding the danger, as soon as the main priest cried "May *hashem* [the Lord] bless you and protect you," that was the signal for us to perform our ritual. We got busy tying the fringes of the prayer shawls together. When it was over and people went to sit down, pandemonium broke out

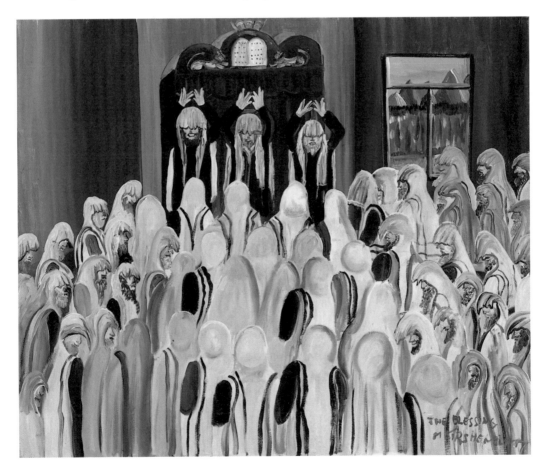

Dikhenen:
The Blessing

because all the prayer shawls fell to the floor and everyone was scrambling to untangle his fringes from those of his neighbors. By that time we were gone. After the service was over, most people returned home. Some remained to pray all night.

It was said that, on Erev Yom Kippur, ghosts wandered around the empty places of prayer. The spirits never frequented places where there were people. However, that didn't faze my friend and cousin Uma. We snuck up to the women's section after the women had gone home and played a trick on them too. The upper part of the body is divine. The lower part of the body is profane. This is the reason that religious Jews, when they pray, wear a sash, or *gartl*, to separate the sacred from the profane. This is also the reason that the women kept bottles of water with them in the women's section, the *vabershe shil*. Should a woman break wind or touch some part of her anatomy below the waist, she would symbolically wash her hands by sprinkling a little bit of water over them. Each woman had a bottle of water for that purpose. The women sat on benches. When they went home, they would leave their little bottles of water near their seats. They expected to find them there when they returned the next day for services. We would go up there when they were gone and empty the bottles on the ground. Imagine, the next day, when the women returned to the synagogue. They were rushing down to the water barrel all day. Man! There were a lot of comings and goings and not much praying that day. We only did this on Yom Kippur, when there were lots of women at the synagogue and they stayed there all day.

The solemnity of a holiday never stopped us from playing pranks. Tisha b'Av, the Ninth of Av, is a holy day, a day of great sadness. This day usually falls in August. During the eight days leading up to Tisha b'Av, religious Jews did not eat meat. On the eve of the holiday, after a hefty meal to carry one through the next day's fast, we went to the *besmedresh* for *marev*, the evening service. After *marev* and the reading of Lamentations, a solemn prayer commenced. The man who recited *kines* (dirges) in a sonorous voice would sit on the floor. Everyone was very sad as they listened to what happened in Jerusalem when the Temple was destroyed. The next day we would go to the cemetery to visit the dearly departed. After someone dies, he is always referred to as the "dearly" departed, no matter how horrible a person he was. In Polish, they used to say "*Każdy nieboszczyk świętym był,*" which means "All who departed were saints."

On Tisha b'Av, they were very busy at the cemetery. For a small fee, there were men who would recite the *El mule rakhamim*, a prayer for the dead. There was a lot of coming and going. Everyone carried garlic to leave on the graves. It was a custom, perhaps to ward off evil spirits. To us youngsters, Tisha b'Av was a great day. First, we were off from *khayder*.

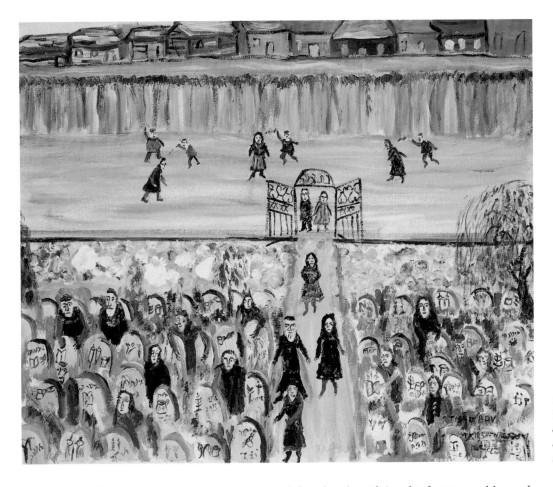

*Tisha b'Av:
Throwing Burrs
at the Women
as They Enter
the Cemetery*

Second, we played pranks. Most women covered their heads with kerchiefs. We would search for girls and women who were not wearing head coverings and throw burrs at them. Once entangled in their hair, the burrs were very difficult to remove. There were plenty of burrs in the cemetery, which was covered with weeds, so we would collect the burrs and, as the girls approached the cemetery, we would accost them. In the afternoon, when the traffic subsided, we would play the rest of the day away. Mother did not make us fast.

Jews say a blessing on the new moon. The moon is a heavenly body and it is customary, every month, when there is the first hint of a new moon, to go outdoors and say a blessing. The new moon must be clear; there must not be even the tiniest little cloud obstructing the sliver of moonlight. The synagogue was the center of Jewish life, so in my painting I show the people saying the blessing in front of the synagogue. I took artistic liberty in showing a full moon.

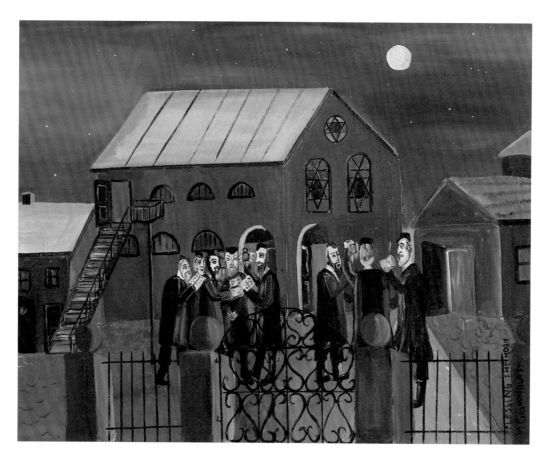

Blessing the New Moon

It is also a custom to say a blessing on the sun every twenty-eight years. Although this happened in my time, I did not witness it. I read about it in the Apt chronicles. It is reported there that the rabbis made announcements in all the synagogues, houses of study, and schools. The entire Jewish community was to assemble in front of the synagogue at the crack of dawn on the eighth day before Passover in 1925 to *mekadesh ʒan di ʒin,* which means "to sanctify the sun." Urish Lustig, a renowned fiddler in Apt, composed a special tune for the occasion. On the appointed day, the town awoke to the sound of a gay march. Everyone assembled, and at five o'clock the chief rabbi, dressed in his festive clothing, with his *shtraml,* his fur-trimmed hat, appeared together with other rabbis and the Jewish community's executive board. The *kleʒmurim* played the Polish anthem, *Jeszcze Polska nie zginęła,* which means "Poland will not disappear as long as we live," and the Jewish national anthem, *Hatikvah,* which means "Hope." The crowd formed a procession and walked to the accompaniment of happy music across Broad Street, along a back street, *di alte valove,* onto a meadow near

the premises of the ritual slaughterer. The rabbi raised his arm to the east. The first rays appeared. Then, little by little, the sun began to rise. The rabbi made a sign with his hand to start the prayers. The musicians prepared their sheets of music, Urish picked up his fiddle, and the ensemble played. I envision the rabbi standing on a table, and that is how I painted the scene.

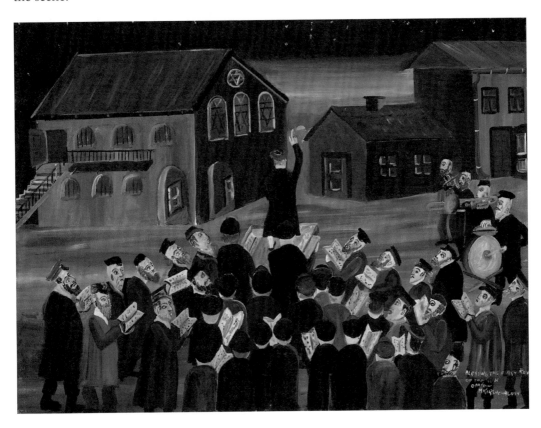

Blessing the First Rays of the Sun

There were three major *bes-medrushim* in town: Upper *besmedresh* (*oybn-besmedresh*), Old *besmedresh* (*alter besmedresh*), and New *besmedresh* (*nayer besmedresh*). Upper *besmedresh* was so named because it was upstairs and almost at the top of Broad Street on the south side of the street. Old *besmedresh*, which was next to the synagogue, was so named because it was the oldest of the three; it was also called Lower *besmedresh* (*inter-besmedresh*) because it was lower on Broad Street. New *besmedresh* was located on the *di vul*, also known as *di alte va-love* and, in Polish, as ulica Starowałowa (Old Rampart Street), which ran parallel to and behind Broad Street.

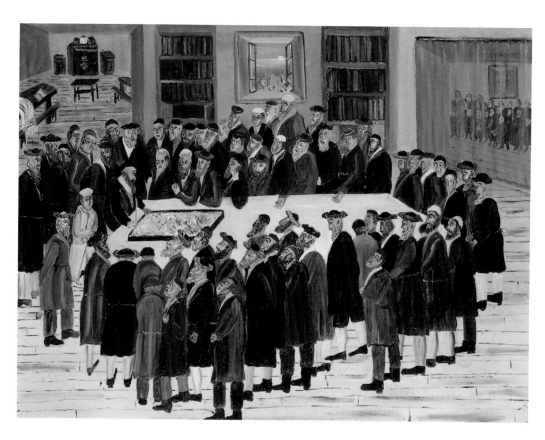

*Saturday
at the Holy
Rabbi's Table*

There were also several Hasidic *shtiblekh* (little prayer houses). Every Hasidic group used to get together. They would pray, sing the *rebe*'s melodies, and expound on his wisdom and miracles. I remember the Gerer Hasidim. There was also a Belzer *besmedresh*, very small, established and supported by a childless couple, Yoykhenen Sukher and his wife, to immortalize themselves. Yoykhenen was known as Yoyne. Hasidim would make a pilgrimage to their *rebe* for the High Holidays and for other holidays if they could. Even though they could not afford to buy food for the table, they managed to travel to the *rebe*, to be in the presence of the holy man. He would sit at the head of a large table and preside over the gathering of his followers. This event was called a *tish* (table). After the *rebe* tasted the food, his leavings (*shiraim*), which were considered holy because of his touch, were eagerly grabbed by his devotees. They pushed and shoved, they almost trampled each other, to get a little taste of the *kigl*, a noodle pudding. Although the majority of the Jews in our town were very observant, not that many were Hasidim.

Everybody went home to celebrate Hanukkah, the Festival of Lights, except those who were on their own: single men, widowers, and old bachelors would stay behind in the *besmedresh*. They made themselves a little ceremony: they lit candles, had a little drink and something to eat, sang a few songs, and spent the evening together.

There is a legend about Upper *besmedresh*, which occupied a huge room on the top floor of a building on the main street of the Jewish neighborhood. Many years before my time, Polish rowdies beat up Jewish students as they passed through a dark passage on their way to evening prayers. The students complained to the *Bezhimezher rebe*, "On our way to the *besmedresh*, we were accosted by evil spirits, and we were beaten up and our hats were stolen." As everyone knows, it is a sin for a Jew to go around bareheaded. The *rebe* was a big man, a six-footer, and weighed about two hundred pounds. He knew the score. He told the students, "Tomorrow night proceed to services the usual way and I will personally drive out the evil spirits." The *rebe* put on a *kitl*, a coat that was white like a burial shroud, and secreted himself in a dark place under a staircase. When the hooligans tried to accost the stu-

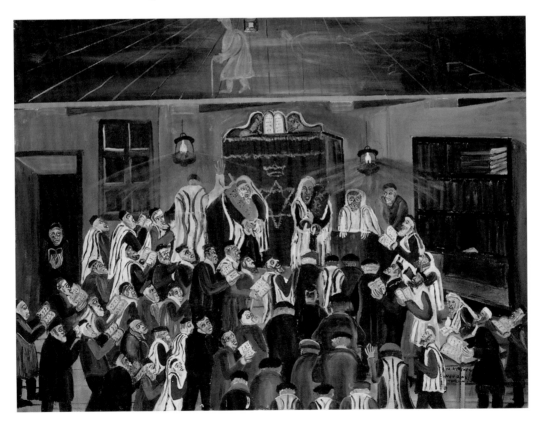

Reading Psalms before the Expulsion, 1942

dents, the *rebe* beat them up with his walking stick to within an inch of their lives. The rowdies thought evil spirits were attacking them and ran off. From then on, they never bothered the students again. As the legend goes, the *rebe*'s soul, his spirit, resided in the attic of the house of study. When the community was in peril, he walked up and down, striking the ceiling with his walking stick. But in 1942, when the Jews were driven out of Apt, the *rebe* didn't help them very much.

I was recently told that *Bezhimezher* is a corruption of *Mezhbizher* and refers to Abraham Yehoshua Heschel (1748–1825), the famous *Apter rebe,* who settled in Międzybórz toward the end of his life. He was known as the *Mezhbizher rebe.* He is the hero of a similar story told in the Apt memorial book by Duvid Pinczewski and Yitskhek Guterman. Old Hasidim told Guterman the story. In those days, evil spirits would grab the *shtramlekh* from the heads of the Hasidim and cause other problems. They told the rabbi what happened, and he instructed them to make a "stick." The stick was a bar of iron about two feet long. It weighed hundreds of pounds. Inscribed on the bar were the words *Avrum Yeshiye Heshl,* as we pronounced his name. The word *Apta* was unreadable because there had been a conflagration in the attic of the *besmedresh,* where the iron bar was kept, and part of the bar had melted. Guterman remembers that, when a famous rabbi came to visit and could not climb up to the attic, twenty boys went up there and brought down that iron bar. With great reverence, the boys would walk around the bar. There emanated from the bar a mysterious aura.

Reb Yeshiye Heshl was also known as *Oyev Yisruel* (Lover of Israel), the title of his celebrated book—*oyev* is how we pronounced the Hebrew word *ohev.* This was way before my time. I always thought of the *Bezhimezher rebe* as a talmudic scholar who taught at Upper *besmedresh,* whereas Reb Yeshiye Heshl was a leader of the community, a wise man. It was said that he was a *khoyze,* a person who could see into the future. I cannot imagine Reb Yeshiye Heshl doing what the *Bezhimezher rebe* did in the legend that I recounted. Would he have had time to teach boys, to chase after hooligans?

Next door to our entrance gate, behind Yankl Damski's tailoring establishment, lived a very pious man called Reb Moyshe Yitskhek. He spent all his time at Upper *besmedresh.* He was so devout that the world held very little interest for him. His wife had a store selling lime. He never worked, so far as I know. I think sometimes on Wednesday, which was a market day, he helped her out. She did a big business around Passover, when all the workers went around with buckets of whitewash and long-handled brushes. For a small fee, they painted the dwellings of the poor people for Passover. Reb Moyshe Yitskhek sat at the *besmedresh* all day and most of the night reading holy books. He fasted every Monday and Thursday.

Of course, that was also a way to save food. He was an unofficial caretaker of the *besmedresh*. After the service, he would go around the place searching for any pages of a holy book or prayer book that had fallen to the ground. He would reverently pick up the page, kiss it, and put it in its proper place, because it was sacrilegious to step on a piece of paper with holy writ. That was how he behaved day in, day out, year in, year out, for as long as I can remember.

One day the powers that be, the sexton and the *besmedresh* committee, decided to clean up the *besmedresh*. I do not know why, but the ceiling beams were black and had never been renewed. The management decided to at least decorate the walls to make them look nice, especially the eastern wall. That's the most important wall because it faces Jerusalem. No one could remember when it had last been painted. They hired a professional house painter, and he did a wonderful stenciling job of butterflies and meadows with flowers. Reb Moyshe Yitskhek was incensed. What did he do when there was no one in the *besmedresh?* At night, when everyone went home, he opened his wife's store, got some whitewash and a brush, and whitewashed the whole thing over. When the congregation arrived the next morning, they were shocked. They asked him why he did it. He answered, "When a Jew recites the eighteen benedictions, he stands in front of his maker. He must not have anything in front of him to distract him. The ornate walls interfere with his concentration. That is the reason there should be no decorations, only white lime." The management had to concede. After that, the place was only ever whitewashed. This story is told in the Apt memorial book. We would also go to Reb Moyshe Yitskhek to exorcise an evil eye.

Lower *besmedresh* was a single-story wooden building attached to a private brick house next to the synagogue, which is the traditional location for a *besmedresh*. Lower *besmedresh* was the town *besmedresh;* it belonged to the *kehile*, the official Jewish community. It was the oldest house of study in Apt, which is why it was also called *alter besmedresh*, and was thought to be even older than the synagogue. During the week, my grandfather went to Lower *besmedresh* for morning prayers. It was five or six buildings from his grocery store and home, which were on the same street. My grandfather would make the earliest minyan, which was at seven o'clock. There was always a minyan going on. One finished and the other started because there were always people there. The first one was at dawn for the laborers. The second one was for the businesspeople. The third one was for the unemployed and ne'er-do-wells.

Grandfather ate nothing before leaving the house. You don't eat before prayers. After the minyan, which lasted fifteen or twenty minutes, he would hang around, look at the holy

books, and chitchat with the guys. He stayed longer in the morning to save a meal, arriving home in time for lunch. That way he could skip breakfast. Breakfast was a piece of black bread, a little cheese, and *bavarke*, a glass of hot water with milk, or else he made chicory, a combination of coffee and chicory that was mostly chicory. It came in cylinders, a black mass. It was called *tsikorye*. Chicory was an important business in Apt.

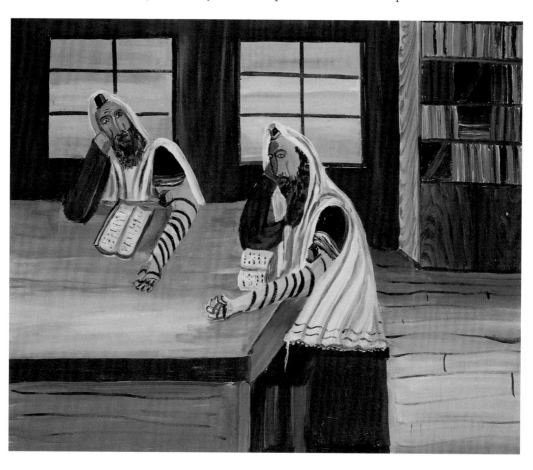

Shakhres: Morning Prayers in Lower Besmedresh

This painting shows a weekday morning service (*shakhres*) in Lower *besmedresh*. You can tell it is a weekday because the men put on *tfiln*, or phylacteries. *Tfiln* are not used on the Sabbath and holy days. Also, on Saturdays, there would be many more people. There were two minyans for the morning services. The first one was so early the sun was still rising and the sky was red. My painting of the *besmedresh* shows the table near the window; everyone preferred that place because of the light. Being that the *besmedresh* is a house of study, I show a case of books.

The man studying the Zohar used to sit next to my grandfather. That man never worked. Whenever I came to the *besmedresh*, he was studying the holy books. I don't know how he made a living. He had a long, unkempt beard. It was matted. He probably never combed it for fear of removing a few hairs. He considered his beard sacred. To pull out even a single hair, even by accident, would be a sin. He used to cough and bring up lots of phlegm and spit it on the floor. His feet were always immersed in a puddle of mucus.

A few men were always hanging around in Lower *besmedresh*. The houses were cold, miserable, and overcrowded. Some people, mainly widowers, bachelors, and people who had no home, or nothing to go home to, would really spend a lot of time there. It was handy because you could always find a minyan there. Besides, they always had company for socializing, and the room was warm. A huge oven made of brick—it must have been about eight feet square, at least, and used wood and coal—heated the big room. During the winter, some men, especially travelers and itinerant beggars, would sleep on benches and tables around the oven. I heard that, when Apt Hasidim traveled to see their *rebes* in other towns, sometimes their prayer shawls and phylacteries were stolen while they slept in the *besmedresh*.

One of my fondest memories is hearing a traveling preacher (*baldarshn*) tell stories on a Saturday afternoon at Lower *besmedresh*. After the Sabbath noon meal, it was customary to get a nice afternoon nap. Upon arising, we partook of a snack called *shaleshides*, the third Saturday meal. My grandfather would then go to Lower *besmedresh* for the afternoon and evening prayers. If there were a preacher in town, I would join him. Between the afternoon and the evening services, it was customary for a visiting rabbi or preacher to tell stories. I wish I had the stories they performed from the Zohar, from the Kabbalah, stories about magic, devils, good spirits, bad spirits, miracles. As a young boy, I found these stories intensely interesting. We were enthralled. The stories took you out of your daily, miserable life. They fired your imagination. At the conclusion of the preacher's speech, the evening service was performed. Who paid him I don't know. He could not solicit money on the spot because Jews are forbidden to carry money on the Sabbath.

Although it was hundreds of years old, New *besmedresh* got its name because it was the last one of the three to be built. This *besmedresh* was known by the old-timers as the *besmedresh* of Rabbi Yankev, who was one of the three rabbis buried in the *oyel*, the hut in the cemetery. It was on Old Rampart Street. There were no houses beyond this *besmedresh*, only a path up a hill leading to a ravine; the path was called *di intergas*, Back Street, or *intern vul*, behind Rampart Street. My grandfather went to New *besmedresh* on Friday nights, Satur-

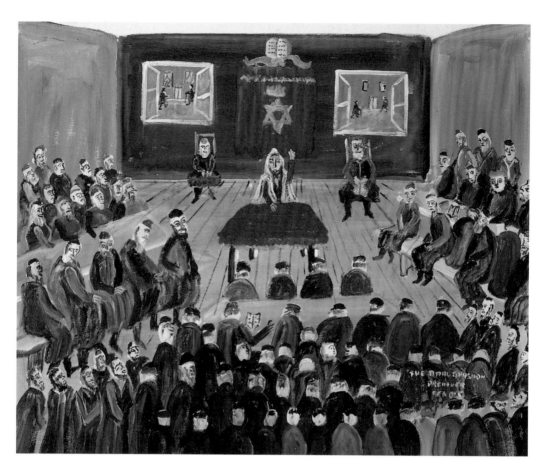

Baldarshn:
Preacher

day mornings, and holidays. Why he did not go there during the week, why he went to Lower *besmedresh* instead, I do not know. He bought a place at New *besmedresh*, a specific seat on a bench, near the window. No one else could sit there. He always sat in the same place, along the southern wall, with his back to the window. The most expensive seats were those near the eastern wall. They would auction off each seat, which was called a *shtuet*, a "city," on the eve of Yom Kippur. The money went for the upkeep of the *besmedresh*.

This painting shows New *besmedresh* toward evening. The men are going to *davn minkhe-marev*, the afternoon and evening prayers. (Men were obligated to pray three times a day— in the morning, afternoon, and evening—but some of the most pious men added an extra session, *khatsos*, at midnight.) It being a weeknight, we children, naturally, are having a good time playing *fusbal*, or soccer, in the yard. You couldn't play ball on a Saturday. We would just kick around a ball made from rags or a tin can. In the corner was a urinal. People thought

nothing of urinating there. It was no big shame to stand there and urinate. It was the normal thing. You can see the water barrel inside the doorway. After urinating, the men would pour water over their hands. The barrel was mounted on the entrance wall, over a cabinet on which there was a basin. To release the water, you pushed up a knob that protruded from the bottom of the barrel. The knob was attached to a brass rod inside the barrel. There must have been a thick leather washer on the end inside the barrel and maybe also a metal gasket, so that when you took your hand away, the brass rod inside the barrel slid down and the weight of the knob helped the leather washer press against the inside of the opening to make a good seal. Though I never saw the inside of the barrel, I surmise that it worked in this way.

New Besmedresh: Playing Soccer during Minkhe-Marev

When my father was home, going to services was no problem, because while the services were going on I played soccer with the boys and my father talked with his friends. He went to the *lokal* of the General Zionist Organization. In one room they had an Ark and a Torah scroll. He only went there on Fridays, Saturdays, and holidays. Things changed when my father left for Canada in 1928 and my maternal grandfather, Sruel Wajcblum, took over. My brothers and I became the wards of my grandfather and had to go with him to New

besmedresh on Saturday mornings. I used to get up very early every morning, so I looked forward to sleeping in on Saturday and holidays, but my grandfather would not allow it. He knocked on the shutters to wake us up about 7:30 in the morning, and we had to jump out of bed and dress. I rushed over to the baker to pick up the bottle of hot coffee and milk. Although you are not allowed to eat before you say your prayers, my grandfather compromised and allowed us to have a piece of Mother's butter cake and a cup of coffee before going to the *besmedresh*.

The Saturday service was long. It started early and lasted all morning. I hated it. I was prone to daydreaming. If I didn't keep my nose in the prayer book and he asked me where we were at and I didn't know, he gave me a flick in the head with his thick fingers. I was sure he made a hole in my skull. It was very painful. It sure woke me up. During the week I would pray at *khayder*.

My own bar mitzvah was not much. I knew my Torah portion, or most of it, and had practiced putting on the phylacteries. My father was away in Canada, and Grandfather was my proxy father. On the day of my bar mitzvah, he came to my *khayder* for the morning service, which I conducted, already wearing the phylacteries. He said the traditional prayer

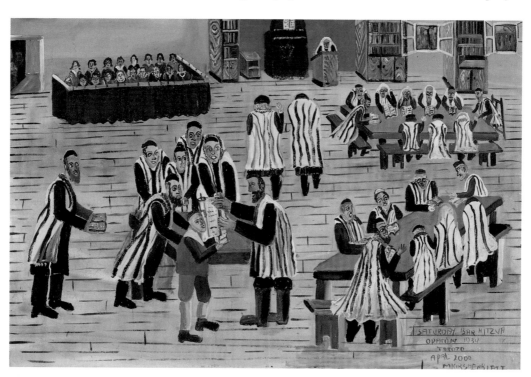

*Saturday
Bar Mitzvah*

absolving my father from my sins. He gave everyone a few candies. He gave me some cigarettes, which my friends and I thoroughly enjoyed.

Taking artistic liberty, I painted a bar mitzvah on a Saturday in New *besmedresh*. Because it is Saturday, no one is wearing phylacteries. The boy's whole family and friends are present. The *besmedresh* had a small women's section, which was marked off with a *mekhitse*. The boy chanted his Torah portion and everyone wished him well. The real bar mitzvah happened during the week, when his father helped him put on the phylacteries. After the prayers, his father said the traditional prayer: "Thank You, oh God, that You have liberated me from the responsibility for his sins." It is written that, until the age of thirteen, the parent is responsible for the son's sins. After the bar mitzvah, the boy is on his own.

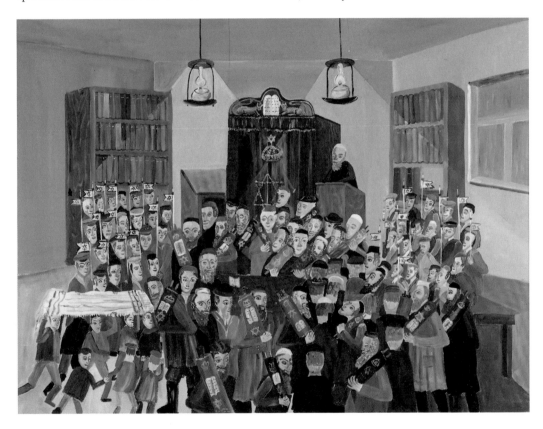

Simchas Torah

We youngsters used to look forward to Simchas Torah. Jews read portions of the Torah each week. By the time we came to this day of the year, we had finished reading the whole scroll and were ready to start all over again. The annual cycle of Torah reading was complete. It was time to celebrate. We would bring out all the scrolls so everybody could dance

and sing with them in a festive procession. The procession of the Torah scrolls is called *hakufes*. This painting shows the *hakufes* in New *besmedresh*. We would follow the adults around with flags. We would put an apple on top of the flag and stick a lighted candle in the apple. The flags were made of shiny paper in bright colors. Some were rectangular, others had two points. They were decorated with a Star of David and an inscription of some kind. We bought them in town and saved them from year to year. Finding the little flags was a big effort. Father would pretend he couldn't find them. Suddenly, a miracle, the flags appeared! This was a little game he played with us. Then, he put an apple on top of the flag and stuck a candle in the apple, and we headed off for the *besmedresh*. We had a great time. We were too small to carry our own Torah scroll, so we made a *malekh*, or angel, instead. We put aside our little flags and candles for the moment. An adult would gather six or eight of us together. He would throw a prayer shawl over us while he carried a Torah scroll. It was as if all of us were dancing with his one Torah.

How did we get so many scrolls? A Torah scroll was never thrown out, no matter what its condition, because it is forbidden to desecrate any page of holy writ or to use it for any profane purpose. When a scroll or a prayer book or a *khimesh* (Pentateuch) got old and dog-eared, when it was beyond repair, it was deposited in the *pulish*. When the *pulish* was full, the holy texts were buried in the cemetery. The synagogue was 500 years old, so there were lots of Torahs in the *pulish*. There was no *pulish* in the *besmedresh*, but there was a cabinet for worn-out scrolls and books. On Simchas Torah we dug out all the scrolls, so a lot of people had a chance to parade with one. This holiday was one of the few times when it was permissible to get a little tipsy.

Of the political organizations, only the General Zionist Organization and the Mizrahi, the Orthodox Zionists, conducted religious services in their meeting rooms and only on the Sabbath and holidays, not during the week. The General Zionist Organization was located in a two-story building just off the northwest corner of the marketplace. Both rooms on the ground floor, facing the courtyard, were supposed to be used for services on Friday nights, Saturdays, and holidays, but in practice one room was used for praying and one for talking. When they were reading from the scroll and the talking in the other room got too loud, they would yell, "Hey, guys! Quiet! We can't hear ourselves back here!" The rest of the week the place was used for meetings and social gatherings.

The men who came here were quite secular. This is where my father went for services and took us with him. We played in the courtyard while he was in the room with the talkers, reading the newspapers and discussing politics and, of course, emigration. My father and

mother were not Orthodox. My father shaved, and he did not normally wear a *yarmlke* (skull-cap). My mother did not wear a wig or go to the *mikve*, but she maintained a strictly kosher kitchen, and we celebrated all the holidays. My father only went to services on Saturdays and holidays. If my father didn't come to prayers with his four boys on Saturday morning, the other people figured he was sick. They started to worry. They would wonder, "Where's Avner? What's the matter with him?" So he would take his *tales* (prayer shawl) and parade the children to services. I do not remember my father ever putting on *tfiln* at home. Nor do I remember him going to services during the week.

The Mizrahi had their own place on Narrow Street, just behind our house, in the lower part of town. Their place faced the street. The entrance was from a lane between Narrow Street and *Klezmurim-gesl*, which was a continuation of Broad Street. It was not really a *besme-dresh* but more of a headquarters for their schools. They used a big room on the third floor of a large wooden building for prayers, mostly on Friday evenings, Saturdays, and holidays. They did not use the premises as a house of study. I went to their *khayder* but never went to any of their services.

The Jewish Street, an old part of town, grew up around the marketplace. Opatów was located at the crossroads of major trade routes and was famous for its markets.

Although Opatów was small by today's standards, it was considered a city. Jews were in the majority. According to the 1931 census, there were 9,512 people, of whom 5,436, or 57 percent, were Jews. I cannot say how the Poles fared, but most of the Jews went to bed hungry.

During my time, Opatów, which is located in southeastern Poland, was the district seat (*powiat*) in the province (*województwo*) of Kielce. Poles were the town officials and the civil servants in city hall and the district seat. They served on the police force and in the post office. Those who held jobs as civil servants considered themselves above the norm.

The postman wore a nondescript uniform. He knew everyone. We once received a letter in the mail without any address. It just said, "Wielmożny Pan Kirszenblat," Honorable Mr. Kirszenblat, with no address. The postman was also the town crier. When the local or the federal government had some proclamation to announce, the postman would stop at various street corners and sound his snare drum. People would gather. He would declare his announcement in a loud voice. The news would then spread by word of mouth. Telegrams were delivered from the post office. Telephones were few and far between. There was one at the post office. Heynekh Langer had one and so did Motek Czerniakowski, the butcher. On the few occasions when my father needed to use a telephone, he would go to Motek's. I assume that others who had big businesses—like Goldman, who had a flour mill, Lewensztajn, who was a lumber merchant, and Mandelbaum, the soap manufacturer and richest man in town—also had one.

I don't know when the first radio came to town, but I recall buying a crystal radio set in Lublin and bringing it to Apt in 1932. I had seen a crystal radio in Drildz the year before. It consisted of a little card with a crystal and a projecting point, on a spring, which I had to aim at the crystal to make radio contact. The spring was mounted on a little shaft, about an inch high, which was attached to the card. The point was on one end of the spring, and a little knob was on the other end. I turned the knob to aim the point at the crystal until I could hear something through the earphones. I ran a wire for the antenna from the top of our shed in the courtyard to the roof. I climbed up a ladder to get to the gable of our roof,

The Drummer:
Town Crier
and Postman

about fifteen feet off the ground. After affixing the wire to the facing of the gable, I ran it to our kitchen window and into the house. I got the best reception at night. I listened mainly to music and sometimes to news.

A boy I knew asked me to help him install a ground wire for a radio for someone in the *monopol*, which was just outside of town. It was a vast area enclosed by brick walls, with beautiful brick buildings on the eastern side of the enclosure. I don't recall what the *monopol*

was once used for, maybe a liquor warehouse, but in my time it was empty, with apartments on the upper floor. There were nice chestnut trees outside the walls. We liked to go there to collect chestnuts in the autumn; we would play games with them and use them to decorate the *sike*, the booth in which we ate our meals during Succoth, the Feast of Tabernacles. The people at the *monopol* who wanted our help already had an antenna. All they needed was a ground wire to act as a lightning rod. We prepared for the job by taking a copper plate to the tinsmith and having him solder a wire to it, since we didn't have the proper tools. At the *monopol,* we ran the wire down from the window and buried the copper plate about three feet underground, close to the building. We attached the wire to the lower half of a small throw-out switch that we had installed on the window casing inside the room. To the upper part of the throw-out switch, we attached the radio antenna. If a storm were approaching, you'd pull the switch handle down to make the antenna contact the ground wire so that, should lightning strike, it would go into the ground. Otherwise, there was the danger of lightning striking the house because of the antenna.

The town intelligentsia was Polish. They served on the board of education and taught in the public school. There was only one Jewish teacher in the public school, and he taught religion to the Jewish students. Poles also ran the apothecary, which made its own medicines. When I got a rash between my fingers—it was called *świerzba*—I went to the apothecary, who gave me an ointment that looked like mustard, and the rash cleared up in about a week. Poles in Apt also worked in various trades, as carpenters, shoemakers, and butchers. Some worked at Mandelbaum's soap factory and Rozenberg's mill. They were also employed in Jewish homes as maids.

There were two chimney sweeps in our town. This was not a Jewish occupation. The chimney sweep would walk around town with a ladder and ropes on his shoulders. He would attach a rope to one of several brushes, which came in various sizes for large and small chimneys. He would then attach a heavy metal ball, similar in size, to the rope below the brush. The ball provided the weight that pulled the brush down the chimney. He would haul the brush back up with the rope.

Most roofs on the bigger buildings were made of galvanized sheet metal. I saw the chimney sweeps walk on the ridge (*szczyt*) of the roofs, from one chimney to the other. There were not that many chimneys to be swept, but apparently the chimney sweeps could make a living. Buildings that required their services were the ones owned by Harshl *kishke* and by Mandelbaum, as well as a few others. They also swept chimneys in neighboring towns. I heard that, during the war, there was one Jew who pretended to be a chimney sweep. He

Chimney Sweep

covered his face with soot so that no one would recognize him. Because chimney sweeping was not a Jewish profession, people assumed he was a Pole, and he survived.

In Canada, children dream of becoming firemen. In Poland, I dreamed of becoming a chimney sweep or, if not a chimney sweep, then a chauffeur—it was a big deal to drive a car. What appealed to me about the chimney sweep was to be up so high. Everyone would envy me. I dreamed of standing high on the rooftop and surveying the whole town and its environs laid out before me. My dream almost came true in Canada when I became a house painter; I used to climb up on the roof when painting the shingles and exterior of houses.

The church was a great point of pride in Opatów. The church originally owned Opatów, which became a private town when it was sold to a Polish aristocrat. The church was an ancient Romanesque *kolegiata*, or collegiate church. It was located on a small hill behind a row of buildings right across from where we lived. The art teacher at the public school took us out to the churchyard and had us draw the windows, doors, and carvings. I would have been about thirteen years old. I always wondered what the church looked like inside. One day, when no one was around, I sneaked into the church. The entrance to the church was from the south side. I saw the altar on the east side and on the west, a niche with a wonderful blue background and a figure of the Holy Mother. She was blonde. I quickly escaped and was happy that I survived, because we children believed that, if a Jew entered a church, he would

Green Thursday Church Procession

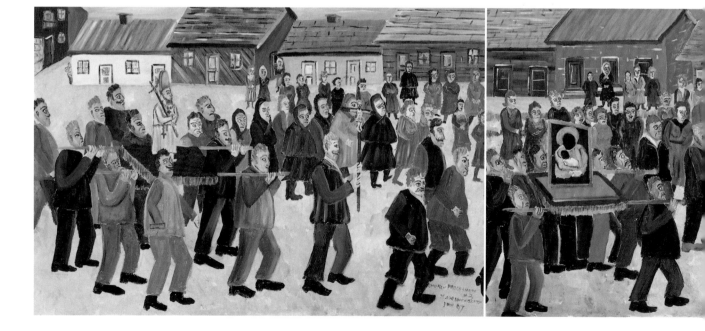

surely die. I put it to the test and survived. Our maid once took my youngest brother, Yosl, with her to mass. He was just a baby, but my mother was furious. The maid never did that again.

East of the church was a big wooden house where the priest lived. It was surrounded by trees. To the west of the church was a big masonry building, which was the residence of the church organist, who was the town's only piano teacher. He taught Alte Rozenberg. Her father was the one who owned the big power mill in partnership with Goldman and the water mill. There were beautiful lilacs in the organist's garden. I climbed in once to steal some lilacs and, as I tried to escape, my pants got caught on the fence. There was no danger of us stealing his tomatoes. Mother would not allow us to eat tomatoes because they grew in his garden—somehow this made her associate tomatoes with the church. Even though tomatoes were just a vegetable, we considered them *trayf* (not kosher) because they were red like blood. Eventually, though, we did eat them. We would buy them from the farmers who brought them to market in the late summer.

Christmas didn't mean much to us, except that we had a few days off from public school, and Easter too. On Green Thursday (*der griner donershtik*), a government-proclaimed holiday, all normal activities stopped. The stores closed. All the children were off from public school, but Jewish children still had to go to *khayder*. For us it was like a normal Sunday. I

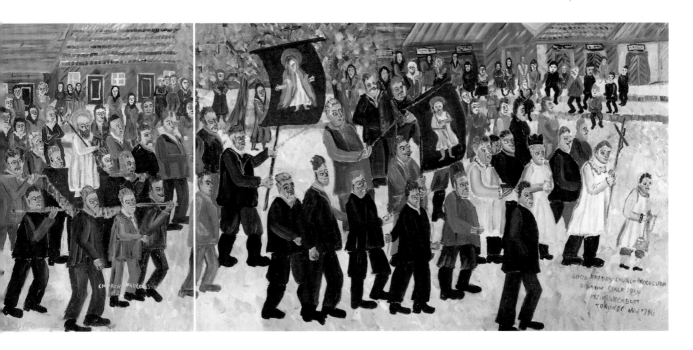

would get up at around seven in the morning, go to *khayder* to say my prayers, go home for breakfast, and return to *khayder*. We older boys would hang around until the younger boys were finished with their morning lessons. We would all head home for lunch, and the older boys would return in the afternoon for their lessons.

On Green Thursday, the town filled up with horses and wagons. Peasants from the surrounding area came to Apt to attend the Corpus Christi service because the church in our town was the parish church. With the church so near our house, I could see everything. Everyone dressed in their finest clothes. It was a serious affair, with long sermons and music. During the morning service, there was a procession. They took all the statues and banners outdoors. Each saint was on a platform mounted on horizontal poles that rested on the shoulders of four young stalwarts, who carried it. One man carried each banner, with pictures of saints and religious symbols, mounted on a horizontal staff that was attached to a vertical pole. In some cases, he was assisted by four others who held four golden twisted cords, with tassels, that were attached to the tip of the pole. They paraded the statues and beautiful banners down the street around the church. Everyone was very somber. Some of the congregants also carried crucifixes. The procession was led by the altar boy, who was dressed in a cassock and carried the censer. An older boy holding a crucifix followed him. The organist came next, followed by the priest. The organist was a big man, maybe 250 pounds. He had a chest like a barrel. His deep basso could be heard a long way off. Even outdoors it sounded like he was singing inside a huge drum.

The big bell slowly chimed its sonorous tones. There were two kinds of bells. The smaller bells were in the church towers and rang daily for services. There was also an enormous bell for special occasions. It was so big, about four feet in diameter, that it had its own house. It would ring for funerals and as a fire alarm. It made a very deep, long sound that you could hear for miles around. This was the bell they rang for the procession. I stood by and watched the procession with my head uncovered.

After the Easter sermon, which emphasized how the Jews tortured and killed Christ, the crowd that filed out of the church was all riled up. It was not safe for a Jew to be seen. Jews stayed indoors. After a few days, everything returned to normal.

Toward the end of summer, when most of the harvest was in, many villages got together and made a pilgrimage to the shrine of the Black Madonna of Częstochowa, known as Matka Boska Częstochowska in Polish. I never went to Częstochowa myself, but everyone knew about the Black Madonna. Her portrait was on our ancient city gate. Częstochowa was a

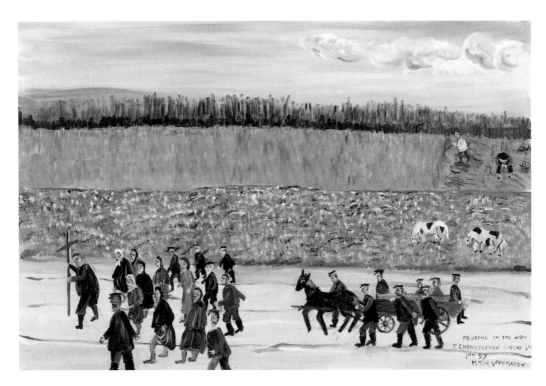

Pilgrimage to Częstochowa

place of pilgrimage because an apparition of the Madonna and Child manifested itself there; the faces were black, which is how she got her name. (As far as I knew, this was the only place in Poland where such an apparition appeared. I was recently told that apparitions of the Madonna also appeared in other places in Poland but that the Black Madonna of Częstochowa was the most important because she was the holy patron of the whole country.) Usually, a group of anywhere between twelve and twenty pilgrims went to the shrine on foot. A person carrying a crucifix led the procession, which was followed by a one-horse wagon that carried their bundles, provisions, and also disabled people. They sang sacred songs as they walked. In good weather, they made camp on the side of the road. In bad weather, they slept in a farmer's barn. They walked up to seventeen miles a day, maybe more. The pace was slow. They would come through our town every year.

Over the years, those who had been helped by her intercession covered the Black Madonna with many jewels. Those who had been healed left their crutches and prostheses. Macoch, who was a priest or a monk, stole jewels from the neck of the Black Madonna. Accompanied by a woman, he escaped with the jewels. Some said she was a nun. I don't remember when or where he was captured. It was a big scandal. When I had a fight with a Christian

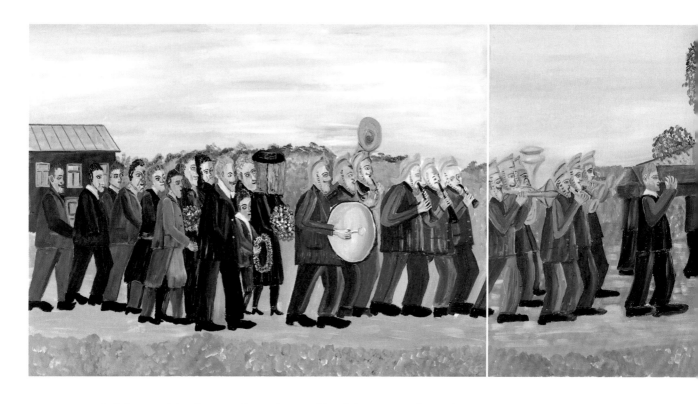

Funeral of the Father of My Christian Friend

lad, he would call me Beilis and I would call him Macoch. Beilis was the victim of a blood libel in Kiev. He was accused of killing a Christian child, draining his blood, and making matzo with it. This happened before World War I. The English king, the German kaiser, and the American government—actually, the rest of the world—implored the tsar to stop this foolishness, because everyone knew that this libel had no foundation. The tsar persisted, even though he was an educated man and knew Beilis was innocent. It was in the tsar's interest to divert the anger of the people from their poverty to the Jew, to the age-old tribal scapegoat. They kept Beilis in jail for two years and tortured him. Eventually, they let him go. Except on such occasions in school, which were rare in any case, I did not encounter much anti-Semitism.

I was the only guy in our group who associated with Christian boys, but dating a Christian girl was out of the question. Rumor had it that a girl who belonged to the same Zionist organization as I did was going out with *shkutsim*, with Christian boys, when she was about sixteen. She matured much sooner than we boys did.

I had two Gentile friends. One of them, I have forgotten his name, played the fiddle. He would come to my house, and I would go to his house. We would practice in each other's

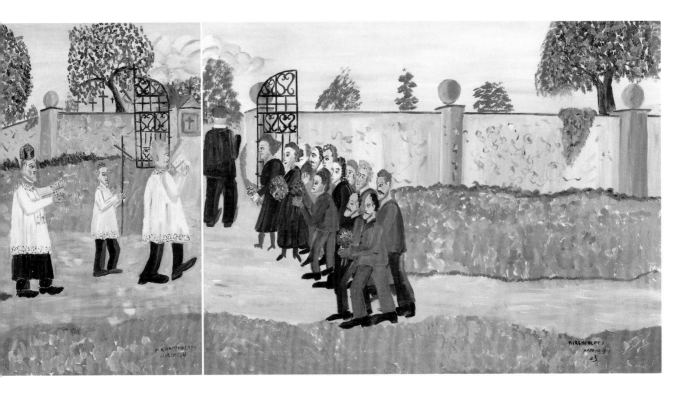

homes. They lived on *Shevske gas,* from *szewc,* which means shoemaker in Polish. His house was about a five-minute walk from my place. We were about nine years old. He was such a lovely boy. His mother was very nice to me. Don't ask me why but his father committed suicide. He blew his brains out. He had a blue mark the size of a bullet hole in his right temple. I had gone there that day to play fiddle with my friend, only to discover his father laid out in a coffin in the parlor. The coffin rested on two chairs. There was no one else there. I saw him lying in the coffin. I was shocked. Here's a man who was alive one minute and dead the next. How would my friend manage without a father? I turned around and left. A while later, I saw my friend and gave him my condolences. I think they moved away not long after.

I don't know how the church dealt with suicides, but I have vivid memories of a Christian funeral and have always associated that funeral with my friend's father. Leading the procession were the priest, an altar boy, and the hefty organist with his tremendous basso, which could be heard for a mile. The big church bell went "Bohhhng! Bohhhng!" When you heard this mournful chime, you knew someone had died. My friend, holding a wreath, walked with his mother. About six men carried the casket. They carried it by crossing arms with one an-

other and resting the casket on their shoulders. When they got tired, other men took over. The caretaker of the cemetery led them to the gravesite. Mourners gathered at the cemetery gates.

Accompanying the procession was the fire brigade, which was strictly voluntary. Brigade members wore navy blue uniforms with gold trim and highly polished brass helmets. They had a band and played for important Christian funerals, Easter processions, and patriotic parades, such as the one on May 3 celebrating the anniversary of the adoption of the Polish constitution. There was one Jewish volunteer fireman, a real tough guy. It was said that he was the only Jew who had a permit to own and carry a sidearm. He also owned a riding horse, which was rare for anyone in Apt, not just a Jew.

Every summer the fire brigade would put on a show. The engineer would issue the command *"Woda naprzód!"* (Water forward!), and the little motor pump that they used for filling the water drums would start. It was a gas motor, manually started by pulling on a string. The firefighters, with hoses on their shoulders, would clamber up their special observation tower. The tower was a triangular structure, four stories high. Somehow the firefighting equipment seemed to work just fine when the brigade was practicing, but not during a real fire. The little gas motor pump only ran when the firemen were showing off how great they were. In an emergency, the darn thing would seldom start.

In the event of fire, the brigade carted the motorized pump to the river. One hose went from the pump to the river, and a second hose went from the pump to the water drums. Each water drum was on a two-wheeled carriage that was supposed to be drawn by a horse. In an emergency, the fire brigade would draft local horses because there were no horses on standby. Of course, there were never enough horses to pull all the carriages, so we had to drag the water drum on its carrier down to the river ourselves. With the motorized pump out of commission, we ended up filling the drums by hand with buckets. This was a slow and laborious process. We formed a relay line and passed the full buckets in the direction of the water drum and the empty buckets back to the river. Once a water drum was full, we hauled it to the fire, where there were about two big pumps on four-wheeled wagons. These pumps were operated manually. At least four people were needed for one pump, two on each side. The whole town turned out to help, including yours truly. A good time was had by all.

I remember the time Kandel's building caught fire. The Kandels were a prominent family, very Orthodox. They owned one of the few two-story brick buildings in Apt. Their building, which was on the south side of the town square, extended from the town square all the

*The Only Jew
in the Volunteer
Fire Brigade*

way back to Narrow Street. On the ground floor was their *azn-gesheft*, their hardware store, where they sold metal tools and parts. The extended family lived on the upper floor. The place caught fire at midnight. The big church bell sounded the alarm and roused the whole town. All capable people volunteered to pull the water barrels to and from the river and operate the manual pumps. They say it was their Christian helper who saved the old grandmother. He risked his life. He carried her out in his arms. I helped to put this fire out. I would have been about thirteen years old.

Kandel's House Is Burning

The fire brigade kept its fire wagons and pumps on the ground floor of a big building, the *shopa*, on *Tsozmirer veyg*, as you entered the town. The upper floor was used for theater shows and other kinds of performances. The brigade practiced its skills on the *torgeviske* (*targowisko* in Polish), a big open area near the Jewish cemetery where the livestock market was held on Wednesdays. I used to climb the fire tower myself, when I wanted to observe Szulc breeding livestock. It was across the road from his property.

Szulc, a big guy with a big mustache, was the town *hycel* (dogcatcher). He cleaned the public toilets, picked up dead animals in town, and caught stray dogs. As a reward for his services, the city gave him a very nice plot on the edge of town, where he had a big wooden house,

built low, with barns and stables surrounding a large courtyard with a well. The house was covered with a gabled roof. His property was about twenty or twenty-five *morgi* (*morges* in Yiddish), which was huge by Polish standards. If a Polish farmer had ten *morgi*, it was considered a big farm. A *morga* was the equivalent of 1.38 acres. I was told that, when the Germans occupied Apt in World War II, they gave Szulc extra acreage because he had a German name.

The public toilets, a messy stinky business, were in a gray building behind the synagogue on the same street, *di alte valove*, as New *besmedresh*. They were built during the late 1920s. There were more than a dozen holes, half for men and half for women. It seemed that the people who frequented that facility never quite aimed at the holes but everywhere else. Just behind the public toilets were a cesspool and a ravine; rain runoff flowed from this ravine through a drainage ditch to the river. The ditch passed under a bridge that crossed *Ivansker veyg*. All the gutters in the city led to the river. The military latrine left by the Austrian occupation forces in 1918 was also in the ravine. One time my cousin Malkele *drek* (Malkele Shit) fell into that latrine. That is how she got her nickname. That latrine was still there when I left in 1934. I remember it being used, but not frequently.

Malkele Drek Fell into the Latrine / Man Cleaning Public Toilet

It was the job of the *hycel* to clean the public toilets. Szulc had two big horses and a large tank on a wagon. Together with a helper, he removed the sewage from the public toilets with a bucket that was attached to the end of a pole and collected the waste in the tank. Szulc would drive the tank to his farm, open the four or five spigots on the back of the tank, and fertilize his land with the waste.

Szulc took the dead animals he picked up in town to his farm, skinned them, sold the hides, and buried the carcasses on his property. My friend Maylekh knew him better than I did because Szulc used to sell the hides to Maylekh's father, who salted them. Szulc also picked up their night soil. Maylekh said that Szulc was a nice person.

Szulc was also the town dogcatcher. You had to buy a license for a dog, but who in town had money to buy a license? The dogcatcher used to pick up dogs that were running around. My uncle Yankl, a brother of my mother, had a dog that was very smart. The dog knew he had three places to hide. There was my grandmother's house, our store, and our house. So whenever the dogcatcher chased him, the dog would run into our store—the door was always open—and hide behind the counter. Occasionally he got caught, but very seldom. That dog could smell the dogcatcher from a mile away. When the dogcatcher left, the dog would go on his way, patrolling the town. That dog really frustrated the dogcatcher.

The way that Szulc caught dogs was with a *stryczek*, a pole with a noose at the end. He would throw the noose over the dog's head and pull on the stick to tighten the rope so the dog could not escape. The stick was about six or seven feet long. If the dogcatcher caught your dog, you had to go to him to get the dog back. You had to pay him. You weren't supposed to let your dog run loose. One day, Szulc actually caught my uncle's dog. It was my job to go to Szulc, pay the fine, and get the dog back. The dog was overjoyed to see me. I remember going into Szulc's house. It was dark and very cool on a hot summer day.

We had a dog whose name was Finka. She was black and white, a tiny little dog, low to the ground, with crooked feet, like Roosevelt's dog. Finka is a dog name, like Rover in English. I was recently told that *finka* means bowie knife, which was popular with Polish Boy Scouts. We had another dog before Finka, but I do not remember it. We fed Finka scraps from the table. That dog never went hungry. Everyone fed her. When Finka wasn't following me all over the place, she spent most of the time in the little doghouse in our courtyard. To prevent her from escaping when we were not there, we tied her with a leash to a long wire stretched across the courtyard. Everybody played with her—me, my three brothers, Moyre Simkhe's daughter Ester, Kalmen Rozenfeld's son, and Faytshu Shayes, the barber's daugh-

ter. Finka was a submissive dog. Whenever I came home, she would just roll over so I would scratch her stomach. I loved dogs. I loved animals. Very few Jews had dogs. Christians were the dog fanciers in town. My uncle Yankl and I were nonconformists. We had dogs.

Electricity came to Apt around 1928. There was one family, Strohmajer, who came from Germany to Apt about 1927. Strohmajer was an entrepreneur. Things must have been pretty rough in Germany for this fancy guy to come to Apt. He opened a plant to produce electricity using a steam engine called a *lokomobil*. He built a new two-story brick residence for his family, an engine house for the *lokomobil,* and a well to supply water for the steam engine and for the plumbing inside his home. His plant was located on a hill at the top of Old Rampart Street not far from the Jewish cemetery.

For the privilege of selling electricity to the town, Strohmajer was required to install streetlights throughout Apt and to provide the electricity for them. To illuminate the very wide marketplace, he installed two high poles, each with its own cross bar to form a T. Each pole had two lights. He lit the town only from dusk to midnight. After midnight he turned off all electricity to the town. Electricity was installed in homes in two ways. Rich people could afford a meter and used as much electricity as they wished. Poorer people paid a flat rate for a specified number of bulbs and specified wattage per bulb. If you tried to cheat and you overloaded the system, the electricity would cut out. Before there was electricity, we used candles and coal oil lamps. Electrical light was not reliable so we kept our coal oil lamps ready for emergencies. I was told that, after I left, someone built a sawmill next to the electrical plant, which provided the power to run the circular saw. I know about all of this because I was friends with Fritz, the younger of Strohmajer's two sons. Being German, Fritz was neither Polish nor Jewish, but something in between. He did not have too many friends. I befriended him.

Even with electricity, the city continued to depend on horsepower. The Trojster family made harnesses and saddles and did leather upholstery. Most of their work was just before spring, when farmers were getting ready to plough. I used to watch them work outside in front of their house. They had little work in the winter, when I presume they worked inside. I saw them upholster a *koʐetka,* a chaise lounge. The filling was mostly horsehair. I don't remember if they used sea grass too. We used straw mattresses, just a few burlap bags sewn together and filled with straw. The first time I saw a spring mattress was in Canada.

Every spring, the whole Trojster team went to Włostów, a large estate five and a half miles away. The owner of the estate was a Polish nobleman. The Trojsters' job was to repair all

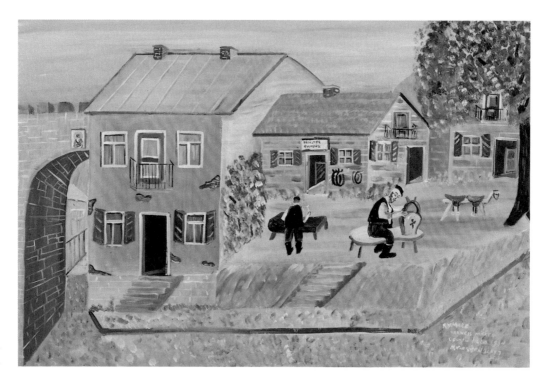

Harnessmakers:
The Trojsters

the rigging made of leather, especially for the horses, and get them ready for the spring ploughing. They stayed at the estate during the week, slept in a barn, and cooked their own kosher food. They came home for the weekends. The estate was enormous, with acres of land, and it included a factory for making sugar from sugar beets. Day and night for a week or two in the fall, after the harvest, wagons carrying sugar beets would pass through Apt on their way to Włostów. Most of the sugar beets came from the west. There must have been a special district there where they raised the sugar beets. We used to chase after the wagons, sometimes stealing a couple of beets. They were so sweet. Farmers drove their huge Holstein cattle to Włostów to eat the *wytłoki,* the pulp that remained after the juice had been extracted from the sugar beets. At first the cattle were emaciated, their enormous hooves curved up in front like Arabian shoes, their noses gray and dry. They were just bags of bones. Four to six weeks later, the cattle were driven back. They were unrecognizable—fat, beautiful, shiny hides, noses black and moist, and the hooves trimmed. They were a pleasure to look at. This sugar factory used a *kolejka,* a narrow-gauge railway, with a little railroad car, to ferry freight back and forth.

The Trojsters did everything that had to do with leather. For horses that pulled wagons, they made a harness that included a padded wood frame covered with leather. Under the frame was a protective collar padded with sea grass, or toe. The collar was called *khomont* (*chomąto* in Polish). Traces attached to the sides of the frame ended in a loop, through which passed a wippletree. The wippletree was attached to the wagon with a chain. To prevent the harness from moving forward when the horse was backing up, a leather strap extended from the top of the harness, along the spine of the horse, to the tail, which passed through a thick loop at the end of this strap. Around the horse's waist was a buckled cinch. Attached to the cinch, along the flank of the horse, was a hollow sheath through which the traces passed, to avoid them chafing the horse's flank. A bridle on the horses' head supported the steel bit in its mouth. Extending back to the driver from the bridle, the reins passed through a ring on each side of the bit and then through a ring on each side of the harness. The reins were called *lejce* in Polish. For steering the wagon and backing it up, the wagon shaft (*dyszel* in Polish) extended from the axle, to which it was attached, along the right side of the horse to beyond its head.

Saddles were more like the English style than the Western style, which had a horn in the front and large back support. Saddles were expensive. The Trojsters bought and sold second-hand saddles and repaired saddles. They also made new saddles. The saddles were for pleasure riding, not for work. Peasants did not generally use horses for riding. The saddles were for the people who could afford to keep horses they would ride for pleasure. Moyshe Czerniakowski's father had such a horse. One day I saw Moyshe riding it on *Ozherover veyg*, near the *shlizhe*, the river slide. He told me he was taking the horse out for exercise but that the horse was consumptive, *suchotnik*, which is how they were able to buy him cheap. In Drildz I used to ride my grandfather's horse bareback. I would take him to the river to bathe him and to fool around. He was not a riding horse but a draft horse.

In Poland, farmers did not need to break in their horses. The day it was born, the foal would follow its mother around while she was working. The farmer would stop the mare to give the foal a chance to have a little suck. When the foal grew up, it was quite natural for him to accept the harness. There were different kinds of horses, most of them draft horses, which were large and muscular.

I was friends with the harnessmaker's children. One Sabbath, it was in the autumn, I was in the orchard with one of their girls. I was fifteen. I threw my coat down on the ground. She kept her legs together and I straddled her. Would you believe I did not know how to do it?

I was lucky. If I had known how and she had become pregnant, I would never have been able to leave Poland. She converted and married a Gentile during wartime. She claimed that she converted to Catholicism not because she was afraid of being persecuted for being a Jew or to save her life, but because she was convinced that Catholicism was the true faith. After the war, she lived in Apt as a Catholic. She later came to New York with her husband and a son. She wanted to join the Apt hometown society and to be buried in the Apt cemetery in New York. They said, "No, you're not Jewish anymore."

Wednesday was market day in Apt. Everyone waited all week for the big day with great anticipation. Most of the business for the week was done on market day. Farmers from near and far would fill the town to capacity. The town was overrun with horses and wagons. Some farmers came very early to get choice spots.

There were three market areas. The main market, on the town square, was for produce, dairy products, poultry, raw materials, and manufactured goods. A second, smaller market was located in front of our house, for the spillover from the main market. A third market, for livestock, was on the *torgeviske*, a big open space on the edge of town, next to the Jewish cemetery. That was where farmers sold their livestock, took their female animals to Szulc to be serviced, or traded a horse up for a better animal.

Jewish artisans set up stands in the main market or sold ready-to-wear clothing, shoes, and other goods directly from their workshops in town. Some, like the ropemaker, peddled their

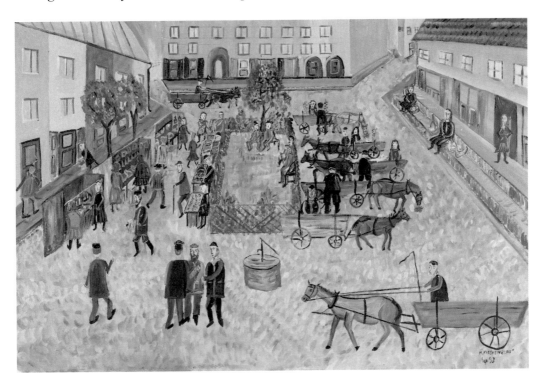

Market Day

goods. On market day, he would circulate among the wagons with his wares on his shoulders. He lived in a courtyard just behind the main square. His daughter was the wife of my murderous *khayder* teacher Moyre Simkhe. Although I was never in the ropemaker's domicile, I remember him storing a spinning wheel in the passageway of the building where he lived. That wheel would turn up to four, maybe more, spindles. His daughter would rotate the wheel. He soaked the ropes in buckets of water to make them more flexible. He would make ropes and hawsers, some of which were as much as an inch and a half in diameter, for the mills and the Włostów estate, where the sugar factory was located. He would also make ropes for traces for the farmers. The poor wagon owner who could not afford leather traces would custom-order flax traces from the ropemaker.

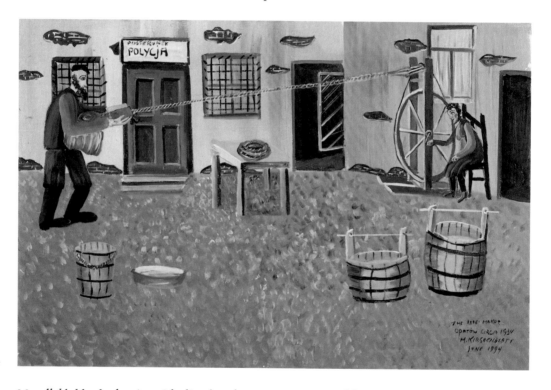

The Ropemaker

Mendl *blakhosh*, the tinsmith, lived at the entrance to Harshl *kishke*'s courtyard. *Blacharz* in Polish means tinsmith; his real name was Mendl Zukerman. His workshop was in a small room with only one window, which faced the street. In the room was a brake, a machine to bend sheet metal, and a wooden stump like a butcher block. He made water pails, pitchers, and other utensils that would not be exposed to high heat. You could not heat them because the solder would melt. Although I don't remember seeing him doing sheet metal roofs, I

assume that he did them too, because he was the only tinsmith in town. If an enamel pot or copper teakettle had a hole in it, he would fix it. From watching him make penny whistles, I learned how to make them myself, and I continue to make them to this day. His were fancier than mine because he soldered the sides of the whistle and inserted a pea so the whistle made a trilling sound, but that cost more money.

I made a much simpler whistle by cutting a piece of tin into an L-shape, folding one leg of the L flat—that's the part you blow—and curling the other leg of the L, which is the part that you hold with your thumb and index finger. I would use scraps from the tinsmith or old cans that were lying around, especially the cans in which salted fish had been packed. We called this kind of whistle a Haman whistle, or *Humen-faferl*. It made a shrill sound. I visited Mendl *blakhosh*'s place, particularly before Purim, when he used to make whistles for the occasion. On Purim, while the story of Ester was being read aloud, we would make noise every time we heard the name of Haman, the villain. The idea was to "kill" Haman by drowning out the sound of his name. I knew the tinsmith's son.

Mrs. Luks sold horsewhips. She was an old lady, a widow, and lived with two daughters next door to the synagogue. She had at least one son. She dutifully opened the door to her store every morning. She must have sold twelve whips a year, but hope springs eternal. Maybe today will be a lucky day and she will sell a whip.

Although there was work for them all week, the porters were out in full force on Wednesdays. There were several porters: two Mayers; Laybl *tule*, who hauled flour from Rozenberg's mill; and Khiel *mister*, so named because he had been to America—hence, "Mister"—and returned to Apt.

The more prominent of the two Mayers was the one with a horse to help him. His horse was bigger than a pony and smaller than a horse, so it ate less than a large animal. To Mayer that horse was a friend. It was customary to whip a horse, but I don't remember ever see-

HOW TO MAKE A TIN WHISTLE

Use a piece of thin sheet metal. The best is a Coca Cola can.

ing Mayer with a whip. With a load, Mayer never rode on the wagon. He always walked alongside the horse, leading it by the bridle. A big day for Mayer was Saturday. After the Saturday noon meal, he would lead his horse to a nearby meadow so the horse could graze. Mayer would stretch out on the beautiful grass and doze, or he would sit and watch his horse. As long as I can remember, he had the same horse. He was the town porter and delivered all kinds of goods.

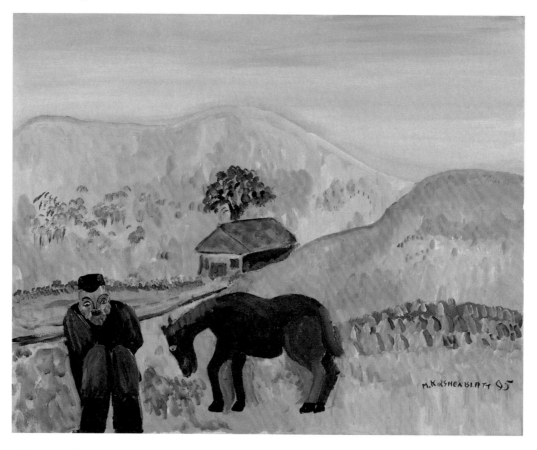

Mayer and His Horse

The second one, Mayer *treyger*, Mayer the Porter, was a little guy, which is why they called him *der klayner* Mayer, Little Mayer. Why he was also called Mayer *droybe*, Mayer the Goose Carcass, I do not know. He would walk around with a heavy rope around his waist. That was his trademark. He could carry a two-hundred-pound bag and sometimes a crate so big you could not see him. It looked as if the crate moved by itself.

The difference between a porter and a carter is that the latter had a wagon or other vehicle for hauling goods. The carter I remember best is Zalmen *goy;* his nickname notwithstand-

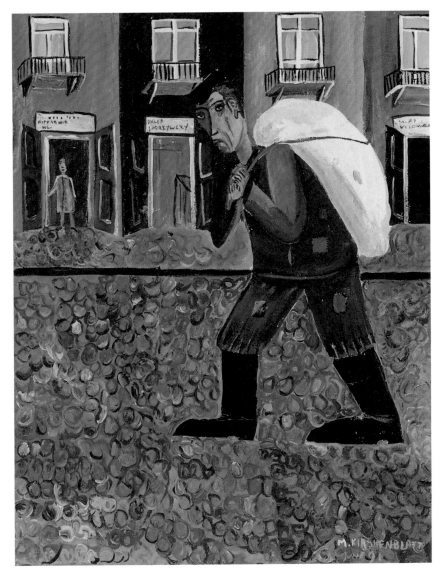

Porter

ing, Zalmen the Gentile was a Jew. His establishment consisted of a place for his wagon, a stable for his horses, and his dwelling. He had a big wagon, with ladder sides, and four horses. His horses were always big and gaunt. Where he got them I don't know. They were old and emaciated. Some were sick. He got the last bit of energy out of these poor beasts and finished them off. He did not go out on trips very often, but we could see a lot of changes in the horses. I assume that he went to the railway station in Ostrovtse, eleven miles from Apt, to pick up freight; that was the closest railway station to Apt. He must have gone other places, too.

Zalmen *goy*'s place was behind our apartment on Narrow Street. The window from his premises, which were on the ground level, looked out onto the lane that led from Narrow Street to Broad Street. In that lane was also a lady who had a little shop in her home. Everything was in one large room—the kitchen, dining room, bedroom, and store. She sold pastries, pumpkin seeds, and candies. Zalmen *goy*'s daughter decided to compete with her. She was not very bright, and I never saw her on the street with the other girls. In any case, she made up her mind to become a business lady. She boasted that she would put the other lady out of business and sold everything at half price. She did her business through the window looking out onto the lane. She did a great business. It lasted about a week.

During the week, we got what we needed from local shops. For the Sabbath, Jews shopped at the Wednesday market. There was not a big variety of vegetables available. I saw asparagus in Apt on occasion, but we never ate it. Mainly we ate root vegetables and cabbage. Mother served *salat*, lettuce, in the summer, but it was different from the lettuce we eat today; the leaves were soft and thin like paper. She also prepared fresh cucumbers with vinegar and sugar. Farmers grew little cucumbers, which we ate raw.

The man who owned the *mangl* (a machine we used to press our linens between rollers) also pickled cucumbers and made fermented bran (*klayenborsht;* bran is *otręby* in Polish), which he sold from big barrels. We made soup from the fermented bran. When you bought sour pickles, you always brought home a little brine (*rosl*): we would bring our own pot and ask the man to fill it up with some of the pickle brine. We used to drink it, and we made soup with it, too. Brine was a big thing; it added a little flavor. The man also had a little mill for grinding matzo into meal or flour. Just before Passover, we would bring all our broken matzos to him.

During the summer, farmers brought their butter to market in an enormous leaf (I think it was a milkweed leaf, but my daughter says it must have been a horseradish leaf) to keep it cool and clean. It was amazing that the butter did not melt. They also made a white cheese, like cottage cheese, only drier. It was in the shape of a heart because of the way they drained the curds. They would place the curds in the corner of a linen bag and twist the cloth to squeeze out the whey. Mother used to put this cheese on top of the oven, where it would dry out and last all winter.

We used both scallions and yellow onions. I saw leeks but we did not use them. We used a lot of garlic. We would rub garlic or onions on bread with rendered goose fat (*shmalts*) and on matzo during Passover. Mother roasted chicken and meat with garlic. (As I mentioned

earlier, on Tisha b'Av, we would leave garlic on the graves; I assume this was to ward off evil spirits. I also remember people wearing garlic around their neck as an amulet.) Mother used parsley, both the root and the green tops, when making chicken soup, and she used fresh dill in soups and when she pickled cucumbers.

We lived on potatoes year-round. A farmer that Mother knew would bring potatoes directly to our house, since we bought them in quantity. A Jewish housewife really had to be a gourmet cook to prepare potatoes fifty-two different ways. When Mother boiled potatoes, the water was not discarded. There was still a little starch and nourishment there. So she would make an *ugebrente zup:* to enhance the consistency and taste of the potato water, she made a dough from flour and water, rolled it into little crumbs, and fried them until they were dark brown before adding them to the potato water. This burned dough, which was called an *anbren,* gave the soup color and taste; my daughter says it was basically a roux. With the soup, which also contained chunks of potato and fried onions, we would eat a piece of bread, perhaps rubbed with garlic or onion and spread with *shmalts.* The flavor was heavenly. Or she would make a *yushke,* a delicious fish and potato soup to which she added sour cream.

My friend's family was poor and his mother used to prepare *golkes,* dumplings made of grated raw potatoes. Every time I would ask my mother to make potato dumplings, she would say, "Don't bother me. I am busy. I am tired." So, one day, my beautiful daughter wanted to make me happy. I asked her about *golkes* and she offered to make them for me. Now I realize why my mother didn't want to make the dumplings. There is a lot of work involved, and it is very time-consuming. My mother was in business and had no time to do this, but my friend's mother was at home. She had time to finely grate the raw potatoes for *golkes.* It was also a very cheap kind of meal. She boiled the dumplings in water and, rather than throw the water away after the dumplings were done, she used that water as a base for soup. Mother did the same with the water that was left after cooking noodles; that liquid was called *po-lifke,* or *polewka* in Polish.

The farmer who sold us potatoes also sold us other vegetables as well as chickens and pigeons. We would take the pigeons to the *shoykhet,* the ritual slaughterer. Mother would clean and roast them. There wasn't much there except the breast. The bones were so soft that they were the consistency of butter. You could eat the pigeon, bones and all. Some guys in town were pigeon fanciers. They used to race them on Sunday mornings. They would watch to see whose pigeons were faithful and came home and which ones were lured into someone else's loft.

In the summer, we would get small red radishes. The big black radishes were available all winter. We would cut the black ones in thin slices (or grate them) and eat them with salt and rendered goose or chicken fat. They were very tasty—a real delicacy—but they made us burp and fart something awful. Can you imagine after such a meal when the men went to synagogue? It is a wonder the place did not explode. The smell from the farts and the *truen* (*tran* in Polish), the fish oil with which they used to clean their boots, was terrible. If thirty men with oiled boots would come into the *besmedresh*, especially in summer, you can imagine the smell. What's more, the men would cough up phlegm, spit it on the floor, and rub it away with their feet. Nobody seemed to mind. It felt like home.

To sustain us through the winter, my mother would stock up on cabbage and root vegetables: both red and white beets, black radishes, potatoes, carrots, onions, turnips, and *korpolis*, which is rutabagas. We would cut *korpolis* in half, scrape out the flesh with a spoon, and eat it raw.

Cabbage (*kroyt*) was plentiful. Mother made *kapushnyak*, a meat soup from fresh cabbage. We loved to eat the core of the cabbage raw. Mother would buy sauerkraut from the man who made it, although she knew how to make it herself. From red beets she would make a borsht. Her summer borsht was thickened with beaten egg yolks and served cold with sour cream. Her winter borsht was made with meat and served hot. Lemon or sour salt (citric acid) and sugar gave the borsht a sweet and sour flavor. It was nice to serve a boiled potato on the side; some people put their potato into their soup bowl, others ate it separately along with the borsht.

From white beets, Mother made a *tsimes:* she would peel and julienne the white beets and then stew them on top of the stove with unpitted prunes, a few slices of lemon, including the rind, a little sugar, and water. This dish made a nice dessert, which could be eaten cold on the Sabbath. She would mix some of the liquid from the *tsimes* with cold water to make a refreshing drink to be served with the meal or in the afternoon when Father awoke from his nap. She stuffed *shtefn*, three-cornered pastries for Purim, with a fried mixture of grated red beets, raisins, sugar, and cinnamon; after these pastries were baked, she would dip them in a honey syrup. We ate carrots raw, but Mother also made a *tsimes* with them: she would peel and dice the carrots and stew them in a little water with salt, honey, *shmalts*, and a little fresh lemon. Some people cooked the *heldzl*, chicken neck stuffed with flour and *shmalts*, in with the carrot *tsimes*.

In 1973, my daughter interviewed my mother, who was born in 1896, about all the dishes she knew how to make. That is how we found out in more detail how she made many of the dishes that I remember eating.

Lemons were used sparingly, as they were imported and expensive, although they cost less than oranges and seemed to last longer. Sliced lemon was served with tea. An orange was a special treat, a real luxury. Mother would occasionally buy a single orange and give each of us a piece. It was customary, if you were sick, to be given an orange, as a farewell gift, in case you did not survive. The citrons (*esroygim*) were for the holiday of Succoth.

You did not throw away the skins of an orange or lemon or citron. You made marmalade. Marmalade was so precious it was served in a tiny spoon, either when you were sick or to company on special occasions. At a party, the hostess would go around and give everyone a taste of those preserves with a little spoon, the same spoon for everyone. It was a great delicacy. At a wedding or a *zukher* to celebrate the birth of a son, everyone had a little taste. Mother bought citrus from Szmelcman, who had a little grocery store. He would import a case or two of oranges, lemons, and citrons. Even the little papers in which each piece of fruit was wrapped were precious. We used them as toilet tissue.

Horseradish, *khrayn*, grew wild all over the hills on the edge of town, by *di intergas*, behind New *besmedresh*. That was where we used to catch butterflies, usually little white ones, with a hat. A great sport! I saw people go to the fields and pull the horseradish out of the ground; they gathered it for themselves. My mother used to buy horseradish and grate it; it burned the eyes, like onions. *Tshakhtsu* (sour sorrel) also grew wild in the fields and people gathered it. We used to pick it and eat it raw. I could identify it by its broad leaf. Was it ever sour! Mother made a cold sorrel soup called *tshav*.

The farmers collected wild mushrooms in the forest. Mother remembers that in the fall, after a rain, peasant women would bring fresh mushrooms to market. What we called *gzhibes*, from *grzyby*, which means mushrooms in Polish, were the best ones: small, round, and silky, they were brown on top and white underneath. *Mashklikhes* were big: they were brown top and bottom. *Betkes* were the cheapest ones: small in size, they were light brown both top and bottom. Peasants also dried mushrooms and would string assorted ones, arranged in graduated sizes, from small to big and back to small. They would tie the string to form a ring. I never went picking mushrooms; we always bought them. Mushrooms were quite nice in soup. Mother made a *krupnik*, a barley soup with dried mushrooms. Her dairy borsht, *milkhiker borsht*, was made with dried mushrooms, cabbage, and sour salt; like her cold beet

borsht, this one was thickened with beaten egg yolks and served cold with sour cream. To make the meat version of this soup, she left out the sour cream, added meat, and served the soup hot. There was even a special mushroom soup for the *kimpeturn,* the woman who had just given birth: this dairy soup was made from mushrooms, *huber-kashe* (oat groats), butter, and potatoes.

Currants and gooseberries, which grew on bushes, were popular. They were cultivated. Currants were called *vamperlekh,* which I think means "wine pearls." There were red ones and light green ones. We always ate them raw. Gooseberries were called *angres* in Yiddish (*agrest* in Polish). Most of them were a pale green, but there were also slightly rosy ones that were less sour. The gooseberry grew to the size of a grape and had little white veins that you could see through the skin. We ate them raw. Mother sometimes cooked them with sugar for a compote. They were very nice to eat.

There were two orchards in Apt that were owned by Christians and leased by Jews. One was on Kiliński Street (ulica Kilińskiego): that one was leased by the Sztarkman family. The other one was on *Ozherover veyg.* There was a lean-to in each orchard, where the person guarding the fruit could sleep. The fruit was guarded until the harvest was over. The lean-to was just two sides leaning against each other to form a triangular interior about six feet high at its peak. As soon as the fruit started to show, the man that rented the orchard or his relative would live there. He guarded the orchard so no one would steal the fruit. He would sleep in the lean-to and his family would bring him food; I do not remember him cooking there. The Jews would harvest the fruit, mainly apples, but also some pears, cherries, plums, and other fruit, and would sell what they harvested. They stored apples in a cool, dark basement and sold them throughout the winter. They would pick over the apples and sell first the ones that were about to spoil.

There were tiny pears called *lezhlkes* that grew on a tree that did not belong to anybody; they grew wild. They were also called *yengolkes,* and they were as hard as rock. We would put them in the straw mattress. After a while they ripened and were very nice to eat. Wild cherries were wonderful. These tiny black cherries were called *karshn* in Yiddish and *czereśnie* in Polish. The flavor was unbelievable. They grew in the forest. Farmers brought them to town. We kids would pick them ourselves. We would sit in the tree and eat them. There was not much meat on them but they were very sweet and juicy. We couldn't be bothered picking out the pits so, basically, we ate the whole thing, pits and all. Then, we would get diarrhea. All the way home, every ten minutes, we would have to drop our pants. Culti-

vated cherries were called *vanshl:* there were red ones and white ones. In summer, Mother would make cold fruit soups from red, black, or sour cherries as well as from plums of various kinds. There were purple plums, *vengerkes* in Yiddish, *węgierki* in Polish, also known as Hungarian plums: *Węgry* means Hungary in Polish. There were also whitish yellow plums and other varieties, such as a *damkhes* plum, which was sweet. Fruit borshts were eaten cold with a hot potato and butter on the side.

Whereas peasants brought produce and livestock to market, Jews such as Khaskl Luzers imported all kinds of delicacies. Father used to send me to Khaskl to buy mustard. The mustard was made with vinegar; it was yellow and sharp and came packed in a tea glass. After you used the mustard, you kept the tea glass. My father loved mustard. I liked mustard too. My grandfather, however, would never have dreamed of going out to buy mustard; that was a luxury he did not need. Across the road from Khaskl Luzers was Lilenbaum, who also sold exotic specialties. Mrs. Lilenbaum was a leader of the Mizrahi, the religious Zionists.

These stores were called *kolonyalne gesheftn,* colonial stores. They sold walnuts, almonds, and filberts. They imported prunes, figs, dates, peanuts, carob (*bokser* in Yiddish), and citrus fruit. The only time I can remember bananas is when Aba Blumenfeld, my aunt Helen's husband, came from Belgium to visit my maternal grandfather in Apt and brought bananas and some other tropical fruit in a suitcase. We bought large quantities of raisins from these stores to make a huge flask (*bitl*) of wine for Passover, about two and a half quarts. The wine was not clear; it was murky. They also carried staples.

I loved to see my mother go to market and bargain and inspect the live poultry, particularly the chickens. First, she would fondle the chicken to see if it were fat. A fat hen was best. Then she would insert her finger into the chicken's rectum. Perhaps there was an egg there as a bonus. An egg would indicate that this was a laying hen. There were bound to be many yolks—these were little eggs that had not yet formed a shell and were all yolk—inside the hen. When cooked, these yolks were beautiful and delicious. They would float around in the chicken soup. She would also make a *farloyrene hindl,* a lost chicken, which was a delicious egg custard, baked in a flat pan. She let it cool before cutting it into cubes and serving it in the chicken soup or as a side dish with meat.

On the Sabbath, we ate chicken. For the major holidays, Mother would buy ducks and geese. The autumn was the big time for geese. She would cut off the feet, chop off the claws, and pour boiling water over the feet to loosen the scaly outer skin, which she peeled off, and the thin yellow skin, which she scraped off. After turning the intestine inside out and cleaning

it, she would wind the intestine around the shank of the foot. This she would put into the soup. It was a great delicacy, and we would eat the whole thing.

Rendered fat, whether from chickens, ducks, or geese, was used for frying, cooking, and as a spread for bread, especially in winter, when butter was scarce. Fat was an important item. If a woman or man were thin, the person had a hard time attracting a partner. The man or woman was suspected of having a lung disease, like consumption. If the man was heavy, the saying was "Look at him! What a belly! He must be wealthy!" The way to test a bride, to see if she were clever, was to ask her what she would prefer, a bowl of chicken soup with one eye or many eyes. If she answered "many eyes," she was finished, because if the chicken soup is rich and there is a lot of fat, it will form one large golden eye on the surface of the soup. If there is very little fat, it will break up into many separate little "eyes." A lot of fat was best.

I would take the chicken Mother bought at the market under my arm to the *shoykhet*. The *shoykhet* killed fowl in his own establishment, not at the slaughterhouse. The place where he killed fowl was on the hill in back of New *besmedresh*, away from the center of town. There were no houses, no trees, no bushes there, just a fence around his property. There were a few blades of grass. I added bushes for the sake of the painting. He did not live there.

Thursday and Friday were his busy days. A lot of people came to him to slaughter their fowl for their Sabbath meals. This is how the *shoykhet* killed a chicken. First, he held the knife between his teeth. Then he grabbed the chicken and crossed the wings so the chicken could not flap them. He put the chicken under his left arm, with its feet up, and with his left hand, he grasped the feathers on the back of the head of the chicken. He pulled the head back to stretch out the neck and make the skin taut, before plucking out a few feathers to expose the skin. He then took the knife and, with one swift stroke, slit the windpipe. He used the thumb of his right hand to depress the split windpipe to ensure that the two sides of the cut were completely separated.

The bench where the *shoykhet* worked only had four holes for inserting the slaughtered fowl so they could bleed. If the *shoykhet* was busy and could not wait for the chickens to bleed themselves to death, he would throw the chicken to the ground after he slit its throat and let it run around like that until it died. At a nearby table, customers would pluck their own chickens and throw the feathers into huge containers under the table. I never plucked the chicken. I took it home, and Mother plucked it.

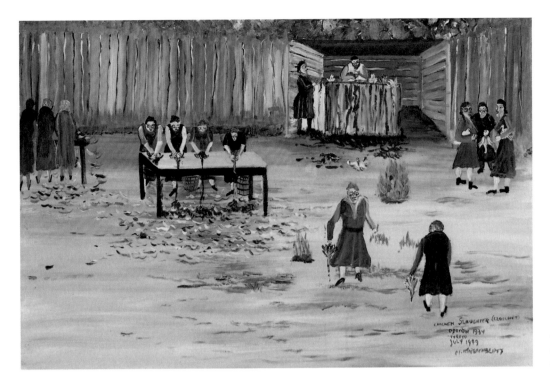

Shoykhet: Slaughtering Chickens

The *shoykhet* did not inspect fowl. He just killed them. When I brought the chicken home, Mother would gut the chicken and inspect the gizzard and heart and also the bones for any abnormalities. If there were the slightest sign of a tumor or other blemish, she would take the chicken to the rabbi to judge if it were kosher or not. If the chicken had a broken bone that had mended, that too was a reason to take it to the rabbi for judgment. If he determined that it was not kosher, she sold or gave the bird away to a Gentile neighbor.

I was told that, to supplement her meager income from begging, Bashe Rayzl would take chickens to the *shoykhet* so the women would not need to do this themselves. Bashe Rayzl and her family were the town crazies. She had a son and a daughter. I don't know whether they pretended to be retarded or they really were below normal intelligence. The daughter had a *parekh*, a huge scab all over her head, and she was always with the mother. We used to harass the son, and he would sing the *kdishe*, a prayer in praise of God that is sung in the morning service as part of the *shimen-esre*, the eighteen benedictions. Bashe Rayzl's husband was not crazy. He was a beggar and would travel around panhandling with his son. They wouldn't go begging in Apt because everybody knew them, so they walked from town to town begging. These were our Apt "nobility." I remember beggars coming to our house.

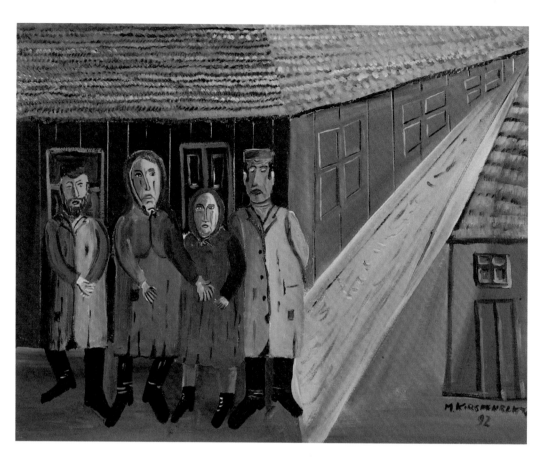

Apt "Nobility":
Bashe Rayzl
with Her Brood

Mother would give them a few pennies. If you didn't have a penny, you would give the beggar a cube of sugar. He would go next door and sell it, after keeping it in his dirty pocket. This is how they struggled to make a living. Bashe Rayzl and her family lived upstairs at the bottom of Broad Street, on the south side. Their apartment had windows, but no glass. How they survived the winter, I don't know.

Some of the women would say to Bashe Rayzl, "I will give you ten *groshn* to take my chicken to the *shoykhet*." Whether they were too busy or too lazy to go to the *shoykhet* themselves, they could afford to pay someone else to do it. After the *shoykhet* killed the chicken, Bashe Rayzl would pluck the feathers right there in the *shoykhet*'s courtyard. The ten *groshn* covered both the slaughtering and the cleaning of the chicken. One day Bashe Rayzl thought it over. Why bother going to the *shoykhet* when she could kill the chickens herself with a piece of glass and keep the money? So she killed the chickens herself and plucked them in her house. The feathers flew all over the place. It was the feathers that gave her away. Af-

ter a few months, when people figured out where the feathers were coming from, they realized that she was killing and cleaning the chickens herself. They confronted her and she admitted to the dastardly deed. That was the end of her chicken career.

It was a custom to transfer your sins to a chicken on the day before Yom Kippur. This was called *shlugn kapures*. Each person would say a prayer while swinging a chicken over his or her head, a rooster for a male and a hen for a female. At the end of the prayer, you would point to the bird and say three times, "You for death, me for life." The chicken was our scapegoat. If you were rich, you would give the chicken to poor people. Otherwise, you would carry the bird to the *shoykhet* to be killed. You would cook it and eat it as part of the last meal before the Yom Kippur fast.

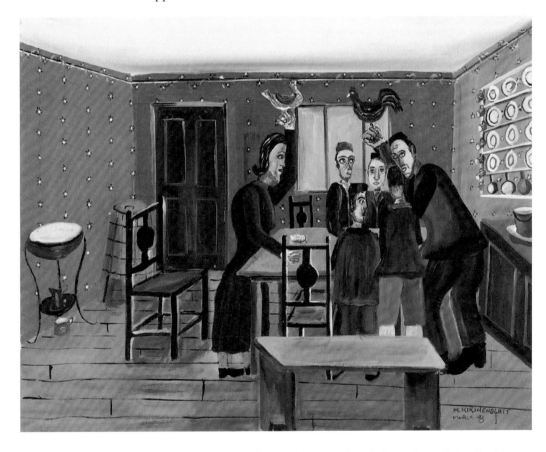

Shlugn Kapures: Yom Kippur Eve

When Mother bargained for a goose or duck, she considered the value of the feathers. I took the bird to the *shoykhet*. Then I went to the woman who dealt in feathers. Her business was located in her home in a lane that led from Broad Street to Rampart Street, just be-

hind the synagogue. She would say, "These feathers are worth so much and so much." Down feathers (*pukh* in Yiddish) were worth more because, when stuffed into bedding, they didn't clump up. The women who worked for her would first pluck the long feathers and then the fine down, which grows close to the skin. She bundled each type of feather in its own white sheet, weighed the bundles, which were huge, and sold them to a dealer. So far as I know, someone else stripped the soft part of the feather from the quill. If I'd had unmarried sisters, no doubt Mother would have kept the feathers to make bedding for their dowries. Or, if we boys had been of marriageable age, she might have saved the down to make a featherbed for a wedding gift. Women collected down for years to accumulate enough to make bedding. Feather bedding was made by hand; if a Jewish woman didn't want to make the bedding herself, she might pay a Polish woman to come to the house to do the sewing.

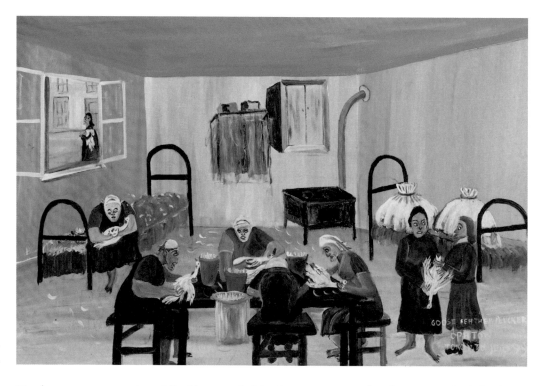

Goose-Feather Pluckers

Feathers were expensive. All pillows and eiderdowns were made of goose or duck feathers. These were so prized that they would be handed down in the family. Around August, farmers plucked the geese live and let them run around naked, except for the wing and tail feathers, which were not plucked. Their skin was blue. In no time at all the feathers grew back. The farmer wanted to get another crop of feathers before selling the geese for slaughter in the fall.

The fall was goose season. This was when farmers force-fed the geese to make them fat. The farmwife would hold the goose between her knees, with the head of the goose in her left hand and a pot of food (I think it was cooked grain or a bran mixture of some kind) at her side. She would put a spoonful of food into the goose's mouth and then shove it down its long neck with a stick. She would do this two or three times a day.

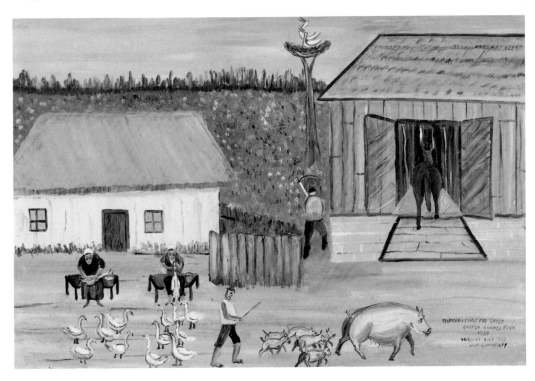

*Force-Feeding
Geese*

Goose fat provided us with eating and cooking fat for the winter. What lard was to the Christians, goose fat was to the Jews. Mother would buy geese before Hanukkah and render the fat. She would also brown onions in it to give it a little color. We ate our main meal at noon. For supper, we would take a thick slice of bread, rub it with garlic or sometimes onions, spread it with some goose fat and a little salt, and eat that with a cup of tea. If you were lucky, there were a few cracklings in the fat.

Farmers took their pigs, cows, sheep, and horses to the livestock market, which was located on the *torgeviske*, from the Polish word *targować*, which means "to haggle." Deals were made by spitting in the palm and slapping hands. The *torgeviske* was located on a raised area next to the Jewish cemetery. The farmers parked their wagons there. When a farmer wanted to buy a horse, he would test its health and strength by seeing how well it could pull. They

Livestock Market

would harness the horse to a wagon. Four men would hold the wheels while someone called out *"Vyo,"* signaling the horse to go.

During the week, but mostly on market day, farmers brought their animals to Szulc for servicing. Szulc's place was across the road from the *torgeviske* and the tower that the fire department practiced on. I used to climb that tower in order to see into Szulc's courtyard. You can see me, in one of my paintings, watching him breed sows, cows, sheep, goats, and mares. A stallion could service two or three mares a day. If a stallion smelled a mare in heat, even from a distance, he would run wild. Big animals like stallions and bulls were quite dangerous around mares and cows in heat. Szulc also bred dogs. Among the Polish townspeople there were dog fanciers. They brought their dogs, especially German shepherds, to be serviced.

Every three to five years, Szulc had to change his breeding stock. When the offspring of animals that had been bred with his stock matured and were ready for servicing, he could not breed them with their fathers, so he would exchange animals with other breeders. In this way, breeding stock circulated around the region. I remember that, when he got a new stallion, he used to mount it and parade around the town to show him off. Farmers brought an-

imals to him for servicing because he had good breeding stock. He was also the only breeder in town. I found out recently that there was a veterinarian in town, but as far as I can remember the farmers knew a lot about animals and took care of their animals themselves. Szulc helped out in serious cases.

As far as meat was concerned, it is written, "Do not remove the calf from its mother for seven days." Every farmer had his favorite butcher. Periodically, the butcher would talk with the farmer when he came to town for the market, or the butcher himself or cattle dealers would go around the countryside to make arrangements for buying livestock. A farmer would have one or two cows. The butcher would inquire as to the welfare of the pregnant cow: "How is the cow doing? When is it expecting?" As soon as the cow dropped the calf, the farmer would notify the butcher, "Gimpl, the calf is here." The farmer wanted to get rid of the calf as soon as possible in order to start milking the mother. The calf at seven days would not be too steady on its feet. It couldn't walk very fast. Besides, if the calf had to walk three or four miles, it would lose weight. The solution was for the butcher to carry the calf, at least part of the way. The calf weighed about fifty or sixty pounds, so the butcher would carry him on his back. Sometimes the farmer would fill the calf with water to make it weigh more. Out of fear, the calf would urinate and wet the butcher. Or, rather than carrying it, Gimpl would insert his finger into the calf's mouth. Thinking his finger was a teat, the calf would follow Gimpl home.

The farmer had a farmhouse, a little barn, and a well. The outside of the farmhouse was clay, the roof was made of a thick straw thatch, and the windows were small. The thick walls provided excellent insulation. It was very cool inside during the hottest days in summer. Storks used to nest near the farmhouse and would come back to the same nest year after year. The farmers considered them good luck. We did not have many storks in our neighborhood. Storks need wetlands, lakes, or rivers.

My mother had a distant cousin, I think his name was Sruel *midlover,* who bought and sold cattle. He had a son I used to chum around with. Midlover—this was his nickname, referring to Mydłów, the village near Apt where he was from—lived on *Lagever veyg,* about ten minutes by foot from town; his property was alongside a road that was next to the Opatówka River, which was handy for watering the cattle. He would buy emaciated cows, fatten them up a little, groom them, and when they looked nice he would sell them. He did not keep them long, maybe four or five weeks; when the market was right, he sold them. He had a beautiful old wooden house with lots of shrubs, bushes, and trees around it. I especially remember the lilacs. There was a small courtyard, and opposite the house was the stable. I

*Butcher
Carrying
a Calf*

used to love to go there in the summertime; it was so cool. His wife would give me cold milk to drink. They always had a milking cow. In the late summer, after the wheat harvest, I used to like to go with him when he drove the cows out to a big field by *Tsozmirer veyg*. He had permission to pasture them there; they would feed on the grass and weeds that remained between the stubble after the harvest. We would head out during the late afternoon, around five or six o'clock, once it got cooler, and let the cows graze for two or three hours. By the time we brought them back, it was dark.

Once the butcher had his cow, he took the animal to the slaughterhouse. There the *shoykhet* killed large animals, mainly cattle and the occasional goat or sheep. He had different kinds of knives for slaughtering different animals. For cattle, he had a knife, a *khalef*, about twenty inches long; for fowl, he used a small knife. The knives were extremely sharp; they could not have the slightest nick. After slaughtering the animal, the *shoykhet* would inspect the vital organs—the heart, lungs, spleen, kidneys, and liver. If there were any irregularity, the animal was considered *trayf*, or not kosher, and sold to the Gentile butchers. Traditionally, the offal belonged to the *shoykhet*. I think he worked out a deal with the butcher, because I saw the butcher sell the offal.

The butcher would skin the animal, open it, take out the organs, and quarter the carcass. He would remove the forbidden fat and veins from the forequarters, a process called *traybern*, or porging, and sell the hindquarters to local Gentiles or to other Jewish dealers who would export them to larger cities. The hindquarters were called *zatkes;* one hindquarter is a *zudik*. Maylekh's brother used to buy the hindquarters of calves, wrap them in wax paper, put them into wooden boxes, and send them to Łódź. He would process about two dozen calves at a time, enough for two boxes.

Maylekh's father would also buy the hides and cure them with salt in a huge cellar under the house where they lived. Whenever someone tried to compete with his business, he would take them in as a partner. The hides came mainly from the butchers and occasionally from Szulc. When hides arrived, they were taken down to the cellar, where Maylekh's brother and a helper would salt them. Then they would fold them in such a way that the tail was tucked in and the horns showed. They stacked the hides, one on top of the other, like bricks. When they had accumulated enough hides, they shipped them to a tannery. They hired porters to bring the hides up from the cellar at night because the hides were smelly and wet. They leaked moisture and blood. After the hides were loaded, the men would throw a few buckets of water on the sidewalk to wash the effluent down the gutters and into the river.

Maylekh's specialty was bladders and skinning small animals. Farmers used to bring hares, foxes, minks, and other animals to him. I saw Maylekh skin them. He began at the rectum, made a cut, and pulled the skin off. Then he stretched the skin on an A-frame to dry. The cow and calf bladders Maylekh bought from the butchers. Because the bladders were wet, they had to be dried out in order to preserve them until they were to be used. Maylekh would insert a little quill into the bladder, blow the bladder up until it was inflated like a balloon, and tie the opening so the air would not escape. When a bladder had dried out, it was very thin and transparent, like parchment. He would flatten the bladders, bundle them together, and sell them to the Christian butchers, who used them for making headcheese.

In Drildz, I watched them slaughter a pig in the abattoir, which was not far from my grandfather's house. I just happened to be there—I had to see everything—when they brought in an old sow, a huge one. The first thing they did was to quiet her down; she was used to people, so she was responsive to their reassurances. A guy then whacked her on the head

with a huge wooden club and she dropped. He thrust something sharp in her throat and the blood started gushing out. He collected the blood in a bucket. Then they hoisted the pig up from the tendons on the back of its heels and wheeled it over to a concrete cylinder, about three feet across, filled with boiling water. They dipped the pig in the hot water for a few minutes, hauled it out, and with a knife scraped off all the bristle. Then, a man came with a big knife and slit open the belly. That's when I left.

After the Jewish butcher had disposed of the hindquarters, hides, and bladders, he would take what remained, the forequarters and the offal, to his shop in town. I remember several Jewish butchers: Katz, who was Maylekh's uncle; Gimpl Wewerman; and the Czerniakowski family, including Yake and Motek. There was also Khamu Itshe Mayers, a cattle dealer and butcher, a huge and intimidating man who was also a loan shark and one of the town gangsters. I remember once when he was sitting on a wagon going around buying cattle, I could see the boards sagging under his weight.

Katz had a butcher shop on Broad Street, two doors up from Upper *besmedresh*, just below Moyre Berman's *khayder*. Yake Czerniakowski had his butcher shop on Narrow Street, just below Zajfman's tavern. He was a tall and muscular man. His wife was a beautiful woman, a redhead, but short and fat. His two daughters survived and live today in Toronto. Gimpl had his shop across the road from my father's store on the corner of Narrow Street in Harshl *kishke*'s building.

Motek Czerniakowski had his butcher shop at the lower end of Broad Street, just west of Lower *besmedresh*. He had a stable in the back of his establishment. Once I saw him and a *shoykhet* killing a cow. He did it in his stable, which was illegal; he was supposed to use the abattoir. He was a powerful man. The cow was on its back thrashing around. He held the cow by the horns and the *shoykhet* took a huge *khalef* and, with one stroke, cut the trachea and main artery. The cow then relaxed. Motek threw some straw on the ground to cover the blood. At that point I left.

After an animal had been butchered, it had to be sold quickly because there was no refrigeration. Even if a housewife were short of money, the butcher would give her credit so that he could get rid of the meat. Gimpl, however, could not read or write. To keep track of his transactions, he would mark the name and the sum on his boots with chalk, in his own signs, and he would know who owed him what. But on Friday, since he had to clean his boots before going to the synagogue, he would go around collecting his debts. Once they were settled, he could clean his boots and erase the whole bookkeeping. Like many other poor people,

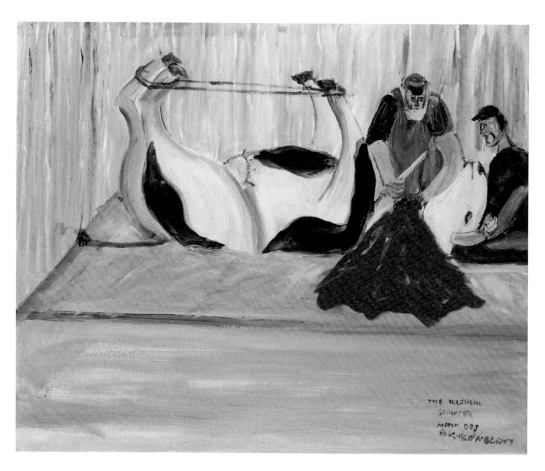

The Illegal Slaughter

he cleaned his boots with *truen* to keep them black and supple. The fish oil prevented the leather from drying out.

Once, before the High Holidays, someone brought a carp to town. It must have weighed fifty pounds. The head must have been twelve inches long. It was huge. They brought it to Gimpl. He cleaned it and sold it in slices by the pound. My mother bought half a head, which was a delicacy for my father. My father would sit and suck on every single little bone. He loved it. It lasted him for two festive meals.

Mother also bought calves' feet from Gimpl for *galerete,* or calf's-foot jelly. We also called it *gale,* for short. I remember seeing piles of cows' and calves' feet lying in the corner on the butcher's floor. In the case of a calf's foot, Mother brought it home, gave it a whack, and knocked the hoof off herself. In the case of a cow's foot, the butcher removed the hoof and cut the foot up into pieces. To prepare *galerete,* Mother would clean the foot, scraping

the hair from the skin. She would then place the pieces in cold water with lots of garlic, salt, pepper, and bay leaves (*bobkebleter* in Yiddish) and bring the mixture to a boil. The foot needs to cook slowly for a long time in order for the flesh to become so tender that it falls away from the bone and the liquid reduces. After the feet were cooked, she would skim the fat from the broth, extract the marrow from the bones, finely chop or grind the skin and the meat, and discard the bones. She then poured the meat, marrow, and broth into a flat pan, stirring the mixture well to prevent the solid ingredients from sinking to the bottom. Some people added chopped or sliced hard-boiled eggs at this point. The *galerete* would gel. This was a great delicacy, but I never liked it. She would make this in winter, as it would not set properly or keep well in warm weather. She would sometimes make it for the Sabbath. People liked to eat it with a little horseradish or vinegar. One day when I was walking down the street with a pan of *galerete*, Mayer Makhl, who was two years older than me, called out, "What do you have there?" I answered, "*Galerete*." He responded, "From now on, your name will be Mayer *galerete*." It didn't stick. I was never called Mayer *galerete*, Mayer Calf's-Foot Jelly.

Everyone had a nickname, often for no apparent reason. There was Yosele *kliske* (Yosl the Little Square Noodle), Yankele *kepkele* (Yankele the Little Head), Yankele *kekl* (Yankl the Little Penis), and Shmiel *hint* (Shmiel the Dog). The Krakowski family were nicknamed the *haymlozers*, homeless. I have no idea why. Some people were called the *uplayzers*, which means the scapegoats; in other words, they should be the ones selected for something bad, instead of me. Even famous people had their nicknames. Moyshe Zalcman, an important writer, was called the *kalte vetshere* (Cold Supper). Shloyme Micmacher, who wrote poetry, prose, and essays, was known as Shloyme *koze*, or Shloyme the Goat. We never addressed people by these names, but we used the names when we were talking about them.

Cured, smoked, and pickled meats—salami, sausage, corned beef—were sold at a kosher delicatessen not far from our house. The proprietor did not prepare the meat himself. He brought it to Apt from out of town. Private people did not preserve meat. This kind of meat was called *ofshnit*. My family could not afford to buy meat from him, but I did taste *parovkes*, which were like hotdogs—we boiled them until the skin cracked—and corned beef that my uncle brought from Radom (Rudem, in Yiddish) when he returned home to Drildz.

Baytsim are bulls' testicles—the Yiddish term is from the Hebrew word for eggs. They come in pairs. They are firm but like jelly. When we put them on hot coals, they would solidify. I watched my father eat them. He cut them into slices. They looked like cheese with a few red veins showing through. I remember that, in Toronto, my mother would prepare this dish

on the coal-burning stove in the back of the store. I assume that she also prepared this dish for my father in the Old Country, but I do not remember because he left for Canada when I was about twelve. We did not eat the bull's penis, but farmers used that organ to make a whip (which, according to my daughter, is called a pizzle in English).

We also ate *grashitse*, which means sweetbreads. Sweetbreads are either the pancreas, which is near the stomach, or the thymus gland near the throat. Saul Marmurek remembers us eating the abdominal sweetbreads. Sweetbreads were difficult to get, but brains were more easily obtained. Mother would fry them with onions. We also ate the inside of the udder fried with onions. It was delicious. It is said that the milk inside the udder was considered *parev*—that is, neither meat nor dairy. We also used to stuff *milts*, or spleen, and roast it. One of my mother's favorite dishes, even in Canada when she could afford steak, was small pieces of lung, cows' cheeks, and spleen fried with onion.

There were several Polish butchers in town. The Polish butcher next to our house sold cooked and smoked pork that he prepared at his home in the countryside and brought to town. Galiński prepared meat products and sold them in his eating establishment. Buchiński was the most prominent one. His shop, a combination delicatessen and restaurant, was on the north side of the marketplace. He sold prepared pork by the pound, either to take away or eat on the premises, including smoked ham, cooked ham, bacon, headcheese, and all kinds of sausage and other pork products. Maylekh used to sell him cow bladders for making headcheese. My teacher Mr. Koziarski would send me running to Buchiński's during recess to buy him a *kanapka*, a smoked ham sandwich on a kaiser roll. He liked *szynka od kości*, literally ham from the bone. I once stole a tiny bit from his sandwich for a taste, just a smidgen so he shouldn't notice. It was good. I didn't die. I was convinced that if you ate pork you would surely die.

The gypsy musicians always stopped at Buchiński's. They would arrive with their homes on wheels, drawn by big horses. Poor gypsies had only one horse and wagon. They erected tents on empty lots. Upon arriving, the women covered the town, telling fortunes and stealing what they could. If my mother wanted to frighten me when I was a little boy and I didn't behave, she said that the gypsies would take me away. The musicians would go to the biggest Polish restaurant, Buchiński's, and play. The place was always crowded, and we Jewish boys would stay outside and observe the proceedings. I remember that one musician had a bass fiddle that was coming apart. He had tied it together with string. The bow was made of a willow branch and horsehair. The gypsies would play music, drink, and make merry. I loved to watch them play.

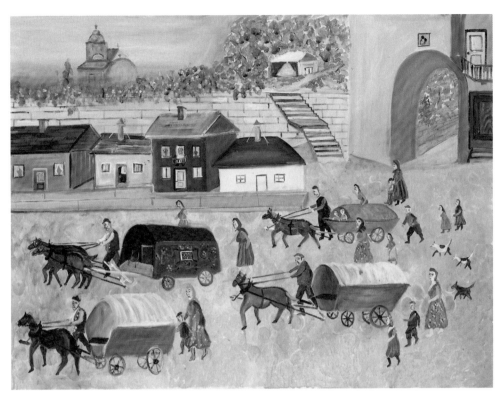

*Gypsies
Arrive*

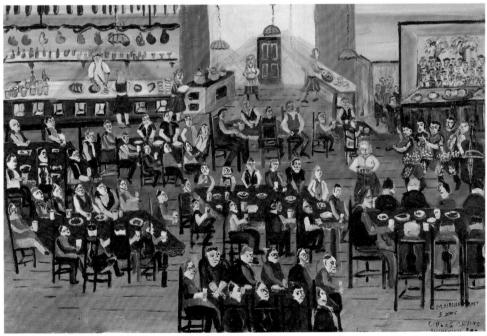

*Gypsies at
Buchiński's*

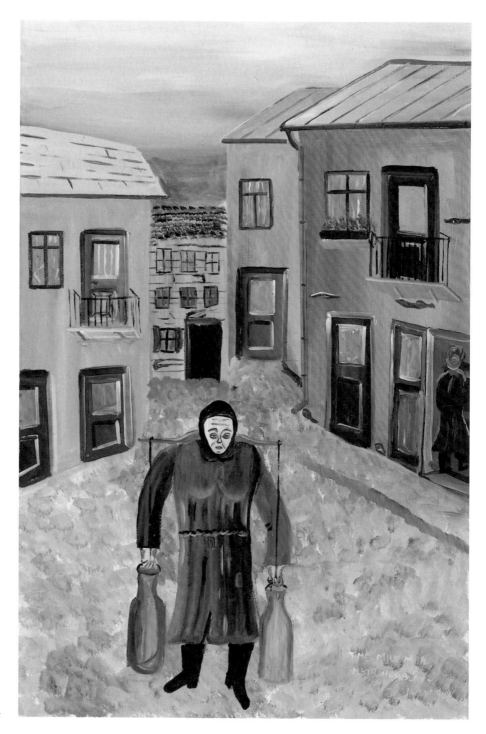

The Milk Lady

Kulniew's restaurant generally considered itself too classy for this sort of thing. The hoi polloi gathered there to eat and drink. Kulniew's also had a pool table. Rich landowners and nobility from the surrounding villages would frequent that place. Whenever the army came through on maneuvers, Kulniew's always catered a big banquet for the officers. No Jews were allowed there except for Aba Blumental, who was known as *der lumer* Aba (Lame Aba) because he had a peg leg. He always stood looking out the little window near the doorway. What was his profession? He was a *meykler*, an agent. You could call him a middleman. The *meykler* matched a vendor and a buyer. If any of the well-to-do Poles, not just from the town but also from the countryside, wanted to buy or sell something or needed services of any kind, he could arrange it. The fee for each transaction was negotiated separately, with payment on the honor system. They would deal with him exclusively. The rear of Kulniew's looked out over the well in Harshl *kishke*'s courtyard. Since the window was almost at ground level, we could peek in. I used to chum around with *der lumer* Aba's son Nunyu. He also had a daughter, Neshe, a little younger than I was. We would fool around, but it was nothing serious. His youngest son, Srulik, was my brother Harshl's contemporary.

We had two cuisines, meat and dairy, and they had to be kept completely separate, according to Jewish ritual law. Milk was an important part of the diet. The *milekh-yidn*, the dairy Jews, bought milk from the peasants. The milk lady would go every morning to a farmer about four miles out of town. She would be back by eight o'clock in time for Mother to boil the milk (to pasteurize it) and give it to us for breakfast. We poured milk on boiled millet (*hirzsh*), seasoned with a little salt, for breakfast or lunch. The milk lady carried the milk in a can, with a dipper and a measurer hanging at the side of it. She would come to your door—she had her customers—and she would sell you one or two quarts of milk, whatever you needed. If she had any milk left over, she would leave it to ferment, and we used to buy that too, although most of the time mother made sour milk herself. Some of the dairy Jews made fresh white cheese from the soured milk.

The milk lady was an old woman. Her husband was a sort of furrier. My mother had a little sheepskin jacket that I used to love to wear. The fleece was on the inside. The skin was dyed red, and the edges of the jacket were trimmed with black fleece. It was old and coming apart. I used to take it to the milk woman's husband to be repaired.

One of the dairy Jews was known as *der koltn*, a corruption of the words *kol tiv*, as we pronounced Hebrew, which means all the best. He acquired this nickname because he used to say *kol tiv* all day. Legend had it that there was one moment in every twenty-four-hour period

during which, if you said the words *kol tiv*, your wishes would come true. Not knowing which moment that was, the *koltn* spent twenty-four hours saying *kol tiv*. Suffice it to say, nothing happened. The name *koltn* stuck to him.

Market day was when the thieves, confidence men, and pickpockets descended on the town to relieve the farmer of his hard-earned few zlotys. They lured the farmers into playing three-card monte, the shell game, and tricked them out of their wares. Things got very bad. These tricks began to seriously interfere with business on market day. It got so bad that the farmers became reluctant to come to town. By the time the peasant had lost money on the shell game and finished drinking at the taverns, he went home with empty pockets. He was lucky to still have his wife, his horse, and his wagon.

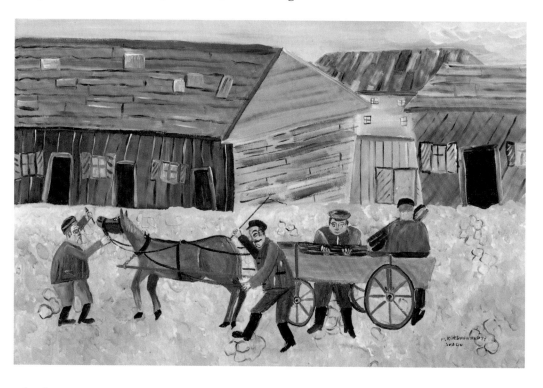

Market Thieves Steal Wood

The thieves were very ingenious. They used every ploy possible to cheat and steal from the poor farmer. One thief would run to the front of the horse, grab the bridle, and threaten to kill the horse. When the poor farmer rushed to the front of the horse to chase the thief off, his accomplices would steal the wood from his wagon. Or the thieves would pretend to buy eggs. They would sit the farmwife down on the curb and proceed to count the eggs into the

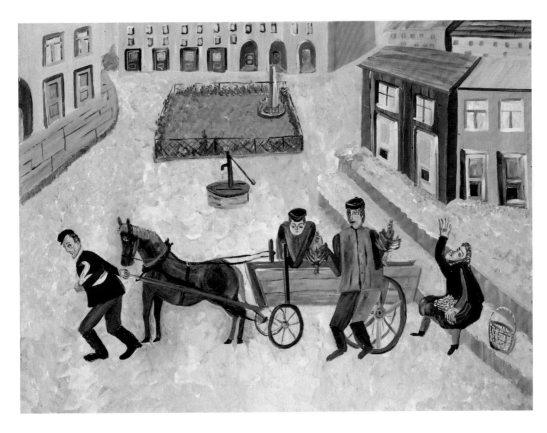

Market Thieves
Steal Eggs

hollow of her skirt between her knees. When her skirt was full of eggs and she could not move, the charlatans quickly emptied the wagon of all her other goods and disappeared.

Sometimes, a thief would wind a red kerchief around his face and go around moaning pitifully. He would target a woman who he knew sold something and had money. He made such horrible moans that it would break anyone's heart. Finally, the poor woman would succumb and ask what ailed him. He replied that he had a horrible toothache, and the man who pulled teeth told him that the only remedy was to suck on a woman's breast. He offered her twenty zlotys, which was a goodly sum. She couldn't resist. She took him to a door entrance and bared her breast, and he proceeded to suck. In the process, he would steal the bundle of money she concealed in her bosom. I never personally saw this happen, but everyone knew these stories. The thieves in Opatów made the farmer's life a living hell. A farmer's life was not an easy one.

Prostitutes also took advantage of market day. Prostitution was legal in Poland, and prostitutes went for a medical inspection every month. There were two Polish prostitutes in

Apt—Jadźka and Świderska—and everyone knew them. They used to hang out around Moyshe Zajfman's tavern across the road from my father's store. That was their main station, although they would circulate throughout the marketplace, hang out around the various bars in town, and loiter wherever the men gathered. Their busiest day was Wednesday, when the market was in full force and the peasants came to town. If the farmer sold his pig and he had a few zlotys left, he figured he would have a good time. Not that the Jewish boys did not like to take advantage of what the prostitutes had to offer, but nobody had the money. I was too young at the time to even dream of anything like this. There was, I heard, a Jewish widow who was bootlegging. Rumor had it that she made herself available to preferred customers. She had a beautiful daughter, who went to school with us.

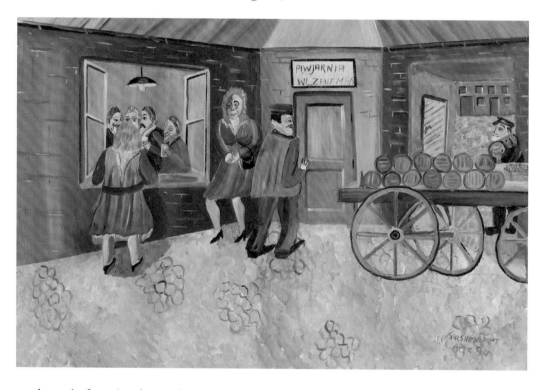

Market Day: Prostitutes at Zajfman's Tavern

At the end of market day, Jadźka would get drunk. Her favorite place to show off her overworked wares was Harshl *kishke*'s courtyard. There, around the well, was always bound to be an audience. She would sing and dance, and people would clap in time. The Jewish men would turn away to face the wall.

Jadźka took her clients to Usok's place. Usok was a Polish guy who accommodated Jadźka and her clients at his home on Old Rampart Street. How he made a living I do not know.

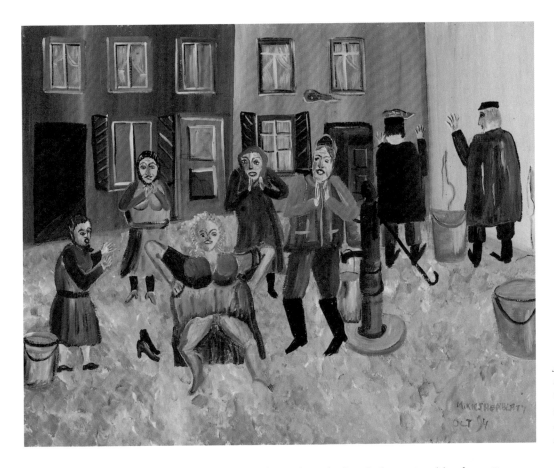

Jadźka the Prostitute Shows Off Her Wares at the End of Market Day at Harshl Kishke's Well

Der groyser Maylekh, Big Maylekh, one of my friends, lived above Usok's place. Because of a ten- to fifteen-foot drop, the roof of Usok's house was level with the yard behind Big Maylekh's place. We used to stand there and look down into Usok's courtyard and through his windows. We couldn't see much, but sometimes we got a glimpse. The window was only covered with a piece of burlap. I liked going to Big Maylekh's because he had a wooden rocking horse, beautifully painted, that I loved to play with. He was a cousin to *der klayner* Maylekh, Little Maylekh, one of my very best friends. Big Maylekh had two handicapped sisters, both of whom had bad legs. His mother was a gorgeous woman. His father, who was short and unattractive, left for Canada during the 1920s. I heard that she treated him terribly. She was a tough bird.

Świderska was very tall and statuesque. She was blonde and dressed well. In my imagination, she looked like Marlene Dietrich. She was a little classier than Jadźka. But she always had a black eye: I don't know why, but she always got the toughest customers and was always beat up. She lived with her brother and his wife in the same courtyard as my grandparents.

The three of them occupied a tiny room, not more than twelve by twelve feet, that doubled as their living quarters and her brother's shoemaking workshop. He was a top-notch ladies' shoemaker, but, unfortunately, he was always drunk and didn't get much done.

Everyone struggled. It was a day-to-day existence. Maybe in the city things were different, but in the small Polish towns life was hard. Competition was keen. One guy would say, "If I can earn enough for salt and water, I'll do that just to beat the other guy." The other guy would say, "I'll work just for the water and be happy." Things got even worse during the late 1920s and early 1930s, when propaganda to boycott Jewish stores intensified and the Christian citizens opened a cooperative.

The farmers, however, still preferred to deal with the Jewish shopkeepers. The cooperative store was beautiful. The food was packaged in jars and neatly arranged on shelves. Everything was scrupulously clean. The salesclerk walked around in a nice white coat. The floor was oiled so it wouldn't raise dust. Everything was sterile. The farmers felt out of place. They would come to town with the same boots that they wore in the pigsty. The farmer with manure on his boots didn't feel like going in there. The cooperative was also impersonal. You couldn't haggle. It lacked that personal touch. In the Jewish stores, the shopkeeper knew the peasant. He greeted him, "How are you? How's your wife? Is she pregnant? Did she have the baby yet? Did the cow drop the calf yet?" After about five minutes of small talk, they would start to haggle. That was the small-town style. Most of the Polish intelligentsia did their shopping in the cooperative, even though it was more expensive. Naturally, in a big city with a large Gentile population, there were huge fancy stores, so when people were told not to buy from a Jew, they could shop elsewhere. In a small town, by and large, the boycott did not work. Of course, Jews would never shop in the cooperative. Nor did the Jewish businessman worry about competition from it. He worried about the competition all around him.

People traveled by horse and wagon. The wagoners who brought goods to town would park their wagons and stable their horses overnight at Szmelcman's. Usually the wagoner would sleep on the wagon in the straw, while the horses rested in the stables. He could not afford to pay for a room. Szmelcman's operation was located in a large, one-story wooden structure that was a block long. Instead of a courtyard, there was a big covered area that extended the length of the building, from Broad Street to Narrow Street, along *Ivansker veyg*. This is where the wagons parked. Wagons would generally enter through a gate from Broad Street and exit to Narrow Street. Surrounding the enclosed area were the stables, five apartments, and three stores. Szmelcman owned the entire building. Occupying the apartments were the Szmelcmans; Pinkhes Zajfman, his wife, and their foster child Moyshele Kajzer; Volu Wajcblum's family; Uma Grinsztajn's family; and a fifth little room, which was the first dwelling I can remember my family occupying when I was a baby. I don't know who moved in after we left for a bigger place.

Uma's family moved there from a much nicer dwelling on *Ivansker veyg*, where they occupied the upper floor of the blacksmith's house, right next to the smithy. When I played hooky so I could watch the blacksmith, I took a shortcut by climbing up a fifteen-foot bluff behind the smithy and cutting across the wheat fields to get back to school. The blacksmith had a nice brick house, but it was a twenty-minute walk from the center of town. I assume Uma's family moved because they wanted to live right in town, or maybe they could not afford the rent. Their new dwelling was one big room with a sagging ceiling; it was dark, with one small window at ground level looking out onto a back courtyard. The entrance to their dwelling was from the area where the wagons were parked. The former occupant was Refuel *tsikerlekh-makher*, Refuel the Candy Maker, who used to live and work in that one room. I would knock on his window, from the little courtyard, and hand him a penny or two. He would give me a few candies.

The stores included my father's leather store, Wajcblum's coal business, and Szmelcman's grocery. Szmelcman had a goat, which roamed around the stables and ate the straw, hay, and oats that the horses dropped. One time the goat somehow managed to get into the gro-

cery, the back of which looked out onto the parking area, and it wreaked havoc. Szmelcman eventually sold the goat to a farmer about six miles out of town, but the goat found his way back, and Szmelcman had to get rid of him again.

Around 1930, some enterprising man imported two Model T buses. The buses were Model T's, not Model A's. They could take about ten passengers each. There were benches along the sides and a bench in the middle. The benches were not upholstered. The men parked the buses in front of Galiński's place, on the main square. They would always have a hard time starting the motors in the morning, particularly in the winter. They would haul out a team of horses and use them to pull the buses until the motors started. I was told that, on the way to Sandomierz, the buses could not make it up a steep hill. The passengers had to disembark to lighten the load, and sometimes they also had to help push the vehicles up the steep gradient. The buses did not last. They disappeared after a short time.

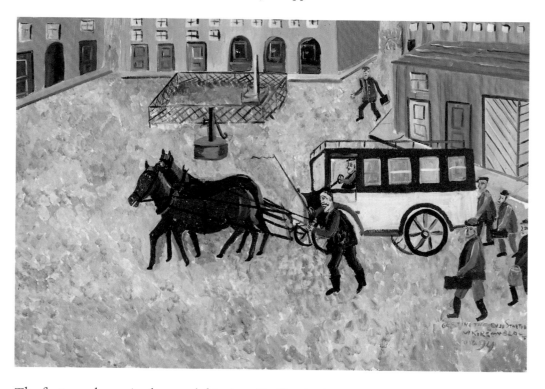

Getting the Bus Started

The first car also arrived around this time. Earlier, in the 1920s, I vaguely remember a car in Apt, but it didn't work. It was a Model T Ford. They took it to pieces, and it disappeared. Benyumen Lewensztajn—we called him Yumen or Yumtshe for short—was the only one in town at the time who had a working automobile. He imported a brand-new 1928 Essex,

an open touring car. He had a chauffeur and a helper, both of whom constantly polished the car. They would take the car down to the river, where they would wash and wax it. Occasionally, maybe once a week, Yumen would take a drive through town to show off his car. He sat in the back, like a gentleman, and the chauffeur, with the helper at his side, drove Yumen around town.

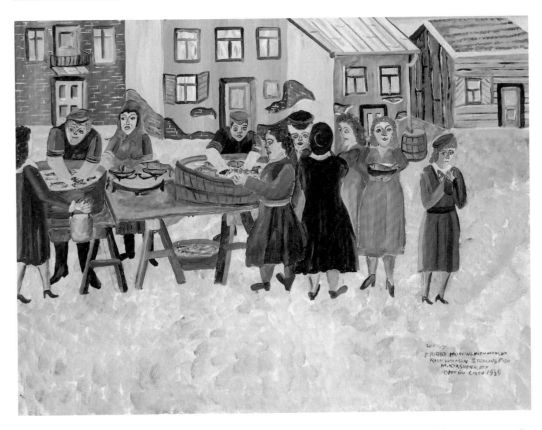

Yumen was very well-to-do. He owned the biggest lumberyard. Although he was not religious, he closed his shop on Saturday. I don't remember seeing him in *shil*, the synagogue, but his daughter went to a Jewish school. She and I went to public school. We were in the school orchestra together. Would you believe it, Yumen's wife was a kleptomaniac. She used to steal. Everyone knew. The merchants would keep track of what she stole, and her husband would write down what she brought home. Every Monday morning, all the merchants would come to Yumen and tell him what they were owed, and he would pay up. My mother told me that Yumen's wife would steal a fish and hide it in her bosom. It was a live fish, of course. Who would want to steal a dead fish? She was a beautiful little woman, always impeccably dressed. There she is in brown, with a matching hat and guilty look, slipping a fish down her dress.

Shortly after Yumen bought his Essex, Goldman, who owned the mill, bought a 1930 Ford sedan, which he operated as a taxi. Within a year or two, big buses, called Mieses—I think they were French—came through Apt. One was larger than the other. The buses provided public transportation between Opatów, Staszów, Ostrowiec, Radom, and other big cities. This did not put the *droshke,* the horse-drawn carriage, out of business. There was one *droshke* in town, and it was pulled by two horses. It was owned by a family who was known as *di hokes.* I don't remember their real name. They were the only ones to own a carriage with a folding top. They ran a passenger service to Ostrowiec, the closest railway station. They always had a full load.

The carriage held eight, and one person could sit outside, beside the driver. The driver's seat, which was a few inches higher than the passenger seat to his left, was called a *koziot,* which means billy goat in Polish. I think the *droshke* made only one round-trip a day. It was always parked on Narrow Street, facing our bedroom window, where I could watch them harness and unharness the horses. They took great care of their vehicle. They were always painting and polishing it. The upholstery inside was worn out, so they covered it with a blanket. One day, they decided to replace the steel-rimmed wheels with rubber wheels. That did not last long. The rubber came off, and they went back to steel-rimmed wheels. Cobblestone surfaces were very rough on the wheels. I remember Reb Shmiel Jurkowski laying down cobblestones. It was a slow and tedious job. In winter, when there was a lot of snow, especially on country roads, people used horse-drawn sleds to get around.

Mr. Goldseker, who collected the tolls from vehicular traffic crossing the bridge along *Ostrovtser veyg,* also had a concession from the government to build roads, and I watched how they did it. First, a wagon would bring large chunks of stone and drop them to the side of the road. Then, another man would break each stone into small pieces, about two-inch cubes, using a small maul. When he was done, he would pile the broken stones into a rectangular pyramid about ten feet long and three feet high. Goldseker would come along and measure the pyramid. On that basis, he would determine how much to pay for the labor. The man who broke the stones was not paid much.

Once the stones were ready, workers would tear up the road with picks and shovels and spread out the broken stones. A huge steamroller would compact the stones. I loved the steamroller, *damfvalts* in Yiddish. I would follow it around. Shiny and black with bright brass trim, the steamroller was a thing of beauty. The operator used to wipe it with a greasy rag to prevent it from rusting and to keep it shiny. A fireman kept feeding coal into the boiler to produce the steam. Two balls would spin at the top of the boiler. I once asked the fireman what

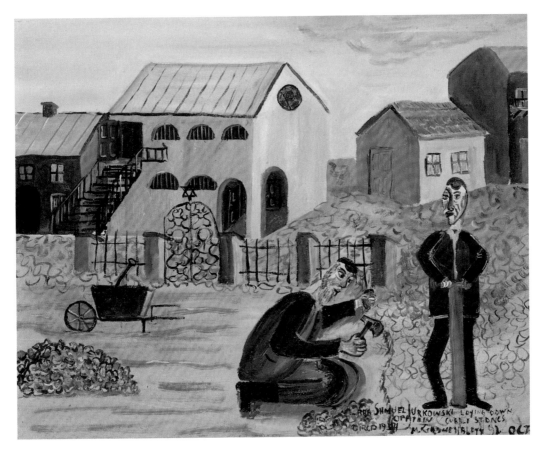

*Reb Shmiel
Jurkowski
Laying Down
Cobblestones*

the balls were for, and he said it was the regulator. Chains were attached to the ends of the enormous roller; as the operator turned the steering wheel to the left or right, he would pull on the chains and direct the roller. The steamroller also had a very nice whistle, which drove the horses crazy. The horses had never encountered a machine that whistled. In order to quiet the horse, they would cover his eyes with a burlap bag so he would not see the machine.

After the stones were compacted, the workers covered them with a thin coat of asphalt. The asphalt didn't last very long. When a horse had a strong piss, he made a hole in the asphalt. This is a joke, but it is true that the roads were not well maintained and that horse urine would accumulate in the potholes and freeze in winter.

We depended on the roads, since the main railway did not come through Apt, so Mr. Gold-seker made a good living from collecting tolls at the bridge and making roads. He was a rich man. He lived in a little estate along the south side of the river, where he had stables and

kept a cow. One day I was sent there to drink fresh warm milk from his cow. It was supposed to be healthy. I liked his youngest daughter, Lalush, but she was shy and wouldn't have anything to do with me.

People who came to town needed a place to park their wagons, eat, and sleep. Jews mostly parked their wagons with Szmelcman, the Poles with Galiński, where they could also eat and drink. Galiński served pork that he had cured and smoked himself. There was no hotel in town, but there were two places in Apt where Jewish vistors could find lodging: Worcman's and Gutmacher's. The Worcmans, who were located at the bottom of Broad Street, had one or two rooms for rent and prepared food in their kitchen for guests. They were sometimes joined by local Apters, including some shady characters. The Worcmans also lived in this place.

Gutmacher's establishment belonged to my maternal grandmother's brother Pinkhes Gutmacher, my granduncle. It was located on *Ivansker veyg*, where this street meets the bottom of Broad Street. *Feter* Pinkhes, Uncle Pinkhes, owned two adjoining buildings, a one-story

Gutmacher's Inn, with Shilklaper Announcing the Sabbath

wooden building and a two-story brick building. He rented out rooms on the upper floor of the brick building to travelers and rooms on the lower floor to the Micmacher family, who never paid rent. The kitchen and restaurant, which was more like a tearoom, were in the front of the wooden building and his apartment was in the back, where he lived with his second wife and eight children. From his first marriage, *Feter* Pinkhes had four daughters and two sons. His first wife died. From the second marriage, he had two more daughters, very nice girls. His wife did all the work, and the girls helped. There was no hanky-panky in his establishment. After all, he had six daughters. In my time, the daughters from his first marriage immigrated to Canada and the United States. One of the sons went to Canada and then Israel.

The tearoom was spacious, with a large window that looked out on Broad Street. People could eat at the table and watch what was going on outside. *Feter* Pinkhes always used to sit at the table looking out the window. Although his place was not quite as posh as Worcman's, the food was excellent, and because *Feter* Pinkhes was pious, most religious Jews preferred to go there. The Gutmachers generally had a big pot of soup on the stove, a *krupnik* made with barley and flanken (beef flank), which they served with fresh bread, and tea, and a shot of vodka, if requested. *Feter* Pinkhes would never allow drunkenness. When guests from the United States came to visit, they would sometimes stay at Gutmacher's, as his place was known. After all, they had come from rich America. How could they stay with their relatives or friends in their hovels, infested as they were with bedbugs and lice? Instead, they would rent a few rooms from *Feter* Pinkhes. The rooms were clean.

The appearance of visitors from America was quite an event. I admired their clothes, which were always a very light color, right down to the white shoes. To this day, I favor light beige clothes and brown shoes. In Apt, we used to wear dark suits so they would not show the dirt. I remember one American guest in particular. After he got settled, he invited all his friends and relatives over and hired *klezmurim* to play a little bit of music. My granduncle supplied refreshments, a few bottles of vodka, and a samovar of tea. A good time was had by all. When the American started feeling good and got a little bit tipsy, he would go out on the balcony and toss pocketfuls of coins to the street. We children were outside listening to the music. As soon as the money came raining down, we would fall all over each other trying to grab the coins. Before leaving, the American hired a *droshke* and rode through town, scattering coins everywhere. A whole flock of children ran after him. We were his parting entourage, escorting him as he left town and chasing the coins that he showered in all directions.

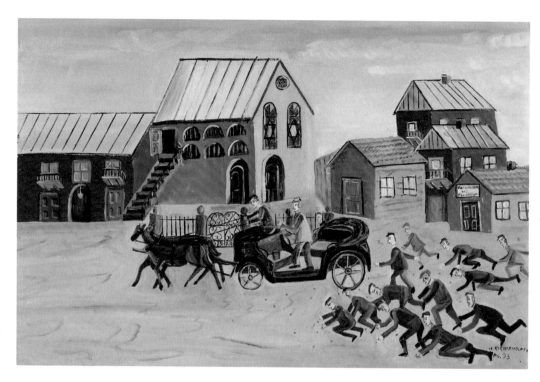

*The Visiting
American
Throwing
Pennies as He
Leaves Apt*

Why did the Micmachers, who lived in one of the apartments in *Feter* Pinkhes's building, never pay rent? The father of this family, Mordkhe, was living in Toronto and refused to support the family. He was known as Mordkhe *fatset*, Mordkhe the Dandy, because he was so fastidious about his appearance. The family barely had enough to eat. He would return to Apt occasionally, stay for about a month, and leave again for Canada. Before we left for Canada, my mother promised Mrs. Micmacher that she would speak to her husband in Toronto and tell him to send his family money and maybe even send for them so they could join him in Canada.

Shortly after we arrived in Toronto, Mother asked Mordkhe *fatset*, "Why don't you bring your wife and children to Canada?" He answered, "What? Bring my wife out so she should wash floors here?" My mother responded, "Is it better that she should stay in Apt and starve?" My mother, being the tough cookie that she was, took a hat and stood in the front of the Labor Lyceum, which he frequented. It was in the heart of the Jewish immigrant neighborhood in Toronto. All the unions for the needle trades and furriers had their offices there. Mordkhe *fatset* was a tailor and belonged to the union. As people left the building, she accosted them and asked them if they would please give some charity for Mordkhe *fatset*'s

wife, thereby shaming him into coming across with some money for his wife and children. He never sent for his family, but he did come back to Apt for a brief visit. He stayed for a month or so but never brought them out and seldom, if ever, sent them any money. You can imagine how poor they must have been if they went to Uma's family, which were the poorest of the poor, to warm themselves.

Mordkhe *fatset* had two beautiful daughters. They dressed to kill. They made their own clothes. When asked how they could afford such beautiful clothes, they were the ones that used to say, "What you have in your stomach nobody can see, but what you have on your back everybody can see." They must have skimped on food in order to dress well. I know that they never heated their house in the wintertime. They would go to Uma's house to warm up. Mordkhe *fatset* had one son, Shloyme Micmacher, who survived the war and came to Toronto. He was an intelligent and self-educated man, also a writer, a Yiddishist. The rest of the family perished at the hands of the Nazis.

Galiński's, the third establishment, also provided a place to park the wagons and stable the horses. He too had a restaurant and a few rooms for rent. You could enter his place from the marketplace or from Narrow Street. Galiński was Christian and served a strictly Gentile clientele. I went to school with his youngest son, Józef Galiński, a big guy and a bully. His older brother had a shotgun and would go up on top of a ruined house, spread out bread to attract the sparrows, shoot them, and make sparrow pie. One day, as my mother and I were going home from the theater, Józef's older brother started up with my mother. My father was in Canada by then. I said to him, "Odpierdol się!" which means "Fuck off!" and took a rock and threw it at him. I broke his glasses. He chased me but I got away. At school, his brother warned me, "Majer! Mój brat cię szuka!" which means, "My brother is looking for you!" Józef was big and I was small. If he had found me, he would have killed me. The thing blew over.

Maylekh told me that, after I left Apt for Canada, he and his friends would gather in a *budke*. By this time, the guys were already working and earning a little money. The *budke* consisted of a kiosk in front, where you could buy candy and ice cream, and a room in back, where the guys would hang out, play cards, dominoes, chess, or checkers and snack on pastries and candies. Maylekh recalled the time a few of the guys put together some money and purchased a tin of sardines. One fellow was short of money and could not chip in. What was he to do? He grabbed the sardines and spit into the tin. Of course nobody would eat them, so he had the whole tin to himself. When I was in Apt, I was too young to go to a *budke*. I was not yet working and didn't have the cash.

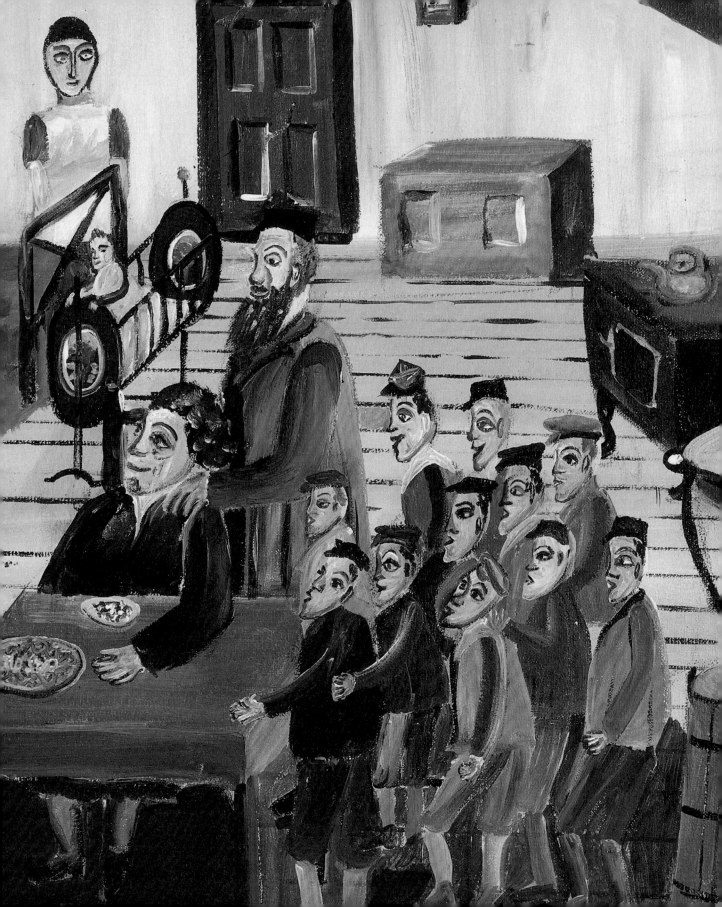

DOMINOES, CHEESECAKE, AND CIGARETTES

My maternal grandmother was called *di grobe* Shoshe, Fat Shoshe, because she was short and heavy. Her married name was Wajcblum, her maiden name was Gutmacher, and her Jewish name was Shoshe Mayer Makhls, which means Shoshe the daughter of Mayer Makhl. Her husband, Yisruel, was very thin. *Di grobe* Shoshe would sit on a small box in front of her little grocery store on Broad Street. A firepot with glowing charcoal kept her warm in the winter. Although my grandmother could not read or write, she was the one who carried on the business. With the store and six children to care for, she was a busy lady. She carried staples such as flour, sugar, salt, herring, and coal oil for lamps. She would go to Warsaw once a year to buy wallpaper remnants and imported delicacies. The smoked sprats (*shprotn*) came packed in two layers in a long wooden case, about twenty-four by fourteen inches. They were dry and very delicious. She sold special foods for holidays. People bought peanuts for the *ofrif*, the ceremony of calling the groom to read from the Torah on the Saturday before his wedding, and carob (*bokser*) for Lag b'Omer. When the figs got moldy and the dates were wormy, she treated us to them.

My mother's family, the Wajcblums, were from Apt. My father's family, the Kirszenblats, were from Drildz, a smaller town twenty-eight miles north of Apt. Before my mother got married in 1915, she helped my grandmother in her store. Mother told me that it was a thriving business. During World War I, when the Russians invaded Apt, the first thing they did was look for whiskey. A Cossack galloped into my grandmother's store on his horse. By this time, there was little left in the store—everything had been sold, stolen, hidden, or requisitioned by the army. The Cossack spotted a few bottles on a shelf. He asked my mother, "What's in the bottles?" She replied, "*Ocet*," which is Polish for vinegar. He didn't believe her. He slapped her. Then he directed his horsewhip at the shelf and sent the bottles tumbling to the floor. Another Cossack on a horse dropped a small keg of whiskey on the cobblestone road. The keg shattered and the whiskey spilled on the ground. My mother remembers seeing Cossacks get off their horses, kneel down, and sip the whiskey from the gutter.

After the Battle of Opatów in 1915, when the Russians drove back the Austrian forces that had occupied the town, a Russian commission supervised the burial of dead soldiers. My

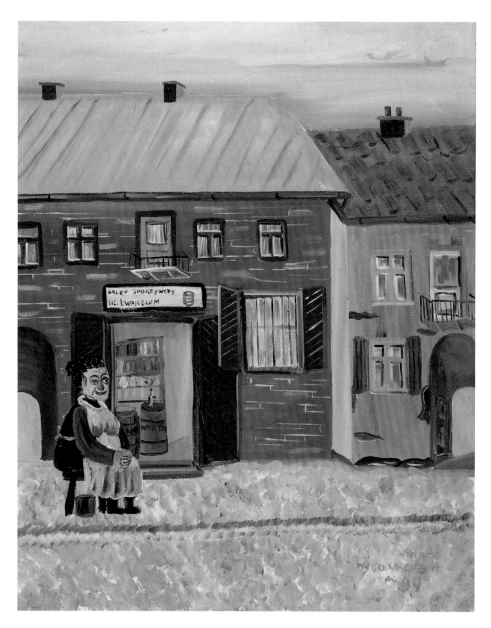

My Grandmother,
Fat Shoshe

mother told me that the officers sat at a long military table outside the Christian cemetery. They registered all the corpses before they buried them in a communal grave, several hundred feet long. I remember seeing that grave. Even though there was no marker, everyone knew the Russian soldiers were buried there. When I visited Apt a few years ago, the mound was gone and nobody remembered it.

The Russian military also brought wagonloads of injured soldiers to town. My mother remembered hearing some of the wounded soldiers beg the Cossacks, "*Dobeyte menya*," which means "Please finish me off. Put me out of my misery." When my mother told me this, she always had tears in her eyes. My mother stopped working in my grandmother's store when she got married. After that she worked with my father in his candy store. After a time, he gave up the candy store and opened a leather store that supplied the shoemaking trades. He was away a lot, so she ran the business.

Whenever I visited Father's leather store, I would go across the street to Fayge Hendl's stand. She sold over-ripe fruit and "crippled" candy. Fayge Hendl sat there on the street five days a week, winter and summer, in rain or shine, snow or sleet, for as long as I can remember. On cold winter days, she kept a cast-iron firepot between her legs to keep herself warm. She would fill it with sand almost to the top, then light a piece of newspaper and put a few pieces

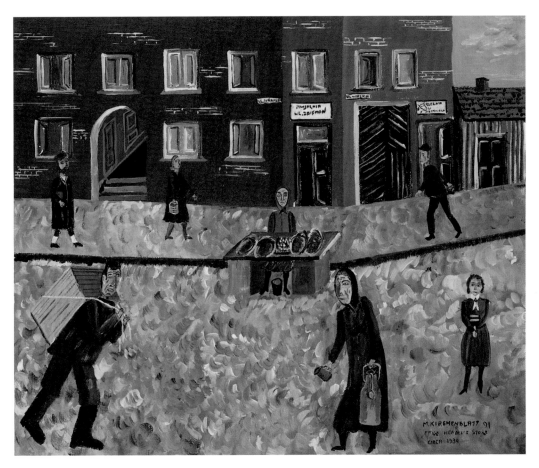

Fayge Hendl's "Store"

of charcoal on top. She kept the firepot going all day long. When the Austrian army passed through Apt after the Cossacks left town, Fayge Hendl was sitting there as usual selling her goods. The soldiers called out to her in German, *"Cigaretten, Cigaretten?"* She did not understand them. She answered in Yiddish, *"S'i' geritn, s'i' gefurn,"* which means "They were riding (on horses). They were riding (in carriages)." They said *cigaretten*. She heard *s'i' geritn*.

My father used to run errands and leave me to mind the store for a few minutes. When he returned, he would reward me with a penny. I would rush over to Fayge Hendl and spend the money right away. I never let it burn a hole in my pocket. I would buy her candy. There was a candymaker in town, the son of Layzer *kozdatsh*. He had his candy factory in a room on Narrow Street, facing Kandel's building. I used to like to watch him make candy. I remember seeing him pull the hot candy into long strands and cut it up on a wooden block. Two women sat all day at a table, where they wrapped each candy in a little paper, twisting the two ends of the paper. The wrapping had a picture of a cow on it, and the candy was called *krówki*, which means little cows in Polish. If some of the candy didn't turn out right, he would throw the seconds back in the pot, together with the ends of the candy strips, and re-cook them. Sometimes he would give me scraps to eat. Most of the time he gave the defective candies to Fayge Hendl at a steep discount. She didn't make very much. Things were so difficult that, even if she made only twenty *groshn* a day, it was twenty *groshn* more than she would have made sitting at home.

My grandfather spent his time in the *besmedresh* studying the holy books and hanging out with his friends. There was not much to do in the store, but he helped out. To make a little money, he would buy pumpkin seeds in a big sack, maybe a hundred pounds or more, from a farmer. He took the pumpkin seeds to the baker on the Jewish Street next to Lower *besmedresh*. In the afternoon, after the baking was finished and the oven was still hot, they would spread the seeds on large baking pans, about four feet by three feet, and roast them. My grandfather took the roasted seeds home, and my grandmother would put them in little brown paper bags. A small bag cost five *groshn* and a large one ten *groshn*.

One is not supposed to handle money or do any kind of commerce on the Sabbath, but my grandmother was always ready to turn a penny. On Saturday, when the young swains were out of pumpkin seeds, they went to my grandmother's. The bags were on the table. My grandmother would pick up the corner of the tablecloth, and the gentlemen would drop the coins under the cloth and then help themselves to a bag. The transaction was completed without my grandmother ever touching the money or handing out the merchandise. I would

say that was pretty clever. As soon as the Sabbath was over and the lights came on, Grandmother could open the store again. She took in a few cents. A big housekeeper she was not.

On Sundays, when it was illegal to do business, my grandmother would sit outside her shop with the door ajar. If someone wanted something, my grandfather, who stayed inside, would slip the merchandise through the partly open door, and my grandmother would take the money. She had deep pockets. They wouldn't make very much on a Sunday, but whatever they made was more than if the shop were closed. Every once in a while, one of the only two policemen in town got ambitious and cracked down. The policemen were always in full dress: a dark blue tunic, buttoned to the chin, rifles with fixed bayonets. The only difference between summer and winter was that in the winter they also wore a greatcoat. They did very little patrolling in the town. They mostly patrolled the periphery and on occasion patrolled the Jewish Street to look for stores that were open on Sundays. If my grandmother got caught, she had to pay a fine or serve time. My grandfather would be hauled in front of the civil court to represent her. Usually, she would be fined about ten zlotys. That was more than a week's salary for a worker. Not wanting to pay the fine, my grandmother would be sentenced to a few days in jail, and my grandfather would serve the time for her. The authorities didn't care who served the time.

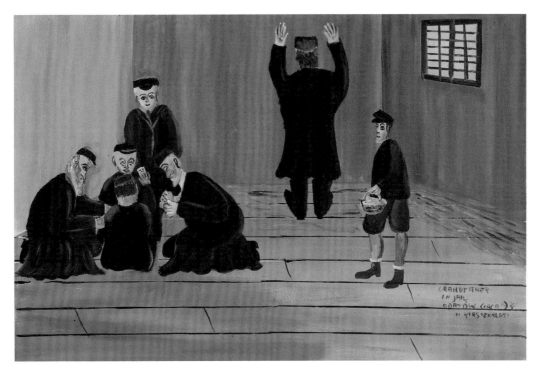

Bringing Food to Grandfather in Jail, ca. 1930

The jail was a two-room affair, one room for women and one for men. The cell was about twelve feet by twelve feet, with a small window close to the ceiling, so that nobody could look in or out. There was no furniture, just a little straw scattered on the floor along the perimeter of the cell. There was an outhouse in a little courtyard.

Grandfather had company in his cell, his contemporaries. Usually there were five or six men there, also pious Jews. Some prayed. Most played cards all day. I don't know whether the turnkey served them food. Even if he did, Jews would not eat it because it was not kosher. Since I was the oldest grandson, my grandmother delegated me to take food to my grandfather. I was told that the brushmaker, Yekhiel Watman, looked forward to jail because he could stretch out and go to sleep. At home, he and his family lived and worked in one tiny room.

My grandfather was known as Sruel, the short form of Yisruel. He had three nicknames. He was called *der hoykher* Sruel (Tall Sruel) because he was six feet tall and there were not many six-footers in the community. He was called Sruel *zelner* (Sruel the Soldier) because he had been conscripted into the tsar's army around 1888; he was eighteen years old at the time. Being so tall, he was consigned to the tsar's lifeguard; no one shorter than six feet was eligible. He must have worked in the army kitchen, because he was also called Sruel *kucharz* in Polish or *kukhosh* in Yiddish (Sruel the Cook). My grandfather had strange hands. We think his hands and feet must have been frostbitten when he was in the army, because his fingers were so thick and stubby. They were square at the ends with extremely tiny fingernails. The skin was red. Nor were his feet normal. They, too, were discolored. I remember seeing them in the *mikve*.

The term of service in the tsar's army could be as long as eighteen years. My grandfather was discharged after seven years. As a result, he did not marry until he returned from the army, at which point he was twenty-five years old. In those days, a groom of his age would have been considered an old bachelor. People generally married at the age of eighteen. My mother was nineteen when she got married, and that was not considered young. I always remember my grandfather as an old man, from my earliest recollection of him when I was about four and he was only fifty. He died of dysentery in 1935, the year after I left for Canada. He was sixty-five years old.

My grandfather introduced me to smoking when I was eight years old. Every Saturday evening after Havdala, the ceremony that marks the end of the Sabbath and beginning of the week, it was cigarette-making time for the whole week. He would place two cartons of

cigarette cylinders, a hundred to a box, on the kitchen table. Then he set out two packages of tobacco. One was first grade and one was second grade. He would mix them together. He had a metal tube that was hinged along its length. He would open the metal tube, fill it with tobacco, close it, and insert it partially into the cigarette paper cylinder. He used a plunger to push the tobacco through the metal tube and into the paper cylinder. As the paper cylinder filled with tobacco, it would slip off the metal tube. I would trim the excess tobacco with a small shears and place the cigarettes back into the empty cylinder boxes. It took us a couple of hours to fill the box with about two hundred cigarettes. He was very meticulous about his cigarettes. They had to be just so—the right amount of tobacco, neatly formed, and nicely trimmed. The cylinders in those days had a mouthpiece, inside of which was a little cotton batten for a filter. This was the only luxury he had. For this, my grandfather rewarded me with a dozen cigarettes, which my friends and I enjoyed. In the fall, we would gather dried chestnut leaves, roll them in newspapers, and smoke them joyfully.

Cigarettes were a government monopoly. That monopoly included tobacco and all tobacco products. Permits were also issued for the sale of whiskey. This too was a government monopoly. These monopolies were issued to disabled veterans instead of pensions. Veterans could lease their permits to someone else for a fee, renewable every year. They were inclined to do this because most of them were incapable of running a business, so they leased the permits to Jews. This is why you could buy whiskey and cigarettes from Jews. I knew of no disabled Jewish veterans. There was a Polish shoemaker, a customer of my father's, who had a leg shot off in the war. Since he could make a better living as a shoemaker, he leased his veteran's permit to someone else. This guy didn't wear a wooden peg but rather a shoe and some kind of prosthesis. Every time he stepped on that leg, it squeaked. He was an alcoholic. I went to his home to collect the money he owed my father every Wednesday at the end of market day. I had to catch him before he got drunk. As a disabled veteran, he had a permit from the government for selling tobacco.

The cheapest cigarettes were Wanda. Cigarettes were also made and sold illegally in the *shvartse shenk*—literally, the black inn, which was a sort of private club in a bootlegger's home. There were several such places in Apt. Kaliszer's was on our street. The one frequented by the local Jewish mafia belonged to the parents of Mayer Makhl, who was a year or two older than me. His mother was a sister to my grandmother Shoshe. His father, Yosl Grinsztajn, was nicknamed Yosl *luptsok*. I used to visit them to pick up giblets, because when Mayer Makhl's mother cooked a goose, we got the giblets. She sold roasted goose and ducks

to the customers at her place, so she had more giblets than she could use. She'd serve drinks, especially whiskey and vodka that she bought at the store. They also made cigarettes and sold them; this too was illegal.

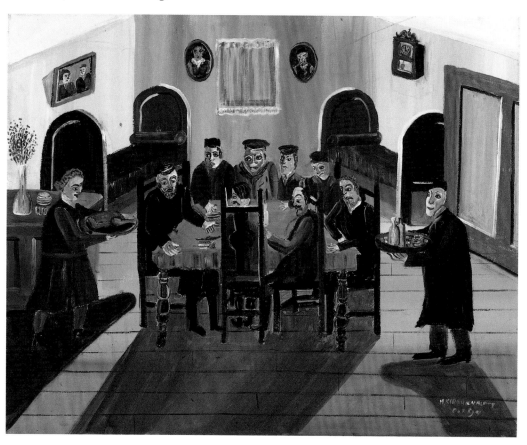

The Mafia at the Bootlegger's Home

Mayer Makhl told me that Khamu Itshe Mayers, one of the biggest mafia guys in town, was a relative. He must have brought them the mafia business. Yosl *luptsok* knew all the receivers in town. If you had a break-in or your laundry had been stolen, you went to him. He knew to whom to go. Some Jews liked to go there to socialize with the owners as well as the patrons. I'm not aware of any Polish bootleggers, but I do know that some Poles patronized the Jewish bootleggers. The bootleggers had to be very careful not to get caught. So too the women who offered sexual favors. I heard that one such woman—she lived near Maylekh's—immigrated with her family to Argentina; the mother and daughter ran a high-class brothel there. The girl was beautiful, but her calves had no muscles. Her legs were like sticks. The mother was hefty.

Yosl *luptsok* had two daughters. Pintshe, my grandfather's nephew, fell in love with one of them. Pintshe used to visit Apt from Wierzbnik, his hometown, which was about halfway between Ostrovtse and Drildz. The girl's parents were against the match even though Pintshe came from a respectable family. The girl herself might have agreed to see him, but she could not go against her parents' wishes. One time Pintshe was in Apt at the same time as my father's brother Arn Yosef, who had come to see us from Drildz, my father's hometown. In despair over his unrequited love, Pintshe got drunk. He came to our house, flopped down on the bed, and fell sound asleep in his clothes and shoes. Arn Yosef was something of a prankster. He inserted big wooden matches between the sole and upper part of each of Pintshe's shoes. We woke him up and, while he was still groggy, we lit the matches. He jumped up and started dancing. That's called a hot foot. The romance eventually petered out. Yosl *luptsok*'s family, the Grinsztajns, disappeared in the Holocaust, with the exception of one son, who spent the war years in Russia and is now living in Israel. Pintshe survived the war. Upon being liberated, he returned to his hometown and was shot by Polish people he probably knew.

I remember my grandfather not only for the cigarettes but also for his lead *dreydl*, or top. We used to play with the *dreydl* on Hanukkah, which celebrates a military victory and a miracle. After Judah Maccabee and his troops defeated the Greek army in Syria, they recaptured Jerusalem and purified the Temple. When they went to rededicate the Temple, they discovered that they only had enough oil for one day. Miraculously, this oil lasted for eight days. We celebrate this holiday, in December, by lighting candles on each of eight nights, eating fried foods, and playing with the *dreydl*. On each of the *dreydl*'s four sides is the first letter of a word in the Hebrew sentence *Nes Gadol Hayah Sham*, which means "a great miracle happened there."

My grandfather made the *dreydl* from the lead seals on parcels delivered to his shop. All year long he would save these seals. They were affixed to the ends of strings tied around parcels so that you would know, by the condition of the seal, if someone had tampered with the parcel. Impressed on the seal was the mark of the company that had shipped the parcel. By Hanukkah, my grandfather had accumulated quite a few seals. To make the *dreydl*, he would melt the little lead seals and pour them into a small wooden mold that was about two inches high. The mold was ancient. I have no idea who made it. It must have been passed down. It was intricately carved and formed a *dreydl* with four wings. The mold was in two parts, which were tied together with a piece of string. To melt the lead, Grandfather would put the seals into a little cast-iron crucible, which he heated on a small Primus machine. Lead has a

very low melting point. He would then pour it into a little hole at the top of the mold. Over the years, the *dreydlekh* would get broken or lost, so Grandfather made us new *dreydlekh* every year. That's how we got our *dreydlekh*. I would give anything today to have that little mold. He used it year after year.

I painted Hanukkah at home with my father, mother, and brothers. We lit the candles and sang *Maoz tsur* (Rock of Ages). I added a few notes to indicate that we were singing. It was a special day for us because we were let out of school early. Father gave me Hanukkah *gelt*, a few pennies for a present, in honor of the holiday. Mother cooked *latkes*, potato pancakes, which are very delicious. She grated raw potatoes, added eggs and flour, and fried the pancakes in *shmalts*, rendered goose fat. There was oil—it was expressed from sunflower seeds and rapeseed—and, though I don't remember Mother cooking with it, she must have used it for deep frying and to make delicacies that were neither meat nor dairy. We ate the *latkes* with a little sugar.

My grandfather's brother Yosl was blind. He was known as *der blinder* Yosl. He was a very handsome man. I remember him with a grey beard. He used to wear black leather suspenders

HOW TO MAKE A DREYDL

1. *Parcel with lead seal*
2. *Lead seal*
3. *Primus burner with pot melting seal*
4. *Parts of wooden mold*
5. *Aperture for pouring in lead*
6. *Mold tied together with thread*
7. *Complete dreydl*

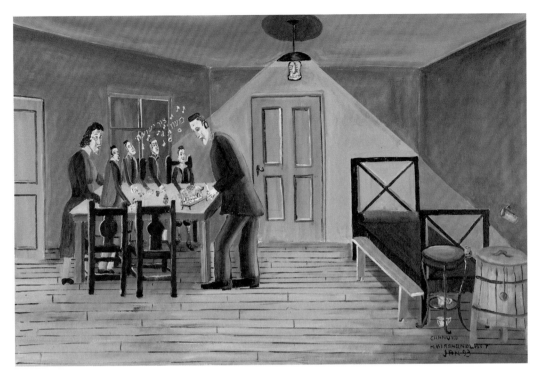

Hanukkah

that were attached to his trousers with a fine metal chain. His wife, Laye, ran a little restaurant in their home. She was my grandaunt. We called her *Mime* Laye, Aunt Laye. She had many virtues but good looks were not one of them. Their apartment was two doors away from my father's store. You entered their place from a corridor that ran between Broad and Narrow Streets. They had two rooms and an alcove. One room was an enormous kitchen that doubled as their living area and the restaurant. Yosl and Laye slept in the little alcove. They rented out the second room to travelers. I don't know where the children slept. By the time I was old enough to remember, only their youngest son was still at home.

Der blinder Yosl used to play dominoes in the kitchen with Laybl *tule*, the flour-porter, by the hour. They sat on benches at a long pine table near the window. From scrubbing with *bielidło,* a bleaching cleanser, the wood table and benches took on a beautiful ivory color. *Der blinder* Yosl was a champion domino player. Laybl *tule* was also very good at dominoes. The minute Laybl *tule* came in, *Mime* Laye would serve him tea and a few cakes or cookies. She would not stop filling his cup as long as they played. Some people added baking soda to the tea to make it dark, so that it would look stronger. That way they could use less tea.

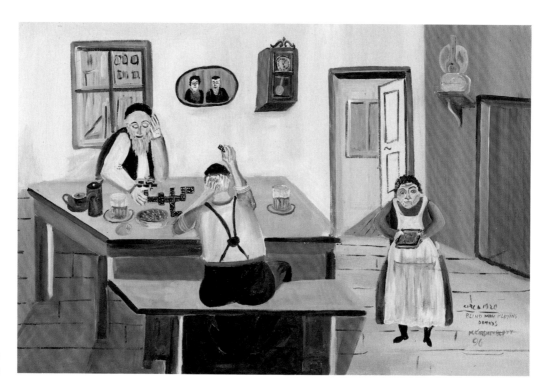

Der Blinder Yosl,
My Blind Uncle,
Playing Dominoes
with Laybl Tule

Mime Laye was a wonderful cook and baker. She was famous for her cheesecake. Select customers from out of town would come to eat there. My cousin Uma and I would visit them on Saturday afternoon to get a treat, *shabes-oyps* (literally, Sabbath fruit). *Der blinder* Yosl would always recognize us by our step and voice. He would call out to his wife, "*Sruels nunikes ʒenen shoyn du*" (Sruel's grandchildren are already here), using a term of endearment, *nunikes*, instead of *ayniklekh* (grandchildren). *Mime* Laye was short, well endowed, and wore a long apron that almost reached the floor. It had huge pockets. When she would reach into her pockets, you wondered what miracle would appear from that magical apron. Sometimes it was a wedge of orange. (She had a special way of peeling an orange. She cut it in quarters and, with her two thumbs, separated the orange segment from the skin. From the skin she made marmalade.) Sometimes it was a cookie or candy or a piece of chocolate. It might be an apple. If we were really lucky, she would serve us a piece of her famous cheesecake.

Under these circumstances, in such a small apartment, they managed to raise five children. The boys were well educated. Antshl and Harshl were deported to Siberia by the tsarist government because of their revolutionary activities. I think that they escaped to China and came to Canada from there. Two daughters, Etl and Bayle, also went to Canada. Just be-

fore Etl left for Canada in 1920, they gave a farewell party. I must have been four years old. I remember Etl holding me up above her head. Her daughter Elsie, who was a little older than me, had a big doll. The arm came off. I remember Etl removing a hairpin from her hair, pulling out the elastic inside the doll, and reattaching the arm. In Canada, the Wajcblums shortened their name to Wise. The youngest son, Mordkhe, remained in Apt.

Antshl became a well-known personality in the Toronto Jewish community. He was instrumental in bringing people to Canada. He had a steamship ticket office, so, in addition to selling tickets, he could help with immigration permits. He was also a justice of the peace and could help Jews with official papers once they were in Toronto. In this way, he reunited many families and kept them in touch with their loved ones in Poland. They could send money to relatives through Antshl, who, as an agent, would transmit the money to his brother Mordkhe in Apt. Mordkhe would then distribute it to people not only in Apt but also in the surrounding towns and villages. You could get your money in dollars or in zlotys. You could also purchase American money from Mordkhe, if need be. Antshl made a commission that he must have shared with Mordkhe. That was how Mordkhe made his living, a nice living. Mordkhe was our unofficial banker. Money from America was not distributed through the bank or post office. It was all handled by Mordkhe.

Mordkhe was a very handsome man. He had a black cane with a silver handle shaped like the head of an elephant, complete with a curled trunk. He used to burn his fingernail clippings in our stove, whenever he came to Shaye the Barber for a shave and a haircut, since the barber was right next to our place. Mordkhe came quite often. In Jewish tradition, you can discard your hair but not your fingernails. Mordkhe would pare his nails, gather them together with a few slivers of wood, deposit them in a little rag, bring the package to our place, and put it in our stove to burn. I used to go on Saturday afternoons after lunch to Mordkhe's father-in-law. He would listen to the *parshe* (Torah portion) and the *gemure* (commentary on the Mishna, the oral law) that I had learned in *khayder* that week. I did not fancy going there.

I remember the time I entered their kitchen without knowing that *der blinder* Yosl had just died. I walked in by accident. That would have been around 1927. I saw him laid out naked on the *tare-breyt*, the cleansing board. The *khevre-kedishe*, the burial society, was in the process of preparing his body for interment. They were washing the body. The board was about six feet long and tapered toward the bottom to funnel the water as it drained into a bucket. I think the board rested on chairs.

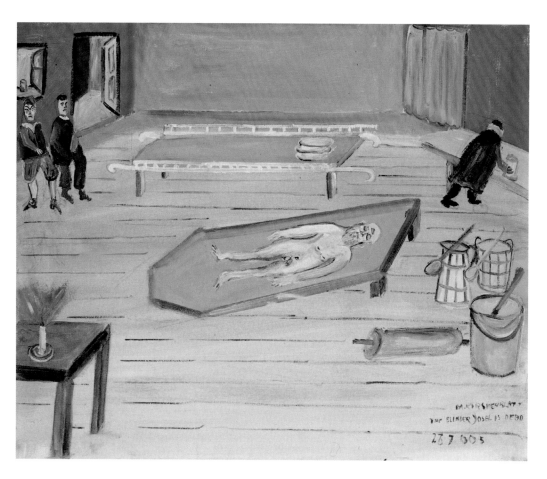

Der Blinder Yosl Is Dead

The literal meaning of *khevre-kedishe* is holy association. It was considered the greatest *mitsve*, or religious obligation, to look after the dead. Men prepared men's bodies and women prepared women's bodies. When someone died, the *shames*, or sexton, went to the *hegdesh* to get their tools and bring them to the home of the deceased, where the *khevre-kedishe* would prepare the body. They used various spoons, scrapers, pails, and other tools to clean the body inside and out. They pared the nails and did everything necessary to prepare the body for burial in the Jewish tradition.

After they finished cleaning the body, they would wrap it in a shroud, called *takhrikhim*, and lay the shrouded body on a *treyger*, a big wooden carrier with legs. You didn't have to lift the *treyger* very high, just a few inches off the ground, and you could easily set it down to rest. For a very important person, the *khayder* boys would be enlisted to follow the bier and recite *tilim*, Psalms. The body would be carried to the cemetery in this way. Yosl *grey-*

ber, Yosl the Gravedigger, would have already dug a grave. He wore thick glasses. He would await the funeral procession at the gates to the cemetery, with an alms box in his hand. Shaking the alms box to make the coins inside rattle, he would chant, *"Tsduke tatsil mimuves"* (Charity will save you from death).

Jews were not buried in a casket. The body was wrapped in the shroud and buried with the board. An ordinary Jew got only a board on top. So far as I know, a Kohen got a board on top and bottom. I saw, when my wife's mother died in Canada, how they placed two pieces of broken pottery, one on each eye, and two twigs, one in each hand, which I understood to be connected to resurrection. This was done in the cemetery. What they did in the Old Country I never saw, but I am assuming it was the same thing.

In our town and probably in every town, there were professional mourners called *di plat-shkes* (*płaczki* in Polish), from the Polish word *płakać,* which means cry. Their primary function was to wail on behalf of the mourners. They were paid to do this. They would follow the bier and sing soulful laments as part of the procession of mourners to the cemetery. When a person was very sick and all hope was gone, as a last resort the family would hire them

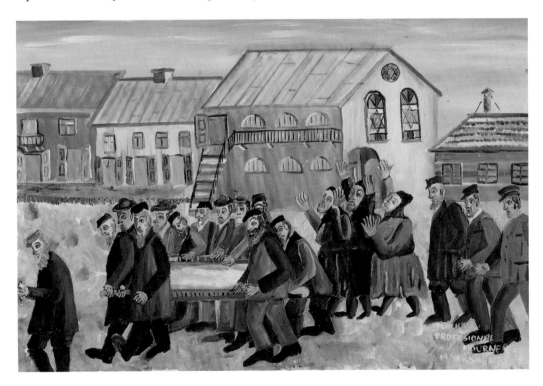

Di Platshkes: Professional Funeral Mourners

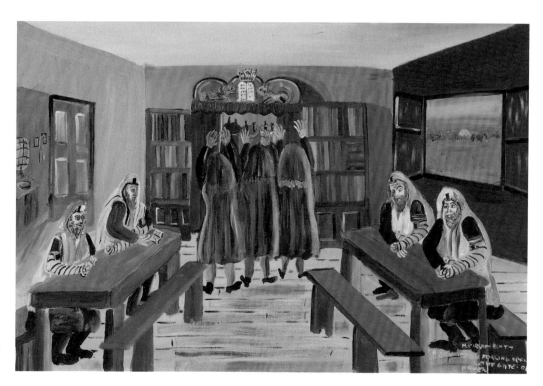

"*tsi rasn toyern,*" to force open the gates of heaven. They would run down the street to the *besmedresh,* rush up the steps to the Holy Ark, pull back the curtain, and fling open the Ark doors to expose the Torah scrolls. Crying and screaming into the Ark, where the spirit of the Almighty was believed to reside, they would beseech Him to save this very sick person from death. In a bid for the Lord's mercy, they would cry out, "This poor man has a family to take care of! Dear God, be merciful for the family's sake!" When we saw this performance, we knew that tomorrow there would be a funeral.

The tombstone was placed on the grave not sooner than thirty days after the person died. There was one Jewish monument carver, a *metsayve-kritser,* in town. I used to watch him by the hour. Weather permitting, he worked outside in a little yard right across from the synagogue. In bad weather, he worked in a little shack where he kept his tools. His place adjoined Sztajnman's house on the north side of the Jewish Street. I used to chum around with one of Sztajnman's sons. Whenever I went to his house, I loved to watch the tombstone carver. He was always busy working.

He had a few blank sandstone slabs stacked up against the wall. A farmer would deliver the slabs to him from the quarry already shaped, the tops rounded. Some slabs were a little big-

ger than others. Sandstone was soft and easy to work. He carved motifs and inscriptions appropriate for the deceased. For a young girl, he made a mourning dove with a twig in its mouth or a broken branch or a candlestick with a broken candle, indicating a life cut short. For a woman, he carved two Sabbath candles in candlesticks, for a man a pair of lions rampant. A hand holding an alms box indicated a charitable man. An open prayer book or Torah scroll symbolized that the man was pious or learned.

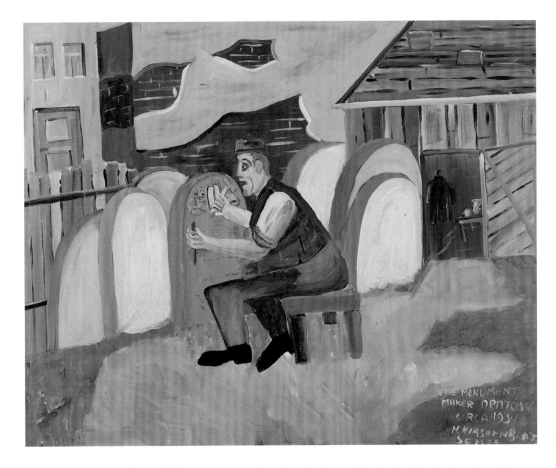

Tombstone-Carver

There were special motifs for a *koyen* (Kohen) and a *layve* (Levite). The Kohanim, who are male descendants of Aaron, were priests in the Temple in Jerusalem. The Levites, who descend from Levi, were their assistants. Not all Kohanim have the name Cohen, and not all Levites have the name Levy. The tombstone motif for a *layve* was one hand holding a ewer that poured water over two hands outstretched. This symbolized a *layve* ritually washing the hands of a *koyen*, which the *layve* would do before the *koyen* performed *dikhenen*, his bless-

ing of the congregation during the High Holiday services. The motif for a *koyen* was two hands extended, palms out, in a unique prayerful gesture—thumbs pointed to one another and a space between the third and fourth fingers.

Using a chisel and a maul, the *metsayve-kritser* carved both the inscription and the ornaments in a shallow relief. When he had finished carving the stone, he would paint it with bright colors. First, he would cover the stone with a robin-egg-blue pigment, mixed with *pokost*, which is linseed oil in Polish. He would paint the carved letters and some of the sculpted ornaments with gold, which he mixed with egg white. The egg white was supposed to preserve the brilliance of the gold. Sometimes he was commissioned to renew a weathered tombstone that had lost its color. That was very seldom.

The Jewish cemetery was not as orderly as the Gentile cemetery. One stone was this way and one stone was that way. Some of the stones were four hundred years old. The old sec-

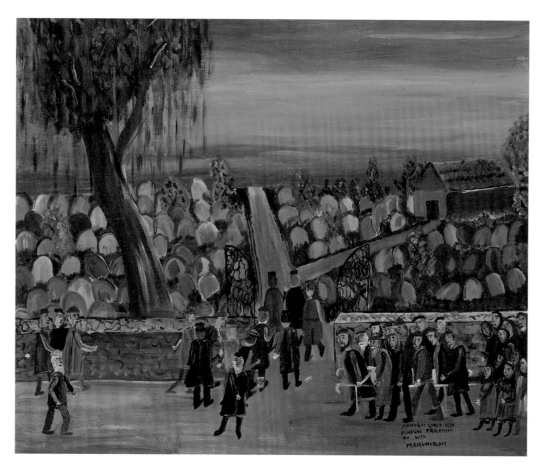

Funeral

tion started near the road, but then the cemetery went back, back, back to the newer section. The cemetery was enormous. It was destroyed during and after World War II. Some of the stones were dumped in the *kanye*, our swimming hole along the Opatówka River. Others were used to form the floors in pigsties and stables. This is what I was recently told. Today the Jewish cemetery is a huge park, and some of the citizens of Apt have made an effort to recover a few tombstones and make a memorial there.

After *der blinder* Yosl died, *Mime* Laye continued to live with Mordkhe and his wife and moved with them to a nicer place on *Tsozmirer veyg*. Mordkhe had no children. As was customary, he took care of his widowed mother. I remember Mordkhe bringing from Warsaw wallpaper that was a gorgeous royal blue with a fine stripe. They had wallpaper in the bedroom. When we went to visit *Mime* Laye and Mordkhe, we noticed that their curtains opened and closed with pulleys. When we came home, mother said, "Oh, I would love to have curtains like that." My father figured out how it was done and made my mother the same kind of curtains.

Mordkhe perished in 1942, but his wife survived. My friend Maylekh told me how he died. Before the Germans drove the Jews out of Apt, Mordkhe had a shoemaker make him a special pair of shoes with hollow heels so that he could hide gold coins in them. But after a dispute with the shoemaker, the shoemaker betrayed him to the Germans. The Germans forced about six hundred Jews in Apt to walk to Sandomierz, which was 21 miles away. Six thousand Jews—the number was so big because Jews from the surrounding area were forced to concentrate in Apt—were sent straight to Treblinka. It was in Sandomierz, where there was a labor camp, that the Germans took the money from the heels of Mordkhe's shoes and shot him.

My mother was the oldest of six children. There were four daughters and two sons: Rivke, Maryem, Sure, Khaye, Yankl, and Eliezer, who was known as Layzer. A seventh child, called Antshl, died in infancy. My mother's nickname was Rivke *kozak*, Rivke the Cossack, because she was a tough lady. Maryem was also called Marmele. The sisters were known by the Polish versions of their Jewish names—Mania (Maryem), Sala (Sure), and Hela (Khaye). The family lived in an apartment in the rear of the store; the store faced the street and the apartment faced the courtyard. I remember all the kids sleeping in bunk beds in a tiny alcove. As a little boy, I liked to snuggle up to Sala and sleep with her.

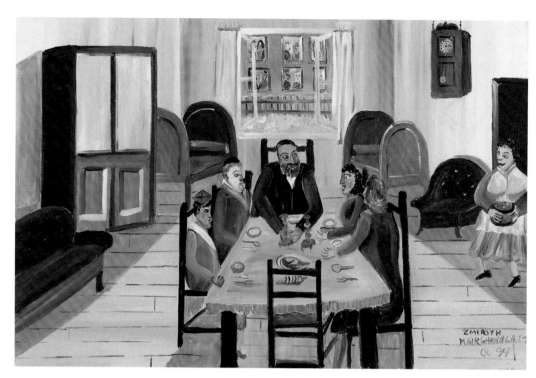

This painting shows the Sabbath meal at my maternal grandmother's. We sang *zmires*, Sabbath songs in Hebrew, so beautifully that neighbors would lean out of their windows to listen. We ate in the bedroom, which served as formal dining and living room on special occasions. The chairs my grandfather bought secondhand at an auction sale from the estate of a Polish nobleman. They weren't very good. Actually, they were broken and the springs were coming out. I didn't include the white slipcovers that were so patched there was very little left of the original fabric, because I wanted to show the color and the shape of the chairs.

My grandparents had separate beds, as was the custom among Orthodox Jews (a man must not touch his wife when she is menstruating), and an armoire. The room was also furnished with a table, two benches, and two chairs. At one end of the room were two windows overlooking their private courtyard, which was about ten by twenty feet. A corridor on the right side of the room led out to the courtyard. Grandmother cooked on a Primus stove in the corridor. She had the only repaired plate that I ever saw. The outside of the plate was encased with what looked like chicken wire mesh. The broken pieces were so tightly held together by the wire that the plate did not leak. I don't know who made the repairs, and I never saw anything like it again.

Let me tell you about my mother's siblings. Her brother Yankl was a handsome man, blond, a real sport. To my grandfather's chagrin, Yankl did not wear a hat, and he ran around with Polish women. Nor did he like to work. To make a little money, he occasionally worked in a brush factory, preparing the wood, or helped out in Szucht's barbershop on Wednesdays, when the farmers came to market. He couldn't cut hair, as he was not a qualified barber, but he was allowed to shave people. The barber also pulled teeth.

At long last, Yankl's parents arranged a match for him with a woman with money from somewhere in Galicia. We did not go to the wedding. They said that he had fallen into a *shmalts-grib*, a pit of fat, which means a pot of gold. In his case, *di shmalts iz farshvindn in di grib iz geblibn*, the fat disappeared and the pit remained. The marriage lasted about a year. I presume that the woman came from a religious family and that he didn't fit in. Yankl returned to Apt. He said he could not stand the marriage and got divorced. After a while, he went to Warsaw. A short time later he brought his beautiful new wife to visit Apt.

On our way to Canada we saw Yankl in Warsaw, where he had settled. He wanted my fountain pen, the only precious thing I ever had. I now regret that I would not give it to him. I brought the pen to Canada, but it did not last very long. The rubber tube inside went rotten, and it did not pay to fix it. What I remember best about Yankl, however, was his dog. That dog was the smartest canine you have ever seen. The dogcatcher could never snag him.

In Warsaw, Yankl eked out a meager living as a porter. I know this from Harshl Wajs, a friend of mine who survived the Holocaust. Harshl worked in a whiskey factory. Next door was the Atlantic chocolate factory, where Yankl would load his two-wheel cart with cartons and haul the goods to the post office or the railway station. He was cheaper than a horse: they did not have to feed, groom, or stable him. With a leather strap attached to the cart and stretched diagonally across his chest, he strained so hard to pull that load that the veins in his neck bulged out; he steered the cart with the *dyszel,* the wagon shaft. On Saturdays, the chocolate factory, which was owned by Jews, was closed, so Yankl would come into the whiskey factory to help pack the merchandise and earn a little extra money. Because alcohol was a state-run monopoly, the whiskey factory was open on Saturday. Harshl was shocked to see what terrible shape Yankl was in: he was once a handsome man, with blue eyes and blond hair parted in the middle; now he was gaunt and pale, completely worn out from the hard labor. Yankl had four sisters: two in Belgium; one, my mother, in Canada; and another in Poland. He complained that none of them helped him. Hard as it was for us, we could have done something. It makes me want to cry just thinking about it. Yankl once sent us a

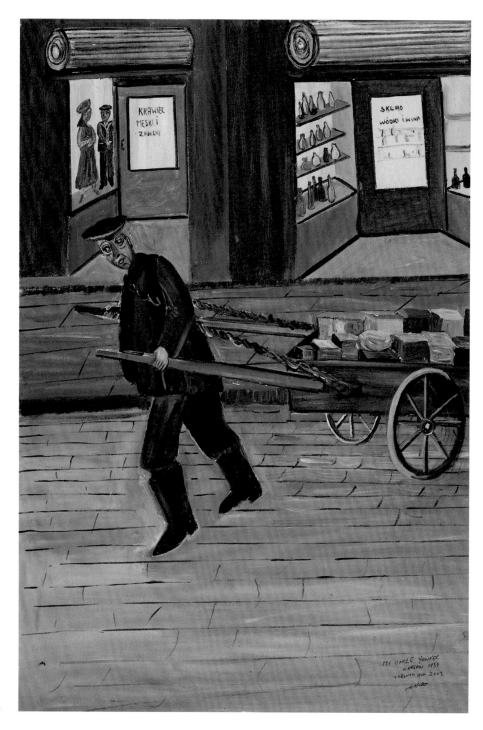

Uncle Yankl,
Warsaw, 1939

photograph of his wife and four young children digging up potatoes and baking them in the open field during their summer vacation. He and his wife and children disappeared like the others.

My mother's youngest brother, Layzer, immigrated to Palestine before we left for Canada. He was a year older than I was. Unfortunately, he died in an industrial accident in Tel Aviv in March 1934. He fell off a scaffold. He had a hammer in his waistband, and the hammer's handle perforated his stomach when he fell. He was interred in the neighborhood not far from where he was killed. A sister who had survived Auschwitz went to Israel to make inquiries. She found a man who had been working with Layzer. He pointed out his grave. She had his body disinterred and moved his remains to a cemetery, where she placed a marker on the grave. When I used to visit Israel, I made a point to visit the grave and say kaddish, the prayer for the dead. When I was there a few years ago, I paid a man two hundred shekels to restore the monument.

Before they were married, my mother's sisters Sala and Hela worked in Tajtelbaum's brush factory, which was located in the courtyard just back of where my grandmother's family lived. The biggest employer in Apt was the cottage industry of brush manufacturing. There were six to eight workshops, and each one employed eight to ten people. These factories were owned by Jews, and most of the brush factories were located in their homes. This was the case with Tajtelbaum's operation.

One of my grandmother's brothers, Sukher Gutmacher, owned a brush factory. His nickname was Sukher *barshtl-makher*, Sukher the Brushmaker. His factory was located right across from my grandmother's store, on the Jewish Street, in a building that had been severely damaged during World War I. The upper floor was a ruin. The ground floor was sufficiently intact to house his brushmaking operation. Sukher made a decent living and owned a beautiful house on Rampart Street, where he lived with his wife, three or four children, and several tenants. One day the southeast corner of the house collapsed. Sukher and his family knew the house was going to cave in. They could see the cracking and sinking. After it collapsed, his daughter Malkele *drek*—she's the one who fell into the latrine—complained to my mother, "I begged my father to let me set it alight so we could collect fire insurance." The old man would not go for it. They ended up restoring the upper floor of the old ruin, creating two huge rooms, one for the kitchen and living area and the other for a bedroom. They decorated the kitchen with sardine tins that had been polished to a high sheen.

Sukher and his friends were smart alecks. My mother told me all about their pranks from the time that she was still single. Sperling, a neighbor, was going to marry a woman from another town. Seeing as he was not too bright, he was an easy target. When Sukher and his friends saw him passing by Sukher's brush factory, they would threaten him, "If you do not set us up with a bottle of whiskey, we'll tell your father not to take you to your own wedding." Or they would call out, "Come here! Here's ten cents. Go to Layzer *kozdatsh* and buy some *kinder-zumekhts* [children's semen]. And while you're at it, buy two cents' worth of *kuter-vortsl* [tomcat penis]." Layzer *kozdatsh*'s candy store was a few doors away. His son had a small candy factory opposite Kandel's house.

I used to visit other brush factories too, particularly the one owned by Yekhiel Watman. He was known as *der geyler* Khiel, Khiel the Redhead, even though he was a brunet. Watman had three children: a daughter, Nakhete; and two sons, Avrum and Hasa. I was good friends with Avrum, who survived the Holocaust and arrived in Palestine during the War of Independence. He was pushed into the army with very little training and was at the front during the assault on Latrun. His job was to carry a rucksack with explosives for the engineers, whose task was to blow up a wall surrounding Latrun. The morning of the day he was killed, he said to his friends, "Today I won't return." He didn't. His jeep got blown up. Hasa survived the war and lives today in New York. Before retiring, he had a successful hat factory.

Nakhete had a special way of washing floors. The way people used to wash floors in Poland was to slosh a bucket of water on the floor, scrub the floor with a long-handled, stiff brush, and mop up the water with the remnants of a burlap bag. The Watmans had rich relatives in the United States who would send them parcels of used clothing. One parcel contained an evening gown with a long train. Having no other use for the gown, Nakhete used to wear it while washing the floor. She would promenade up and down the soapy floor with the long wet train of the gown trailing behind her. When she reached the end of the room she gave one twist with her hips and the train whooshed across the floor. She and her parents disappeared in the war.

Watman's place was on ulica Niecała (Incomplete Street), in a miserable wooden building on the verge of collapse. The house was leaning. He lived there with his family, all five of them, in one small room no more than ten by twelve feet, facing the street. There were two steel cots, one along each wall, a small table, and not much else that I can remember, besides a little shelf with the brushmaking supplies—the wood, bristles, and wire. The factory itself was in a freestanding wooden building that he built in the courtyard for that pur-

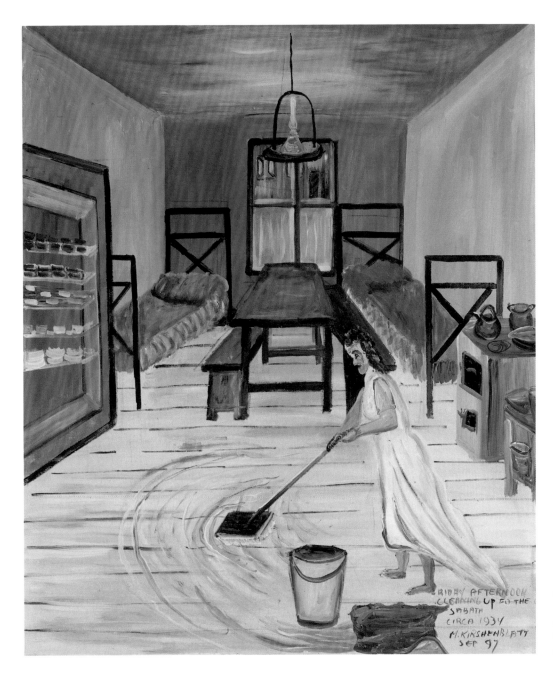

Nakhete: Washing the Floor in Wedding Gown on Friday Afternoon

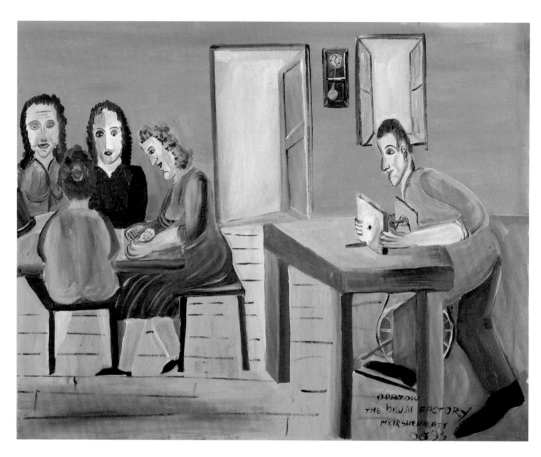

pose. His factory, which employed about five people, made shoe brushes and clothes brushes for export, not for local consumption. Where they sent them I do not know. I would stand around and watch each step of the process.

The farmer would bring the wood to the brushmakers already cut to size. The wood was called *olekh*, which means alder. The leaves of the *olekh* tree resembled elm, except that *olekh* was a beautiful soft wood, sometimes pinkish in color, with few if any knots and very little grain. It would not crack or splinter. All in all, *olekh* was very good for carving, unlike elm, which is fairly hard. *Olekh* was the only wood used for making brushes, so far as I know. The farmer would cut the *olekh* to the desired size and deliver it to the brushmakers. A helper would split the wood with a broad axe and a maul to the required thickness. He would then put the wood into a vise and, with a spoke shave, would smooth both sides. Then he stenciled the outline of the brush and the holes onto the wood. Using the spoke shave, he would follow the outline to shape the wood. With a special rounded chisel, he made a groove along the sides of the brush for a better grip.

Usually one man shaped the wood part of the brush and bored the holes. Avrum's father bored the holes. He had a callus the size of a silver dollar on his chest from constantly pressing his body against the boring machine, which was operated by means of a foot treadle. The borer worked at a table about as high as his navel. There were two parts to the operation: the drill, and the apparatus on the table for supporting the brush slab. The drill was at-

HOW TO MAKE A BRUSH

(Top row) Farmer brings wood to town. ▪ *Sawing wood into slabs.* ▪ *Splitting slabs using a broad axe and mallet. (Middle row) Using a spoke shave to shape the wood, which is held steady in a vise.* ▪ *Beating the tangled horsehair with two sticks, like pool cues, to untangle it.* ▪ *Pulling the horsehair through the sharp teeth of a metal comb. Combed horsehair is on the second table. (Bottom row) Boring the holes for the bristles.* ▪ *Antsiers attach bristle to the wood.* ▪ *Finishing the brushes: flattening the wire, glueing veneer to wood, polishing the veneer with orange shellac. Packing the finished brushes in boxes. Yudis, who had been a nurse in the tsar's army, is standing in the front. The factory was in her house.*

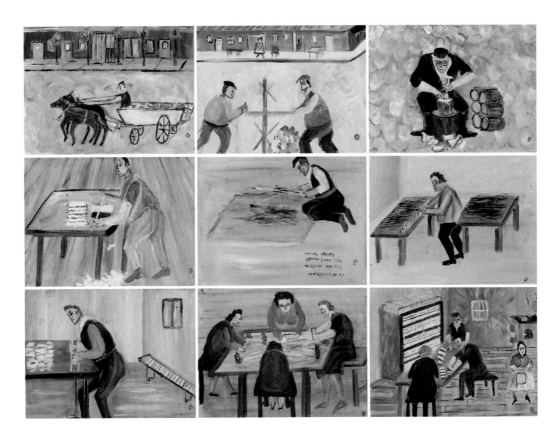

tached to a shaft by a chuck. In back of the drill was a small transmission wheel, which was connected by a leather belt to a large wheel under the table; that wheel was turned using a foot treadle. To support the brush handle, the borer would hold it against a piece of wood mounted on two tracks, four to five inches apart, which were attached to the table. Holding the brush handle against the support so as to maintain a perfect ninety-degree angle, the borer would pull the brush handle, together with the support, along the tracks toward himself, having already lined up the hole he wanted to make with the drill. He would press the wood against the drill and let it pass through a hole in the support. After a hole was made, he would push the handle and the support along the tracks away from himself. He would then move the brush slab to the next hole that he wanted to make, aligning it with the drill, and repeat the process.

After the borer made the holes, the wood went to the six or eight girls and women at the tables, who put the bristle in the holes using wire that was wound around sticks attached to their table. If memory serves me, the *antsiers*, as they were called, got paid by the hole; each brush had so many holes. On the table was hog bristle in two colors: white and black, or brown. The bristle used to arrive at the factory already cut to about three-inch lengths. It was pressed together in the shape of a large, flat, circular cake and held in place with a yellow string. We treasured that yellow string. We would play with it and make all kinds of things.

To insert the bristles into the brush slab, the *antsiers* would take the end of the wire that was wound on the stick, form a U at one end, and push the wire through the hole so that the U would protrude. Then they would insert the bristle into the U and yank the wire back into the hole to wedge part of the bristle in the hole. Using the same continuous length of wire, they would repeat the process, hole by hole. They would make a pattern: the outer two rows of bristle were black, then two rows of white, and the rest black. A man would trim the bristles with very sharp sheep shears to form an even surface.

When the *antsiers* were finished, they would take the brushes to another table, where a man would flatten the looped wire "stitching" on the upper surface of the brush handle. Then he would go to the hot glue pot, apply glue to the back of the brush with another brush, and attach a piece of veneer a little larger than the slab. When the glue was dry, he would trim the veneer. Then he would dip a pad in orange shellac and rub it on the veneer to give it color and make it smooth and shiny.

They also made brushes from horsehair. I recall seeing them prepare the horsehair. They placed a pile of it on a blanket lying on the floor. A man used two long sticks that looked like pool cues to lift the hair and beat it in the air by hitting the sticks against each other. This seems to have loosened up the knotted hair. Then he combed the hair through a special device. It consisted of very sharp, shiny metal blades embedded in a wooden board that was securely fastened to a heavy table. The board was a few feet long, about five inches wide, and two inches thick. The blades were about five inches high, a quarter of an inch wide at the base, sharp on both sides, and tapered to a very sharp point. The blades were arranged in parallel rows, about an eighth of an inch apart. A man would grasp a hank of prepared horsehair and throw it over the comb so that he could pull the hair through the comb. After many pulls, the hair was straight. Once he had combed all the horsehair, he collected the residue and pulled it through so as not to waste a single hair. These hairs were usually much shorter, so he would bundle them separately. Using sheep shears, he would trim the ends of the bundles before cutting each bundle to the lengths that he needed.

Work started very early in the morning, at the crack of dawn. In the winter they finished at dusk. In the summer they worked a little later. They did not even stop for lunch. They kept working even as they ate. The girls sang all day long as they worked. When one girl stopped, another girl started, particularly my aunt Sala. Although she was very poorly educated, she had a wonderful voice and an ear for music. In her old age, we could request any aria from any opera and she could sing it. Opera was her passion. A lot of the youth drifted into the big cities, to Warsaw and Łódź, in the busy season, looking for work. Mostly tailors and furriers went. When they returned, they brought back all the latest songs.

Saturday nights after *shabes*, my mother's sisters used to give parties. They invited boys and girls. They were eighteen to twenty years old. I was nine or ten. They would push the table, benches, and chairs against the wall to clear an area for dancing in the main room of my grandmother's house. I would sit on the little red sofa and watch. Grandmother was happy because I was chaperoning. My grandparents, though Orthodox, were understanding and would make themselves scarce for the evening so the young people could have a good time. They served boiled salted chickpeas (*nahit*), lima beans (*bobes*), and roasted pumpkin seeds, all from my grandmother's store.

One guy played the mouth organ beautifully, and he was in high demand for parties. He played all kinds of music, including modern tunes. Another guy was a dance teacher and taught everyone the latest steps—waltzes, polkas, tangos, fox trots. In one dance, everyone made two rows and joined hands to create an arch. Then a couple walked under the arch

together. The musician was a capmaker by profession. I think he was my grandmother's neighbor. The kids used to gossip about him. Whether it was true or not, I do not know, but in retrospect it seems highly unlikely. They said he had a *triper*, the clap (gonorrhea), and that he carried his dripping *shmekl* (little penis) in a little tin, which he kept inside his trousers, so as not to stain them.

Mania and Sala married the Rotsztajn brothers Yeshiye and Bernard. The Rotsztajns grew up in Planta, a little village about a mile south of Ivansk. They measured lumber for the Jewish sawmill there and made a good living. Even in the depths of the Great Depression, Yeshiye and his other brother, Yosl, had plenty of work. I spent one summer holiday in Planta when I was about eleven years old. That would have been in 1927. By then, only Yosl was still there. Bernard had left for Belgium, and Yeshiye had moved with Mania to Niekłań. (Do you know what Niekłań sounds like? It sounds like "Don't lie.") Yeshiye was a charmer, a gentle man, but ugly; he looked like his father, who was short and swarthy. Yosl was handsome; he looked like his mother, who was tall and beautiful. Even though the father had raised the family in a small village without a school, he managed to educate himself and his children in religious and secular subjects.

When I was in Planta, the father, who was very pious, was already advanced in years and the mother had gone blind, so Yosl was doing most of the work. Yosl and his wife were just married and did not yet have children. They lived in a two-room cottage on the premises of the sawmill. They slept in one room, and I slept in the other room with the son of the sawmill proprietor. The boy was very religious. I don't know what his job was, but I do remember that all night long he would get up and drink a lot of water. Thinking back, I believe he must have been a diabetic. I earned my keep by helping out. A bunch of chickens ran around the yard, big chickens that laid huge eggs. It was not necessary to feed them, though we sometimes scattered a little grain. Mostly, they scratched around the yard and ate worms, or picked at the whitewashed walls and ate the lime. Their diet must have been deficient in calcium because some of them laid eggs that were missing their hard shell. The egg had only its inside membrane.

Down the road from the cottage lived the Polish forester. I remember the time he killed a big buck deer and carried it home on top of his horse. The buck was huge, about five or six hundred pounds. That was the first time that I ever saw one, especially up that close. I saw it hanging in an open stall in his yard before he had skinned it. His job was to manage the forest. He would patrol the woods on horseback to prevent poaching. He lived in a big

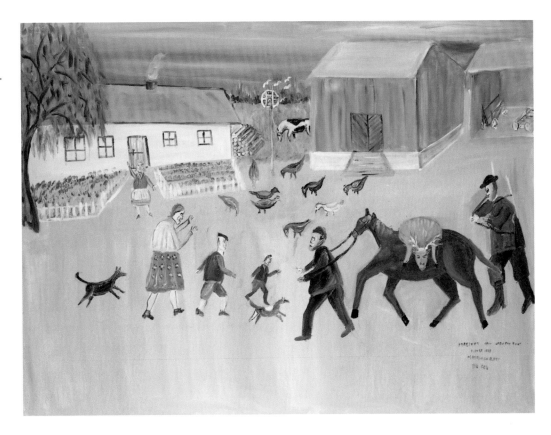

*The Forester
Back from
the Hunt,
Planta, 1930*

wooden house with a thatched roof, about two hundred yards from our place. On the hottest summer day, his house was very cool inside. He and his wife were a handsome couple. I admired them.

The Rotsztajns specialized in calculating how many boards and planks could be cut from a tree. They knew the best way to divide each tree so as to yield the most cut lumber with the least waste. They could calculate how many cubic feet of usable lumber came out of a tree that was as much as three feet in diameter and fifty feet long. These calculations were complicated and required great skill. Yosl had a book with tables to guide him. He showed me how to make the calculations, and I helped him.

After the tree arrived at the sawmill in Planta, they put it on a trolley, on rails, with the butt end first. Yosl made marks on the butt end to indicate the thickness of the planks to be cut. The tree was then rolled to an upright gangsaw, prearranged to cut the tree to the specified thicknesses. As the tree went through the sawmill, several workers would secure the cut

boards with a chain so that they would not fall apart. Each cut board was carried to a table with a circular saw, where it was manually trimmed. The waste was chopped up and, together with the sawdust, fueled the sawmill boilers.

I visited Yeshiye and Mania in the village of Niekłań, which was a long way from Planta, between Wierzbnik and Końskie in the northwestern area of what is today the province of Świętokrzyskie. To get there, I traveled by horse and wagon to Ostrowiec, took the train to Końskie, and went from there to Niekłań by horse and wagon. I spent several summer holidays with Mania and Yeshiye. The last time I visited them was the summer before I left for Canada. The land around Niekłań was sandy. The main industry was forestry. The Polish government divided a huge tract of forest into sections, one section to be cut each year and the trees replanted. Mostly they grew pine. Yeshiye worked for a lumber business that cut timber for supporting mineshafts in Germany. I remember going with Yeshiye into the forest. Two stalwarts followed him with saws and axes. He had a hatchet. One side was sharp; the other side had a seal. He would mark which trees the two men should cut. The trees were tall but not thick. They were eight to ten inches in diameter, just right for mineshaft supports. Since they had been planted at the same time, the trees were pretty much the same size.

After the trees had been felled and removed, the farmers would come and take away the stumps and brush. They were not paid, but they could keep the stumps, which they used for fuel. Fuel was in such short supply that the farmers' wives would occasionally visit the forest to pick up little twigs or branches that had fallen to the ground. They gathered them up in a big blanket and carried them home on their backs. Nothing grew on the forest floor, not even mushrooms, because the ground had been picked clean.

The logs were carted to a huge assembly yard, and Yeshiye would make little cuts with his hatchet to indicate the lengths into which the logs should be cut. Then, by hand, two men cut the trees to his specifications to form the maximum number of supports from the material at hand. They would pile the supports in enormous stacks and eventually load them into flat cars, to be hauled by train to Germany. Yeshiye was responsible for calculating the cubic footage of the shipment.

I remember a swampy area about half a mile from where Yeshiye lived. We picked berries there called *solniki*, which means salty berries. They actually tasted salty. I chummed around with a buddy there whose father was also in the lumber business. He was older than I was. We would sit outside on the porch, and I would play the fiddle. We fooled around with girls.

And we almost derailed a train. Not far from our house was the railroad track. We used to go up close to the tracks and watch the trains go by. Once I noticed that the spikes holding the tracks were loose and easy to pull out. We pulled out a few and inserted one into a joint between the rails with the idea of flattening it to make a little toy. When the locomotive hit the spike I saw the whole machine lurch to the side. I wonder to this day what the engineer must have thought. After about a hundred cars ran over it, the protruding spike bent over and flattened out. It made a good hoe to dig and play with.

Yeshiye must have married Mania around 1918. Several years later, Yeshiye encouraged his brother Bernard to marry Sala, Mania's sister. Bernard was already in Belgium when he brought Sala there to marry him in the late 1920s. Bernard worked for a coal mine. I think he was a bookkeeper. Once Sala made a success of her own ladies' wear business in Liège, where she sold both ready-to-wear and custom-made clothing, Bernard left the mine to work with her. Sala brought her sister Hela to Liège, and Hela opened a store that sold umbrellas; she too made a success of the business. Hela married a man from Klimontów, a small town twelve miles from Apt, whom she met in Liège. During the war, Bernard and Sala sent their only daughter to a convent where Bernard worked as a gardener. Hela sent her son to a different convent, and her husband, Aba Blumenfeld, survived by passing as a non-Jew. With his big mustache, he looked like a Frenchman. Sala and Hela survived Auschwitz. They all returned to Liège after the war.

I am not a Holocaust survivor. I found out how my mother's family was executed from survivors who came to Toronto right after the war. They had seen the atrocities with their own eyes. My grandmother and two of my mother's five siblings were still in Poland when the war broke out: Yankl, his wife, and four sons were in Warsaw; Mania and her husband, Yeshiye, and her two children were in Niekłań. Yeshiye's brother Yosl and his wife had moved from Planta to Łagów, and no one knows what happened to him.

The Germans entered Apt on September 6, 1939, and established military rule. A few months later, in 1940, Yeshiye was forced to abandon his job in Niekłań and bring Mania and their two children back to Apt. Grandfather was dead by then and Grandmother was living alone, so they moved in with her. Their daughter Ester, who was already sixteen years old, got busy in Grandmother's store. She went to Maylekh's father's store to buy a few essentials for the business. Ester had turned out to be a beautiful and intelligent young woman, according to Maylekh, who was still in Apt after I left.

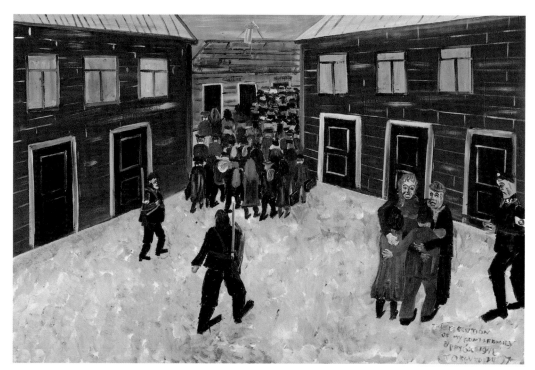

Expulsion from Opatów, 1942: Execution of My Grandaunt and Family

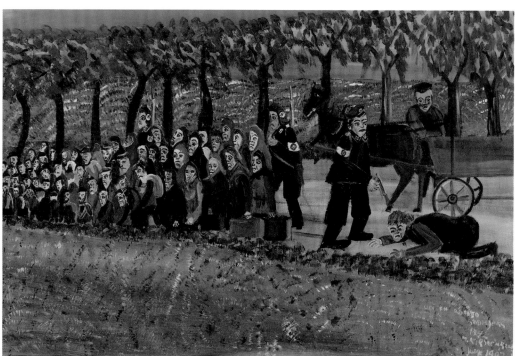

Execution of Grandmother on the Road to Sandomierz, 1942

The ghetto was established in 1941. It was an open ghetto in the sense that Jews from Apt and the environs were confined there, but there was no wall. Yeshiye became the postman in the ghetto. When the Jews were expelled from Apt on October 20–22, 1942, Mania refused to be separated from her children, and the whole family was shot in front of Grandmother's house. Mania was a beautiful woman, with long blonde hair and blue eyes, like my mother and me. My grandmother was old. She was short and fat. On the march out of Apt to the labor camp in Sandomierz, she could not keep up the pace. She lagged behind, fell to the ground, and was shot on the spot. Her body was thrown onto a wagon with the corpses of other people who could not walk fast enough. Thousands of others were forced to march to the train station in Jasice and were transported to Treblinka.

My father's family lived in Drildz, twenty-eight miles from Apt. It took the better part of a day to get there by horse and wagon. Iłża, as Drildz was known in Polish, was half the size of Apt. It was famous for the ruins of an ancient castle on top of a mountain. According to legend, the walls of the castle lasted so long because the mortar was made with egg whites. A very steep path led to the top of the mountain. The more progressive Jewish youth would gather there on Saturdays. I once climbed up on one of the turrets, and I could see for miles around. The surrounding countryside was flat for as far as the eye could see. The castle was in the perfect place to defend the town.

My grandparents' house, which they owned, was built right into that mountain. It was on the edge of town along the road that led to Ostrovtse. The front door opened into a little shop where they stocked a few groceries. Beyond the store was the kitchen; this was the main living area. On the right side of the kitchen were the stove and a chaise lounge on

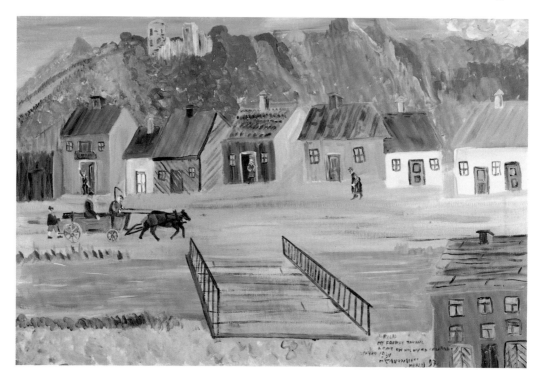

Iłża, Father's Hometown: Father Bids His Parents Farewell before Leaving for Canada

which my grandfather would rest. A door on the back wall led into a huge root cellar, dug right into the mountain, where they dumped all the potatoes, rutabaga (*korpolis*), beets, carrots, and cabbages to feed the family over the winter. A door and a window on the left side of the kitchen led to the yard, which extended up the mountain to a stable. Next to the window was a staircase to the upper floor, which you entered through a trapdoor.

My grandfather, Yankl Kirszenblat (they called him Yukl), was small in stature and very gentle, like my father. A prominent citizen in the Jewish community, Yukl took pride in taking us to the synagogue on Friday nights and Saturdays. He smoked Płaskie cigarettes (*płaski* means flat in Polish), with golden tips. They were expensive. My grandfather never inhaled. He kept puffing all day long. His short gray beard—he trimmed it—was always brown, with gold flecks. He didn't do much besides look after the wagon and horse. My grandmother, Khane, was a tall woman. She wore a wig. She was smart and tough. She was the engine of the family. She ran the business and she was the disciplinarian, although I never saw her raise a hand. It was a peaceful household. Yiddish was spoken at home, but my grandmother spoke fluent Polish because she came from a more progressive home in a larger city, Radom; the population of Radom in 1931 was almost 80,000 people, of which about a third were Jews. My grandfather, who grew up in Drildz, spoke Polish, but not as well. Drildz, with less than 5,000 souls (about a third were Jews), was tiny in comparison with Radom.

The girls attended public school and were good students. My father used to boast about his sisters, especially his youngest sister, Shayndl, who was my age. He would bring samples of her handwriting to Apt and ask me, "Why can't you be as good a student as she is?" He never noted that she didn't have to go to *khayder* the way I did. The family belonged to a book-of-the-month club and also subscribed to magazines. Everything was in Polish. I remember one humor magazine, *Bocian*, which means stork.

The boys had to serve in the Polish army. My father served for a short time during World War I. My mother told me that he got so sick with typhus that his mother came for him with a wagon and two horses to bring him back to Apt. She walked in front of the horses in order to move big stones out of the wagon's path so the wagon would not bump. My mother nursed him back to health. I was already born by then. My father's brother Shmiel was conscripted into the Polish army during the 1920s. I remember him coming to visit us in Apt in his Polish uniform; he wore a long, khaki greatcoat and a saber. I don't recall any of the other boys serving in the army.

Sometimes the whole family gathered in Drildz for Passover. I vividly remember the Passover seder in my grandfather's house. The kitchen was whitewashed especially for Pass-

over. Enormous copper pots and pans hung on the wall by the stove. They were polished to a high shine. The insides were tinned and looked like silver. Those utensils were kept kosher for Passover use only.

There was a mob of people. My grandmother had eleven children in the course of twenty-two years. She gave birth to her youngest child, Shayndl, around the same time my mother gave birth to me, in 1916. Mother told me that, when she brought me to Drildz as a baby, I nursed at my grandmother's breast while Shayndl nursed at my mother's breast. Why they swapped us, I don't know. This is what my mother told me. So, counting their eleven offspring, their spouses, and children, the immediate family was twenty-three people. Add a few poor relatives and guests, and there were thirty persons at the table.

To feed such a crowd, my grandmother would buy a huge tom turkey as big as a small calf. It weighed about fifty pounds. She stuffed the skin of the neck with ground meat, matzo meal, pieces of fat from the bird, and hard-boiled eggs. When stretched and filled, the neck was almost a yard long. Grandmother placed the bird and the stuffed neck in a huge copper roasting pan and put the pan in the oven. The firewood did not get very hot, so the bird roasted slowly for about twelve to fifteen hours. The aroma of onions and garlic emanating from the oven made my mouth water. I can still smell and taste it today. Of course, the Passover seder ceremony was scrupulously observed. I couldn't wait for the food to be served and had to try hard not to fall asleep. Finally it was time to eat. Grandfather did the honors. He carved the turkey. When the stuffed neck was served, each slice, with the white and yellow of the egg in the center, would look very pretty. Near the door leading to the yard was a small table with the Prophet Elijah's cup. At the appointed moment, we would open the door for Elijah to enter.

I remember Grandfather's horse looking in the window from the yard. At street level, the yard was a flat area about twenty feet by twenty feet; that's where they parked the wagon. A path led up the steep mountainside to the stable, which was dug into the mountain on the same level as the three bedrooms on the second story of the house; the stable wall was attached to the back bedroom. In the stable was a stall for the horse. To make the oats go further, they would mix them with *sieczka*, which means chopped straw in Polish: they used a special machine to cut the straw into quarter-inch pieces. Horses don't like straw. That horse was so smart he would exhale air from his nostrils to blow away the straw, so he could eat just the oats. The horse would come down the hill to drink, and that's when he would look in the window.

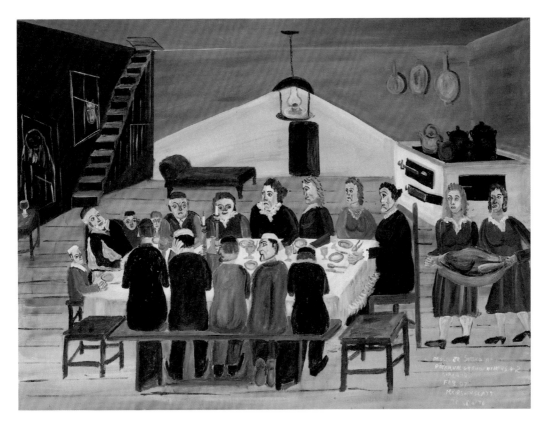

Passover Seder at My Paternal Grandfather's

I painted the seder scene more than once. In the first painting, I made my grandfather big because he was the head of the house, even though he was actually a small man. When I re-painted this scene, I made my grandmother much bigger. I sit near my grandfather, because I am the oldest grandchild on both sides. You can see the servant girl, a Gentile girl, help-ing to serve the food. Although they had electricity, it was not reliable, so there was always a coal oil lamp as a backup for emergencies. When I visited Iłża several years ago and knocked on the door of my grandfather's house—Polish people now live there, and they let me in—I was really shocked at how small the kitchen was. I remember it being *huge*. I said to my-self, "My God! Is that it?"

When I used to visit Drildz in the spring, a special treat was strawberries (*truskavkes*). They were very rare; I never saw strawberries in the market in Apt. My aunts in Drildz bought strawberries from a neighbor who cultivated them in his garden; they were bigger than wild strawberries, and to us they were like jewels. During the spring I would help plant vegeta-bles, especially potatoes, which were our staple food. My grandparents owned one *morga*

(about one and a third acres) in the country and rented another *morga* from a farmer right next to it. For a small fee, the farmer would plough the land for planting. There was no shortage of manure: they used everything, not only from the cows and horses but also from people. The evening before going out to the field, we all sat together in the kitchen cutting up potatoes for planting. The next morning, very early, we went by wagon to the farm, where we planted the potatoes. Then, a few weeks before the potatoes were to be harvested, the stalks would be stomped flat to the ground to stop them from growing and let the potatoes in the ground grow. By harvest time, the stalks would be dry.

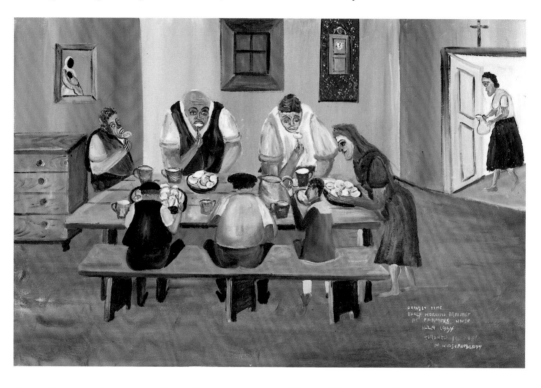

Harvest Breakfast in Farmer's Home, Iłża

I would return for two weeks in the summer and, if I could, again in late September or early October, around Succoth, to help harvest the potatoes. I could not come every autumn, because I was not allowed to miss school. During the harvest season, we would leave Drildz very early in the morning for the farm. The farmer would serve us breakfast, hot milk with boiled potatoes, in his hut. The poor farmer could not afford to consume his own milk, so he diluted the milk he drank with water. Then we spent the day digging up potatoes. Any family that had a cubic yard, about two hundred pounds, of potatoes was set for the winter. They would not starve.

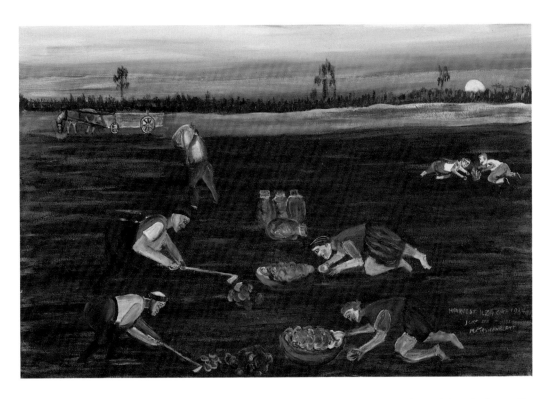

Potato Harvest, Ilja

There was already a chill in the air, so we kept a fire going all day in the field with the stalks from the potatoes. The most delicious potatoes were the ones we roasted in the field during the harvest. We used to put the potatoes on the ground and cover them with a very thin layer of earth so they would cook without burning. Then we put the potato stalks on top of the earth and set them on fire. After a while, we would dig the potatoes out with a stick and mix them into the fire to harden the skins. In no time the potatoes were roasted. We broke them open and ate them. Sometimes the skin came off by itself. The outside was crisp and the inside was powdery. They were delicious, even better than cake. We ate them all day.

With such a big family, there were plenty of people to help out with the harvest, but a big family also made for crowded living conditions. Six children were still living at home during my time: Yokhvet, Rivke, Sruel, Duvid, Royze, and Shayndl. Where did they all sleep? There were three bedrooms on the upper floor but no passageway, so you had to go through one room to get to the next one. The front room, which faced the street, was for my grandfather and grandmother; they had a deer hide on the floor instead of a rug. The middle room was for my father's sister Yokhvet and her husband Yekhiel.

Yokhvet married late, and so far as I know they never had children. Her husband was a lovely man, but he gave me the impression that he thought he had married beneath himself. He was from a big city, Kielce, and considered himself more intellectual than us. His parents—the family name was Złoty, which means golden in Polish—owned a restaurant in the center of town. When my mother and I visited Kielce, the provincial seat, to take care of our papers just before we left for Canada, we ate a wonderful barley soup at his parents' restaurant.

I remember the bedroom set that my grandparents bought for Yokhvet. The wood was called *cioć:* I would say that it was bird's-eye maple, given what I know about wood now. The set, which consisted of an armoire and a double bed, was factory made and brought from Warsaw. It was unusual—it was considered unseemly—for a married couple to sleep in a double bed, because among religious Jews a man cannot touch a woman when she is menstruating and for a week after. She is considered unclean until she goes to the *mikve,* so during this period they must sleep separately. My parents had two beds, and my grandparents had two beds, although I noticed that my grandparents pushed their beds together. When I was little, I would sleep with Grandfather. Shayndl, who was exactly my age, would sleep with Grandmother. The other five children still at home slept in the third room.

Five children—Avner, Laye, Harshl, Shmiel, and Arn Yosef—had already left home. Avner, my father, was in Apt with us. Laye lived in Lublin with her husband, Laybl, and their two children; I apprenticed with Laybl, who was an electrician, just before I left Poland. Harshl, his wife, Tsipe, and their two children lived in Drildz; I don't recall what they did for a living. Tsipe was a good-looking woman but a little deaf. All four of them perished. Shmiel went to Canada and sent for Arn Yosef. I remember Arn Yosef being so fussy about his food that he would prepare his own breakfast. He would cut his own onions—they had to be sliced just so—and bring specialty meats from Radom such as *paruvkes,* which were like hotdogs, and *ofshnit,* which was like corned beef. I used to beg him for some. He would give me a tiny taste and gorge himself on the rest. He was also a *fatset,* a dandy. He wore the best clothes. He got married in Canada.

The third room was huge, with beds all around the walls. In the morning when my grandmother would come in to wake one of the boys to go to work, she would go around and feel everybody's legs under the blankets to find the person she was looking for. Once I was a little older, I would sleep with Duvid, the youngest son, and she would get us mixed up. She would pull my leg instead of my uncle's, saying, "Get up, Duvid, get up!" Twice a week, he had to leave very early with the horse and wagon to buy things in nearby cities for the

family business. Duvid was a good-looking man, tall, thin, and blond. He was my favorite. They even said that I resembled him. I remember him traveling the twenty-eight miles to Apt by bicycle. I don't remember him getting married, even after we left. I also remember Royze visiting Apt.

My grandfather had his own horse and wagon to haul goods for the family business, a large grocery store on the main street of Drildz. I used to like to arrange the display windows. They sold matches, sugar, coal oil, salt, flour, whiskey, and other staples. They were a retail operation. On market day, shopkeepers from small villages in the area would buy in bulk from them. My grandmother ran the store with the help of her children. After market day, when she walked home with two bags of money, two of her sons would walk on either side, guarding her with the switches jockeys use on horses. They were tough.

Each week, Duvid would make two trips by horse and wagon to buy goods, one to Radom, which was twenty-five miles away, and the other to Ostrovtse, which was fifteen and a half miles away. He and a driver would leave as early as two o'clock in the morning and return very early the next morning, so as to do the traveling by night and the business by day. At three or four miles an hour, it would take my grandfather's horse five or six hours, because the horse also stopped to rest along the way. Although they were not traveling particularly long distances, the horse could not go very fast with such a heavy load.

On the outskirts of Drildz on the way to Radom, there was a steep hill. Horses usually had a difficult time making it up the hill with a loaded wagon. A farmer lived right at the foot of the hill. The way he made his money was by attaching his horse to the other horses to help them get up the hill. One day I followed a loaded flatbed wagon with two beautiful horses. When they came to the bottom of the hill, the driver stopped and fed the horses. After that, when he tried to get up the hill, the horses couldn't make it. He went to the farmer, who agreed to help him. When the farmer attached his little horse and gave it one whip, the whole outfit moved. The farmer also offered the following advice. Don't let the horses cool off before they climb the hill. If he wanted to stop, he should do it at the top of the hill, not at the bottom, and he should wait to feed and water the horses after they reach the top.

My grandfather's horse, if the load was too heavy for him, would look back. As soon as he saw them lighten the load, he would move. I remember another farmer who had a little horse. When that horse was carrying too much of a load, he wouldn't move either, so they lit a little fire under him. He took off like a shot.

When Duvid and the driver got to their destination, they would park the horse, feed and water him, and leave him to rest there all day. Duvid would walk around to the various wholesalers to buy goods for the store. In the late afternoon or early evening, he and the driver would take the wagon to each place to pick up the merchandise. Then they went home. After every trip, my grandfather would go out into the yard and inspect the horse for injuries. If he ever noticed any sign that the horse had been whipped, he would threaten to whip the driver. He would say to the driver, "You don't have to whip that horse. He does the best he can."

That horse was so smart he could find his way home without a driver. I saw this for myself on the way back from Radom just before I left for Canada. I was sent to Radom to see a cousin, who was an eye doctor, about a problem with my eyes; my cousin put something in my eyes and said not to worry. That afternoon, I went to the movies. I saw Wallace Beery and Jackie Cooper in *The Champ*, which came out in 1931. It was the first talkie movie I had ever seen. I was so enthused about the action and the fighting that I've never forgotten it. I was especially touched by the relationship between the father and the son. The father was so big and the child so small. They were so close. The father was very gentle to the son. He pampered him. The child was worried about his father, who was a boxer. When I saw Jackie Cooper, a nine-year-old in the film, sitting on his father's lap and steering a Model T Ford, I thought to myself, "Would I ever have such an opportunity?"

Radom seemed like a big and bustling city to me. The stores were very busy. Porters were walking with loads or pulling carts. There were buses and the odd car. It was a going concern. By the early 1930s, there was already a bus service to Radom, so I was able to go to Radom by bus. I would return to Drildz late at night with Grandfather's horse and wagon, which was loaded up with merchandise that Duvid had purchased that day. Going to Radom was an adventure, especially riding in the wagon. The driver would let me handle the reins. He would give me the whip and say, "Give him a little tap, a little encouragement." The horse was so sensitive that even the lightest touch of the whip made him move. In Poland, if you want to make a horse go, you say, "Vyo!" In Canada, you say, "Giddyup!" In Poland, if you want the horse to stop, you say, "Prrrrrrrrr." In Canada, you say, "Whoa!" To make the horse pee, the driver would whistle. The horse knew exactly where to stop for a rest, at which point the driver would give the horse a little bit of food and water, let him rest a little while, and then go on. You didn't have to tell the horse what to do. You never had to beat him. The driver did not even have to hold the reins. He would tie them to the wagon, sit

there and doze off, and the horse would slowly walk home. The horse knew exactly where to go. When the horse stopped, you knew you were in front of your house.

We would drive into the yard and unhitch the horse from the wagon. The driver would neatly loop the reins and traces around the horns of the harness and let the horse walk up the hill to the stable. Then the driver took off the harness and put food into the trough. When the bus service started up, Duvid would send the driver with the horse and wagon on the five-hour journey starting in the wee hours of the morning, and Duvid would take the bus, which took half an hour at most. Shortly thereafter, the family bought a Dodge truck and started hauling, not only for themselves but also for other people in town. At that point, they sold the horse and wagon.

By Polish standards, my father's family seemed rich. My grandparents owned the grocery store in town and a *shenk*, a tavern, two doors away. One of the sons, Sruel, ran a brick factory, and Yokhvet and her husband, Yekhiel, had an egg crate business. What made it possible for Yokhvet and Yekhiel to go into this business was the introduction of electricity to Drildz around 1930. Their workshop was located in the electrical plant in the middle of town. The electrical plant housed a steam boiler and electric generator. Electricity only ran at night, so during the day Yekhiel could use the premises. He harnessed the power of the boiler to run a circular saw for cutting boards from very long beams. Yekhiel and his workers would cut three-quarter-inch-thick boards for the two ends of the crate and its center partition, and three-eighths-inch boards for the rest of the crate, but they did not assemble the crates. The egg dealers did that. The boards would be delivered to the egg dealers, who would nail them together, leaving spaces in between. Egg crates were big, about six feet long, two feet wide, and eight inches high. To pack the eggs, the egg dealer would put down a layer of straw, place rows of eggs on the straw, cover the eggs with another layer of straw, then put down a layer of eggs and another layer of straw. They packed the eggs pretty well. Once, when my uncle Sruel brought a load of egg crate boards in his truck from Drildz to Apt, I helped him unload them. They had been specially ordered by one egg dealer.

The children helped out in the various family businesses. During the week, the girls took care of the *shenk* after they came home from school. On market day, when the farmers would come in and things got busy and even rowdy, the boys would work there. They sold whiskey and beer by the glass and snacks such as pickled eggs. I would clean off the tables and put away the empty bottles. Although the whole family was raised around alcohol and cigarettes, none of them drank or smoked, except for Grandfather, who loved those cigarettes with the gold tip.

There was one *shiker*, a drunk, who used to come to the *shenk* and beg for a drink. Sometimes they gave him a drink, but most of the time they chased him out. He came from a very well-to-do Jewish family, but his family would not give him a cent. He was the town drunk. His wife and children were embarrassed. Mostly, Jews came to the *shenk* for a little glass of cold soda water. To give it taste and color, the girls would add a tiny spoonful of syrup. There were two kinds of syrup: the cheap one was sweetened with saccharine and artificially colored red; the good one was made with real raspberry juice and sugar. The girls hid the good stuff under the counter for special customers or for when an inspector came in to check, because it was forbidden to use saccharine. You had to be on the alert to spot the inspector. When the inspector came in, the girls quickly hid the saccharine drink and took out the real stuff. The inspector would say, "Give me a glass of soda water," and they would serve him the real thing. If the inspector caught you selling saccharine, which he rarely did, he would fine you, and out the window went a month's profit. Everybody else got the saccharine drink.

Why was saccharine illegal? Sugar in Poland was relatively expensive. The government had a monopoly on sugar. All sugar in Poland was made from sugar beets. Poland exported the sugar beets to Germany at a loss to compete with the cane sugar that Germany imported from its former colonies in Africa, where labor was cheap. Poland was eager to acquire German manufactured goods like bicycles and needed the foreign currency, so it sold its sugar beets so cheaply that German farmers fed their pigs Polish sugar beets. In order to make up for what it lost by underselling its beets to Germany, Poland taxed the sugar consumed by its own citizens. So, to protect the domestic sugar market, it was against the law to use sweeteners like saccharine. The profit margin on sugar was so small that shopkeepers had to make what little profit they could on the bags for the sugar.

I know this from what I saw in Apt, but it applied to Drildz too. Yekhiel Katz, the father of my friend Maylekh, had a grocery store in Apt. It was a little bigger than average. Yekhiel could afford to buy a whole bag of sugar, which weighed 100 kilograms (220 pounds). The only profit to be made on that transaction was the weight of the paper bags that he put the sugar in plus the value of the cotton sack containing the sugar. By the time he finished weighing out 100 kilos of sugar, he had the equivalent of 101 kilos. The extra kilogram was the equivalent of the weight of the paper bags. He made another few zlotys from the cotton sack. My grandfather in Apt would buy ten or twenty kilos of sugar from him, weigh it out in bags, and sell it in his own store at cost or marginal profit. He had to stock sugar, even if he made no profit on it.

My uncle Sruel had the brick factory outside of town. It was very primitive. Everything was done by hand. They mixed the clay in a pit with the help of a horse. The pit was about six feet deep and thirty inches across. They inserted a big auger into the pit and then filled the pit with dry yellow clay and water. They attached an eight-foot shaft to the auger, a whippletree to the shaft, and the horse's harness traces to the whippletree. The horse would walk in a circle around the outside of the pit for hours until the clay had been mixed to the consistency of butter. Then they would dig out the clay and place it in molds to make the bricks. Once the bricks had dried in the sun, they arranged them for firing. They would stack two or three rows of bricks around a pile of firewood to form a large cylinder about four feet in diameter and five feet high. Then they covered the outside of the brick cylinder with firewood and set the whole thing on fire. They would keep feeding the fire for a day or so until the clay was baked. The yellow clay turned red after it was fired.

On the same premises where my uncle had the brick factory, there was a pottery. The pottery belonged to a peasant who used the clay that my uncle prepared for bricks. The potter could turn out a pot in minutes. He would dry the pots in the sun. Only the inside was glazed, a little of the glaze spilling over onto the outside. Then he would stack the pots up outdoors, cover them with firewood, and keep a huge fire going until they were baked. Or he would fire them inside the brick cylinder. On market day he would load the pots onto a wagon filled with straw. Upon arriving at the market, he would display them on the ground beside his wagon. From what I observed, he did a brisk business. The pots were cheap. As far as I know, the pots were mainly used by farm women to store milk.

My grandfather died of arteriosclerosis around 1930, not long after my father left for Canada. Grandfather's death was no surprise, even though he was only about sixty years old. He had been a sick man. Shortly after he died, my grandmother remarried. Her second husband, Beyrl, was a nice man, very gentle. Just before we left Poland, we came to Drildz to take our leave. On that visit, a girl, a friend of one of my aunts, took me to a silent movie. It was a patriotic movie about the Polish air force. It showed tiny biplanes; the tail of the biplane could not have been more than ten or twelve feet long. The movie was projected on a creased bed sheet in the fire hall. They did not have a piano, so four fiddlers provided the music; they played out of tune. We sat on benches. We were the only spectators: just the two of us and the four fiddlers and the movie. It was a miserable night, cold and drizzling outside. The girl walked me home, and when she hesitated to say good night, I had the feeling she was hoping for a kiss. I wasn't in Drildz long enough to form lasting friendships.

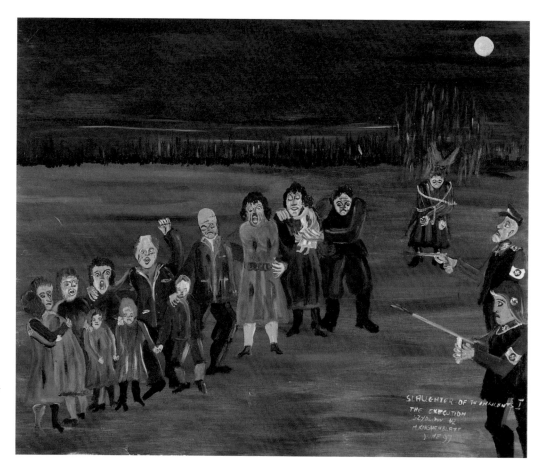

Slaughter of the Innocents I: Execution at Szydłowiec, 1942

I didn't realize how hard the family struggled until after my mother's demise, when I found a letter that my father had saved from his mother. Around 1929, my grandmother had complained to her three sons in Canada, "You have been in Toronto for years and you are still working for someone else? You are not yet in business for yourself? We are struggling. The government just levied a heavy tax on us, and we do not have the money to pay it. Your sister Rivke is already twenty-six years old and not yet married. She is considered an old maid. A matchmaker brought her a groom from Lublin, a very nice man with a business, but he wants a dowry. I don't have the money for a dowry." When the Polish government raised taxes, Jews seemed to suffer most. It seemed to us that Jews had to pay higher taxes to make up for what the Poles could not pay. This was during the Depression.

I found out how my father's family perished from a letter sent to my father right after the war by someone who had witnessed the atrocities. I was there when my father got the news. He was hysterical: he immediately started shaking from the shock and never stopped until

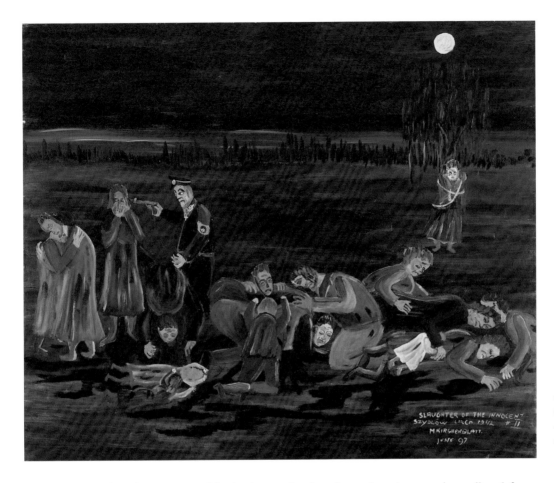

Slaughter of the Innocents II: Execution at Szydłowiec, 1942

the day he died. I don't know if he had a stroke, but from that time on, he suffered from Parkinson's. I have painted two pictures on the basis of that letter. I could not figure out how to paint these scenes until I saw Goya's paintings of the executions during the Napoleonic war at the Prado Museum in Madrid.

My father and two brothers were in Canada. His mother, three brothers, five sisters, and their husbands and children were still in Poland. My grandmother was a powerful woman. She hoped that, by holding the family together, they could help each other. That was unfortunate. Had they scattered, perhaps some would have survived.

The whole family was interned in a ghetto in the town of Szydłowiec, not far from Drildz. This is where Jews from the Radom district were brought. In the fall (I think it was in 1942), the chief of the ghetto noticed a big influx of young men. They caught a young lad and tortured him until he revealed that many youths had been hiding out with the partisans in the

forest all summer. In the fall, when the Christian boys returned to their villages, the Jewish boys, having nowhere else to go, returned to the ghetto. They could not remain in the forest during the winter because it was too difficult to find food and too easy to be tracked in the snow. They had no choice but to come back to the ghetto. They didn't know what was awaiting them. That lad informed on my father's family.

Having discovered that my uncles had been hiding out with the partisans, the Germans took the whole family out to a nearby field. They lashed my grandmother to a tree and, before her very eyes, they shot her entire family. Then they shot her. That's how my father's family was exterminated.

My mother was about eighteen years old when her parents first tried to make a match for her. The first candidate was Usher (Asher) Wajcblum, a distant relative. When Usher's mother came to inspect the prospective bride, she declared that she came wearing a big apron with two deep pockets, one pocket for a dowry for her son and the other for a dowry for her daughter. My mother walked out of the room when she heard that. When my grandfather heard what Usher's mother said, he replied, "I should give you a dowry for your daughter? What's the matter with my daughter? Is she a cripple? Does she have an impediment? She is a beautiful woman. I am required to give a dowry for my daughter, but not for your daughter."

Usher eventually married another woman—with an impediment. She was a little deaf. Usher's family was poor and the girl's family must have provided a sizable dowry to compensate for her defect. Usher became a kind of paralegal. He wrote petitions on behalf of Polish peasants to the city, county, and local courts regarding disputes over land, business dealings, and the like. His busiest day was Wednesday, when the farmers came to market. Typewriters were not that common, so one had to have a nice legible hand for writing the documents. Usher made a good living from that. I was very friendly with the family. They had two fine sons and a daughter. The oldest boy, Khayim Harshl, was one of the few young men to attend gymnasium in Apt and university, probably in Warsaw. He became an engineer. He survived the war. The youngest child, Khanyu, was a beautiful girl. She disappeared during the war. Fromek was the middle child. He was one of my best friends. He died while fighting in the Polish cavalry during World War II.

On another occasion, a matchmaker came to my grandparents and said he had found a very nice man for Rivke by the name of Avner Kirszenblat. He came from a very respectable family in Drildz. A meeting was arranged, and Avner came to Apt. Avner took Rivke for a nice walk with a chaperone trailing about ten feet behind. They liked each other and met two or three more times. The wedding was arranged, and they got married in Apt.

My father moved to Apt when he married my mother. My mother told me that my father was quite happy after the wedding to live with her parents, which was customary, but she did not like the idea. One day when my father returned from a business trip, he said to her,

"I'm going home to rest. I am tired from the trip." She said, "Where are you going?" He replied, "I'm going home." She countered, "No, no. You don't live there anymore. You live here now." And she took him to the new room and few meager possessions she had managed to acquire in his absence. My father looked at her and noticed something different. "Rivke," he asked, "how come you are not wearing the wig?" "Oh," she answered. "I sold it back to the wigmaker. Now that I no longer live with my parents, they cannot tell me what to do. I used the money to buy the few things we have in our room." When my mother got married in 1915, the Jewish custom was to cut the bride's hair and replace it with a wig. My mother boasted that she would not allow her hair to be cut. As a compromise, she wore the wig on top of her own hair, but the moment she moved out of her parents' home, she discarded the wig. Mother was a beautiful woman with light brown, wavy hair.

I remember the wigmaker in Apt, although I don't remember if she was the only one in town. She was a widow with three sons, Yumen, Itshe, and a third one whose name I do not recall, and one daughter, Tobe. I know that Itshe survived the Holocaust in Russia and moved to Israel. I was friendly with the older son. I seldom went to their place, but I remember that they lived and worked in one relatively large room in a nice brick building, with a big window that faced *Ivansker gas*. The worktable was against the window. The room smelled of coal oil and burning hair. Orthodox women brought their wigs to her. The wigs were well worn. You might say they were well inhabited. Coal oil was used to kill the lice while heat was used to curl the hair and style the wigs.

Six months after my parents moved into their own room, I was born. The room was on *Ivansker gas*, right next to my father's leather shop. You could smell Szmelcman's horses, which were stabled in a covered area right behind our place. Our room was tiny, about eight by twelve feet. There were two doors, one from the street and the other to the area for the horses and wagons. There were no windows. There were two small iron beds, one for Mother and another for Father, with a small table between them. At the foot of one bed was a cradle. At the far end of the room was a little iron stove, close to the ground, with two burners and a chimney made of sheet metal, which was used for cooking and heating. There was a small cabinet beside the stove. There was no brick oven.

I painted my mother in confinement with my brother Vadye (short for Ovadye in Yiddish, Ovadyahu in Hebrew, Obadiah in English), who was two years younger than I was. I am in the crib. On the chair you see a key. My mother told me that, when she gave birth to me, she had a very difficult time. I was the first one. My grandfather put a key under the small

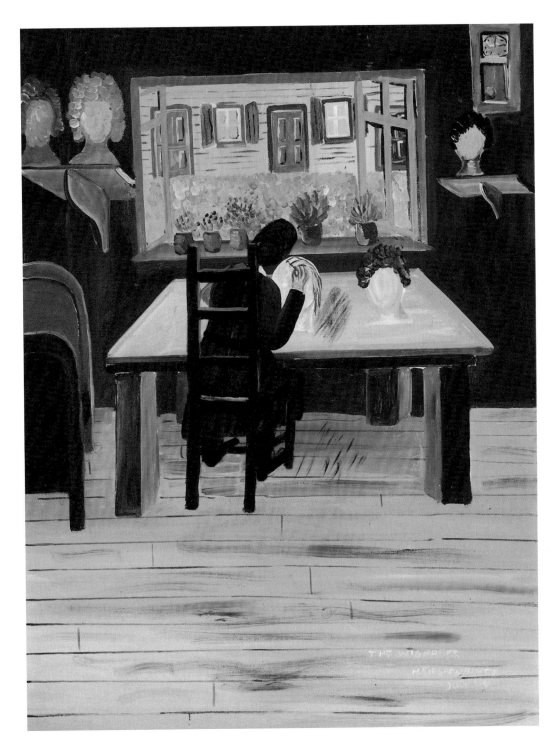

The Wigmaker

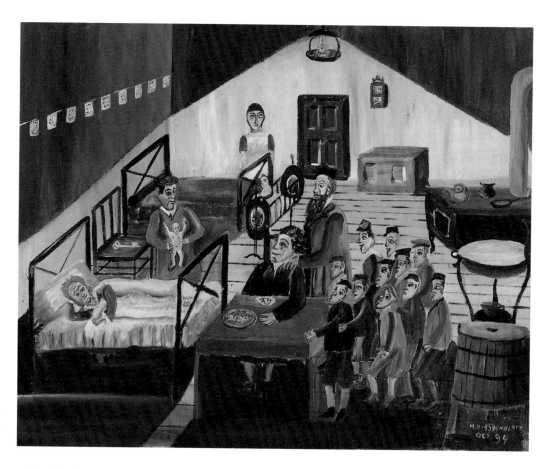

of her back to "open the gates" and make it easier for the baby to come out. My father is holding up the baby. My grandparents are at the table. *Khayder* boys used to come every evening during the week between the birth and the circumcision to say the Shema, one of the most important Jewish prayers. This was to keep away the evil spirits because during this period, when the boy is still uncircumcised, he is in danger. The *khayder* boys would be rewarded with candy. On the wall there are excerpts from the Psalms. This too is to ward off evil spirits and the evil eye. On the table is a *reshinke*, a flat cake made from cookie dough. Two intertwined coils of dough make a decorative border, with an almond in every section. In the center are the words *mazl-tov*, congratulations, written with a coil of dough. *Maczek*, tiny balls of multicolored sugar, were sprinkled over the whole thing. (My daughter says they are called sprinkles, hundreds and thousands, or nonpareils in English.) It was customary to serve this cake to the guests at the party after the circumcision and to save the piece with *mazl-tov* written on it for the *kimpeturn*, the woman in confinement.

About a year after Vadye was born, we both nearly died. This is my earliest memory. I remember my brother and I being grabbed, wrapped in a blanket, and carried outside on a cold rainy day. Many years later, my mother told me that my brother and I almost suffocated because of carbon monoxide. Mother had tried to make the coal in the iron stove burn more slowly by cutting down the draft, so it would last longer. She closed the damper too tight, which closed the chimney. Instead of the fumes going out, they filled the room. Mother was working in Father's leather store, which was one door away from our place. Fortunately, Mother came in to see how we were and noticed that we were almost unconscious. I would have been about three and Vadye would have been one.

A few months later, I got the measles. It was the custom, if you had other children that had never had the measles, to put them all together to infect them so they would all get the measles over and done with. It was said that you do not feed children with measles. After about three days, my brother and I were ravenous. It was Friday, and my mother had prepared a pot of *farfl*, a kind of toasted pasta with fried onions and mushrooms. We got ahold of the pot and ate the whole thing. I got sick from eating so much on an empty stomach. From that day forward, I never touched *farfl* again.

Just before my second brother was born, we moved to a larger place, which is where we lived until we left Poland. Harshl, who was four years younger than I was, and Yosl, who arrived six years later, were born in our new place. I was ten when my youngest brother was born. I remember his circumcision. At the time, I found it a disgusting procedure, particularly the custom of sucking the blood after removing the foreskin. The *bal-metsitse*, the man who sucks the blood, was a man with a large beard and a mouth full of rotten teeth. My father insisted he rinse his mouth with spirits, ninety-five proof. At the time I promised myself that, when I grew up and had a male child, I would not allow this procedure. Maybe that's the reason I only had daughters!

There was a boy in Apt, Pinkhes Czerniakowski, whose circumcision was botched. The *shoykhet*, the ritual slaughterer, was also the *moyel*, the circumciser. He cut off the foreskin with his small *khalef*, a very, very sharp knife that he used for the ritual slaughter of fowl. This time he must have slipped because he made an incision on the glans of the penis right through to the urethra. How did this happen? Maybe he neglected to use the customary protective shield: ordinarily, the *moyel* would insert the foreskin into a slit in a shield that protected the head of the organ. In any event, Pinkhes was left with an unusual penis. To amuse ourselves, we would give him a penny to hold the tip of his penis so the urine would spray out in an arc from the top of the glans. This was great entertainment.

If the child was a firstborn male, as I was, there was another ceremony, the Redemption of the Firstborn (*pidyen-haben*). It is written, "Every firstborn among the children of Israel, both man and beast, is mine." In reality, the Temple could not accommodate all firstborn males, so they developed a ritual whereby these children could be redeemed. Among the Jews, all the different tribes disappeared, except for the priests and the Levites. My maternal grandfather was a Levite. My wife's father was a Kohen. Membership is handed down from father to son. To this day, a descendant of the priests officiates at the redemption ceremony. The parent is obligated to pay the priest in silver to redeem the child from the priesthood. But in reality, the man that officiates usually brings the silver, which he gives to the father so that he can symbolically participate in this ritual. The father gives the priest twelve pieces of silver, and the priest returns the child. The child now belongs to the father. Although my *pidyen-haben* would have taken place in my first home, I painted it in our second home.

When a child was born, it was placed in a swaddling cushion. The *vikl-kishn*, as it was called in Yiddish, was a long, narrow pillow, made of white linen, filled with down, and decorated with a little frill around the area where the baby's head rested. The swaddling cushion was about twice as long as the baby. Mother placed the baby on the top half of the cushion and brought the other half up over the legs and as far as the neck, to cover the child. She tied the cushion together with little strips of cloth attached to its sides.

My mother breast-fed all of us. There was something wrong with her breast when I was born, and she had to have an operation in a hospital. I remember her feeding Yosl. Mother did not hide her breast when she nursed the baby. When the baby got teeth and bit on the nipple, my mother complained bitterly. That was when she stopped nursing. To pacify the child, she would put a little lump of sugar into a white piece of cloth and let the baby suck on it. When the baby was ready for solid food, she would heat some milk to a lukewarm temperature and drop in some challah. The mother or whoever else was feeding the baby would take the moistened challah into their mouth, masticate the food, return it to the spoon, and feed it to the baby.

Vikl-Kishn: Swaddling Cushion

Mother would entertain us when we were small with a little mouse that she made by tying a white handkerchief a certain way. She would lay the mouse on her arm, where it would move suddenly, as if by its own volition. She could produce this mouse at a moment's notice, with only a hanky. Pull on its tail and the mouse would disappear, leaving nothing but a square of cloth.

By the time my youngest brother was about two and I was twelve, I could not move without him. My mother always insisted I take him along. Being the oldest, I had to take care of the youngest. If I went to play soccer, I sat him down in a corner on my bundle of clothes. Of course, I kept my eye on him. He would usually stay there quietly. By and large he listened to me. If he didn't, I could always threaten not to take him along. He was like a growth on my back. If I didn't take him along, I was forbidden to leave the house, and if I didn't obey Mother I got it with a piece of kindling wood across my back. There was no such thing as child abuse. We assumed that getting beaten was how it was supposed to be.

It was a lot for Mother to take care of the four of us and run a business, especially after Father left for Canada. She needed help at home. I remember three maids: the first was Jadźka, the second was a Jewish woman, Maryem, and the last and most memorable was Jadwiga.

Jadźka was about nineteen or twenty when she came to us from the countryside. She cleaned the house, cooked when mother was in the store, and helped out with the children. She was the one who took Yosl to church when she wanted to attend mass and couldn't find anyone to take care of him. She was lucky she didn't get fired; she never did it again. Jadźka stayed with us for a few years. The Jewish maid was with us for only a year or two, before someone arranged a match for her. She was not good-looking; she had funny eyes. Mother helped her to get established: she gave her a little money and a few things for setting up her home. Mother was very proud of that.

One day after the Jewish maid left, a tall, gaunt woman arrived at our door with her meager possessions in a little bundle. My mother exclaimed, "*Boże mój!* Jadwiga!" (My God! Jadwiga!) They fell into each other's arms, had a little cry, and sat down for a long chat. Now an old lady, Jadwiga was on hard times. I asked my mother who this old lady was, and this is the story she told me.

After my mother was born—she was the oldest of six surviving children—her mother had a problem with her nipples and could not nurse, so she had to hire a wet nurse. Jadwiga was my mother's wet nurse. Jadwiga always managed to have a child at the same time as my grandmother did; this was how she was able to nurse six of Grandmother's children for her. Mother said that Jadwiga became a wet nurse after having an illegitimate child, and as far as I know she never married. In any case, Jadwiga left her own children to be cared for in her village; she was from the area of Klimontów, about fifteen miles away. Since she couldn't go home for Christmas or Easter because she was nursing, my mother's family would help her prepare the *dratsn gerakhtn,* the thirteen courses required for the celebration of *Boże Narodzenie,* which means the birth of God. The Polish Catholic Christmas Eve was celebrated with a special meal, usually meatless, and a midnight mass. Mother remembers this as *na mszę,* which refers to the custom of paying for a mass to be conducted in the name of someone, usually deceased, on the day of their birth or death or on a holiday. Jadwiga ate her Christmas meal alone at a corner table in Grandmother's kitchen, as she also did for Easter.

The Christmas meal included such delicacies as *kapuśniak,* a cabbage and tomato borsht; mushrooms that were served with the borsht; *pirogn* (*pierogi* in Polish), "ravioli" stuffed with cheese; various kinds of fish (carp and herring were customary); *gołąbki,* stuffed cabbage; *golkes,* boiled dumplings made from grated raw potatoes; *paluszki,* dough fingers, dipped in poppy seeds, baked, and drizzled with boiled honey; *ratsokhes* (*racuszki* in Polish), deep-fried puffs; fruitcake with chocolate and *maczek,* nonpareils; and thin wafers and wine.

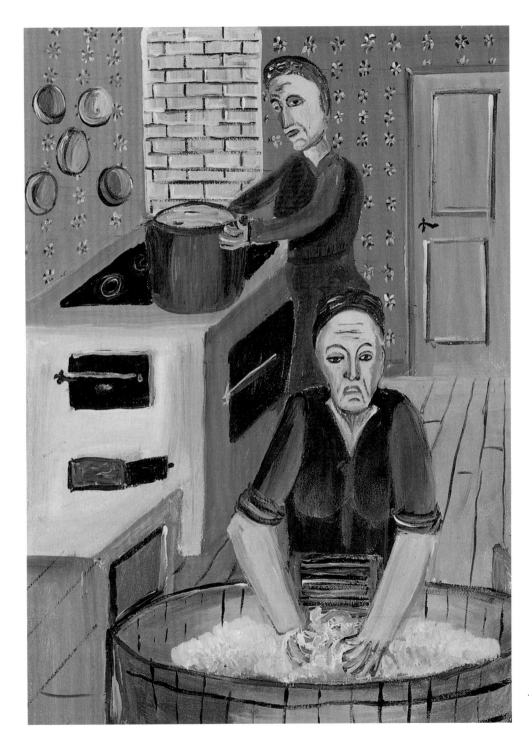

Portrait of Jadwiga (detail from *Jadwiga Washing Laundry*)

During the Easter season, Jadwiga decorated eggs and took them around. Mother also mentioned *chrust*, a flat crisp pastry that is deep-fried and dusted with powdered sugar, and *pączki*, a kind of jelly doughnut dusted with powdered sugar, as well as *kliskelekh*, little boiled square noodles, served with a meat gravy, and kasha, or buckwheat groats, served with *shmalts* and meat gravy.

After the last child was weaned, Jadwiga stayed on in my grandmother's house to work as a maid. She even learned a little Yiddish. After about twenty years with my grandmother, Jadwiga went to Belgium, where her brother was working in the coal mines near Liège. He was a bachelor and asked her to join him and keep house for him. She stayed there for about fifteen years, until he died. After that, she came back to our town and looked up my grandmother, who sent her to my mother. I was about twelve years old, and Jadwiga must have been well into her fifties by then.

Jadwiga came to my mother and said, "Rivke, I would like to work for you." Mother took her in. We had only two rooms, but there was always room for one more. Mother prepared a straw mattress. During the day it was stored under my bed in the kitchen. At night, we pulled it out, and Jadwiga slept in a corner. She had very few clothes and kept all her things in a little footlocker. She became our maid. You can see her, in my painting, washing the heavy laundry.

Jadwiga worked for us for less than two years, because she got very sick. We called the doctor, and he suggested that she go to the local hospital. I knew then that she would never return. In our town, people went to the local hospital to die. Knowing what I know today, I believe she had stomach cancer. She craved sour milk. My mother fermented milk for her every day. The cream would rise to the top and form a beautiful yellow layer. You could not buy sour milk in the local stores. Because I was the oldest, I was delegated to take the sour milk to the hospital every day.

On the way back, I would step into the morgue, a little building within steps of the hospital. A chapel was in front and tables in a back room. The cadavers of those who had died in the hospital were placed on those tables, waiting to be picked up by relatives. I was fascinated. The bodies were just lying there. It was summertime. I remember the corpse of a young boy. He was seven or eight years old. His body was not even covered. There were flies all over him.

After a few weeks, Jadwiga passed away. She left a note and a little money. In the note, she requested that my mother use the money for a decent funeral and a requiem mass. Jadwiga

did not trust her relatives. She did not want to be buried like a dog. Mother went to the local priest and said, "Look, this is the situation. Whatever it costs, I have the money she left, and she wants a proper funeral." Mother ordered the coffin from our neighbor, Mr. Wojciechowski. His workshop was next to Kulniew's tavern on the marketplace, in Harshl *kishke*'s building. He made coffins exclusively for the Christians in town, since Jews did not use coffins. Every morning, on opening his shop, he would display an unfinished coffin outside of his establishment. I don't know why he had to advertise. In any case, we got a very nice casket.

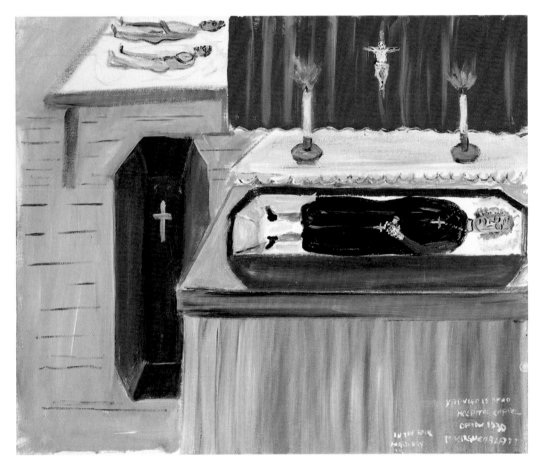

*Jadwiga
Is Dead*

This is how we made the arrangements. There were no funeral homes. Normally, the family would come to take the body home. They would lay the body out on a table and dress it up. I remember seeing a young woman decked out in a white wedding gown, lying in her coffin, in her family's home. They lived near the cooper, on the street leading to the river. I did not know the family, but, from the death notices posted around town, I knew a young

woman had died. As I was passing by their house, I saw people walking in, so I followed. I stepped in, took off my hat, stood there solemnly with my head bowed, took a good look, and left. I had to see everything. Several years earlier, when I was about nine years old, I had seen the father of one of my Christian friends lying in a coffin in their home. Since Jadwiga had no relatives in Apt, I assume that the nuns who worked in the hospital prepared her body in the morgue. We went to see her laid out in the chapel.

There was no hearse in town, so several men would normally carry the remains. However, the hospital was on the outskirts of Apt and relatively far from the church, so we hired a horse and wagon to bring Jadwiga's body to the church. The coffin was closed. All the honors had been done in the hospital chapel. The mass for her was held in the church. Whatever family was left, her cousins and relatives, came from a nearby village. Mother and I did not go into the church to listen to the service. I feared that I would surely be struck dead. We waited outside. After the service, the coffin was placed on the wagon. Mother, my brothers, and I followed the wagon to the cemetery, where the priest said a prayer at the grave and sprinkled holy water. There wasn't a big crowd, just a few people: my family and a few of Jadwiga's relatives. We gave them her few belongings. She had the funeral she wanted.

After a while, my mother arranged for a steel cross to be placed at her grave. Every so often, mother and I would lay a few wildflowers on Jadwiga's grave. However, we were not able to say a final farewell to Jadwiga because we left Poland in January during a very cold winter, and the cemetery was covered in deep snow. Jadwiga was such a wonderful, kind person. Mother was always busy at the store, so it was Jadwiga who looked after us. She was the one who fed us and bathed us. She was a surrogate mother to us. If there is a paradise, she must surely dwell there.

By the time I was four, we had left our first home and moved to ulica Kościelna *(di time gas)*, which means Church Street. We were on the south side of the street; the church was behind a row of houses on the north side of the street. Across the road from our house were two acacia trees. During the late summer, we used to take the blossom, remove the petals, and eat the pistil. It was sweet.

We had two rooms: a kitchen and a bedroom that also served as a formal living and dining room. The kitchen window looked out onto the courtyard, and the bedroom window overlooked Narrow Street. Our dwelling was on the south side of the courtyard. You entered our dwelling from the courtyard, through a little wooden vestibule; a door from the

Kitchen

vestibule opened to the kitchen. All the action was in the kitchen: it was the hub of the house. By average standards, our kitchen was spacious. Near the only window in the kitchen was a table, with a bench in front and a chair at each end. The corner chair was most desirable, because one could sit and observe the comings and goings in the courtyard. Every day, when we came home from school for lunch, the four of us boys stormed into the kitchen like a stampede of horses. Everybody tried to get to that corner. Whoever was first got it. Believe me, many a fight broke out over that spot.

On the kitchen wall was *di rame,* the frame on which we placed the plates and hung the cups. Below it was the *vashbank,* where we did the dishes. We kept a basin and bucket of water on the *vashbank.* The *vashbank* was a little lower than a table. I remember that my mother would bend over to wash the dishes. Under the *vashbank* was a cupboard for all the pots and pans and extra dishes. In the opposite corner of the room was the barrel where we kept drinking water, a wrought-iron wash stand, a basin that fitted into the washstand, soap, and a ewer.

My bed was in the corner of the kitchen. The wall beside my bed would drip with moisture in the winter. Our dwelling was made of solid brick. There was no insulation: the outer wall was the same as the inner wall, and in winter that wall got cold. The cooking and the heating of water for washing created a lot of warm air. Upon hitting the cold wall, the warm air condensed and beads of moisture would run down the wall. That dampness was called *wilgoć* in Polish. To prevent me from touching the wet wall, we placed a mat made of bulrush stalks—they were hollow reeds—against the wall, from the floor to about two feet above the cot. That helped somewhat. In the summer, the wall dried out. Under my bed was the plumbing, a chamber pot.

My father was often away on business and left Apt for Canada when I was twelve. We all missed him terribly, particularly my mother. As a young boy, I wondered if we would ever see him again. There were some abandoned women in Apt: their husbands were in America, and their families never heard from them again. Mother had a few women friends. Most of them were single: Malkele Gutmacher, her first cousin; Tsirl Damski, the daughter of Yankl Damski, the tailor; and Rivke, the daughter of the *klezmer* Mayer Volf Lewak and a friend of Tsirl Damski. Some, like Layele Szulman, were married; others, like Tsirl Wajcblum, who was a first cousin to my mother, were widowed. Wajcblum was her maiden name; her husband was Ise, I do not remember his last name. I only saw him in photographs; he was a very good-looking man. I remember Tsirl coming to my mother in tears to tell her that her husband had been killed by a streetcar in Paris; he had moved there during the 1920s. Tsirl lived with her father and infant daughter in a small village called Bombrov about two

miles from Apt along *Tsozmirer veyg*. Their house faced the road. Her father's nickname was Avrum *bombrokiver*. He was a handsome man in traditional dress, with a *kapote*, *yidish hitl*, and beard.

The women would get together *uptsizitsn* (to sit around) in our kitchen and gossip, tell stories, and sing a few songs. Mother would make a cup of tea. Sometimes they played *tarnitshke*, which is like bingo. Each person had a white card divided into squares, with a number in each square. The caller would draw a number from a bag of little disks, which were a little smaller and thicker than a Canadian dime, while the players used blank disks to cover their squares as the numbers were called, if I remember correctly. Sometimes I played too if they were short a person. On occasion, my father would play 66, a two-person game, at home: this game was played with Old Country cards, European style. One of the cards was called an *aykhu*, which means acorn: it was decorated with oak leaves and acorns.

If the women were visiting in the evening, I would go outside in my nightshirt and pee right in front of the door, since I could not use the chamber pot in their presence. My cot was in

the kitchen, so I used to go to bed and pretend to be asleep, hoping my loud snoring would encourage them to leave. They would break up around ten o'clock. I was glad because I could finally fall asleep.

Malkele was a regular visitor. Her father, Sukher Gutmacher, and my mother's mother, Shoshe, were siblings. Malkele was a good-looking lady, but she was cursed with the nickname Malkele *drek,* Malkele Shit. The story is that, during World War I, the Austrian army occupied Apt. They built a military latrine. It was a ditch about eight feet long and three feet wide. At each end was a wooden post. There was an upper horizontal bar about five feet from the ground and a lower horizontal bar about two feet off the ground. The routine was that you got ahold of the top bar, stepped on the lower bar, squatted, and did your thing. This poor woman, when a teenager, was unfortunate enough to fall in. After that, she had trouble getting married. Whenever a matchmaker brought a prospective groom, everything was great until some smart aleck whispered the story of what happened into the ear of the young man. Then the match was off.

Malkele would come to our place, sit in the kitchen, and chitchat by the hour. She lived across the road from my grandmother's grocery store and had the farthest to go to get home. My mother delegated me to escort her. I was no more than fifteen years old. She was so tall, I barely reached her shoulder. She was also well endowed. We would walk arm in arm, and I would rub the back of my hand against the side of her breast. She knew what I was doing but pretended not to notice. Suffice it to say, I looked forward to escorting her home whenever I could. I heard that, in wartime, she got married in Apt. She disappeared with everyone else.

The kitchen was the warmest room in the house. There was a wood-burning stove in the corner. The brick sides of the stove were covered with clay to seal the surface and then whitewashed. This is the same technique they used on the exterior walls of buildings. Along the narrow side of the stove were two doors to the fire. We put the wood into the stove through the larger door. The wood rested on a steel grate; the ashes would fall through the grate, and we would remove them through the smaller door. We could control the fire by opening or closing the little door to the ashes: the more air we let in, the more quickly and the hotter the fire would burn. The baking oven was a metal box inside the brick stove. It

Military Latrine

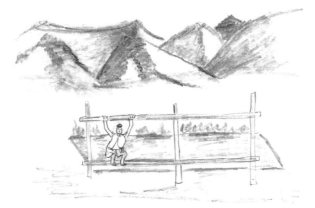

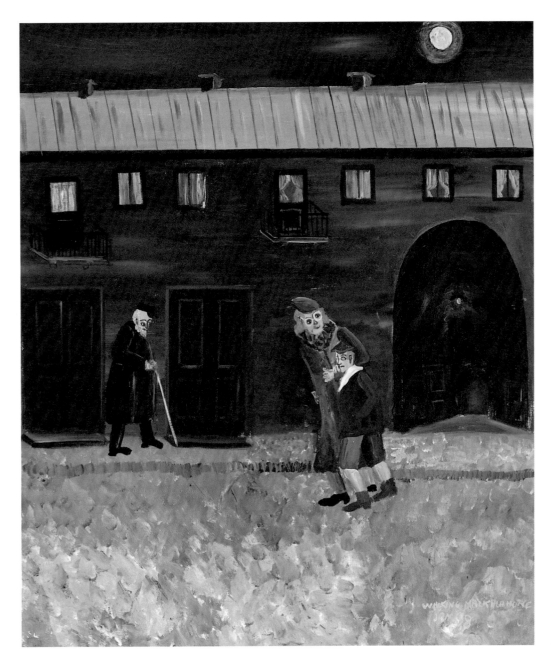

Walking
Malkele Home

was surrounded by the fire. The door to the baking oven was on the wide side of the stove and had a latch handle. When the fire died down, the bricks and metal retained heat.

The surface of the stove consisted of a large metal plate. Four holes in the metal plate served as burners. Each burner was covered with three or four concentric rings: you could control the heat by adding or removing rings. Mother would remove all the rings from one of the burners to expose the hot coals when she was making a *meygl,* a stuffed chicken neck. To make a *meygl* she would clean the skin of the chicken neck of pin feathers (*penkes* in Yiddish) as best she could, fill the skin with flour and chicken fat, season it with salt and pepper, and sew up the ends. Then she would put the *meygl* on the hot coals for a few seconds to expand the air inside the skin and make it inflate. The fire would also singe the fine feather fuzz and make it easier for her to scrape the skin clean. She would then place the *meygl* in a pan and roast it together with the chicken in the oven. The stuffing would expand and the skin would stay inflated and become crisp. This was a great delicacy.

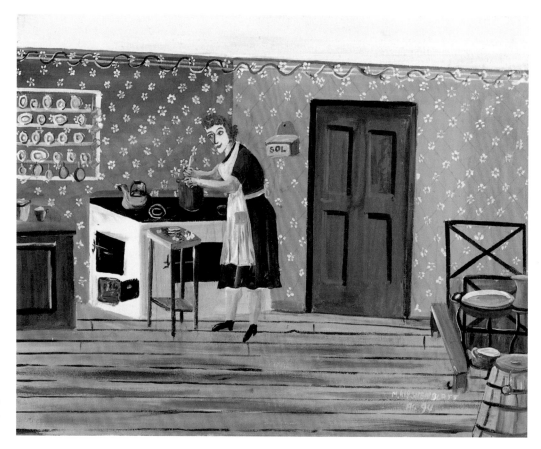

*The Soup Pot
Never Left
the Stove*

The soup pot never left the stove. When Mother was ready to cook, she would light the fire. The hottest heat was under the front two burners. She would set the soup pot on one of the back burners so the soup would cook slowly, and she added scraps throughout the day: a piece of carrot, a potato, some barley, a bit of chicken, or even some meat. By the end of the day, there was soup. You didn't even wash out the pot, because a little bit of flavor remained on its surface. Even now, I feel that a day without soup is not a day.

Mother would buy three or four cheeses in the fall from farmers at the market and dry them out on top of the tile oven in the bedroom. The cheese was a soft white cottage cheese, a fine curd, like what we call in Canada pressed cottage cheese or farmer's cheese; it was available fresh only in the summer after the cows had dropped their calves and started producing milk. The farmer's wife would let the milk sour. Then she put the curds in the corner of a cloth like a pillowcase and squeezed out the whey: that's what made the cheese in the shape of a heart. Most of the time, we ate this cheese fresh in the summer with bread and butter. Mother also used this cheese to make blintzes, cheesecake, and *kreplekh*, which are like *pierogi*. Or she would make a *blote*, which means mud: a *blote* was a mixture of white cheese, chopped raw radish, cucumber, scallions, and sour cream. The only cheeses we had in winter were the ones that had been lying on top of our oven for several weeks. They would turn yellow: the longer they stayed, the yellower and harder they got, until there was only a thin stripe of white cheese inside. We liked to chew on the hard cheese or to eat slices of it with bread and butter. This was the only hard cheese we ever had; it did not last the entire winter.

The whitewashed brick oven in the kitchen was connected to the tall tile oven in my parents' bedroom. The tile oven was called a *kaflane oyvn* (*kaflowy* means tiled in Polish). The white tiles were about four by eight inches and beveled. The oven sat in the corner, with only two sides exposed, the third side forming the wall between the bedroom and the kitchen: this is where the tile oven and the kitchen oven were connected. The tile oven also helped to heat the kitchen. The fourth side of the oven, its back, was against the bedroom wall.

On the narrowest side of the tile oven were three little doors, one above the other. We opened the middle door to put coal into the oven; we opened the bottom door to remove the ashes that fell through a grate; and we opened the top door to get at a big teakettle of water. The teakettle sat in a cavity the shape of a twelve-inch cube, the bottom of which was lined with a metal plate. During the winter, when the oven was on, there would always be hot water for tea.

Since we spent most of the time in the kitchen, we almost always waited until evening, when everyone was home, to light the fire in the tile oven. We would start the fire with kindling wood, which we called *kin* (pronouned "keen"). *Kin* was pinewood that was naturally saturated with resin, which made it burn like crazy. You would chop it up into small pieces; the moment you put a match to it, it caught fire. It burned so uncontrollably that, if you wanted to curse somebody, you would say, "*Zolst brenen vi kin*" (You should burn like kindling). We got kindling from a farmer who would bring a load of firewood into town, pine logs about four feet long; in summer by wagon, in winter by sled. Most of the wood was delivered in the summer. We would pay woodchoppers to saw the wood in our courtyard.

Once we got the fire started with kindling, we would put on firewood. When the firewood got going, we would add a great big lump of coal to keep the fire burning; coal by itself would not burn. We screwed the doors to the coal and the ashes tightly shut so there would be no draft. Then we adjusted the draft: if there were too much draft, the fire would burn too quickly and waste fuel. Hot air circulated through the oven, while the smoke, controlled by a damper, went out the chimney. The coal would glow inside.

The oven was very nice but not very efficient. I would sit with my back to the oven, with a cup of tea, while doing my homework. The closer you were to the oven, the warmer it was. Although the oven did take the chill out of the air, the air was cool when you were three or four feet away from it. When someone came into the house during cold weather, the first

OVEN CROSS SECTION

1. Kitchen stove. 2. Fire pot. 3. Ash pit. 4. Baking oven. 5. Heating oven extending to the kitchen. 6. Flue to the chimney. 7. Heating oven. 8. Damper. 9. Flue circulating smoke and heat to chimney. 10. Heating box only for tea pot. 11. Main fire pot. 12. Door to heating box. 13. Door to fire pot. 14. Ash pit. 15. Door to ash pit. 16. Winding flue heats all oven extending to kitchen.

thing he did was to lean up against the oven, with his hands behind his back, to warm his bones. The big lump of coal in the tile oven would have gone out by about midnight, when everyone was already asleep. By morning, that room was quite cold.

The kitchen, where I slept, was unheated at night. In the wintertime, Mother used to heat up a brick, wrap it in a rag, put it in my bed, and slide it around to heat things up; otherwise, going to bed was just like slipping into ice. The bedding consisted of a straw mattress, feather pillows, linen sheets, and a *perene*, a thick featherbed, which was very warm. We brought the featherbed to Canada. When I got up in the morning, I would jump into my clothes as fast as I could. I was the first up, and Mother had not yet lit the fire in the kitchen stove. It was so cold in the morning that there was a thin sheet of ice on the water in the barrel. To wash, I would put water in my mouth to warm it up, spit it out into my hands, and wash my face with it. I would rinse with cold water. That woke me up in a hurry.

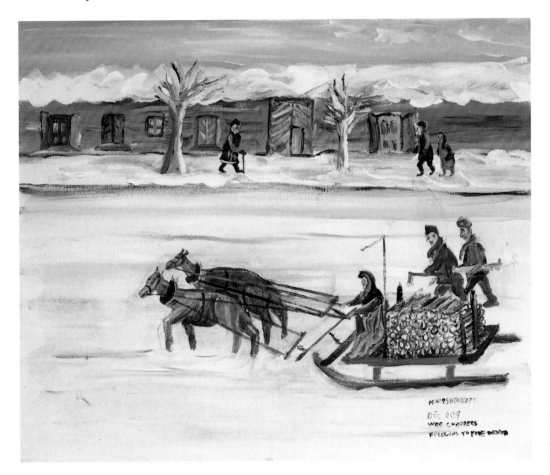

Woodchoppers Follow Sled Carrying Firewood in Snow

My three brothers slept with my parents in the other room. Mother and Father slept in separate beds. Vadye and Harshl slept on a daybed, a *shlufbank*, and Yosl, the youngest, slept in a metal cradle. I remember that cradle vividly, because even as a boy of four or five I used to love rocking in it. When Yosl was too big for the cradle, he slept with my parents. One night he would wet my father's bed; the next night he would wet my mother's bed.

The bedroom doubled as a formal living and dining room. We would eat in this room on the Sabbath and holidays. I was dismissed early from *khayder* on Friday. Mother did not go to the store on Friday so she could stay home and prepare for the Sabbath. There were beautiful smells in the house, particularly in the cool weather, when Mother baked at home. She would make her own challah, butter cake, and *mandlbroyt* (almond bread, a cookie baked twice, like biscotti). When she roasted a chicken, she was generous with garlic and onions. While my father was still in Apt, two brothers from a poor family would eat the Sabbath midday meal with us. Their mother was widowed, so they were considered *yesoymim*, orphans. They would have been about twelve and fourteen years old.

In warm weather, I would take Mother's challahs and cakes to the baker's oven, because it was too hot to bake at home. Friday afternoon, by about three o'clock, the baker would be finished for the day and the oven would still be hot. That's when I would pick up the challahs and cakes for the Friday night meal and bring the food to be cooked for the Saturday meals: coffee and milk for breakfast, and soup and *tshulnt* for the midday dinner. The *tshulnt* was a stew of beans, potatoes, and meat. The baker would put the dairy dishes on the left side of the oven and the meat dishes on the right side. Everything cooked slowly overnight in the baker's oven, which retained the heat from Friday's baking. You are not allowed to light a fire on the Sabbath, but cooking food in the radiant heat of the oven was allowed. I was delegated to bring this food to the baker on Friday and pick it up on Saturday.

Preparation for the Sabbath was a big production, what with the baking, cooking, and cleaning. Mother got up very early Friday morning. After she was done with the cooking and baking, she bathed us in a big wooden laundry tub in the kitchen. The last thing she did was to scrub the kitchen floor. Both the floor and the kitchen furniture were made of unpainted pine. Mother poured a bucket of water on the floor, got down on her knees, and scrubbed the bare wood with a brush and a scouring powder called *bielidło*. It was a combination of bleach and abrasive. She would mop up the water with a rag. From constant scrubbing, the floor and furniture became a beautiful ivory color. You could see the grain in the burnished wood because the scrubbing wore away the softer part of the grain and exposed the pattern. We had to remove our muddy shoes when we came into the house.

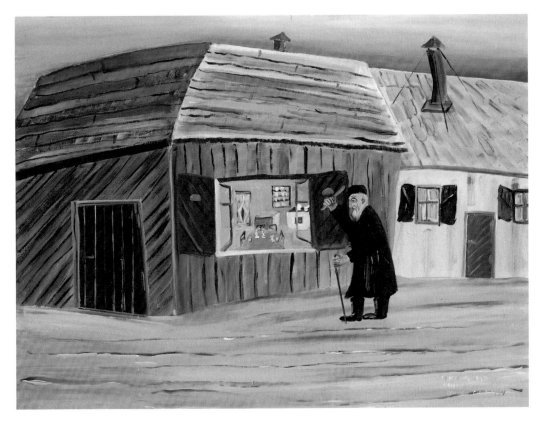

Shilklaper

Mother then set the table for the Friday night meal with the best linen. The Sabbath begins Friday evening, precisely at sunset. Many people did not have clocks or watches and could not tell when it was time to light the Sabbath candles. A *shilklaper*, or knocker, went from house to house. He would rap on the shutters and cry out, "Women, women! It's time to light the candles and go to the synagogue." Through the window, in my painting, you can see the table set for the Sabbath.

We all wore our Sabbath best. We stood around the table, with Mother at the helm. She covered her head with a crocheted kerchief. Looking proudly at her family, she would stretch her arms in an embrace over the candles, cover her face with her hands, and pray silently. We then took off for the *besmedresh* for the Friday evening service, returning home after about an hour for the Friday night meal.

Saturday morning I picked up the coffee and milk from the baker, who was located on Narrow Street, around the corner from us. The coffee, a mixture of coffee and chicory, was in a pot. The milk was in a stone bottle, probably salt-glazed stoneware; it was beige with flecks

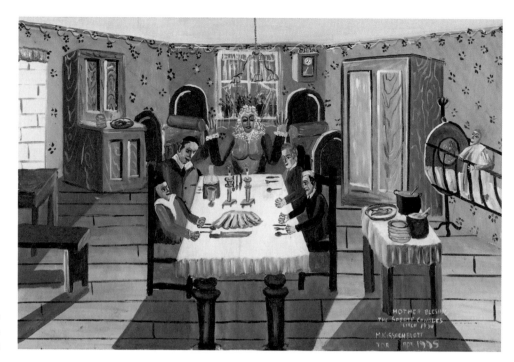

*Mother Blessing
the Sabbath
Candles*

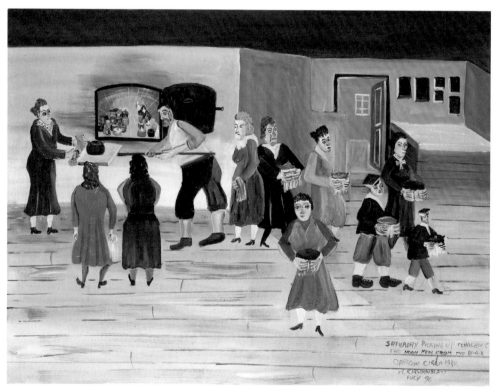

*Picking up
Saturday's
Tshulnt from
the Baker*

and sealed with a cork. The milk would simmer in the bottle all night. By morning it was a deep yellow brown color and creamy: it had become thick like condensed milk. It was delicious. I can still taste it. After morning services I picked up the *tshulnt* and soup. The baker must have had about fifty customers. To this day, I don't know how he knew which pot belonged to whom. He was paid a few cents for his services, but not on the Sabbath itself.

The baker raised a nice family. One day he died. Someone took me to the *shive*, the mourning, and pointed out a glass on the windowsill. The water in the glass was quivering. I was told that the baker's soul was cleansing itself before escaping through the window to heaven.

It was customary that, on Saturday afternoon, after a heavy meal, people would lie down for a nap. When I was six or seven years old, there wasn't much to do then. I had a cousin my age, and we went to school together. We would play in our kitchen on Saturday afternoons. There weren't many toys to play with, so we used whatever we could find: we liked to line up the kitchen chairs and benches and play trains and wagons. Father would emerge from his bedroom, which was right next to the kitchen, and beg us, "It is such a beautiful day. Why don't you please play outside?" Not until I was a married man with children of my own did I understand why my father wanted to get rid of us on a Saturday afternoon.

My parents' bedroom was a nice room. The exterior wall was so thick that the windowsill was more than two feet deep. Mother filled the windowsill with plants: red geraniums, aloe vera, which we used for medicinal purposes, oleander in big wooden planters, and fuschia. We kept the gramophone in this room. We got it from one of my father's aunts, *Mime* Maryem: she was my grandfather's sister. She lived in a small town. When she was about to immigrate to Canada, my father went to say good-bye to her and brought back her gramophone. We considered it the first gramophone in Apt, although others have also claimed that honor. With it came one record: Rossini's William Tell Overture. This was the first classical music I heard. We played it incessantly. We would open the windows and all the neighbors would line up to listen to the miracle: some people wondered how a whole orchestra could fit into such a small horn.

Because we played this record so often, we overwound the spring in the gramophone and broke it. Inside the mechanism was a spool around which a spring was wound. The spring, which was originally about twenty inches long and half an inch wide, was attached to the spool by means of a little hook on the end of the spring that fitted into a little hole in the spool, so the spring would maintain its tension. The other end of the spring was attached to the mechanism that turned the turntable. That hook kept breaking off. I took it to be repaired to old Mr. Lustman, the goldsmith, whose shop was on a little street off the town

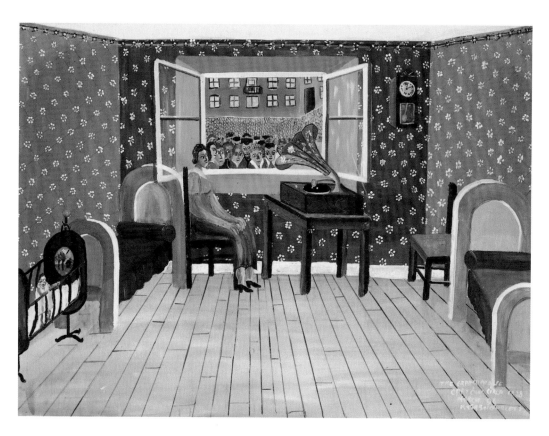

square. I saw him take out the works, and sure enough the spring was loose. Using the end of the spring, he made a new little hook and attached it to the spool. The machine worked, but we had to repair that hook so many times that the spring became too short to allow us to wind the gramophone up completely. As a result, we had to keep rewinding it. The record would start out at the right speed and slow down after a few moments, picking up again as we rewound the machine.

We lived with very little furniture for several years because furniture was so expensive. We had just the meager possessions that we had brought from our first little room to our new home: a small table, a bench, the old metal beds, and the cradle. I was already a big boy when my parents could finally afford to have furniture made. My father went to the cabinetmaker and ordered two beds, an armoire for clothing and bed linens, a credenza for china and table linens, and a dining table and six chairs. My father bought the wood for our furniture from Srulke Szulman, the father of my friend Mayer. Szulman was a religious man. His lumberyard was on ulica Kilińskiego, at the bottom of a steep drop, on the north side

of town. I remember going there with my father and the cabinetmaker to select the wood. Everything was made of quarter-cut oak, except for the credenza, which was made of pine.

The cabinetmaker's shop was on *Ivansker veyg*, just before the bridge, opposite the restaurant of my grandmother's brother Pinkhes. I used to step in on my way to and from *khayder* to see how our furniture was progressing. It took the cabinetmaker several months to cure the wood completely: he would put it out to dry in the morning and take it in at night. When the wood was thoroughly dry, he cut it to size. His two helpers used tiny planes, then small planes, and finally big planes to trim, level, and smooth the wood. With long even strokes, they removed shavings as thin as paper. Then they measured everything, marked out the mortises, tenons, and dovetailing with a pencil, and carved them out with a chisel.

The cabinetmaker sent the woodturner blocks of wood that had been cut to size for the legs of the table and chairs. The woodturner was located on *Takhl-gesl*, Little River Street, a few doors away from the cooper. The woodturner had a long beard. He would tuck his beard into a bag tied around his neck so that it would not get caught in the woodturning machine. Without even using a template, the woodturner did all four legs exactly the same. The table legs were massive. The chair legs were the same design, but smaller. The lathe was operated by means of a foot treadle.

When the legs had been turned and all the parts sandpapered, the cabinetmaker would announce, "Tomorrow we are going to glue." He used horse glue. It came in the shape of chocolate bars. He would break it up and put it into the glue pot, a double boiler, and cook it. Everything was laid out. They brushed on the glue, clamped everything together, and left the furniture there to dry. After sanding the furniture again, the cabinetmaker announced, "Tomorrow we are going to varnish." Before applying the varnish, they cleaned up the shop and sprayed water everywhere to settle the dust. They applied three or four coats of varnish, drying each coat thoroughly and sanding it before applying the next coat. Finally, they polished the furniture to a high sheen. A porter delivered this furniture to us on his back.

It was a beautiful armoire, about seven feet high, five feet wide, and two and a half feet deep. There was a mirror on one of the two doors. On the left were shelves for bed linens, shirts, and underclothes. On the right side, which was a little bigger, we hung clothes. The table was so heavy that I could iron my only tie when it got creased. I would bend the tie around the pages of a book. Then, as I crawled under the table and lifted it up with my back, one of my brothers would slip the book under a leg of the table. By the next morning the tie was pressed and the creases were gone. This was custom furniture. It was built to last forever. We had to sell that furniture when we left Poland.

Our cabinetmaker was one of three Jewish carpenters that I remember in Apt. One of them was Duvid Shabeyrishns, Duvid the son of Shaye Beyrish. He was accused of murder. I don't recall a murder in my seventeen years in Apt, with two exceptions: a police officer who was murdered on patrol in the countryside, and the violent death of Khamele *malosh* (Khamele the Housepainter) during a dispute with Duvid Shabeyrishns. There were two types of carpenters in Apt. The Polish carpenters did rough carpentry on buildings, and the Jewish carpenters did the finishing work, including the doors, sashes, frames, and all the inside trim. Jewish carpenters also made furniture. The Polish carpenters said the Jewish ones

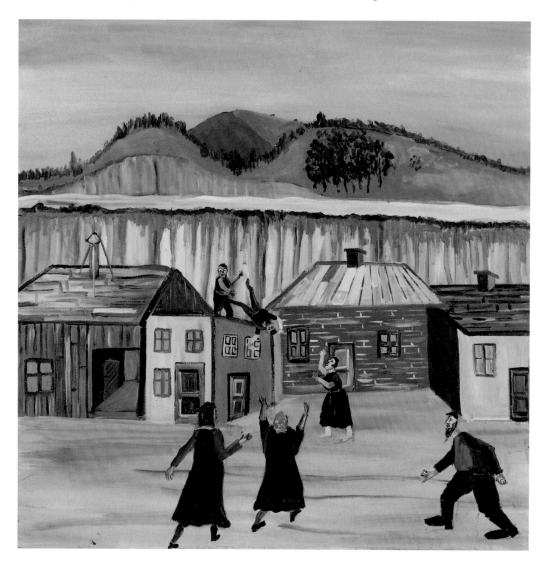

Homicide: Argument between the Painter and the Carpenter

were cowards because they were afraid to climb up high to do the roofs. Khamele lived next door to Duvid; they shared a roof. One day, while working on the roof, they got into an argument. Whether the carpenter pushed the painter or the painter slipped and fell, nobody knows. One thing was sure: the painter died. Duvid claimed that Khamele fell off the roof. Others said Duvid pushed him.

Ordinarily, if two Jews had a civil dispute, they did not go to a municipal court. They went to a *bezdin*, a Jewish court, which consisted of the rabbi and a few prominent citizens. In this case, the carpenter was taken to another town because trials of such a serious nature had to go to a higher court. Also, because of the violent nature of Khamele's death, the government demanded an autopsy, even though autopsies are forbidden in the Jewish tradition. They found Duvid guilty and sentenced him to hard labor. In one of my paintings, you can see Khamele falling from the roof. In another painting, you see Duvid, wearing chains, being escorted to the wagon that took him to jail. He served a long sentence. That was a black mark on the family for the rest of their lives. This happened in my time.

Khamele *malosh*—*malarz* means painter in Polish—did our house a few years before he was killed. He was one of about three housepainters in town, the best of whom was Maylekh Sobol, who made a nice living. A tall, handsome man, Sobol had a very nice basso voice

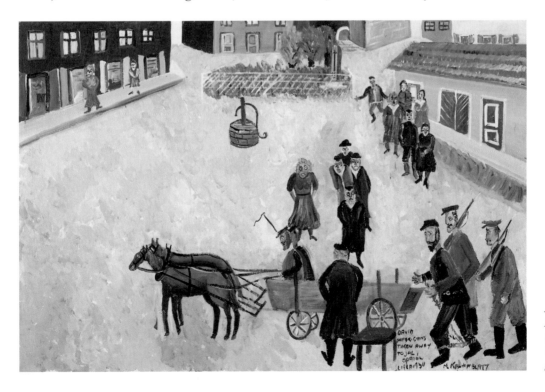

Accused of Murder, the Carpenter Is Taken Away to Jail

and performed in the local amateur theater, but he was in poor health. Sobol was too expensive for us, so when we decided to repaint our place, we hired Khamele *malosh*. That would have been in 1926, about the same time that we had our furniture made, when I was ten years old.

The average house had very little decoration: the walls were usually whitewashed. Every Passover everybody did their spring cleaning, which included whitewashing the house. Old men walked around with a long-handled brush and a bucket of whitewash. We would joke that women would call out to one of the old men, "*Reb Sruel! Kimt aran in shmirt mir os man lekhl*," which means "Mr. Sruel! Come in and smear my little hole [in the wall]."

We were exceptional: the walls in our dwelling were beautifully painted. We were middle class and a little above the average. Both rooms in our home were painted green, one a light shade and the other darker. Both were very nicely stenciled. Our kitchen walls were decorated with beautiful hunting scenes. The bedroom walls were decorated with roses and a garland border near the ceiling. Water-soluble paint was used for the walls and ceiling. Oil paint was used for the wood trim and doors and for the bedroom floor. Khamele *malosh* did not paint the trim. I got some white paint and painted the trim with Mother's help. The floor in the bedroom I painted a walnut brown. We used a walnut-colored wax and heavy polisher to maintain that floor. The polisher consisted of a weight, about ten pounds, with a brush under it and a long handle that swiveled. The kitchen floor was not painted.

We got the oil paint from an old Jewish lady who had a little paint store. Her name was Fraydl Nukhem Mayers, Fraydl the daughter of Nukhem Mayer. She used to wear a *kupke*, a turban with a knob in the front, instead of a wig. This is how she sold paint. She had an old can with two inches of dried-out paint in the bottom that must have weighed a ton. She would weigh the can. Then she would put pigments, linseed oil, turpentine, and drier into the can. For white paint, she used zinc white. She would weigh the can again. You would do your painting, and when you were finished, you would bring back the can and she would weigh it again. This is how she knew how much paint you used and how much to charge you.

Khamele *malosh* began the work in our place by wetting everything down with a brush to strip off the old paint. Then he washed the walls. After that, he patched all the nicks, nail holes, and cracks with plaster of Paris. For a primer he used a soap solution. The night before Khamele was to start painting, Mother would make a big basin of starch by boiling flour and letting it sit overnight to gel. Khamele came the next day with pots of paint powder and added them to the starch mixture. He began by painting the ceiling white, using a calcimine

brush, which is specifically for water-soluble paint. A calcimine brush is wide, with a short handle: four-inch bristles are set into a piece of wood about seven inches wide, three inches high, and two inches thick. Khamele painted with very small strokes, flicking his wrist back and forth, to avoid leaving lap marks. Water-soluble paint dries quickly, so by making quick small strokes he could cover a large surface before the edges of each stroke had a chance to dry and leave a mark. He used the same brush for painting the walls green. The following day he returned to put on a second coat, either the same color or a little lighter or darker. He had to be careful when applying the second coat. If he brushed too hard or wet the wall too much, he would loosen the first coat. While the paint was drying, he worked on other jobs elsewhere in town.

When the walls were dry, Khamele brought catalogs and invited us to choose from about thirty patterns. What would you like? We chose a hunting scene for the kitchen. It showed a forest, with a stag jumping, a guy on a horse, a castle in the distance, a bridge, and a few trees. He would make the pattern on the wall with stencils, one for each of four to eight colors. The stencils were called *shablones* in Yiddish. There were little holes in the stencils, registration marks, to allow him to line the stencils up with one another. The hunting scene was oval in shape, about five inches by six inches, and there were six hunting scenes on one stencil. Each stencil was about twenty-four inches wide and fourteen inches high. Khamele applied the paint in small dabs, using a quick circular motion. He began by stenciling the first color on the whole room. Using a second stencil, he applied the next color to the whole room. He repeated the process several times to build up the scene with various colors and stencils. By the time he was done, the scenes were scattered across the whole room, with spaces in between. It was beautiful. This was a day's work. When he was finished, we washed the floor and that was it.

Hunting Scene: Stencil and Calcimine Brush for Painting Wall

The stenciled walls were not waterfast: you could dust them with a dry cloth, but if you used a wet rag, the decoration would come away. The paint on the wall by my bed, which got so wet in the winter, was always a little darker because it was moist. It did not get damaged because the reed mat protected it, but if you touched that area when it was wet, the paint would come off. Otherwise, the paint lasted a long time and did not even change color. Stenciled walls were a luxury. When I left Apt, I visited a rich house. They didn't have beautiful walls like ours. I did not go through their bedrooms, but

I remember that the kitchen was whitewashed. Wallpaper was practically unheard of. My grandmother brought wallpaper remnants from Warsaw; they were so precious that people would buy a small piece of wallpaper, about six feet long, just enough to put behind a wall clock, which was the center of attraction in the room. The only time I ever saw a wallpapered room in Apt was at Mordkhe Wajcblum's place.

I recall the time that a ceiling in the bedroom of our home needed redoing. First, the plasterer built a raised platform so he could reach the ceiling. After removing the existing ceiling, he nailed wire to the exposed ceiling planks. He brought long reeds—I don't know where he got them from—and tucked them between the wires and the planks; the rushes were placed at a right angle, not parallel, to the wire. The wire held the reeds in place, and the reeds served as a kind of lathe. When that was done, he applied a mixture of sand and lime over the wire and reeds. When that mixture was dry, he applied a finishing coat of gypsum with a trowel. The surface was nice and smooth.

The last thing we did at night, before going to bed, was to close the wooden shutters. The house was hermetically sealed at night, even in summer, when the heat was stifling and the house was like an oven. Sealing the house at night goes back many years, from the time of pogroms, when fear was a constant companion. The windows were quite high off the ground, so Mother or Father would have to go outside to secure the shutters. This was accomplished by means of a big steel bar. One end of the bar was attached to the outer window casing and, when not in use, hung vertically. At the other end of the bar was a ring from which a very long spike was suspended. When bolting the shutter, we would pull the bar up and position it horizontally across the middle of the shutters. We inserted the spike through a hole in the window casing so that the spike came all the way into the room. We then inserted a small spike through a hole in the big spike to prevent it from being pulled out.

The doors were locked with one big slide bolt, a lock, and a hook and eye, which made it difficult to get to the outhouse at night after the door was bolted. There was no indoor toilet, and no one wanted to go out in the middle of the night to use the outhouse, especially in the winter. Who would undo all the bolts and all the locks to go outside to urinate? Not only our front door but also the vestibule door and the outhouse were locked. As a result, everyone used the slop basin at night. It was in the middle of the kitchen floor. It was my job to empty the slop basin every morning. It was too far to go to the outhouse, so I just chucked the urine into a gutter that led from the yard to the back street.

Our outhouse was at the very end of our courtyard, near the gate to Narrow Street. The outhouse had two or three holes. Unfortunately, when some of the neighbors had to relieve

The Pisher

themselves at night, they broke the lock and defecated everywhere except into the hole. When I would come there in the morning, I had to be very careful where I stepped. We wiped ourselves with newspaper or with little squares of tissue paper that we got from Szmelcman, the one who used to import citrus wrapped in little squares of tissue paper: he would save the papers and give them to us. That was our toilet paper, when we could get it. When I relieved myself in the field, I used grass or leaves to clean myself. People also used to piss in the corner of our courtyard near the gate; we would get rid of the stench by spreading quicklime on the area. Imagine having the problem in the morning of where to get rid of your bundle if you didn't have a toilet. You had to squat someplace behind someone's fence and do it.

The outhouse was part of the *śmietnik,* or manure pit, a rectangular concrete pit about twelve feet long, six feet wide, and three feet deep. The pit was half below the ground and half above. On top of one end of the pit was the outhouse, a wooden shack containing a toilet

with two or three holes. The pit itself did not smell too bad because it was sealed with a wooden cover. Every Wednesday, at the end of market day, when everyone had left, there was always a lot of manure, straw, and hay on the ground in front of our gate because this is where the farmers parked their horses and wagons. There was one farmer who would sweep up the debris and dump it into the pit; he was not really a *stróż*, a caretaker, because he was not paid. The pit extended from the back of the outhouse all the way to Narrow Street, where there was a gate. Once a month, when the farmer came to collect the waste, he could get to the pit from that gate; he did this at night, when everyone was asleep. He would carry the waste to his farm on his horse-drawn wagon and use it for fertilizer.

How we survived under such unhygienic conditions I don't know. We fought a constant battle against bedbugs and lice; it was very hard to prevent infestation. If you hung your coat up in a public place or school, you did not know whose coat was next to yours. Mother was on constant alert. As soon as I got home and she saw me start to scratch, she immediately made me change my undergarments and threw me into the washtub. It was a battle to keep clean. It was a full-time job.

Father used to travel a lot on business. He went to big cities such as Warsaw, Kraków, and Radom to buy leather supplies for the store. Whenever he saw something new, he brought it home: a scrubbing board, a manual laundry wringer, or a pump with insecticide called Flit, a trade name for DDT. We were the first to own such a pump. Within a month, there were no more bedbugs. Our house was built right on the ground without a basement; the house may originally have had dirt floors, and our wood floors were right on the earth, without ventilation. The floor would often rot and needed to be replaced. One day I watched the carpenter rip off the old floor boards. Underneath were hundreds of cockroaches, *karaluchy* in Polish, big ones, more like beetles. I never saw them in the house, only under the floorboards; they did not look like our cockroaches in Canada. We "flitted" them. Whether they came back I don't know. We left before the floor needed to be replaced again.

Just before Passover, we did our spring cleaning. All the furniture was taken out into the yard, and everything was torn apart. All the books were taken out and aired: we let the wind blow through them. The beds had to be cleaned scrupulously and the straw mattresses emptied. We poured boiling-hot water into all the seams and joints in the bedsteads to kill the bedbugs and their eggs. After we got the Flit, my father would spray everything with Flit. That helped a lot to keep the bedbugs under control.

The mattresses were made by stuffing straw into a rectangular burlap bag that had a slit up the middle. Every year, before Passover, we emptied the mattresses of the old straw. It would have deteriorated and lost its spring by then, so most people took their old straw to the bonfire where we burned *khumets*, or leaven, just before Passover started. We would refill the mattresses with fresh straw that we bought from the farmers, who knew to bring straw to market just before Passover.

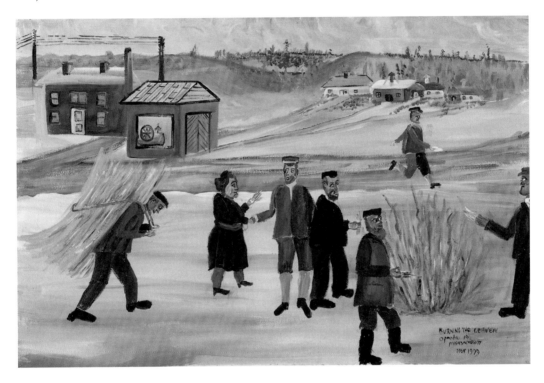

Burning the Leaven

Spring cleaning included a search for any trace of leaven. Leaven is prohibited during Passover, the holiday that commemorates the exodus of the Jews from Egypt. The Jews left in such haste that their bread did not have time to rise. This is why, during Passover, we are prohibited from eating leaven. We would use a goose wing, with the feathers still attached, as a duster (*feydervish* in Yiddish) for sweeping the leaven into a cloth. To destroy the leaven, we used to go to an empty place on a back street, *intern vul,* on the south side of town. A man tended a big fire for just this purpose. You had to pay him a small fee for throwing your *khumets* into the fire. To get out of paying this fee, one guy would divert his attention while another guy threw the *khumets* into the fire when the man wasn't looking. If he noticed, he would rush over to the fire, grab the piece of *khumets*, and throw it back at the guy. In one of my paintings, you can see a man bringing his old bedstraw to be burnt and several people

paying for their *khumets* to be burnt. A boy is trying to sneak his *khumets* into the fire without paying. You can also see the electricity plant for the town and the steam boiler inside it. Electricity came to Apt around 1928.

There were few facilities to wash, and water and fuel were expensive, so bathing was a challenge. Every Friday, until I was twelve years old, I would sit with my three brothers in a great big wooden washtub in our kitchen. We weren't able to heat enough water for each of us to bathe separately, so Mother used to wash us all together. When I was thirteen, I said to my mother, "Please! You've washed me long enough. I'm getting to be a big boy." After arguing with me, she relented, "You can go to the *mikve* with your grandfather." My father was in Canada by this time.

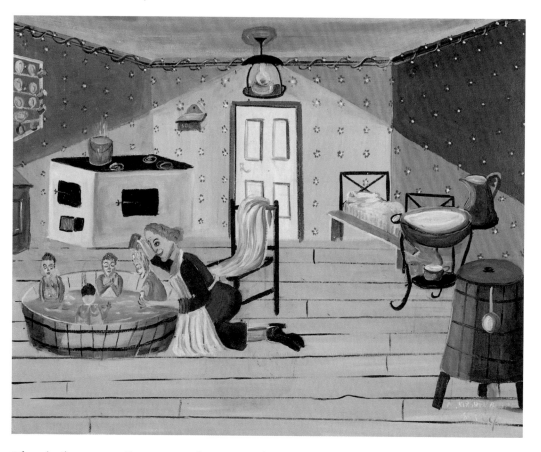

Friday Afternoon Bath

They built a new *mikve* on *Ivansker veyg* in the 1920s. In the back of the *mikve* was a well that had a wheel pump rather than a handle pump. I once helped pump water into the *mikve* and got in for free. It was fun to pump the water. The women went to the *mikve* on Thurs-

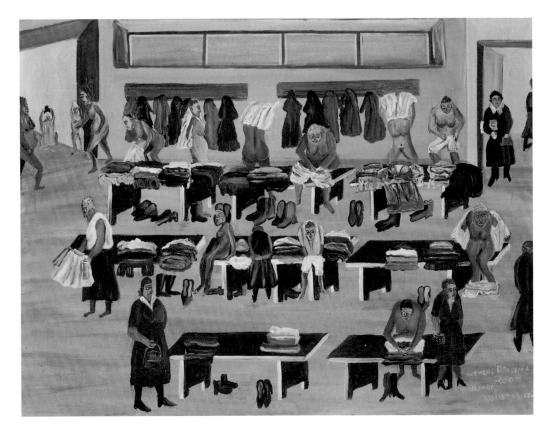

Mikve: Women's Dressing Room

days, and the men on Fridays. I think women could also go to the *mikve* on other weekdays to purify themselves after their menstrual cycle. Once a woman was purified, she could have sex with her husband. I was told that a religious man would sit outside the entrance to the *mikve*, holding out his hand. When a woman had purified herself and was leaving the *mikve*, she would gently touch his finger. Maybe this would help her conceive, to give birth to a boy who would grow up to be a pious man. They used to tell a joke about this custom. The *rebetsn*, the rabbi's wife, went to the woman at the head of the line to touch the man and said, "Please let me go ahead of you. The *rebe* is waiting." The woman at the head of the line answered, "Oh, yeah? The whole city is waiting for me." She was a prostitute.

The *mikve* proper was a small square pool about four feet deep, with steps leading down into it. The water was heated by means of a wood-burning oven that sat right in the *mikve* next to the steps. It looked like a tall barrel and extended from the bottom of the pool to about two feet or more above the water. The *shames*, the beadle, added fuel to the oven through a little door above water level. A chimney led from the oven to the outdoors. When you soaked in the *mikve*, you had to be careful not to go too near the hot oven.

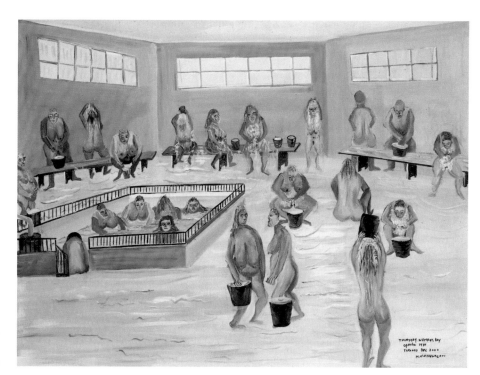

Mikve:
Thursday,
Women's Day

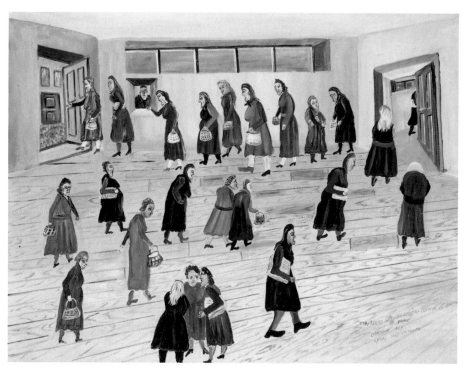

Mikve: Women
Touching Man

You brought your own soap and towel. The *mikve* provided a bucket. Before soaking in the *mikve*, you washed yourself. First you filled a bucket with hot water from the *mikve* and dowsed yourself while sitting on the white tile floor, a little stool, or a bench. Then you took another bucket of hot water and soaped yourself. Finally you filled your bucket with hot water once again and rinsed yourself. Once you were clean, you stepped down into the *mikve* for a hot soak. I went to the *mikve* a few times, but I didn't like what I saw. I saw a lot of deformities. One man had a hernia the size of a watermelon. He couldn't wear trousers. He had to wear a skirt. There were men with scabs. These people often had nicknames inspired by their deformities. Simkhe *parekh* (Simkhe the Scab) was so named because his head was covered with a huge solid scab. Avrum *biye* (Avrum the Lump) had an enormous purple growth the size of an egg bulging from the side of his head. He sat opposite my grandfather in the *besmedresh* during prayers. He was an egg wholesaler. He lived on Narrow Street, a few doors east of my father's store. I knew his son, who was called Khaml *piter* (Khaml Butter), for no apparent reason. Seeing men with such deformities wasn't a pleasant thing. So Maylekh and I would pay the *shames* to bring buckets of hot water from the *mikve* to fill a bathtub with water: the *mikve* had bathtubs in a separate section, but there was no running water, only a drain for getting rid of the dirty water, which ran into the yard. That was our weekly wash.

Once I went with my grandfather to the steam bath rather than to the *mikve*. The steam bath was on *Lagever veyg* on the other side of the river from the power mill. A tree there had tiny little pears, very hard, which we gathered and placed inside our straw mattresses to ripen. The proprietor was Yankl *beyder*, Yankl the Bathhouse Attendant. The steam bath had wooden benches and buckets and a hot oven with red-hot stones. You opened the door of the oven and threw a bucket of water on the hot stones. You had to step away very quickly before the hot steam rushed out. We would pour a cold bucket of water over ourselves when we felt too hot. We would take a short-handled broom made from oak branches with the leaves still attached, work up a soapy lather, and scrub ourselves with the oak leaves. Then you would hold up the broom as high as you could so that the leaves would reach up to the hottest part of the room and you would beat yourself all over with the hot leaves, reaching across your shoulders to your back, to your *playtse*. Not everyone wanted to pay to have someone else do this for them: there was a *shmaser* there, a man who would heat up the soapy broom and beat you on the shoulders and back with it for a few pennies. We called this procedure *geybn a playtse*. The steam bath was a Jewish enterprise.

Mother washed our shirts, socks, underwear, and nightshirts every week, using the washboard and wringer that Father brought back from one of his trips. The wringer (*wyżymaczka* in Polish) did not last long, however. It was such a novelty that all the neighbors borrowed it. In no time at all, the rubber on the rollers stretched out, and we were back to wringing our laundry by hand. My father would not replace the rubber because you could not say no to the neighbors, and it would need replacing again in no time.

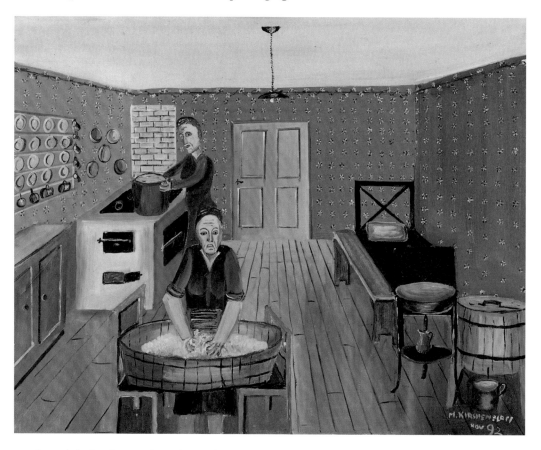

Jadwiga Washing Laundry

Mother did the heavy laundry—the bed sheets, pillowcases, and tablecloths—once a month. Without running water, this was a very big job. She would hire a woman to wash the heavy laundry in a big wooden tub in the kitchen. After the laundry was boiled and washed, it had to be rinsed. Water was at a premium because you had to pay a water-carrier for every bucket, so it was too expensive to bring the water to the laundry. Instead, the women took the laundry to the water. They put the soapy laundry into a sheet and took it down to the river, where they could rinse it in running water. They would swoosh the laundry in a

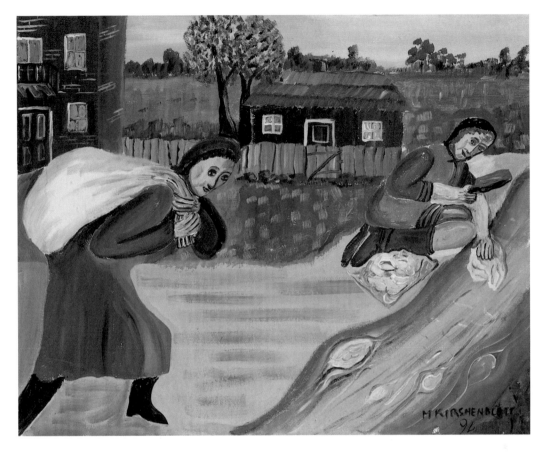

shallow part of the stream, beat the laundry with a wood paddle on a nice flat rock, and rinse it again. After wringing out the laundry, they would bring it home and blue and starch it. Bluing makes white look whiter and prevents it from yellowing.

In nice weather we hung the laundry to dry in the courtyard. Otherwise, we hung it in the attic next to Moyre Simkhe's apartment. If you were unlucky, thieves would climb the ladder to the attic in the middle of the night and steal the laundry. To get your laundry back, you had to rush over to a particular man who would arrange a pay-off for the return of the stolen goods. You had to be fast, or the thieves would sell the goods to a receiver. Then it would be too late. A middleman knew where to find the thieves: they liked to hang out at the local bootlegger's place, which was called a *shvartse shenk* in Yiddish. There were several such places in Apt. Bootlegging was an honorable profession; it was like running a private club in your own home. The thieves would gather around a table in the bootlegger's bedroom to discuss the day's business: loan sharking, whose home got broken into, and the

*Stealing
the Laundry*

like. They knew everything. The lady of the house would roast a goose or a couple of ducks. The aroma of garlic, onions, and roasting fowl is still in my nostrils. It could cost as much as a laborer's weekly pay to get the laundry back; a worker earned a zloty and a half a day. If you paid the money, the next morning you would find the laundry back in the attic. It would be in exactly the same order as the thieves had found it. This was a point of honor among the thieves.

We did not iron the heavy laundry. We took it to a man in our neighborhood who owned a mangle. His place was at the bottom of the Jewish Street. The mangle literally pressed the laundry smooth. The basic idea was to put rollers wrapped with linens between a platform and a heavy box so the weight of the box could straighten out the creases. The mangle was a huge machine. It practically filled the whole room.

Here is how it worked. The platform rested on the floor: the entire machine was more than twelve feet long, four feet wide, and about two and a half feet high. A woman wrapped her linens around a hardwood roller, with grips at either end. The roller was only about six inches in diameter, but once the laundry was wrapped around it, its diameter increased to over ten inches. Two such rollers, which had to be more or less the same thickness, were then placed on the smooth platform, under the two ends of a box that contained about a ton of rocks.

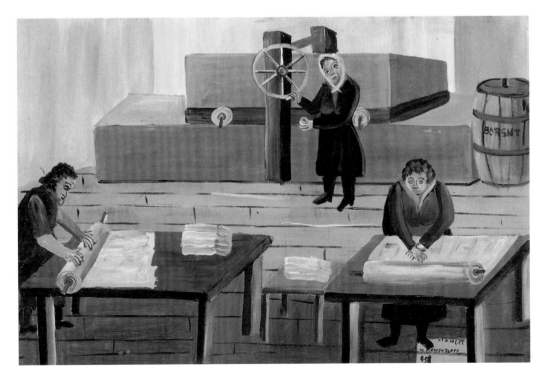

The Mangle

There were two gears, one small and one large, in the center of the machine. The owner or one of the women would grab the handle of a wheel that drove the gears and turn the wheel to make the box move about six feet to the right or left. As the box moved, it forced the rollers to roll. In this way, the women would roll the rollers back and forth many times. The weight of the box on the moving rollers would straighten the laundry and make it smooth. To remove one roller and add another, they would move the box to the far right or left and let it tilt up slightly to release the roller. As I mentioned before, the proprietor supplemented his meager income from the mangle by selling sour pickles and fermented bran as well as grinding matzo into flour or meal for Passover. Even with all these trades, he still made a very poor living.

Given these conditions, staying healthy was a challenge, and, if you got sick, it was difficult to get good treatment. There were two hospitals: a general hospital, where Jadwiga died, and a hospital for contagious diseases. Both were on the outskirts of town, just east of *Ostrovtser veyg* on the north side of the river. The general hospital in Apt was not exactly a first-class facility. It was housed in a two-story brick building. In front of the general hospital was a chapel; the back room of the chapel was a morgue. The morgue could be entered from the back of the chapel or from the grounds. Near the general hospital, on the north side of the road, were a girl's public school and the office of a Polish eye doctor. I visited her when I had an eye infection. She rubbed a blue substance on the insides of my eyelids.

The hospital for contagious diseases was housed in a few low wooden buildings, which looked like barracks. The hospital grounds were vast, about thirty acres, and stretched east alongside the river. Most of this land was used for vegetable gardening and an orchard. The patients tended the beautiful garden. Along the fence grew large bushes of currants and gooseberries. I could see into the garden from across the river, where there was a private orchard that the Sztarkman family used to lease. They would harvest the fruit each year. Their son Arn lives today in Toronto.

Jews didn't have their own hospitals. Nor did they go to the Christian hospitals in Apt. If Jews needed a hospital, they went to Warsaw. Before leaving for Canada, my father had a double hernia and went to Warsaw for surgery. Mrs. Goldman was also taken to the hospital in Warsaw. I used to play with her son. They lived near the public school. Here's what happened to her. Coal used to come in large chunks. One day, when Mrs. Goldman was breaking up a big lump of coal with the blunt side of an axe, she injured her finger. By the time they realized the seriousness of her condition, blood poisoning had moved up her arm,

and her arm was blue. By the time they got her to the hospital in Warsaw, which was 118 miles away, it was too late, and she died of blood poisoning. It was different for the Gentiles. Nuns ran the main hospital, there were crosses everywhere, and the food was not kosher. Jews went to specialists, or they died at home.

For ordinary ailments, there were Jews in town who specialized in various treatments. There were qualified Jewish medical doctors and dentists. Dr. Rabinowicz, a delicate old man, tiny and frail, lived in Mandelbaum's building. He made house visits. Dr. Wasner, a young doctor, started practicing medicine in Apt during the late 1920s. He, too, made house visits. He was a funny kind of guy: they used to say that, when he went to visit Zalmen *goy*'s wife, he would tell her to turn over on her *pośladek*. *Pośladek* is Polish for hindquarters or bum. Dr. Wasner lived with his family in an apartment that he rented from the Sztajnmans on Broad Street, facing the synagogue. There must have been Polish doctors in Apt, because the hospital on the outskirts of town did surgery. To my knowledge, however, we did not generally avail ourselves of their services.

Mr. and Mrs. Starec were qualified dentists. I never went to a dentist, but my mother, who had to have all of her teeth removed, must have gone to them. Mr. Szternlicht, a dental technician, made her dentures. He had his office and workshop on the upper floor of a building on the west side of the marketplace. You entered through the courtyard. Mr. and Mrs. Starec had their office in their home, which was on the steep street where we used to sled in the winter. We called this street *Startsove gas*, after them. They were located close to the bottom of the street, next to Mandelbaum's oil-pressing establishment. *Startsove gas* ran from Kiliński Street up to the marketplace. I don't remember ever seeing Mr. and Mrs. Starec in the synagogue. They were assimilated.

At the market end of *Startsove gas*, on the northwest corner, was the building where I went to school one year: the public school used one room on the upper floor, which was accessible from a staircase on the outside of the building. That was the year I had to repeat grade five. The Turek family, who were Christians, lived on the floor below. Their son was retarded, but harmless; he did not work. If we irritated him, he would give us candy. A woman in the same building, at street level, raised turkeys. During recess, we used to annoy the tom turkeys to excite them. We would gobble at them to make their throat wattles turn bright red. Their necks would recede, and the lobes of wattle on their beaks would shake. Their feathers would puff up, their tails would spread out like fans, and their wings would flutter. They would make a great racket with their gobbling. Outside of this building, on the cor-

ner of the street, was a huge model of a bomb, mounted on a small concrete pedestal, with an inscription urging everyone to donate money to help Poland arm itself in case of war. This was in the 1930s, not long before I left.

Szucht, the barber, also pulled teeth; he used no anesthetic. His barbershop was on the marketplace, and most of his business was on market day. The farmer would come with a sore tooth, and Szucht would pull it out. They used to joke that, if he pulled out the wrong tooth, he would tell the farmer, "Don't worry. I'll pull the right one out for free." The farmer would point to the tooth, and the barber could never be sure he got the right one. He was no dentist. Jews did not go to Szucht. They went to Mr. and Mrs. Starec. As for getting my hair cut, I went to the Jewish barber on our street. He was related to the family with the hunchback daughter.

Avrumele Sztruzer, another barber, was also a *feltsher*, a kind of paramedic. His daughter Malkele, who later became a medical doctor and heart specialist in Israel, told me that he had a library of medical books. People would go to the *feltsher* for minor ailments: colds, upset stomach, cuts and bruises, aches and pains. A *feltsher* could also treat ailments with bleeding and leeches, or *pyafkes*. I never saw leeches being used or bleeding, but I vaguely remember overhearing Luzer *klezmer* talk about a cousin of his wife in Ozherov, a *feltsher*, who did bleeding. He apparently had a brass basin and a scalpel for that purpose. What a *feltsher* could not treat himself he would refer to a medical doctor.

When Father had an upset stomach, Mother would give him baking soda dissolved in water. She kept an aloe plant on the windowsill and treated minor cuts, burns, and boils by cutting a piece of aloe and applying the juice to the wound. If you had an infected boil, the aloe would soften it up so it would open and the pus would be drawn out. We boys could also take care of minor cuts ourselves. We wrapped cobwebs around the wound: that would make the blood coagulate and stop the bleeding. Or we would pee on the wound to disinfect it.

There was also Yudis, who had been an assistant nurse in the tsarist army; that qualified her as some sort of a doctor. She lived with her son, who was a brushmaker, in back of my grandfather's house. She wore a huge white apron with a deep pocket. That's where she kept all her medicines. If you had a sore throat, you went to her. She looked in your throat. Then she reached into her pocket and took out a little bottle and a swab, which she used for the whole city. She swabbed your throat. I presume the tincture in the dark brown bottle was iodine. It was said that she made an ointment from chicken droppings, which she applied to blisters to soften them.

If someone had a boil on the neck or arm, which was quite common, he went to this old man with a long beard. I never visited him, but I heard about what he did. He smoked a pipe with a long stem and a big bowl at the bottom. I believe there was a little trapdoor at the bottom of the bowl, which he would open up so he could drain some of the tobacco juice: it was a mixture of nicotine and spit. He would smear this on the boil. I think he also had another profession—setting bones: if you dislocated a limb, most often a shoulder, he would snap it back into place.

Cupping, or *shteln bankes*, was something you hired a medical doctor or someone else to do to you in your home if you were feeling ill, perhaps with *kater*, or catarrh, as the result of a chill. I learned how to do cupping by watching someone else do it to my mother. Then I could do it to her myself. I would have been about fourteen years old.

We owned our own set of twenty-four cups. First, I sterilized the cups. While they were cooling off, I put a little alcohol on a cloth and cleaned the skin on Mother's back from her shoulders to the small of her back. Then I took a swab, but bigger, more like a wick—it was a stick with cotton batting on the end of it—and dipped it into alcohol, lit it with a match, and inserted the flame inside the little glass cup to create a vacuum. I quickly applied the cup to the skin. Not enough heat and the cup would not stick. Too much heat and the cup would pull too hard on the skin. The amount of heat determined the strength of the vacuum, and the greater the vacuum, the more the cup would suck in the flesh and draw the blood toward the surface of the skin. When I had applied all the cups, I would cover my mother up to keep her warm and leave the cups on her body for five or ten minutes. When the skin had darkened inside the cups, I would just pop the cups off. It doesn't hurt. The cups would leave solid dark circles—they were slightly raised—on the skin; the greater the vacuum, the darker the circle that would form and the better the cupping would draw out all the sickness, or so we believed. People walked around with black circles on their backs for months. In extreme cases, the doctor would administer *gehakte bankes:* this involved scoring the skin before applying the cups so that the suction would draw blood. (I am told that in English this is called wet cupping.)

When we got colds, Mother would make a *gogl-mogl* by mixing hot milk, raw egg yolk, and honey to sooth our sore throats. To prevent colds, Mother would make us take a tablespoon of cod liver oil every day in the winter. I would eat a piece of herring to take away the taste of the oil. She would buy an entire jug of cod liver oil, enough to last all winter for the whole family. We got the cod liver oil from Zylberman's drugstore, which sold patent medicines, soap, perfume, and cosmetics, not prescriptions.

As for babies, they were delivered at home by midwives. My friend Harshl recalls there being two Jewish midwives: Itele and her daughter, Mrs. Warszawska. The midwife, or *akusherke*, that I remember was a hefty Polish woman, and she attended everyone. She brought her tools in a little wicker case. I remember her coming to our home when my mother was in labor with my youngest brother, Yosl. Everyone delivered at home, unless there was a complication. If there were something the midwife could not handle once the birth was under way, she called the doctor. If a complication was known in advance, the woman could go to a bigger city to get more specialized care. Although my mother had been nursed by a wet nurse, Jadwiga, she nursed her four sons herself.

Babies cry a lot. When we couldn't figure out what was wrong, there was a strong possibility of the evil eye. One night my youngest brother cried uncontrollably. We tried to pacify him. There were no pacifiers like the ones we know of today. What we did was to put a piece of challah inside a nice clean white cloth, tie it so that it looked like a nipple, dip it in warm milk, and let the child suck on it. It didn't help. There was no consoling him. My mother was convinced that someone had given him an evil eye. Yosele was an exceptionally beautiful child and attracted envious glances. My mother got me out of bed—my father was in Canada by then—and sent me next door to Reb Moyshe Yitskhek; he lived in a little windowless dwelling in the passageway to Narrow Street, next to the entrance to our courtyard. He's the one who whitewashed the synagogue so the men would not be distracted during prayer by decorated walls. He was a very pious man. Barefoot and in my nightshirt, I knocked on his door. Imagine! It was three o'clock in the morning, and the man was frightened. He opened the door carefully with a lit candle in his hand and asked me what I wanted. I explained that my brother would not stop crying and that my mother was convinced he had the evil eye. He asked the child's name and the father's name. I responded, "Yosef, son of Avner Laybish." He went into a corner, murmured something, and told me to go home. Everything was going to be all right. By the time I got home, my brother was sound asleep. Whether it was from the prayer or Yosele just got tired, I don't know. That must have been in 1927. Yosele would have been a year old and I was about eleven.

There was another way to calm children as well as chickens. If a child were cranky or teething, the mother would give it a poppy seed candy bar to suck on. This consisted of about 75 percent poppy seeds and 25 percent sugar. I don't know whether it was the seeds or the sugar, but the child would soon calm down and fall asleep. If the chickens in a farmer's yard were noisy and disturbed the farmer's guests, the farmer's wife would throw a few handfuls of poppy seeds to the chickens, and they would quiet down in no time.

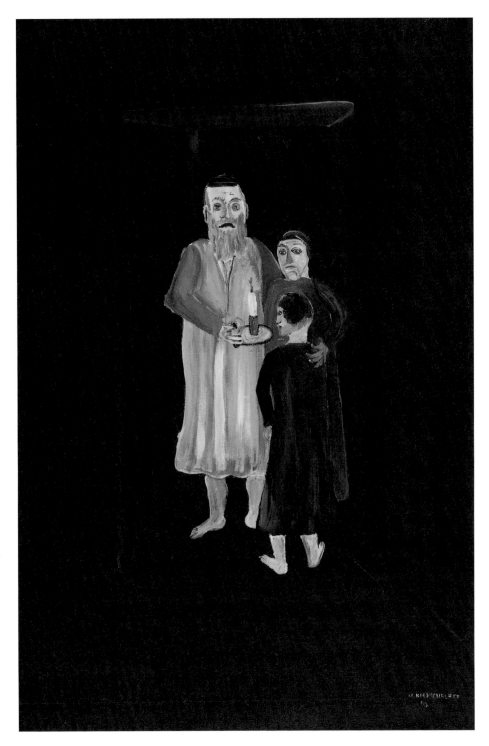

*Exorcising
the Evil Eye*

Lilith Paying a Midnight Visit to My Sick Father

We had our own ideas of how the body worked. My father, who in his later years suffered from Parkinson's disease and had great difficulty speaking, spent his last days in the hospital. One morning he woke up and, in a clear voice, declared, "I had a visit from Lilith last night." In Jewish mythology, Lilith was Adam's first wife. She did not behave—actually, what happened is that she would not lie beneath Adam—so God chased her out of paradise. She wanders around the world as a bad spirit. She steals baby boys before they are circumcised; that's one reason we put amulets in the room where the mother gives birth. It is also said that, when a man has a nocturnal emission, it is because he was visited by Lilith. She arrives in the night to rob men of their semen.

T he building in which we lived occupied an entire block. You entered our courtyard from the gate on ulica Kościelna, or Church Street. If you were to walk straight through our courtyard, you would find a gate to Narrow Street. As I already said, on Wednesdays, the whole of Church Street was used as a small marketplace. This area was large enough to park quite a few wagons on both sides of the street. It was right in front of the gate to our courtyard. I used to love to go out and pet the horses, speak to the farmers, and see what they had for sale. One time when I was out there, a stallion had an erect penis

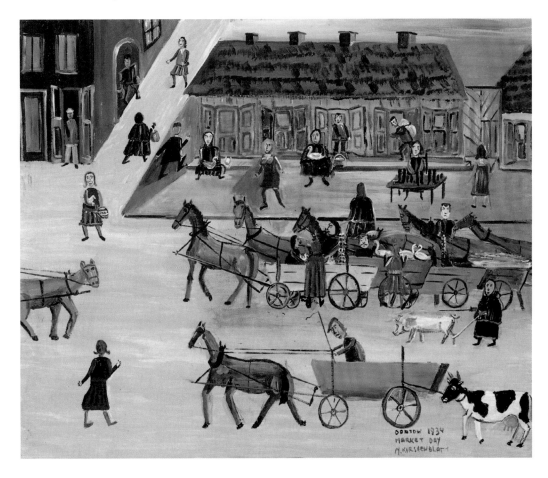

Market Day in Front of Our House on Church Street

more than two feet long. The farmer went over and hit the penis, yelling "*Schowaj to! Schowaj to!*" (Hide it! Hide it!). A stallion that smelled a mare in heat could be very dangerous. He would take off, a runaway, and cause a lot of accidents and damage. Some brave guy would have to catch up with him somehow and grab him by the bridle. In one of my paintings, I show a woman leading her pig with a string around its rear leg and a stick to encourage it along. Seventy-five years ago, the farm women still wore regional costume: wraparound skirts and capes made from homespun linen, dyed black. They did not wear underpants, so when they had to relieve themselves, they held out their skirts, spread their legs, and urinated standing up. Rumor had it that, if the farmer had a good day, his wife would give him a zloty to visit a prostitute. The lady in red was the town prostitute.

The barbershop was the first premises to the left of our courtyard gate. The shop faced the street; the barber and his family lived in a room behind his shop facing the courtyard. His name was Shaye *fryzjer,* Shaye the Barber. His oldest child, Faytshu, was my age. She was very pretty. I liked her a lot. When we were about eight or nine, we used to play together. There was another girl our age, and she always wanted to play doctor; Faytshu would not participate in these games. One day Faytshu got very sick with appendicitis. The appendix is called *ślepa kiszka,* which means blind intestine in Polish. By the time they decided to take her to Warsaw for surgery, her appendix had burst and she died. This was a shattering experience for everyone who lived around our courtyard. It was the first death of someone I knew; I would have been about nine years old at the time. Shortly after her death, they moved away, and a Polish butcher rented their place. He sold strictly pork products but lived in the countryside, where he processed and smoked his meat products. The butcher had access to our courtyard.

Next to the Polish butcher was Khaml Rozenfeld's tavern, which faced the street; he lived with his family in a room behind the tavern facing the courtyard. Khaml was short for Kalmen. His nickname was Khaml *shtiper* (Kalmen the Pusher), referring to his sexual prowess, because his children kept coming at short intervals. I was not friends with his kids. They were Orthodox: they wore the *yidish hitl,* the *kapote,* and the *tales-kutn,* a fringed undergarment. Rozenfeld's tavern consisted of one room, a few tables and benches, and a bar. He sold cigarettes and served whiskey and beer, and pickled eggs. During the week, business was slow. Most of Rozenfeld's business was on Wednesdays. Jews were not drinkers. They might go to a *shvartse shenk,* a bootlegger, which was more like a club, or to Moyshe Zajfman's on the weekend.

To the right of our courtyard gate lived one of the Zajfmans. This was neither Moyshe, who owned the tavern, nor the Zajfman who owned Yarmye's Hotel. To tell the truth, there were so many Zajfmans that it's hard to remember which was which. In any case, this Zajfman had a business, making soda water, that was located elsewhere in Apt. Next to him was a passageway from our street to Narrow Street. Those who lived to the right of the passageway had their own courtyard. There was an entrance in this passageway to the home of Avrum Urbinder, a classmate of mine. The windows of his home, which came almost to the ground, overlooked our courtyard. Everyone in his family was a redhead. I envied Avrum because, after he completed public school, he was lucky enough to apprentice to Słupowski, the printer. Printing was an honorable occupation. Avrum's father left very early for Argentina. Just before we left for Canada, Avrum joined his father there and changed his name to Alfonso. I corresponded with him for many years.

On the other side of the passageway was the entrance to the home of Reb Moyshe Yitskhek, a very pious man who spent most of his time at Upper *besmedresh*. As I mentioned before, he was the one who whitewashed the newly decorated *besmedresh* interior and exorcised an evil eye. His wife was the one who sold lime in a little shop further up the street, on the south side. Also accessible from the passageway were a brushmaker, Mayer Tajtelbaum, and a tailor, Yitskhek Szerman, both of whom lived where they worked.

On the far corner of the passageway, where it met our street, was the home and workshop of Yankl Damski, another tailor. *Der shvartser* Khiel, Khiel the Brunet, the red-headed cobbler whose only surviving son wore white pajamas, was next to him. How he got this nickname and why his son wore white pajamas I will explain later. Then came the Laks girls, who had a small candy store: it consisted of little more than a shelf or two with a few boxes of chocolates and several jars of various candies. Finally, at the corner of our street and ulica Niecała lived Wojciechowski, the city coffinmaker. They were an unobtrusive family. His youngest daughter, Zosia, used to play with my youngest brother, Yosl. We used to tease him. On a recent visit to Apt, I asked about her. The people who were living in Wojciechowski's house told me that she was still alive but lived some distance away and was very sick.

We shared our courtyard with seven neighbors. We rented our two rooms from Mrs. Słupowska, a Jewish woman with a Polish-sounding name, who lived next door to us with her son Avrum and his wife. They were very friendly. Her husband must have died young as we knew nothing of him. The old woman had asthma. To treat it, she used to get little wooden boxes of green powder, put the powder on a small saucer, and light it with a match.

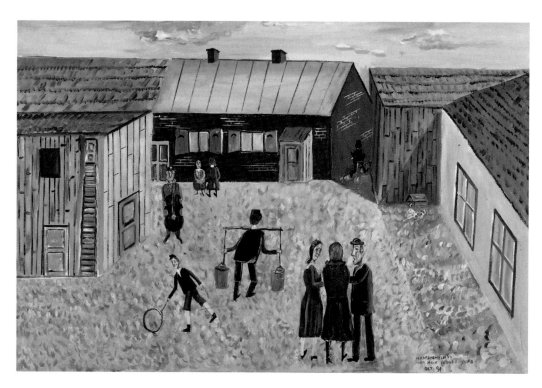

Courtyard

When I went in there, she would be bent over a little mound of smoldering powder; cupping the smoke with her hands, she would deeply inhale it. It was supposed to help her. They also told her to smoke special cigarettes for her health. When Moyre Simkhe beat the living daylights out of me and left three big blue marks on my back, my mother took me to the Słupowskis to show Avrum my bruises, and Avrum reproached Moyre Simkhe for his brutality.

After the demise of our wonderful old asthmatic landlady, Avrum and his wife moved away, and Yosl Tsalel Volfs's son, Beyrele Wakswaser, moved in with his wife. Beyrele, a very nice and charming man, befriended me. He was a Communist and went to jail for a short time. After he was released, he got married. Beyrele was employed at Mandelbaum's soap factory—in what capacity, I don't know. Although a laborer, he was a well-read man. He subscribed to a little magazine about the size of *Reader's Digest* but fewer pages, more like a pamphlet; the magazine featured biographies of famous people and digests of literary works. I found it fascinating.

Beyrele talked to me a lot about different things. This is how I first got acquainted with Freud, Marx, Lenin, Engels, Sacco and Vanzetti, Michelangelo, Galileo, Copernicus, and Madame

Curie, whose maiden name was Maria Skłodowska. The Poles were very proud of her: she won a Nobel Prize for her research on radioactivity. Beyrele also introduced me to Sherlock Holmes and Shakespeare. There were only secular books in his home. Some were in Yiddish, but most were in Polish. It was unusual to have so many books; he must have had some disposable funds to accumulate so many of them. They were all current books. I remember their colorful jackets. Beyrele was an intellectual—there was no doubt about that—and he added a lot to my development. He was a wonderful man. About two years after he moved in, we left for Canada. I heard that he immigrated to Brazil, where he lived happily ever after: he would no longer be harassed by the local police.

Upstairs was Luzer *klezmer,* Luzer the Musician, my violin teacher. He played the trombone and bass fiddle, neither of them very well, and supplemented the living he made as a musician by teaching music and by buying, selling, and repairing violins. Luzer and his family lived in two rooms.

I would go up to his apartment for my lesson, which lasted an hour. I played all the positions from the first to the end. We played duets: I played first violin and he played second violin. I remember playing compositions from an entire book by Mazas, a famous French violin teacher. Luzer *klezmer* told me to practice. That was about it. Looking back, I don't think he did a very good job. He never taught me vibrato, theory, or anything like that. I often regretted that I didn't have a better teacher, though I'm grateful that he taught me how to read a sheet of music and appreciate classical music, which I passed on to my children. I'm also grateful to my mother, because I'm the only one in the family who was taught music.

By Apt standards, Luzer *klezmer* was a tall man. He wore a derby hat. He never wore a shirt, only a celluloid dickey and cuffs under his jacket; when he used to dig in his ear with his pinkie, the celluloid cuffs would make a clicking noise. His wife, Rukhele, had rheumatism. She was our personal weather forecaster: when she would exclaim, *"Es brekhn mir di bayner"* (My bones are aching), we knew it was going to rain, and it usually did. I used to greet her with the words, "Rukhele! Is it going to rain tomorrow?" She would look at me with disdain and refuse to reply. Silently, she was saying, "Wait until you reach my age!"

Downstairs from them was a widow with two sons. I have no idea what she did for a living. They lived in one room, maybe ten by twelve feet. There was a trapdoor in the floor of their room leading to a dugout area under the floor. Mother would put glasses of milk there to ferment; that was how she made sour milk. It was cool there in the summer, so, in-

stead of spoiling, the milk would ferment nicely. One of the boys, I think it was the younger one, had a hobby: he made fretwork from plywood. He made beautiful birdcages, corner shelves for knickknacks, and many other things. I think he worked from printed patterns. I used to watch him use the fretsaw, sand all the edges of the wood very carefully, and assemble the parts. I was most impressed with the birdcages, which he made in different sizes. I don't know if he sold them, but he kept making them. The room was full of his handiwork. He must have been sixteen or seventeen years old, when I was about eight. He was traditional and wore a *yidish hitl*.

When the widow and her two sons left, Nusele Lustman, the goldsmith, moved in. Nusele and his father were the two jewelers in town. The old man mostly did repairs in a workshop on another street. (He was the one who fixed our gramophone when we overwound the spring.) Nusele had immigrated to the United States, but later he returned to Apt. I have no idea why. Nusele brought two novelties back with him: toilet paper and wooden clothespins. The clothespins that I made in school were in one piece, cut from a rectangle of wood; the ones that Nusele brought back from America were made with two strips of wood and a spring. I was most impressed with the toilet paper, which was better than the old newspapers we normally used.

Nusele opened a shop facing the courtyard and made jewelry, mainly gold rings. I used to watch him by the hour. Nusele melted gold in a metal crucible. The crucible, which had a handle, was oblong, about two by eleven inches. The trough on its upper side was just big enough to melt a small quantity of gold. He would place pieces of gold in the trough and melt them using a methyl hydrate torch. The torch sat on the bench, its nozzle pointed at the gold; the mixture of air and methyl hydrate made a bright blue flame of sufficient pressure to melt the gold. I used to help him by squeezing the ball that forced air into the torch. He melted the gold into long bars that were about three-eighths of an inch thick and about four inches long. He must have added something to make the gold hard and change its color from bright yellow to a reddish shade, which was called fawn gold.

When he was ready to make something, Nusele used a set of drawers as his work table. He would pull out the drawer that was at the height of his chest and brace it against himself. Then, leaning over the drawer, which was lined with white paper to catch all the gold filings, he would cut long strips of gold with a little hacksaw. He would later gather the filings and re-melt them in the little metal crucible.

I liked to watch him make rings. He generally used precious and semiprecious stones such as rubies, sapphires, amethysts, and opals. He made the claws using little pincers and the torch. For the most part, he sold rings that he had already made; he could adjust the size. He presented them on a tray. If someone wanted a custom-made ring, he took their size using a set of standard ring sizes and fitted the finished ring to the size indicated on a tapered rod.

Nusele had another little business on the side. He would make a *krake*, a device for getting rid of lice, from the selvedge of woolen fabric. People would bring him long strips of cloth that he would dip in mercury; little beads of mercury would stick to the fabric. I once saw him do this. An old woman came to him, and I asked him what he was doing. He said that people would wear the *krake* next to their skin in order to kill lice.

Next door to Nusele Lustman was Kalmen Rozenfeld, the tavern keeper, and above him Moyre Simkhe, my *khayder* teacher. You can see the steps leading up to Moyre Simkhe's dwelling. Near the staircase to Moyre Simkhe lived Shaye the Barber, the one whose daughter died of a burst appendix. Immediately after that he moved out and the Polish butcher moved in, as I mentioned. Moyre Simkhe occupied half of the attic. He had two large rooms: one of them with the rafters exposed, and the other one a step lower. In an opening under the eaves, I saw bedding, so I assume that his five children slept there. The other half of the attic, which was above the butcher's shop, was where everyone in our courtyard would hang their laundry in bad weather; it had a separate entrance, and you had to climb a ladder to get to it.

As badly as he beat us, Moyre Simkhe beat his wife and children even worse. He had two daughters—Ester, who was my age, and Fayge (we called her Faytshu)—and three sons. As soon as the sons were old enough, they left home. When Moyre Simkhe went on a rampage, you could hear their screams down the street. With all the yelling, we were sure he had killed someone. When it was over and everyone came downstairs and into the courtyard, we counted to check that everyone was still alive. The most unfortunate was Moyshele, the youngest son. Moyre Simkhe beat Moyshele so relentlessly that he became a kleptomaniac. I heard that when Moyre Simkhe left for Argentina, before the war, he had to leave this son behind because the boy had a police record and the Argentineans wouldn't let him in. The boy disappeared in the Holocaust.

Come the holiday of Succoth, the Feast of Tabernacles, we would make one *sike* for all the families that shared our courtyard. The *sike* is a temporary booth that commemorates the temporary dwellings that the Israelites made in the desert when they left Egypt. We built

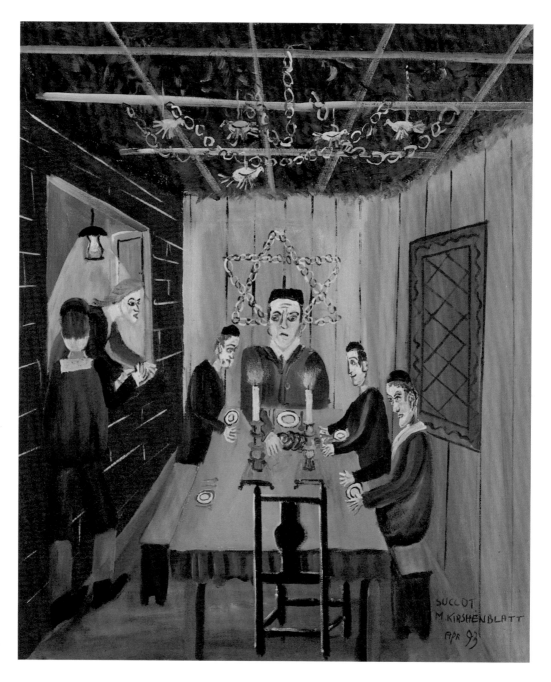

*Succoth
in the Sike*

our *sike* with boards. We only had to construct two sides, because we tucked the *sike* into a corner of the courtyard between the wooden wall of our vestibule and the masonry wall of our dwelling. The peasants, who referred to the *sike* as *kuczka*, brought the pine or fir boughs to market just before the holiday. We would put these boughs on top of the *sike* so that we could see the sky through the roof of the *sike*, as is required. My friend Maylekh had a fancy *sike* with a cover that they could lower when it rained.

We decorated our *sike* with birds that we made from empty eggshells. We made a hole at each end of the egg and blew out the white and the yolk. We fashioned a bird's head from a little piece of moistened challah; we made the wings by pleating a special kind of paper that was brightly colored and shiny on the underside. As the candles on the table burned, the heat from the flames circulated the air and the birds would turn around. We hung up apples, gourds, and paper chains that we had made from colored paper. We also strung chestnuts and hung long strands of them in the *sike*. We put a big Star of David and a little piece of carpet on the wall, anything to decorate the *sike* and make it festive. You had to watch out, because people used to come and steal the decorations. They would take anything of value left inside the *sike* at night.

During Succoth, which lasts seven days, you're supposed to eat your meals in the *sike*. Succoth falls in late September or early October; by then, the evenings were getting quite chilly. Our family ate only supper in the *sike* and only on the first two days of the holiday and on Friday evening. The Orthodox Jews in our courtyard ate in the *sike* more often. With so many families, we had to eat in shifts. Our kitchen window opened directly into the *sike*. This was very handy: Mother could just open our kitchen window and serve the food directly into the *sike*. I remember that Moyre Simkhe would yell up to his wife, who was upstairs, to bring the *tsimes:* "*Tobe, Tobe! Farges nisht dus teykhesl!*" (Tobe, Tobe! Don't forget the little arse!). The tail of the chicken, which is nice and fat, was his favorite part. She would add it to the *tsimes*, a sweet stew made of carrots, apples, prunes, and pieces of fat. We would laugh because of the double meaning.

On the west side of the courtyard, stretching from Urbinder's window to the toilet, were two storage sheds. One was ours; we kept our kindling wood and coal there. I cleared an area in this shed (*kamer* in Yiddish), where I organized a theater. I would make up a story, and a few of us would perform. I charged five pennies for admission; four or five kids, sometimes six, would attend. One day, when I had learned in school about how coal is formed, I buried a piece of wood in the shed hoping that it would turn into coal.

My father's first business in Apt was a little store where he sold candy, ice cream, and soda water by the glass. To make soda water, he filled a copper balloon with water and carbon dioxide. It was a big container, in the shape of a flask, with a siphon attached to its narrow neck. The balloon could take about ten gallons. They placed the balloon in a sawed-off barrel filled with ice to keep it cold in the summer. Father also tried his hand at smuggling shirts. What he told me was that he went to Vienna on business and met Moyshe Pizl, a youngster from Apt who was all of seven or eight years old. Pizl later told me that my father dressed him in six or seven shirts at the same time in order to smuggle them into Poland.

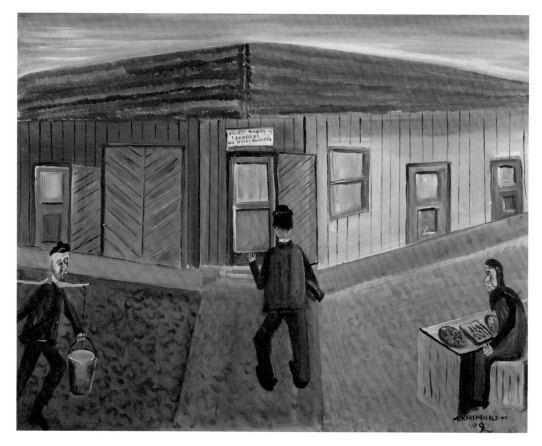

Entrance to My Father's Store

Inside My
Father's Store

After a few months, my father gave up the little store. It was not a success. He then opened a shop for hard and soft leather, findings, and other shoemaking supplies in Szmelcman's building. It was a small place, maybe ten feet square, and there wasn't much merchandise. I don't ever remember a time when my father was not in the leather business.

Father was away much of the time, buying leather in Kraków and other big cities, so Mother used to run the place. Father would buy big cow and horse hides (*fel*) for the soles of shoes; soft hides of calf (*krom*), thin and supple goat hide (*gimʒe*), patent leather (*lakier*), and *kep* for lining boots and shoes. *Kep* came from the heads of animals, so those skins had to be flattened out. They were baled in small bundles of about a dozen pieces and sold by weight. *Kep* was yellow. *Gimʒe*, which was very pliable and expensive, came in brown and black; black was the most popular. *Lakier*, an expensive, high-gloss black leather, was used for fancy shoes, especially for women. I once roused my mother's ire when I destroyed a new pair of patent-leather shoes playing soccer during *khalemoyd*, the days in the middle of Passover.

When my father brought a shipment of leather to Apt, he would not store it in the shop for fear of theft. He kept it at home under his bed or on top of the armoire; he only kept one hide of each kind in the shop. He sold the sole leather by weight because this leather was of uneven thickness. It was thickest in the back and thinned out toward the flanks. On the shelves were a few packages of little steel "horseshoes" to protect heels, little nose caps for toes, metal tacks, wooden pegs, special sandpaper, hog bristle and wax for the twine, and lasts— in short, everything a shoemaker needed.

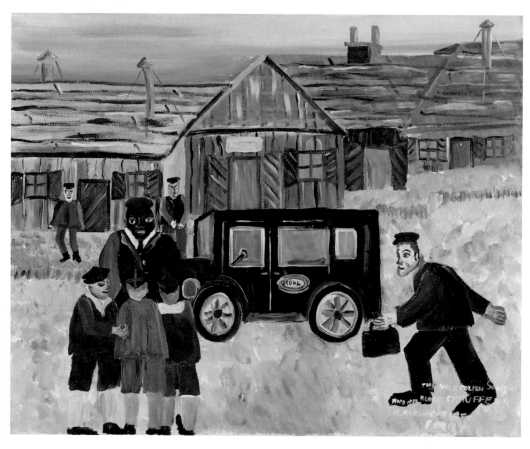

The Shoe-Polish Salesman and His Black Chauffeur

Erdal shoe polish was the most popular brand in Poland. Every spring a salesman would come to town in a car loaded with cases of shoe polish, which he would sell to the local stores. As an advertising attraction, he had a black chauffeur. This man was really black. Having never seen a black person before, we used to follow him around. He was the biggest attraction in town. Although it was warm, he would be fully dressed in a three-piece suit, white shirt, and tie. He would sweat and was shiny. Not knowing any better, we thought the salesman polished him up every morning to show off the shoe polish.

Shoemaking proper consisted of two trades: the *shister* (cobbler) made the hard sole and assembled the shoe, and the *kamashn-makher* made the uppers from soft leather, the part that is called *kholefkes* in Yiddish. A third trade was the *latacz* (*latutnik* in Yiddish), which means patcher. He did repairs, replaced heels, and patched leather footwear of all kinds. The *kamashn-makher* had the highest status and the *latacz* the lowest. I apprenticed to a *kamashn-makher* for a short time.

I was very interested in trades and used to watch the cobbler who lived next door to us by the hour. I watched him so closely, I could probably make a pair of shoes, even now. All our shoes were custom made, although shoemakers did make ready-to-wear boots for farmers. I remember going to the cobbler to be fitted for shoes. The first thing he did was to take the measurements. Most of the shoemakers were illiterate. They had their own system of measuring. The shoemaker took a piece of paper about fifteen to eighteen inches long and folded it over three times to make a strip about an inch wide. First he measured the length of your sole and made one tear. Then he measured the instep and made another tear. The third tear indicated the width of the foot, the space between the big toe and the small toe. He knew exactly what those tears meant.

HOW TO MAKE A SHOE

- *Measurement paper.* - *Last.* - *Inner sole. S[e]wing.* - *Covering sole.*
- *Hard sole tacked down.* - *Heel.* - *Finished ankle shoe with lace holes.*

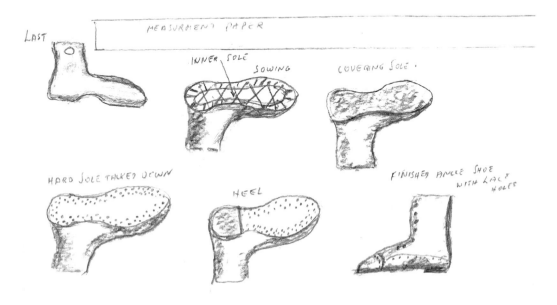

Once he had the measurements, the shoemaker gave the order to the *kamashn-makher*. At the *kamashn-makher,* you chose the style and color. There were not many styles for me to choose from: I could order either ankle boots or regular shoes, which we called Oxford shoes, or *latshn* in Yiddish. He made all kinds of fancy patterns. He would cut leather in various shapes, perforate it with holes large and small that he made with a small punching machine, and apply the decorative piece to the upper. He also added extra stitching. The *kamashn-makher* would buy the leather from our store. The most expensive leather for uppers was *gimze;* the next best was *krom*.

The *kamashn-makher* then prepared the upper, complete with its lining and tongue; he made little holes for the laces with a punch and used a little hand press to attach metal eyelets to the holes. After the *kamashn-makher* had completed the uppers, he delivered them to the cobbler. The cobbler would pick the last that was closest to his measurements. In Polish, the word for last is *kopyto,* which is the same as the word for hoof; in Yiddish, it is called *kopete*. Then he would build up the last wherever it was smaller than the person's foot. If, for example, a person had a bunion, the shoemaker would take small pieces of leather and attach them to the last where the bunion was. He used tacks and glue to fasten leather scraps to the wood and a rasp and sandpaper to shape the last so that it would conform to the person's foot.

The cobbler made twine by placing hog bristle into the lay of linen twine, together with wax, which helped secure the bristle. He would roll the twine between his palms to make it firm; he also waxed the twine to make it easier to thread through the leather.

The sole was fashioned out of four pieces of leather—the first midsole, the second thin midsole, the hard outsole, and the soft insole. First, the cobbler put a thin midsole on the bottom of the last. Then he put the upper on the last and tugged the bottom edges of the upper down so it would tightly overlap the first midsole: the midsole was thus between the last and the edges of the upper. To hold everything in place, the cobbler threaded twine through holes he had made with an awl along the bottom edges of the upper. He threaded the twine through the upper from one side of the sole to the other in a crisscross fashion and pulled it tight. Because the soft upper leather would gather and bunch under the last, he had to pound the gathered leather flat before gluing the second midsole, maybe from *kep,* over it.

As he was doing all of this, the hard outsole, which was less than a quarter-inch thick, was soaking for about twenty-four hours in a bucket of water. When it was ready, he put the wet leather on a stone and beat it with a mallet. The outsole needed to be soft and flexible

so that it would conform to the shape of the last, which was not flat, as there was an arch. Beating the wet leather also made the leather a little larger. The cobbler now placed the last on the beaten leather and drew an outline around the last. This outline served as a guide for cutting out the outsole, which he then tacked to the last.

Now he was ready to make the holes for the square pegs that would fasten the outsole to the upper. He made a light outline about an eighth of an inch from the edge of the outsole as a guide for the holes. The cobbler made round holes in the sole by driving his awl through the leather and into the last. Then he pounded square pegs into the round holes, spaced in two or three staggered rows to form a very nice design. Only after this outsole was attached to the last did he trim it to fit the shoe with a special knife. This knife was small, sharp, and bent, so that it would cut the sole without damaging the upper. To finish the outer sole nicely, he used a rasp to make the pegs level with the sole and a piece of broken glass to shave the surface of the outsole. Finally, he licked the outsole with his tongue and slid the handle of the hammer over the moist leather again and again to give it a very nice shiny smooth surface. The outsole became a light brown and the pegs stayed white: the pattern stood out beautifully thanks to the contrast of the light pegs against the darkened leather sole. For added effect, he might make a decorative indentation with a little chisel along the outside edges of the outsole.

For men's shoes, the heels were made of layers of leather. Before attaching a heel, the cobbler would apply a special liquid polish, either a dark brown or black, to the edges of the sole and to the heel. He used a small brush with a wire handle; the bristle was embedded in the twisted wire, similar to a bottle brush. He nailed the heel to the sole and used wooden pegs to attach the final layer of the heel. On request, he would attach steel horseshoes to the heels and thin nose caps to the toes. The horseshoes had countersunk holes in them for nails. The nose caps came with sharp little triangular wedges that had been pressed out of the nose cap: when tapped into the sole, those sharp little wedges held the nose cap in place. Horseshoes and nose caps helped to prevent the heel and tip of the sole from wearing out as quickly; we also liked the way capped shoes would sound. I remember a fad for shoes that squeaked. The shoemaker knew how to do this too.

For ladies' shoes, my father sold all kinds of wooden heels. As I already mentioned, the best lady's shoemaker in town was the brother of Świderska, the prostitute. He, his wife, and Świderska lived in a tiny room, which doubled as his workshop. In a corner of the room, he had a little table and a stool. In the summer, the door was open and I could see inside.

He would shape the wooden heels for ladies' high-heel shoes; he would sculpt them. His shoes were a work of art. Unfortunately, he would rather sit at the tavern with his buddies than work.

To remove the last from the shoe, the shoemaker inserted a hook into a hole that went through the top of the last, just above the ankle, and pulled the last out of the shoe. The hook was about a foot long, with a T handle; it had to be long enough to retrieve the last from a boot. He would then rasp the inside of the shoe to level all the protruding wooden tacks and make the surface smooth before gluing the insole over the tacks. With little bit of shoe polish and a few strokes with a brush, the cobbler finished the shoe.

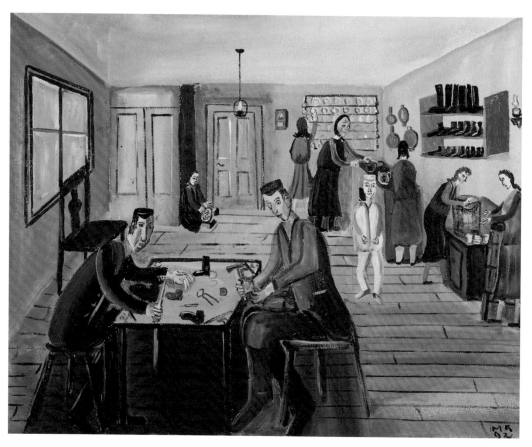

Boy in the White Pajamas

I remember even before my father left for Canada seeing how the cobblers lived. In my painting, you can see all the action. The drinking water was in a barrel on the floor. The wooden bucket on the cabinet contained water for soaking the leather to make it flexible. You can see all the tools and each step in the process of making a shoe. There is one cobbler I will

never forget, our neighbor *der shvartser* Khiel, Khiel the Brunet, and I've painted him. As I mentioned earlier, although he was a redhead and all his children were redheads, they called him Khiel the Brunet. To confuse matters further, they nicknamed a brunet Khiel in town *der geyler* Khiel, Khiel the Redhead. One day my mother sent me to *der shvartser* Khiel in the early morning on an errand. It was before they had a chance to rise. When I walked into that room, there were people sleeping everywhere, wall-to-wall, at the head and foot of the beds, on benches and tables, and on the floor. The whole family lived and worked in two rooms.

Der shvartser Khiel was so poor he could not pay his income tax (*dochodowy* in Polish). When he knew the tax collector was about to arrive, he would hide anything of value. The tax collector, seeing that *der shvartser* Khiel couldn't come up with the money, would take his tools and anything else he could find, put them out onto the street, and auction them off right in front of the cobbler's workshop. Meanwhile, *der shvartser* Khiel had arranged for a neighbor to place a low bid: "Moyshe, you bid. I'll pay you back." It was a put-up deal. Everyone knew, so no one else would bid. The tax collector settled for the pittance he got from the auction and wrote off the rest. After the tax collector was gone, *der shvartser* Khiel repaid his neighbor, which was considerably less than he would have paid in taxes, and got all his tools back. The poverty was unbelievable.

Der shvartser Khiel had seven daughters. Every time a male child was born, something happened and the child died. Every Jew wants to have a son so that there will be someone to say kaddish, the prayer for the deceased, for him after his demise. In desperation, *der shvartser* Khiel went to the rabbi and implored him: "Am I to die without a male heir? Who will say the kaddish after I'm gone? I have seven daughters. Can I afford another one? Where will I find dowries and grooms for them all?" The rabbi thought for a while, then came up with a solution. He said, "Go home. When your wife gets pregnant and it's a baby boy, do exactly what I tell you." First, he gave Khiel an amulet and told him to make the boy wear it all the time: it would ward off evil spirits. Second, the child must always be dressed in white: the white clothes would fool the Angel of Death, the *malekh-hamuves*, into thinking the boy was already dead and not taking him, since Jews always bury their dead in white burial shrouds. A boy was born. *Der shvartser* Khiel followed the rabbi's instructions, and the boy survived. When I left Opatów in 1934, the boy was eight years old. I was told that even as a teenager he still wore the white pajamas. He was dressed in white in 1942 when the Jews of Apt were expelled, never to return.

I also remember an incident with a *kamashn-makher* in town. His name was Beyrl Czereśny, which means cherry (*czereśnia*) in Polish. Beyrl had many children, and he was poor. When he complained to his friends about his problems, they told him about condoms. He said he would make one himself from goat leather, *gimze*, which was very soft. One day his wife got sick. The doctor came to see what was wrong. He found the leather condom inside Beyrl's wife and removed it. When her mother heard the news, she ran up the street wailing, "Oy, oy! The baby is not yet born and he's already made the uppers." I knew the guy. He used to buy leather from my father. His workshop was right next door to Moyre Berman's *khayder* on the upper stretch of the Jewish Street.

My father finally had to leave Poland secretly because his business failed. Until then, he had eked out a fairly good living: we were never short of food, and everyone got a new suit of clothing and new shoes for Passover. All that changed when my father went bankrupt through no fault of his own. I was twelve years old at the time. One time father went away to Kraków to buy heavy leather for soles. He arranged for it to be sent to Apt. The way they shipped leather was in a huge bale about three feet across: they would fill two hoops of metal baling with leather hides that had been rolled up inside one another. The bale was quite heavy. This time, someone held up the train and stole my father's leather.

As luck would have it, the railroad company found the leather. Maybe it was my father's leather, maybe not. Who knows? It was the same weight, but it was cut up into little pieces. It had very little value once it was all cut up. With a whole hide, my father could lay out the soles and heels to waste as little leather as possible: the shoemaker would come to him with the size soles he needed, and my father would cut him a piece of leather and charge him according to the weight. A whole cowhide might be eight feet long and five feet wide. Given its irregular shape and that it was thicker in the middle than at the edges, you lose a quarter inch here, a quarter inch there, and even more at the edges. There were also two prices: the thicker pieces from the back of the hide cost more money than the thinner pieces cut from the sides. But from the little pieces they found, you could barely even make a pair of soles; the pieces were so small the only thing you could do with them was make heels. Why the thief cut up the leather I do not know. All I know is that they found bags and bags of little pieces of leather.

In any case, the government said, "This is your leather. This is what we found and it is yours. We don't owe you anything. You have no case." My father was devastated. He had issued a promissory note, a *veksl*, to pay for the leather, but he had no money in the bank to cover

it. This was a very serious thing in Poland. It was not like here. You could not renege on a promissory note. You had to pay up or it was immediate bankruptcy.

Believe it or not, we had our own mafia in Apt. I don't know about the *gemiles-kheysed* (Jewish interest-free loan society), but there sure were loan sharks, and my father was deeply in debt. The head of the mafia was Khamu Itshe Mayers, a butcher by profession (in more ways than one) and a loan shark. He was an intimidating presence thanks to his enormous size: he was more than six feet tall and must have weighed three hundred pounds. In the synagogue, he occupied the space of three people. He used three lecterns: he would put his prayer book on the middle one and his big hands on the other two. So when my father needed to borrow money to make good on the promissory note, he went to Khamu Itshe Mayers for a loan. Father figured that, by the time he had to pay off the loan, he would have settled with the government railway company, received money from the insurance company, and be in a position to repay the loan. He was negotiating with the government to reimburse him for the leather; after all, it was their railroad, and they were responsible.

To make a long story short, my father never received compensation for his loss, not from the government and not from the insurance company. Because he worked at such a small profit margin with such low investment capital, everything collapsed if there were the slightest hitch. As long as he bought on credit, sold the leather, and paid the bills with what he just earned, the ball kept rolling. The moment the ball dropped, he was dead. He survived from day to day, from *veksl* to *veksl*. It made no difference that the leather wholesaler to whom he owed the money was Jewish.

Business in our small town was very precarious. Most of the businesses operated with American currency. The Polish zloty was convertible, but it was too volatile. It went up and down, so people did business in American dollars. This was the time of the Great Depression. It was a hand-to-mouth existence, even though we were not too badly off. However, once my father became so deeply in debt, he had to escape. At the time, two of my father's younger brothers, Joe (Arn Yosef) and Sam (Shmiel), were in Canada. They were both upholsterers and making a nice living. Joe's wife was making good money selling used pianos. Joe and Sam wanted to bring their youngest brother, Duvid, who was single, to Canada. It was 1928. Immigration was difficult under the best of circumstances and pretty much impossible for a married man with children, like my father. Duvid did not want to go. He was running his mother's store in Drildz. He did not like the idea of leaving a relatively comfortable life in Poland to risk everything for a new life in Canada, where he would need to learn

a new language and establish himself economically. In Drildz, he ran the family business: he didn't work for somebody else.

After preparing the papers for Duvid three times, Joe and Sam told him that this was his last chance. Duvid refused to go, and my father volunteered to go in his brother's stead, using his name and papers. In a very short time, my father left. First, however, he had to take care of a double hernia. I remember him wearing a special prosthesis, a spring metal belt covered with leather, with two metal balls that fitted into the groin to support the areas that had been ruptured. He had the operation in Warsaw. I remember him returning in bandages. As soon as he healed, he left.

My father had to depart in secret. He used to go out of town often, so when he left town this time nobody knew it was for good. If the loan shark had the slightest suspicion, he would never have let my father leave in one piece. He would have killed him or, at the very least, maimed him. Only my mother knew that Father would never return to Apt. My father first went to Drildz, so he could say good-bye to his parents. His father was already very ill with what I later surmised was hardening of the arteries. My mother then sent me on my own to Drildz by horse and wagon without telling me why she was sending me. I was happy to go. When I got to Drildz, my father was already there and awaiting my arrival. That's when I found out that he would not return to Apt. Being the eldest, I was the only one to be informed of my father's departure. I was strictly warned not to tell anybody. I had to keep my father's departure a secret.

The next morning my father left for Canada. My grandfather lay on a chaise lounge in the kitchen, where he would rest all day. He rose with great difficulty, went to the front door, and with tears running down his face walked to my departing father, crying, "Son, my son, my firstborn, I will never see you again." The wagon took off with my father. I ran after it for a while and then stopped to see my father and the wagon disappear over the crest of a hill. I felt very sad. I used to write my father very nice letters. In the fall, I would collect colorful maple leaves and enclose them in my letters to him. I sent him drawings and wrote to him all about what was happening in school.

Grandfather died two years later—in 1930, if I'm not mistaken. My aunt Yokhvet's husband, Yekhiel, told me that, after they washed Grandfather's corpse, they rubbed him down with ninety-proof spirits, which made his skin look fresh and pink. My grandmother did not wait very long before remarrying. She was a powerful woman. Her new husband (we called him *Feter* Beyrl, Uncle Beyrl) smoked a pipe. He had a few pipes. I snitched one of them and smoked it on the bus to Radom, when I went there to see about my eyes. People on the bus objected.

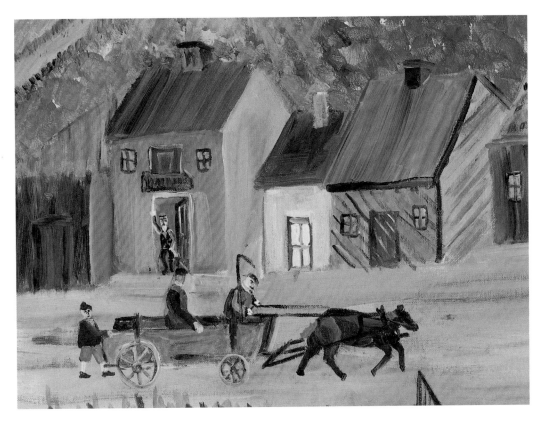

Detail from
*Ilža, Father's
Hometown:
Father Bids His
Parents Farewell
before Leaving
for Canada*

When Khamu Itshe Mayers found out that my father had left, he came to our house. I was there. He loomed in the doorway, filling up the entire entrance, and berated my mother. She told him that my father would send money from Canada and that the loan would be repaid. He called her names and gave her a slap across the face. She started to bleed from the mouth. She was in shock. I felt terrible. What could I do? We both cried. It took my mother several months to liquidate the business. As soon as my father started working in Canada, he sent money home regularly, a portion of which was earmarked for repaying the debt. Khamu Itshe Mayers wanted exorbitant interest, so my mother went to the rabbi. The rabbi summoned Khamu Itshe Mayers and decreed that, since my mother was alone with four young children, he was lucky to get the principal back; thanks to the rabbi, Mother did not have to pay the interest. This is how we eventually got to Canada. If not for that disaster, God knows, I probably wouldn't be here to tell the tale.

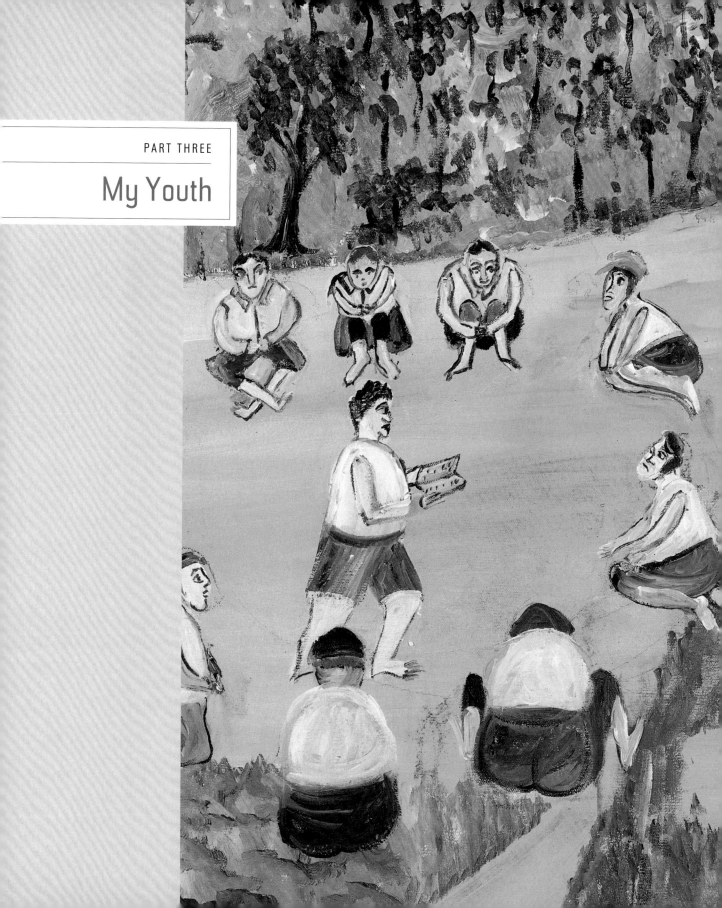

My Youth

ROBBED OF MY YOUTH

Basically, I was robbed of my youth. I started *khayder*, the traditional Jewish primary school, when I was four years old. The first *khayder* I attended was located off Broad Street. It was a one-room affair. The place was dark and dingy. There were two beds, one on each side of the room, and a stove in the corner. The recreation for the children during recess was to take out the kindling wood in the morning, stack it up in a square as high as a chimney, and bring the wood back inside in the evening.

The teacher was Shayele *melamed*, Shayele the Teacher: his full name was Shayele Hochmic. In the morning his youngest son, Harshl, came to pick up the little boys, including me. He was the *belfer*, the teacher's helper. By the time we reached the *khayder*, there were about five of us trailing him. We stayed there for the better part of the day. It was like a babysitting service. My mother sent me there, not so much to learn as to get me out from under her feet. She worked in my father's leather store. Even at that early age, we learned the Hebrew alphabet. The way we learned was by rote.

In one of my paintings, I show my first *khayder*. You can see the *kantshik*, a cat-o'-nine-tails, on the wall. This stick, with its nine or so knotted strands, was the teaching aid. It was a convincer. If you didn't know the lesson, you got a few shots of this, and the next time you knew it. Actually, I do not remember there being a *kantshik* in my first *khayder*. I put the *kantshik* in this picture because I saw them in other *khadurim*. It was there as a kind of warning. But Shayele *melamed* did hit me. I had acquired the habit of suddenly blinking uncontrollably. He would slap me until I stopped blinking my eyes: he would say, "Look at me!" Whack! This method may not have been very scientific, but it worked. Otherwise, Shayele *melamed* was actually a nice man. He was also very good-looking, with a reddish beard, but his wife was ugly. After his demise, his children immigrated to Canada. His son the *belfer* went to Palestine. All the sons were handsome like the father; the girls resembled the mother.

By the time I left Shayele's *khayder* after two years, at the age of six, I could read the prayer book. I had now advanced to the Yavne *khayder*, where Moyre Simkhe, "the butcher," was my teacher. The Yavne schools were organized by the Mizrahi, the Orthodox Zionists, and were already quite progressive, although the method of teaching was more or less the same as in my first *khayder*. We still learned by rote, but the teacher used a big stick or strap instead of a cat-o'-nine-tails as a teaching aid.

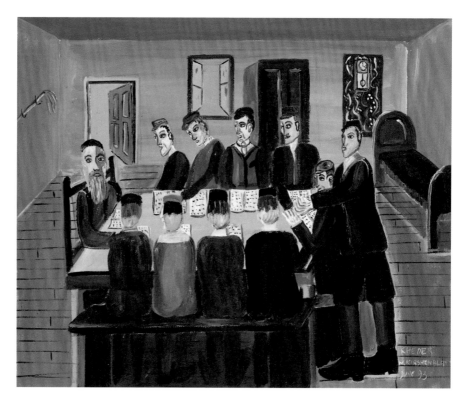

*Shayele
Melamed's
Khayder*

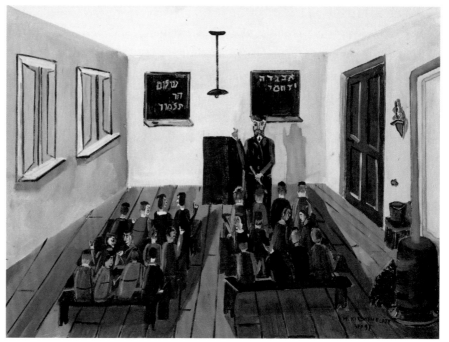

*Moyre
Simkhe's
Khayder*

The Mizrahi school system was one of the biggest in town, with about 150 children enrolled, if you figure that these schools employed three teachers, each teacher taught two classes, and there was an average of twenty-five children to a class. The other big school system in town was organized by the Agudah, which represented Orthodox and Hasidic Jews. They were not Zionists. Being Orthodox, they created separate schools for boys and girls. The girls went to a Beys Yankev school.

The General Zionist Organization established their own school, called Tarbut, which means culture in Hebrew, in the early 1930s after I had already finished my schooling. As I mentioned earlier, my mother helped to establish Tarbut, together with a few other women, including Srulke Rozenberg's wife. My youngest brother, Yosl, who was born in 1926, was one of the first to enroll in that school. He wasn't there for long, because we left for Canada in 1934, around the time the Tarbut school opened. It was progressive: they taught modern Hebrew, secular subjects, and Jewish studies from a modern point of view, using Hebrew as the language of instruction. Their students did not *davn* in the morning the way I had to. Nor did they have to attend school on Saturday. The Board of Education recognized them, which meant that a student who attended the Tarbut school could transfer to a Polish school or continue in a gymnasium, a high school, after graduation. There was a Polish gymnasium in Apt but not a Jewish one.

There were three Yavne schools, one for boys younger than six and two for boys older than six. The older boys went either to Moyre Simkhe's *khayder* or to Moyre Berman's. Their full names were Simkhe Milsztajn and Yekele Berman. The older and younger boys had different schedules, which were coordinated with the Polish public school (*szkoła powszechna* in Polish). As a result, the *khayder* was in operation all day and evening. In the morning, while we were in public school, the younger children were in *khayder*, and when we were in *khayder*, the younger children attended the public school. In the winter, the young ladies went to the *khayder* in the evening to learn to pray in Hebrew and to read and write Yiddish.

We older boys came to *khayder* at about seven o'clock, said our morning prayers, went home, grabbed a bagel or something else for breakfast, and took off for public school, where we had either four periods until noon or five periods until one, with a ten-minute recess between each period. We went home, grabbed a fast lunch, and returned to *khayder* until six or seven o'clock in the evening. That was another five-hour session. We went home for supper. That was not the end of my working day. I had to do my homework and practice my violin.

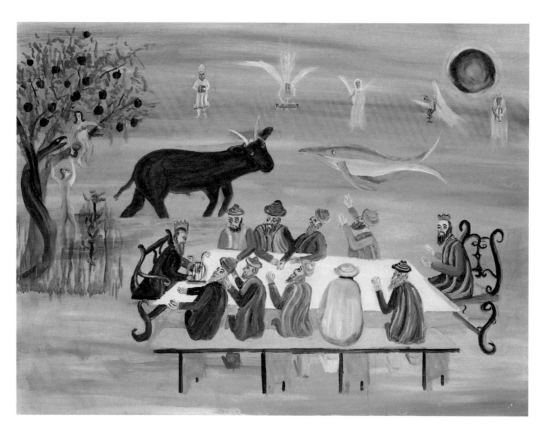

When the Messiah Comes, the Righteous Will Feast on the Leviathan

Even Saturday was not completely free. At about two or three o'clock in the afternoon, we went to *khayder* and studied *Pirke uves* (Wisdom of the Fathers). If we behaved, the *melamed* did us a favor and told us a nice story, perhaps about the Leviathan and how, when the Messiah comes, the righteous will feast on the Leviathan and the huge red ox, the *shorabor,* in paradise, with King David playing his harp at the table. Nice as these stories were, we did not appreciate them because we were eager to get outside and play. Around the time of my bar mitzvah, we started learning Talmud. After the Saturday noon meal, I was obligated to take my *gemure* and the rabbinical commentaries on it and visit a prominent citizen, a scholar. I had to recite the week's portion that I had learned. If I did not perform well, it was humiliating. On Sunday, we did not go to public school but we still had to attend *khayder.* The older boys came for prayers in the morning, went home for breakfast, and returned. We sat around for the rest of the morning, went home for lunch at noon, and returned to *khayder* for the rest of the day. We were constantly kept busy.

Unlike the conservative *khadurim,* where there was one room and everyone sat around the table, at the Yavne *khayder* we sat at desks, four of us to a bench, and there was a blackboard. In the corner was a coal-burning iron stove, which was used sparingly, because coal was expensive. The room was just warm enough not to shiver and just cold enough not to fall asleep. Electricity, which came to town around 1928, was local and not very reliable, so we depended on a coal oil lamp, which was on the wall, in emergencies. In winter, it would be dark when we went home from *khayder,* so we used to carry small lanterns. They were made by the tinsmith from sheet metal. Some of them had a candle inside, others a coal oil lamp. Mandelbaum made the candles. The coal oil came by the barrel from Ostrovtse. The rich kids had carbide lamps.

Even with all these new kinds of schools, there were still many small private *khadurim.* They said that, if you had no other way to make a living, you became a *melamed,* a *khayder* teacher. The teachers did not make much money and had a hard time collecting what little tuition they were owed. One day when Fromek Wajcblum, one of my best friends, was going home for lunch, Moyre Simkhe, our teacher at the Yavne *khayder,* told him to bring the tuition money. When Fromek returned to *khayder,* the teacher asked him, "Where's the money?" Fromek replied, "My father told me to tell you that he's not home."

It was here, with Moyre Simkhe, that the brutal beatings really began. Moyre Simkhe was a tough disciplinarian, but, let me tell you, whatever he knocked into my head remained: I can still read and pray and lead a congregation. Corporal punishment was a normal thing, but he went overboard. We were always getting into trouble, and Moyre Simkhe took a sadistic pleasure in punishing us. We especially liked to frighten the girls. One winter evening, four or five of us got some white wrapping paper from the grocery store of Maylekh Katz's parents. The paper was about four feet wide. We covered ourselves with this white paper and stood murmuring on the steps to the *khayder* as the girls came out after classes. It was pitch dark. All that the girls could see by the light of the open door were white shapes making strange whispering noises. The cries went out, "*Shaydim! Shaydim!*" (Demons! Demons!). They rushed headlong back into the *khayder.* Moyre Simkhe was no fool. He took the oil lamp and approached us. We didn't move. He reached out and grabbed Itshe Cwajg's cap. We all took off. The next morning everyone returned to *khayder* except Itshe. The teacher sent one of the students to fetch him. Itshe's mother, who was the wigmaker, said he could not come to *khayder* because he had lost his cap. The teacher sent the student back to Itshe's house with the cap, and the student returned with Itshe. That was an occasion for one of many beatings.

Looking back, I was a tough kid. I was always getting into trouble. My father left Poland for Canada when I was twelve years old, and my mother had to deal with four boys aged twelve, ten, eight, and two. She had such a difficult time. I drove my teachers crazy. I spent my youth wearing a rope around my waist. Why? Moyre Simkhe's favorite punishment was to lock us up overnight in the *khayder*. When this happened to me, I would instruct my friends, "Go tell my mum that I'm here." She would bring a basket of food, and I would lower the rope and pull up the basket. Meanwhile, Moyre Simkhe was at home happy with the thought that I was at *khayder* starving. But sometimes at midnight he took pity on me and came to let me out.

One morning when we came to *khayder*, Moyre Simkhe was taken aback by a foul smell. He issued his first order: "Everybody line up!" As we stepped into the room, he inspected our shoes to make sure that we were not tracking anything into the room that we may have stepped into on the street. Finally, we all sat down. The teacher sniffed around and eventually identified the source of the fetid odor in the coal pile. After some intense detective work, we figured out that one of the boys had been locked up in the *khayder* overnight. I do not remember what he did to deserve this. The toilet was outside the building, just an outhouse. But since he was locked up from seven in the evening until seven in the morning, what was he to do about relieving himself? He dug a hole in the coal pile and defecated there. We used the coal bucket to clean up the shit and remove it from the room. We threw it into the outdoor toilet.

On another occasion, a Sunday morning, we entered the *khayder* for morning prayers and again there was a very bad odor. Again, Moyre Simkhe lined us all up and inspected the soles of everyone's shoes. As luck would have it, a heavy tomcat odor emanated from Volu Wajcblum. It happened that Volu, on undressing before bed, had left his clothes either on the floor or on a stool. His tomcat must have urinated on them. Moyre Simkhe sent him home to be deodorized and change his clothes. Apt was full of smells, so it is not too surprising that Volu would not have noticed. Volu's family sold coal from a little shop in Szmelcman's building. They sold coal by the pound to people who were too poor to buy more at a time.

Beating was a regular thing. One day Moyre Simkhe forced my head into a bucket of water to stifle my screams as he beat me. He had to chase me around the room to catch me first. What did I do to deserve this? Urbinder's son was in our class, and he threatened to tell Moyre Simkhe that we had played hooky. This is what happened. Urbinder had a bookstore near Kulniew's restaurant. He and his family lived at the eastern end of the marketplace a

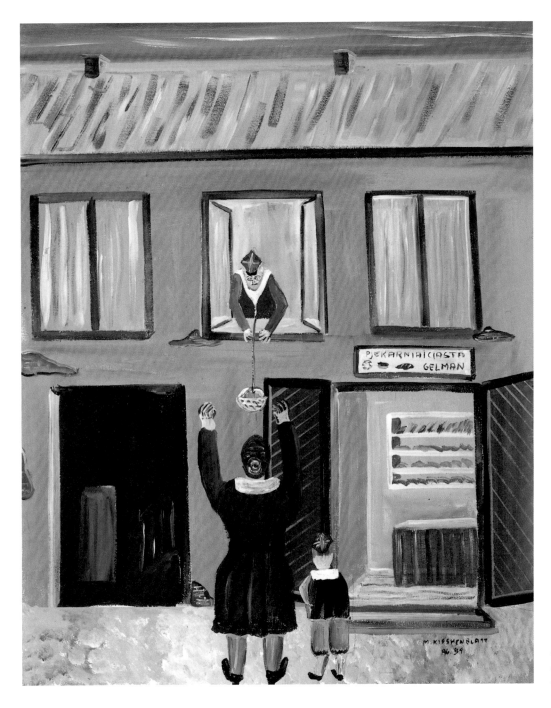

*Overnight in
the Khayder,
Mother Bringing
Me Food*

little past Garden Street, next to the photographer and tailor, on the second floor of a big brick building. One day the tailor had a guest, a young lad from Radom; I think the boy was the tailor's nephew. This boy belonged to the same Zionist organization, Shomer Leumi, as my friends and me. The tailor gave a party, and a few of us decided to play hooky from *khayder* and join the fun. When the party was over, we all filed out of the tailor's establishment. Urbinder's son looked down from his balcony and saw us on the street. He yelled out, "I know who you guys are. I'm going to tell the teacher. Ha! Ha!" We started to sweet-talk him. We told him we would reward him if he did not tell. If he would come down, we had a treat for him. I guess he was not very smart, because he came down. He soon realized the mistake he had made and tried to run away. Someone tripped him on the cobblestone street, and he fell into a pothole. It was about a foot deep and filled with stinking black water and horse urine. When we saw what happened, we fled.

The poor boy went home crying. He told his mother who the culprits were. She grabbed him by the arm and paraded through the town toward the courtyard where Moyre Simkhe and my family lived. Moyre Simkhe's apartment was on the second floor. A covered staircase, with about twenty steps, led to their place. Moyre Simkhe's wife was a meticulous housekeeper. She scrubbed each and every step with *bielidło*. The stairs were a beautiful creamy white from all her scrubbing. Just imagine that boy dripping black ooze as he went up those white steps to show Moyre Simkhe what we had done. His wife never did get the steps clean after that, no matter how hard she tried to remove the black stains.

The next day we all got a royal beating. I ran away and Moyre Simkhe chased me around the room in a rage. I was screaming at the top of my lungs. When he caught me, he forced my head into a bucket of water to stop the screaming and proceeded to beat me mercilessly. By that time, a lot of people had gathered outside the *khayder*, but nobody interfered. At least the beating saved me from being locked up overnight. He must have thought the beating was punishment enough.

Toward the end of my *khayder* career, when I was about fourteen years old, Moyre Simkhe gave me another terrible beating. What did I do to deserve it this time? One Saturday afternoon, a hot summer day, we decided to play soccer. There wasn't much time for play, so we took every opportunity. We went to the *torgeviske*, the open area where the weekly livestock market took place. In the heat of the game, we completely forgot to go to *khayder* for *Pirke uves*. Besides, nobody had a watch in those days. The *khadurim* of Moyre Simkhe and Moyre Berman were not too far apart, just four or five doors from each other. The two teach-

ers were waiting with practically empty classrooms. They got together for a conference and came to the conclusion that they should look for us. They knew where to find us. There were two entrances, upper and lower, to the *torgeviske*. Each teacher took an entrance. We saw Moyre Simkhe first at the lower entrance. With a hue and cry, everyone rushed for his bundle of clothes. We were stripped to the waist. It was a hot day. We all rushed to the upper exit, where we encountered Moyre Berman. We were trapped. They marched us back to our respective *khadurim* for *Pirke uves*. Usually after the lesson, the teacher would tell us a story. Not this time. We were dismissed. We went home worried about what fate awaited us. We knew we were in for it.

The next day, Sunday, we came to *khayder* as usual for the morning prayers. After the prayers, we were supposed to go home for breakfast while the younger boys studied, and then return to *khayder* and wait for the younger boys to finish before going on with our studies. This time, Moyre Simkhe said, "No way! You stay right here!" After the younger boys were finished, it was our turn to sit down at the benches to study. But instead of teaching us something new, he had us repeat previous lessons. I even remember what we were reading: the *gemure buve baytse*. What was it about? If an egg is born on the Sabbath or a holy day, is it kosher? This was a very long and complicated discussion.

In the front row sat my friend Pinye (Pinkhes) Czerniakowski. He was a very stubborn individual. He sat with his elbow on the desk, leaning his face on his hand. He said he would not repeat the lesson; he had not had his breakfast. Moyre Simkhe took off his belt, which was connected in the center by a steel ring. He kept hitting Pinye on the arm, until you could see eight or nine blue rings on his flesh. His whole upper arm was blue with bruises. Pinye would not give in. Moyre Simkhe became so enraged that he took his broomstick and started hitting everybody at random. I was sitting on a bench with Uma and Maylekh, two of my best friends. They bent over and hid behind the desk. I bent over too, but my back was exposed because I sat nearest the aisle. Then Moyre Simkhe let me have it. I got the worst of it. His fury spent, we returned to the task at hand. After a little while, we were permitted to go home for lunch.

When I got home, I showed my mother the three dark-blue stripes on my back where he had beaten me with the broomstick. The welts were an inch wide and six inches long. My father had already left for Canada. Next door to us lived our landlady, Mrs. Słupowska, with her son, Avrum, and his wife. My mother called Avrum over to show him what Moyre Simkhe had done to me. Avrum was livid. He waited for Moyre Simkhe to come home. The

moment he saw him enter the courtyard we shared, Avrum assailed him: "You butcher! You have no right to teach children!" Avrum complained to the Mizrahi school board, but they did nothing about it. That was the last straw.

My mother was at her wit's end. Where was she going to send me? The only choice was an old-fashioned private *khayder*, so Mother took me out of the Yavne school and enrolled me in Yankele Zishes's *khayder*. This was the third and last *khayder* I attended. It was in the teacher's one-room home, which was located in a little square behind Kaplanski's building—Kaplanski had a clothing store where Mother bought my youngest brother, Yosl, a coat and hat made of fake monkey fur. There was a long table and benches in the center of the teacher's room, a bed on each side, and a stove at one end. We sat around the table.

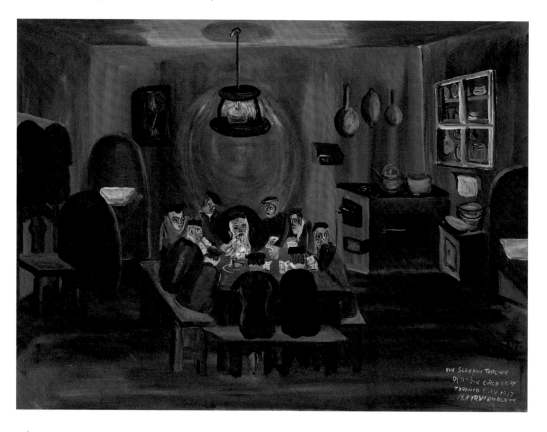

The Sleeping Teacher

There was one small window next to the door leading to the courtyard. It was dark and stuffy, especially in the summer. You could hear the flies buzzing around. We learned everything by rote. Naturally, for the teacher it was boring to listen to us repeat a passage from the *gemure*. He would place his chin on the table on top of his hands and stretch his beard

out on the table. As we droned on, he dozed off. That was very inviting. The one little window did not let in enough light, even on a hot summer day, so there was a big taper, a thick candle, in the middle of the table. One day an enterprising young student had the bright idea to dribble the melted wax on the teacher's beard, gluing it to the table. We suddenly stopped droning and the *melamed* awoke with a start. He jumped up and left half the beard on the table. To lose so many hairs from one's beard was a big sin. He was so angry he chased us out. We were sent home for the rest of the day. This was an unexpected bonus, a few free hours. I did not go home for fear of being hit with a bit of kindling wood for my misbehavior, so I played until it was time to go home. This sort of prank was nothing original. *Khayder* boys have done this for generations.

Adultery was not much heard of in our town. By and large, people were too busy to adulterate. I know of only one case, and guess who was the culprit—Yankele Zishes! What hap-

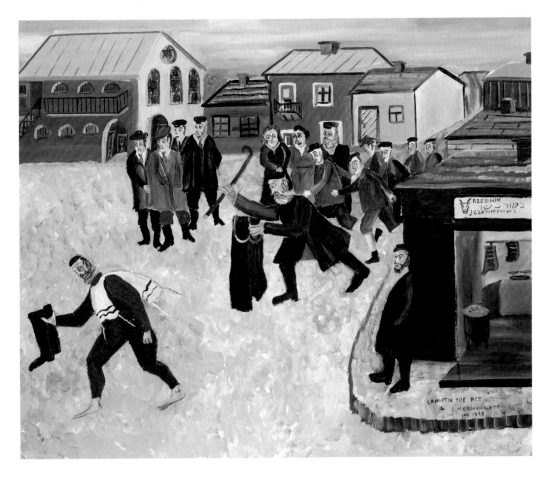

Caught in the Act

pened is this. Baynish *poker,* Baynish the Drummer, was out of town playing music with one of the two Jewish bands in town. Baynish returned home earlier than expected and found Yankele Zishes in bed with his wife. Yankele didn't have time to dress, so he grabbed the first thing he could, his boots, and took off down the street in his red long johns and barefoot, clutching his boots. Baynish grabbed Yankele's trousers and chased him halfway across town until Yankele reached home. It was the cause of great merriment for a long time.

I am the first generation of Jews who went to compulsory Polish public school. On the first morning, my mother took me to the Polish public school. I was six years old and cried bitterly. I was inconsolable. They cut my golden locks. They cropped my hair so close to my scalp that I couldn't recognize myself in the mirror. However, I got over it in a few days. Everyone had their hair cut short to prevent lice. Lice were a perpetual problem. The religious children also had short-cropped hair, but they had *payes,* side locks. I never had *payes* and once I left *khayder*—at age fourteen—I no longer wore a hat. Even when I was younger, when I went out with the guys on Saturdays into the countryside, I did not wear a hat. Until about the age of seventeen, I had beautiful blond curly hair, particularly in the summer when my hair was bleached from the sun. I never liked wearing a hat, although it was taboo to go around bareheaded.

The majority of students at the Polish public school were boys, and more than half of them were Jewish. Some of the Christian boys came from our town and some from the outskirts of Opatów. There were maybe fourteen or more Jewish children in a class of twenty-five. There was also a public school for girls near the hospital on *Ostrovtser veyg.*

All the teachers in the public school and gymnasium were Poles. A Jewish teacher was eventually hired to teach religion to the Jewish children so they would not play out in the yard and make noise when the Christian children received their religious training. The Jewish religious teacher, Mayer Melman, was a knowledgeable man. He had a beautiful clean white beard, wore Jewish garb, and spoke flawless Polish but with a slight accent. Poor man, we gave him such a difficult time. All he ever taught us—in Polish—was *tanakh,* the Jewish Bible, and Mishna. We had been learning those texts for years at *khayder,* although, thinking back, I now realize that he had a more enlightened outlook. We were angry because the religion class deprived us of an hour of play. We had precious little time for playing because we attended one school or another for eight to nine hours a day. There was no physical education. We got our exercise by playing soccer. Until the age of ten or twelve, I would run with a hoop by the hour, covering the town from top to bottom until late in the evening.

Christian Boy Scouts Marching

Mr. Wrona taught arithmetic. *Wrona* means raven in Polish. He was a handsome man, tall and blond with blue eyes; he really looked Polish. He belonged to the Endekes, which was an anti-Semitic right-wing organization. He was also head of the Polish Boy Scouts, which were called *harcerże*. No Jew could join the Polish Boy Scouts. It was a very patriotic organization. They used to walk around the schoolyard with seven-foot pointed poles and drill with them as if they were rifles. They would go on route marches. The principal was Mr. Ulanowicz. His wife was also a teacher. Mr. Jasiński taught geography. I don't recall what Mr. Krakowski, who lived on *Lagever veyg,* taught.

In my day, you were not expected to advance beyond grade seven. Only a very small percentage of children went to high school or gymnasium, so they crammed into us as much as possible during the seven years we were in primary school. In grade five, I was already making maps of the world. They taught us the Mercator projection. We studied all the sciences, though not in depth, of course. That was impossible. By the age of fifteen, I had a

smattering of physics, chemistry, algebra, trigonometry, and calculus, plus reading and writing. They also taught music. We had a school orchestra made up exclusively of violins and mandolins. I played violin. We played classical music, including Strauss waltzes. We performed for the festivities at the end of the school year. It was an all-around education.

Mr. Koziarski, who lived on *Tsozmirer veyg*, was my favorite teacher, and I was teacher's pet. I was even in his house once. He taught me to appreciate Polish literature and how to think. I was an avid reader from an early age. I would take books out of the school library. My favorite author was Henryk Sienkiewicz. He wrote *In the Desert and in the Forest* (*W pustyni i w puszczy*), which was intended for children, *Quo Vadis*, and a great trilogy: *With Fire and Sword* (*Ogniem i mieczem*), *The Deluge* (*Potop*), and *Pan Michael* (*Pan Wołodyjowski*). His books were about ancient Polish history. I also loved the Polish national poets, not only Adam Mickiewicz but also Juliusz Słowacki. They were on the school curriculum. We had to memorize Polish poetry, and I still remember the opening verses of *Pan Tadeusz* by Mickiewicz. By the time I was twelve or thirteen, I had read everything of interest in the school library, which had a limited collection of about two hundred books. I devoured whatever there was. Mr. Koziarski once showed me the teacher's library on the third floor of the school, in the attic. The books had beautiful jackets. I asked him if I could read these books. He gave me other books, including nonfiction. My reading time was extremely limited because I was busy in the mornings at public school and afternoons at the religious school. Even so, if a book interested me, I would read it cover to cover.

All of a sudden word got around that Esperanto was going on. It was something new, something to learn, so my friends from the Zionist youth organization and I got ahold of a book and learned a few words every day. We imagined that one day the whole world would speak one language, and it would be Esperanto. I believed that there would be more understanding and tolerance if people could speak to one another. We knew that a Jew, Ludwik Zamenhof, had created Esperanto—a street in Tel Aviv is named after him—and that there were Esperanto organizations where people got together and spoke the language, though not in Apt. Mind you, Yiddish was a pretty universal language too: no matter where you went, there were Jews and they spoke Yiddish.

All in all, it was hard to study. Conditions at home were very congested. There was no privacy. During cold weather, I would do my homework in the bedroom, with my back against the warm tile stove. In warm weather, I would leave the house. If I had to memorize a poem, I couldn't do it at home. I would rise at the crack of dawn and sit just outside the gate to

our courtyard, on the steps of the butcher shop. It was very quiet with no distractions, and I could learn the poem quickly. Inside, at home, it would be impossible with three younger brothers running around and Mother socializing with her friends.

Mr. Koziarski was impressed with my command of the Polish language. I had a good vocabulary and no accent, in part because Polish maids took care of my brothers and me. The older Jews spoke Polish with an accent. Mr. Koziarski was the one who had me accompany him when he took the 1931 census. I must have read Yiddish literature, too, but I can't recall. I do remember reading a book by the famous Yiddish writer Joseph Opatoshu when I first came to Canada. There were also several writers of local note in our town, including Shimshn Pizl, who was secretary of the Jewish Pen Club, Moyshe Zalcman, and Shloyme Micmacher. The famous Y. L. Peretz married a woman from Apt. Incidentally, my mother was also a reader. By the age of sixteen, she had read the *Decameron,* and after she died, at the age of ninety-four, we found a Yiddish translation of Thomas Mann's *The Magic Mountain* in a kitchen cupboard.

I was not the best student, but I excelled in my favorite subjects, which were Polish literature and poetry and manual training. Mr. Iwanek was my manual training teacher. The books in the school library were old, and they had been used so many times that they became dog-eared and fell apart. In manual training class, besides making wooden objects such as coat hangers and clothespins, we rebound books. First, we removed the pages that had separated. We attached them to each other by pasting the edge of each to a strip of good paper. If the corners were gone, we pasted on a new corner although there was no print on it. Then we sewed the book together again by stitching each signature. To hold all the signatures together, it was necessary to run the thread through the signature and around a strip of cloth, called *wąsy,* or mustache, which had been applied horizontally across the spine. There were two or three such mustaches, depending on the size of the book. The ends of these mustaches were later attached to the cover.

We then placed the sewn pages in a press and glued the spine of the book to stiffen it. We melted glue in a double boiler. The glue, which was made from horses' hooves, came in large brown bars. After the glue was hard and dry, we trimmed the three sides of the stitched pages with a special circular knife. The lower board, on which the book rested, was larger than the upper board, which served as a guide for the trimming. The upper board was also thicker because the circular knife had to rest on that board in order to cut straight. We then removed the trimmed pages.

With a mallet, we tapped the spine to give it a convex curve, which automatically gave the right edges of the pages a concave curve. We put the book back into the press and glued the spine again so that it would hold its curve. When the glue was dry, we removed the book from the press and glued the mustaches to the hard cover. Then we applied a thin sheet of paper called *dusza*, which means soul in Polish, over the inside of the cover to prevent the cover from warping when the outside paper was applied. We covered the spine with a reinforced strip of canvas, which we attached to the outside of the cover. We left a small space

HOW TO BIND A BOOK

▪ *Two pages split.* ▪ *Pasted together. One piece of pape[r]. Added corners.* ▪ *S[e]wing. Double fly leaf.* ▪ *Inside s[e]wing.* ▪ *Put in vi[s]e with the book trimmed with round knife in the vi[s]e glue the spine. After it hardened it was beaten with a m[a]llet to give it shape convex concave.* ▪ *Knife.* ▪ *Back into the vi[s]e again and glued to keep its shape.* ▪ *Paste on hard cover.* ▪ *Paste on canvas to back of book not touching spine but lapped over on hard cover. With special tool press down canvas to give the hard cover a[n] edge.* ▪ *Open. Paste in piece of paper called* dusza *(soul) to prevent warping. After past[e] the fly leaf to hard cover.* ▪ *Ap[p]ly canvas corners.* ▪ *Paste on finishing paper, tucking in behind.* ▪ *Paste on fly leaf to hard cover covering the lapover. The book is finished.*

between the cover and the spine and, with a little tool, made a groove in that space, so that the cover would open neatly, where it meets the spine. We also applied canvas to the corners of the cover.

To make the covers look nice, we bought a dark marble paper for the outside cover and glued it on, so that about half an inch of the canvas on the cover was still showing. We decorated the endpapers ourselves. First we made a very thin paste by boiling flour and water. Then we put the paste on two sheets of paper, scattered blobs of color on them, pressed them together, separated them, and let the paper dry. Once we had glued the endpapers to the inside cover, the book was finished.

Mr. Iwanek taught me to do this. Maylekh told me that, when the Germans invaded Apt, they gathered all of the intelligentsia together and shot them, including all my public school teachers, except for Mr. Iwanek. His name sounded Ukrainian and they assumed he was of Ukrainian descent; I always thought he was Polish.

I had a very good art teacher at the public school in Apt. He taught me perspective, using the railroad tracks and rows of trees as examples. Showing me pictures, he explained how the tracks or rows of trees converge the farther away they are. If you want to draw in perspective, you made a point here and drew all the lines toward it. If you wanted to measure the distance between objects that were closer or farther from you, you held a pencil between your index finger and your thumb, closed one eye, and lined the pencil up with the object, marking its height with your thumb on the pencil. He taught me how to mix colors: primary, secondary, tertiary. We did watercolors; I remember making a watercolor of a coat hanging on a hanger. I made different colors, as if there were light shining on it from the side. A few girls asked me to make watercolors like this for them. The art teacher also took us to the church courtyard to paint various views of the church architecture, including the windows, doors, and carving. Even today I use what I learned then.

As I mentioned earlier, one year my classes were held in a room in a building on the corner of *Startsove gas* and the market; that was the year that I had to repeat grade five. I returned to the regular school the following year. During the year on *Startsove gas*, I learned how to make cubes in manual training. Using stiff white paper, we made square cubes, rectangular cubes, and even pyramids. Then, we pasted strips of brightly colored shiny paper along the edges of the cubes, mitering the corners. We pasted a contrasting smaller square on each side. This was a project. We were marked on how precisely we made these cubes— crisp folds, sharp corners, and neat pasting. To this day, I know how to make a cardboard box. There isn't much that I learned in school that I forgot.

My father knew how to draw. I remember when I was doing homework that he drew me a stork and a wooden pitcher. The stork was outlined very delicately, with every feather clearly indicated. The pitcher was wide at the bottom, narrow at the top, with a wooden handle. He used a thin pencil and ruler. I was impressed with how very precise he was. He also had beautiful handwriting. When they were courting, Father wrote Mother a long letter in tiny script, each letter absolutely distinct, on the back of a postcard.

The Polish school took us on several excursions. When I was about ten years old, we went on a school outing to Słupie, a small neighboring town, which sat at the foot of Holy Cross Mountain. At its summit was an ancient Benedictine abbey called Święty Krzyż, which means Holy Cross. We went inside this beautiful old monastery, where the monks showed us all kinds of artifacts, including a lovely wall hanging that was supposedly made with gold thread by Queen Jadwiga, also known as Hedwig. She was a very pious woman. She married the Lithuanian prince Jagiełło in the fourteenth century; their marriage unified Poland and Lithuania without spilling a drop of blood. That started the Golden Age of Poland. Most of Poland's kings were of foreign stock, especially Hungarian, Austrian, German, and Swedish.

The monastery, which dates from the eleventh or twelfth century, takes its name from a legend. What they told us was that, hundreds of years ago, a monk wanted to meditate, so he took a walk through the forest one summer morning at dawn. He stopped to pray. When he opened his eyes, there appeared before him a stag with huge antlers. Caught in the antlers was a piece of wood. The stag knelt before him and offered him the piece of wood. The angels that accompanied the stag proclaimed that this was a piece of Christ's original cross. That's why this place was called Holy Cross. This piece of wood was deposited in a reliquary. All the Christian boys were allowed to look in and see the piece of wood and touch it. But, of course, being a Jew, I was forbidden to do that. As a matter of fact, they sent us out before they did whatever they did inside. The Christian boys told me about it. We were also told there were catacombs where some ancient knights were laid out in full armor.

Within this monastery, which was built like a fortress, carved into the mountain, was a really severe penitentiary. (I recently learned that, as punishment for the 1863 Polish Uprising, the tsarist authorities made a big part of the monastery into a very harsh prison.) The prison was divided into two sections: one for hardened criminals and murderers, and the other for political prisoners. Most of the political prisoners were young Communists, because it was illegal to be a Communist in Poland during the 1930s. I saw the hardened criminals with chains around their waists, chains attached to their hands and feet, carrying a heavy steel ball. This is how they worked all day, climbing up ladders, with that outfit. One guy

The Legend of Święty Krzyż: Monk Receiving a Piece of the Holy Cross from a Stag Accompanied by Angels

was shingling or repairing the roof. I could see him up there with the ball and chain hanging from his body. The political prisoners we did not see. Strange, but I never heard of a prison riot or of demands for better conditions.

We also took a school excursion to the ruins of an ancient castle, called Krzyżtopór, which was about nine miles southwest of Opatów. It stood all alone in the middle of a meadow, way out in the country with nothing else in the vicinity. The four outside walls of the building were still standing. There were four gates for the four seasons. Inside, there were twelve doorways for the twelve months, fifty-two rooms for the fifty-two weeks of the year, and 365 windows for the 365 days of the year. We were told that there was a tunnel leading from the castle itself to Klimontów, so that, in case of siege, the knights could escape.

For the excursion to a famous porcelain factory in Ćmielów, a very small town but the center of china production in Poland, everyone had to report to school early. Waiting for us was a huge wagon, with ladder sides, drawn by two big horses. About thirty of us piled into the wagon, which was about twenty feet long. There were no seats. The wagon was filled

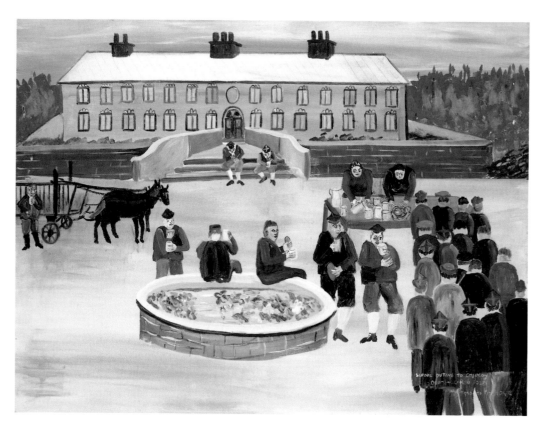

School Outing to Ćmielów

with straw, and we had a good time tumbling around. After a few hours, we arrived at the porcelain factory, which was eleven miles from Apt. They showed us how they made all kinds of china dishes, bowls, and cups and how they applied decals. The way the women working there made a gold stripe on the china was to put the plate on a turntable and hold a brush to the dish as it turned. We saw how they dipped the chinaware in the glaze and fired it. They told us that the clay was imported. I was told recently that the factory is still in operation today. By the time we finished seeing the porcelain factory, it was afternoon, and we were taken to a huge estate. I remember a massive residence with a big courtyard. The owners of the estate gave us fresh milk and black farmer's bread for lunch. The bread was really fresh. I will never forget it. That would have been about 1926, when I was ten years old. We arrived home at about six o'clock in the evening. What a glorious day!

When I got into trouble, the *khayder* teacher was usually the disciplinarian. Once, however, it was up to the principal of the public school to address the problem, though he had no idea

who the culprit was. Here is what happened. There were two walnut trees in front of Zylberman's drugstore at the northeast end of the market facing the city garden. Early one morning, at dawn, I went with Uma and a few other friends to get some walnuts. We threw stones at the tree to knock down the walnuts. By accident, we broke the drugstore's display window.

That morning at eight o'clock, as we were about to start the school day, Zylberman marched straight to the public school principal to complain that someone had broken his window. He figured that, since there were many Jewish schools and only one public school, he would start with the public school. Everybody had to stand up with their palms outstretched. (The walnuts have a thick green skin surrounding the hard shell. When you peel them, the fleshy skin stains your hands brown.) Whoever had brown hands was pulled out, except for one boy, whose family's occupation was to buy walnuts, remove the skin, and store them. Everyone in his family had black hands from this work. He was let go. My friends and I were summoned to the principal's office. Our hands were, of course, stained brown. The principal called the parents in and informed them of what had transpired. They had to pay to replace the window. It was a large and expensive window. My mother beat me for this with a piece of kindling wood. Later, Zylberman's son Hillary opened a big drugstore in Toronto. He became famous for importing medicines from Europe.

The Zylberman drugstore was not an apothecary: they did not fill prescriptions. They sold patent medicine, perfumes, cosmetics, soap, toothpaste, and that sort of thing. The apothecary was owned by a Polish pharmacist and was located a few doors east of Zylberman. The apothecary was a big store, with a black oiled floor, dark counter, and a white marble top, if memory serves me. Hundreds of white jars sat on the shelves. You could see the pharmacist prepare your prescription. He weighed each ingredient with a very fine brass scale, using the tiniest little weights to measure minute amounts. With a porcelain mortar and pestle, he pounded ingredients into a powder. He mixed ointments on a marble surface with a small fine spatula and packed them into little circular wooden boxes.

Zylberman's father, Yoyne, was the only Jewish lawyer in town. He was known as Yoyne *leyrer*, because he started out as a teacher. There were also two Polish lawyers in Apt. Yoyne was a very important personality. He prayed at the General Zionist Organization, where my father went. He was a six-footer, a very handsome man. He had a wife, a midget. How she brought forth such a beautiful family is amazing. They had nine children and saw to it that all of them were well educated. They spoke Polish at home but still gave their children a

religious Jewish education. I went to Moyre Simkhe's Yavne *khayder* with Yoyne's youngest child, his son. His daughter Mania and I were in the public school orchestra together; she played mandolin and I played violin.

I graduated from public school at the age of fifteen, because of that year I had to repeat for skipping too many classes. Instead of going to school, I had spent hours observing everything that was going on in town. I gave up on *khayder* at the same time I should have finished public school. To attend gymnasium, or secondary school, which was not government sponsored, was very expensive. Not everybody could afford it, and you needed good grades to get in. The religious youth could not take advantage of the Polish gymnasium because classes were held on Saturdays and Jewish holidays; they entered a yeshiva or went to work in their parents' business. The biggest yeshiva was in Upper *besmedresh*. I went to work.

Spring! After a hard winter, the trees started to bud and the willows were already green. We could start taking long walks in the meadows, *di lonkes*. We would test the water in the creek and lie down in the grass. We enjoyed the luxury of being able to stretch out again in the open air and bask in the sunshine. We would breathe deeply and feel our lungs expand. It was a feeling of euphoria.

Majówka! The May morning air! I would get together with my friends early in the morning. The best air was at dawn. We would get up at 4:30 or 5:00 and escape the congested house. Our favorite spot was the edge of the nearby Christian cemetery, which was on a grassy hill. You could see the entire town from there, but that was not the main appeal. We liked to walk around in the heavy dew with our bare feet. They said it was healthy to run around barefoot in the dew. What we loved most was to stretch out on the thick grass—we didn't mind that the grass was wet—feel the cool air, and take a little nap in privacy. There we could breathe freely, far from the snoring and other noise of daily life. It was the greatest leisure to go there and sing songs, tell stories, read books and poetry, and talk about girls. There were no houses nearby, so we were all alone. Our talking and singing would not wake up the dead.

One of my paintings shows the entrance to the Christian cemetery. The mausoleum is in the front, which was the oldest part of the cemetery. Farther away was the newest part, and it wasn't as lovely as you see in the picture. There was a little slope from the cemetery wall to the dirt path. We used to walk for miles along the dirt path to the end of the cemetery and beyond it. Next to the dirt path was a little grass and a very steep bluff, straight down to the creek, across from which there was a big plain. On that plain was a substantial farm. Sometimes the farmer would chase us away.

With spring came Shavuot (Pentecost), the festival that celebrates the giving of the Torah by Moses to the Israelites. Best of all, we got two days off from school. On the meadow where we used to romp around, there was a pond. Around the pond was a marshy area where we gathered reeds and willow to decorate our homes for the holiday. The house was scrubbed clean and bedecked with greenery scattered on the floor, walls, and furniture. On the win-

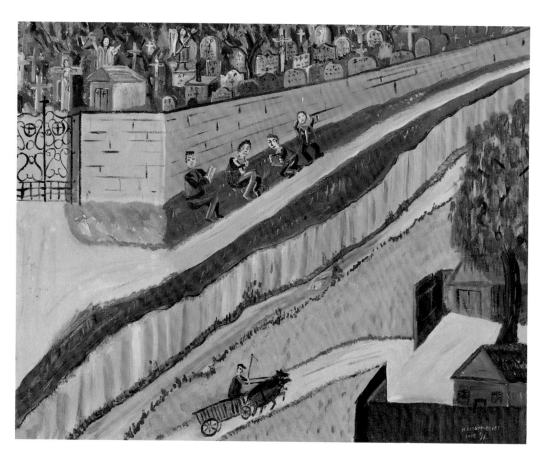

Majówka: Enjoying the Spring Morning at the Christian Cemetery

dows we put *shevieslekh*, beautiful paper cutouts, which we made ourselves. It was kind of a competition to see who could make the nicest ones. If you could not make them yourself, you could purchase them at a shop. Father would save the *shevieslekh* from year to year between the pages of the festival prayer book. I remember how to do so many things, but not how to make *shevieslekh*. They were a little like cutting paper snowflakes. It was also customary to eat dairy food on Shavuot, and Mother made delicious blintzes, cheesecake, and cold soups from fruit.

The weather in Poland was more or less the same as it is in Canada. It would get quite hot in summer and absolutely stifling inside our homes. At night, we used to close the shutters and bar the doors, no matter how hot it was. During the hot summer nights, the overcrowded house was a like a steam bath.

As my friend Maylekh once said, "We waited for summer like for the Messiah." During the hot weather, we liked to slide down the *shlizhe*, where there was a steep drop in the river

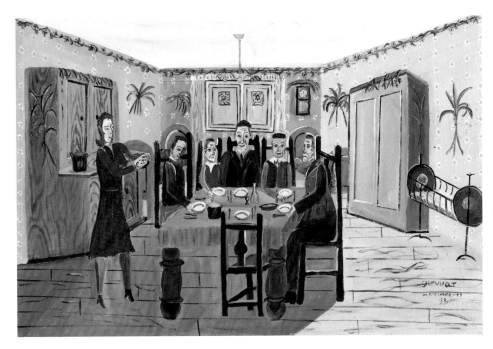

Shavuot

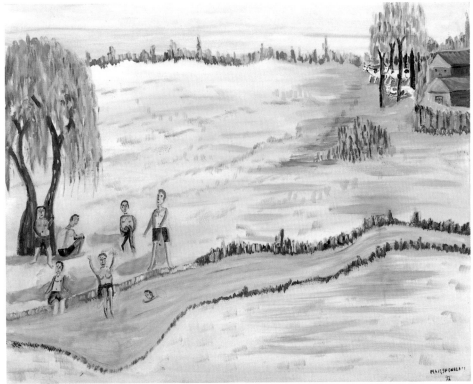

*Swimming in the
Meadow Pond*

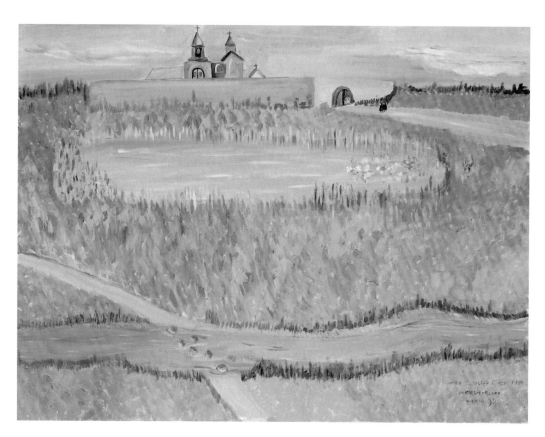

*The Cloister
and Nuns as
Seen from the
Meadow*

bed, and swim in the *kanye*, a deep pool in the eroded bend of the Opatówka River to the east of town. I had no bathing suit so I used to wear my mother's underpants. Both the waist and the legs were elasticized, but they were so big that I had to pull them up and fold the extra fabric over like a skirt. These pants were once black. From the sun, they bleached to a light grey. I didn't know why my mother would wear black underpants until I found out from the maid who worked for my uncle in Lublin. I was apprenticing to my uncle as an electrician. The maid was a mature woman of about twenty-five. I would have been about fifteen. We were alone and fooling around, when she said to me, "Foolish boy, can't you see that I am wearing black underpants [*majtki*]?" She explained why she was wearing them. She was menstruating. We didn't get much of a sex education. Shortly before we left for Canada, Father sent a parcel of secondhand clothes. Among the items was a one-piece bathing suit. I only wore that bathing suit once. It was for a photograph. In September, the water was already ice cold. We would take a dip in the early morning before going to school. Sometimes there was already a thin layer of ice on top of the water. That is how much we hated to let the season change. Those dips were how we said good-bye to summer.

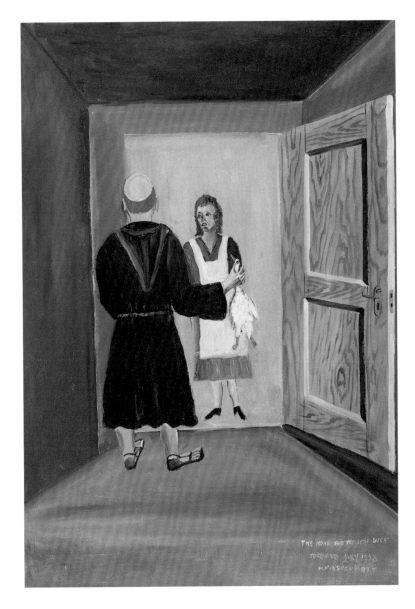

*Monk with
Dead Duck*

There was a pond in the *lonkes* that we passed on the way to our swimming hole. In the dis-
tance, you could see a cloister. In the pond were ducks and small fish. One day, when I was
about ten years old, I was fishing in the pond and a duck got ahold of my bait. By the time
I pulled the duck out, it had drowned. After I got home, a monk came to our door with the
duck. My mother was horrified to see the monk holding the dead duck by the throat. He
came to collect. My mother paid. She then beat me with a piece of kindling wood. My fa-
ther seldom punished me. He was away a lot. My mother did the beating.

Always a fisherman, I had a string and a hook in my pocket at all times. Sometimes I used a wicker basket. It was oval and about thirty-six inches long and fifteen inches wide. I would slip the basket into the narrowest point in the creek to prevent any fish from getting through. Then I would go about a hundred yards up the creek, agitate the water with a stick, and walk in the water to chase the fish downstream. When I returned to the basket, I would find two or three tiny sunfish in it. They were too small to keep. I was just playing.

Although we got two months' vacation from public school, we had only two weeks off from *khayder*. Sometimes the weather was so hot that Moyre Simkhe would teach the *khayder* class outdoors under trees near the cemetery. It was a nice outing. Outside Moyre Simkhe's *khayder*, there was a dusty area, a courtyard of sorts, an outhouse, and an abundance of flies. In the summer, we would catch flies. On the back of a fly, between the wings, there is a tiny bony area. We would insert a very thin sliver of wood, about an inch long, into that bony area and race the flies. If one died there were lots more, and we were good at catching them. In cherry season, we would use the stems from cherries to make a gallows for hanging the flies or a guillotine to decapitate them. We called this game *tliye*, which means gallows in Yiddish.

On Saturday afternoon in the summer, the more progressive youth gathered in the Ozherov orchard, where there was a swing. The swing was attached to two posts with very long ropes. In my painting, I show the swing attached to a tree. The boys would show off for their girlfriends, and people paid a little for a turn on the swing. Religious youth shunned this practice, since Saturday was meant to be a day of rest and they read holy books. Swinging on the Sabbath was not allowed. Nor would they have approved of the people in the painting. No one is wearing a hat, and boys and girls are together. We didn't care.

People worked a six-day week. Saturday was the only day off. When we were not on vacation, the only time we had a break, besides the Sabbath, was on religious holidays. On Lag b'Omer, our *khayder* teachers took us out on an excursion. The holiday, which occurs on the thirty-third day of the period between Passover and Shavuot, celebrates the lifting of the plague that killed many of Rabbi Akiba's students during the Bar Kochba rebellion against the Romans. Moyre Berman and Moyre Simkhe took the older boys in their schools on an outing to a forest. We marched in military formation, with our teacher leading the way and one of the boys carrying the Jewish flag. Our *khayder* was, after all, a Zionist school. The way to the forest was along *Tsozmirer veyg*. This was also the route to our swimming hole, *di kanye*. Visible in the distance to the north were ancient ruins. As we passed these ruins,

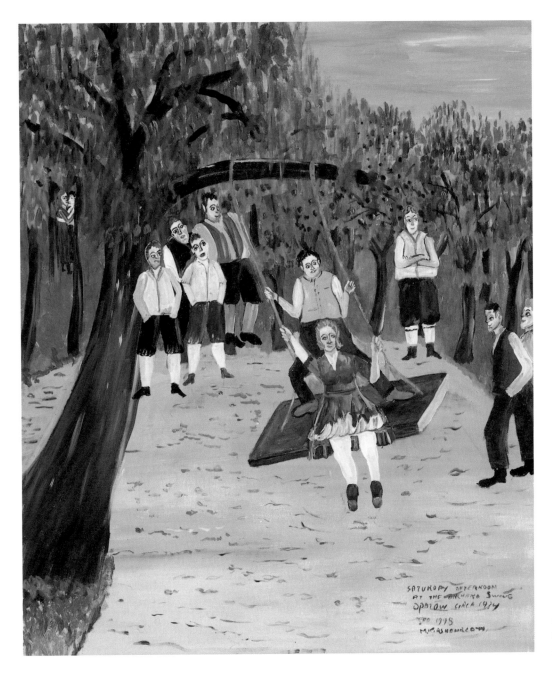

*Orchard Swing
on Saturday
Afternoon*

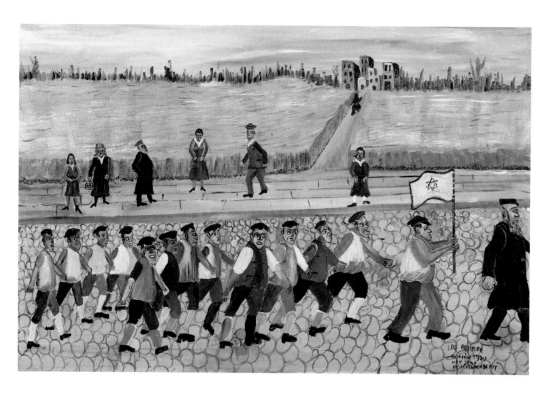

Lag b'Omer

we used to call out *"kliskelekh mit arbes"* (tiny pasta squares and peas). A loud and clear echo would come back. Whenever we passed by this spot, we always hailed the echo. We called these ruins "the echo place."

After a joyful march of two or three miles, we arrived at the forest, a wooded area with a few large trees and a lot of bushes and small trees. After a little rest and a snack, we were free to roam and play. The toys associated with this holiday were weapons: swords, bows and arrows, wooden rifles, and guns. We were like the soldiers who fought to free Judea from the Romans and who would need to fight in our day for a Jewish homeland.

Some boys played with bows and arrows made on the spot. Others played with swords made of branches: we would tie two pieces of wood together with a string. After we saw *Zorro*, we all made swords and had sword fights. I used to make a toy gun, or *biksl*, from a hollow key, a nail, and a string. I would flatten the bottom of the nail by rubbing it on a stone so that the nail would fit snugly into the hollow of the key. Our favorite place to flatten the nails was the two big red sandstone blocks on the sidewalk in the marketplace outside Buchiński's restaurant. We would rub away and watch people promenading in the evening. There were grooves in the stone from where we had rubbed our nails flat. Flattening the nail was called *makhn a nugl*.

Once the nail was ready, I attached one end of a string—it was about twelve inches long—to the top of the nail and the other end to the top of the key. Then I would fill the hollow of the key with the compound from the head of a big wooden match, the part that ignites. The way I did this was to scrape the head of the match against the sharp edge of the hollow of the key so the compound would break up into little pieces and fall into the hollow. Two matches would usually yield enough compound for one bang. Today I know that the compound was phosphorus trisulfide.

To fire the gun, I would insert the nail into the hollow of the key. Then I would grasp the middle of the string so that the key would hang in a perfectly horizontal position. Guiding the key with my left hand, I took a good swing against a stone. When the key and nail hit the hard surface, the concussion made the compound explode. The gun would go off with a big bang. Sometimes, I would hit the gun against the sole of my shoe to make it go off. Some children could afford to buy black cap guns. They were flimsy tin toys made in Japan.

Many of us searched for frogs, snails, and leeches in the creek. I'd keep the frog in my pocket. If you stuck your hand in my pocket when I was a boy, you never knew what you'd find. We also drank water from this creek. After finding a snail, we put it down in a clearing and tried to encourage it to come out of its shell. We chanted:

> Ślimak, ślimak, pokaż rogi.
> Dam ci chleba, na podłogi.

> Snail, snail, show us your horns.
> We will give you bread on the floor.

My friend Harshl remembers a different version:

> Ślimak, ślimak, wypuść rogi.
> Dam cie sera, na pierogi.

> Snail, snail, let your horns out.
> I will give you cheese for pierogi.

After one kid got tired of trying, another guy would start to chant. If the snail finally came out of his shell, after we had tried so hard, there was a great celebration and congratulations to the guy who did the chanting. Everyone rushed over to have a look. Then we tried to find another snail for a snail race. By then, it was time to gather and start the march home. Lag b'Omer was a wonderful day. It ended too soon. Too bad it only happened once a year.

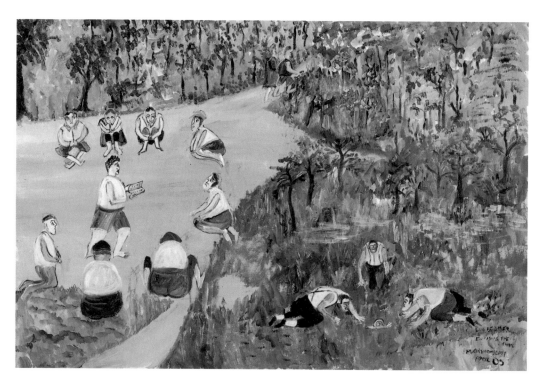

Teasing the Snail from Its Shell

Holidays were the time when I wore my best clothes. I destroyed my holiday best more than once while playing games. One Passover, the dealer in cigarette cylinders took delivery of a huge box of them. He stored the empty box under a staircase. I was maybe twelve years old, and I had a brand-new trench coat. We were playing hide and seek, and I hid in the box. When I jumped out, I made a big rip in my trench coat. Mother gave me a beating.

Everyone got a new outfit for Passover. One Passover, my father had a shoemaker make a beautiful pair of patent-leather shoes for me. During *khalemoyd*, the intervening days of the holiday, there was a big soccer match on the *torgeviske*. (There was no special playing field in Apt, so the *torgeviske* was the main place for soccer.) There were no bleachers, of course, so we just stood around. All of a sudden, the ball came my way. I gave it a powerful kick and ripped away the sole of my new shoe from the tip to the heel. You can imagine what happened to me when I got home. The shoes were brand new. I had only worn them a few times. The shoemaker repaired the one I tore.

Not that my father did not love soccer, too. When there was an important game in town, my father was the only parent who took us out of school so we could attend the game. He did not tell the teacher the reason he wanted us. He'd just say, *"Ikh darf hubn di kinder,"*

which means "I need the children." He went to two *khadurim:* Moyre Berman's *khayder,* where my brothers studied, and Moyre Simkhe's *khayder,* where I was enrolled. Father would walk us up Broad Street to the *torgeviske.* One end was slightly uphill, so the teams drew lots for who would go first. The whole city came to see the game. Jewish teams played Christian teams. Sometimes the Jewish and Christian teams in Apt got together to play out-of-town teams. Mandelbaum's son was the best soccer player on the Jewish team. He played center. He was a star. I often saw him play. He wore that little net cap the players wore to cover their hair. He was about six years my senior. Moyre Berman's son Arn was a great goalkeeper. He was tall.

Soccer, or *fusbal,* as we called it, was the game of choice. We made up teams. Of course the owner of the ball got to choose his own position. The most desirable position was center. Somewhere, I don't know how, we acquired an old soccer ball. On the outside it was sewn together with a leather thong. The ball kept tearing all the time at the seams. Every time it would tear, we would take the ball to the shoemaker, who would sew it up. There was a balloon inside. It was full of patches, so whenever there was a leak, we'd put new patches on it. We took turns blowing it up, since we didn't have an air pump. It kept on bursting and we kept on repairing it. If you didn't have a ball like this, you played with a rubber ball. If you didn't have a rubber ball, you made a ball out of rags. One guy would come with something to kick around and, before you knew it, there were two teams with maybe three to five people on each. The guys on the sidelines would scream and yell and kick with their feet. It was very exciting. They would take turns, and those who watched would get to play.

We needed nothing but two sticks and two rocks to play *palant,* a game like baseball, but without the ball. I played this game from the age of about six until I was old enough, about ten or eleven, to play soccer. We played in spring and summer, after *khayder* and, if we could get away with it, on Saturdays. Our favorite place to play *palant* was in the open space behind the public school not far from my house, but we had to be careful not to break windows. We could also play in the middle of my street, which was wide, or down ulica Kościelna in an empty space opposite the house where the organist lived. On the south side of ulica Kościelna lived a tailor. He got the nickname Duvid *lip* because he had a *geshpoltene lip,* a split lip. I always thought it was a harelip, but one of my friends recalled that someone once struck Duvid with a prayer book and split his lip.

To play *palant,* you place two rocks about ten paces apart. That would be approximately thirty feet. The first rock is home base. The other rock is second base. That is where the catcher stands. One stick, the *klipe,* is about eight inches long and an inch thick. It serves

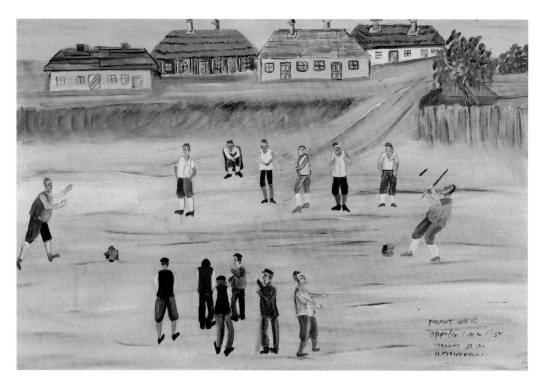

Playing Palant

as the ball. You throw the *klipe* up into the air and hit it with the second stick, the bat, which is about thirty inches long and an inch thick. Alternatively, you place the *klipe* on the ground and hit it with the bat so that it flies up. While it is in the air, you strike it with the bat. The batter runs to first base, touches it with his bat, and runs back to home base, and touches it with his bat. At the same time, the catcher is trying to catch the *klipe* and hit the batter with it before he reaches first base or home. If the batter succeeds, he gets to play again. If he fails, he steps down, the catcher goes to bat, and another player takes the catcher's base. There are no teams and no points. You are either in or out. You could play with as few as two people or as many as eight or even more. Many people liked to watch. If they felt like taking a turn, they could join in. It was basically a pick-up game. It was not a competitive sport.

We took advantage of every opportunity to play and improvised with whatever was at hand: nuts, chestnuts, cherry stems, flies, snails, cow eyeballs, goose neck bones, string, buttons, scrap wood, twigs, paper, wire, cans, and thread spools. My tools were the *knipik*, my favorite penknife, which I always carried around, and a sharp piece of glass for shaving wood. The penknife was very simple: the handle was one piece of wood, with a slit in the middle for the blade, a cheap piece of metal, which was attached with a pin. The *knipik* had no spring. It was very cheap. Even to this day, I carry a penknife.

We made our own toys, and I knew how to make more than twenty different ones. *Khayder* boys would show each other how to make them. Some were seasonal. Others were for holidays. All of them were disposable. When we were finished playing with them, we just threw them away. We could always make more.

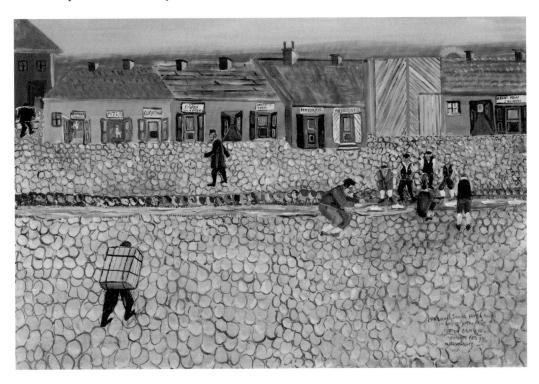

Sailing Paper Boats in the Gutter after Rain outside My House

During Passover, we played nut games similar to the games played in Canada with marbles. After a rain, we'd make paper boats and float them in the gutter where the rainwater was running, right in front of our house. In the autumn, we played *himl* with chestnuts. We made thirteen holes in the ground—three vertical rows with four holes each and one hole above the three rows. I don't remember exactly how we played the game. We would kick cow eyeballs around like footballs. The girls played jacks with the neck bones of geese: they boiled, cleaned, and dried the bones first. We knew how to do various string tricks and played cat's cradle. *Etl-betl*, which means Etl's bed in Yiddish, was both the word for cat's cradle and the name of one of the patterns. Names of the other patterns included saw, mattress, and river.

The boys played with buttons. We put a button on a flat surface and flicked it with the thumb and third finger. The idea was to hit one button against another. You tried to hit the other button in the center. If you hit the button, you could take it. If you missed, your button re-

mained on the surface and the other player took his turn. Or we made a buzzing button by threading a string through two holes of a button and tying the ends together to form a loop. If you stretched and released the string with the right tension, the string would twist and the button would buzz. The principle is the same as for a twist drill.

I knew how to make a miniature wagon (*veygele*) and wheelbarrow (*tutshke*) from scrap wood. I fashioned the wheels from the flanged ends of wooden thread spools, smoothed the rough edges with a scrap of sandpaper that I took from the manual training class at public school, and greased the wheels with chicken fat. I also made spinning tops from wooden spools. I would saw off the flange and stick a piece of wood or a pencil stub through the hole. When the top spun, the pencil would make a nice pattern.

In the spring, when the branches were young and the bark slipped off easily, I made a whistle and a willow horn. To make the whistle, or *faferl,* I took a smooth willow twig, about four inches long and half an inch wide. First, I made the mouthpiece. I made a small half-circle incision in the bark, about one inch from the top of the sheath, and removed the little piece of bark so as to make a hole. On the opposite side of the sheath, I cut away a small portion of the twig, both the bark and the wood, so the whistle would rest comfortably on my lower lip. Using a rock or knife handle, I then tapped the twig to loosen the bark so that it would slip off in one piece. I sliced a thin, one-inch length from the side of the stripped twig, moistened it with my mouth, and fitted it back into the top of the bark sheath. I then reinserted the rest of the stripped twig into the bottom of the sheath, but not all the way. The pitch of the whistle depended on how far I inserted the twig into the bark sheath. Finally, I cut off any excess wood sticking out from the bottom of the bark sheath.

We called the willow horn a *trompayte* (trumpet) or *shoyfer.* A real *shoyfer* was made from a ram's horn and blown during services for the High Holidays. To make a toy *shoyfer,* I scored the bark of a willow branch, wet the bark with my mouth to make it more supple, and tapped the branch gently to loosen the bark from the wood. I peeled the bark off in a spiral. Then I coiled the bark to make a horn in the shape of a cornucopia. To prevent the bark from unwinding, I inserted a little wooden pin through several layers at the wide base of the *shoyfer.* The narrow end was just big enough for a reed that I made from a small twig. To make the reed, I slipped the bark off a tiny twig about a quarter inch in diameter and two inches long. The bark came off in one piece. It formed a little cylinder. I carefully removed the top quarter-inch of the outer bark of this cylinder. Then I tucked the reed part way into the narrow end of the *shoyfer.* I gently bit the exposed end of the reed in order to flatten it. I wet it with my mouth to make it more flexible so the reed would vibrate when I blew into it. To make

a sound, I would place the end of the reed on top of my tongue, close my lips to hold the reed in place, and blow. The reed would vibrate and the horn would make a bellowing sound: the longer the *shoyfer,* the lower and louder the sound. The biggest one I ever made was about twelve inches long.

I made other things from willow as well. To make a whip, I took a willow branch about four or five feet long and cut strips of bark down the length, leaving them attached toward the top of the branch, which was the handle. Then I removed the wood inside and braided the bark. As long as the bark was wet and supple, it made a perfect whip.

We made two kinds of slingshots. One slingshot was made from a forked branch, two strips of rubber cut from a discarded bicycle tube, and a rectangle of leather to hold the stone. The second slingshot was more of a stone thrower: it was called *katapulta* (catapult) in Polish and *Duvid hamaylekh protse* (King David slingshot) in Yiddish—*proca* in Polish means sling. We tied a long string to each end of a rectangular piece of leather or rag. Then we would place a stone on the leather, grab hold of the ends of the string, and twirl the slingshot with the stone in it, picking up enough speed to eject the stone and send it a good distance.

I also made various toys out of paper: a noisemaker (*knaker),* airplane, pinwheel, hat, accordion, fortune teller, inflatable frog, and *kiker,* which was something like a kaleidoscope, because you would look through a tube of paper into a folded paper diamond that had a

HOW TO MAKE A WILLOW SHOYFER

1. Thin willow branch. 2. After incising bark only, wet it, strike with handle of knife to loosen bark and slide off bark. 3. Peel off from end of tube green part only. 4. Piece of willow about fifteen inches long one inch dia. Incise in a spiral, bark only, and wet with tung [sic] and spit. Strike with knife handle. Peel off bark. 5. And roll bark overlapping each time. 6. Make a pin from a thin branch. Insert in large end to prevent unrolling. 7. Insert reed.

few bits of colored paper in it. You could see a pretty pattern by holding the *kiker* up to the light. I used cardboard to make a *payats*, or clown, which danced when you pulled a string. The limbs were attached to the torso with little pieces of wire. I tied strings to the limbs so that when I pulled the controlling string, which ran vertically down the back of the clown, all the limbs would move.

My favorite toy was the hoop. I ran around with a hoop from the time I was about five until I was about fourteen years old. I loved to run all over town in the evening, especially in the summer. I covered miles and miles. I would start running from my house, up Broad Street, maybe stop for a minute to say hello to my grandmother, continue up to the top of Broad Street, down Garden Street to the marketplace, take a couple of turns around the square, and return home. This was only one route. Sometimes we had races. I propelled my first hoop, or *rayf,* by hitting it with a stick. When I got older, I made a pusher from wire. The

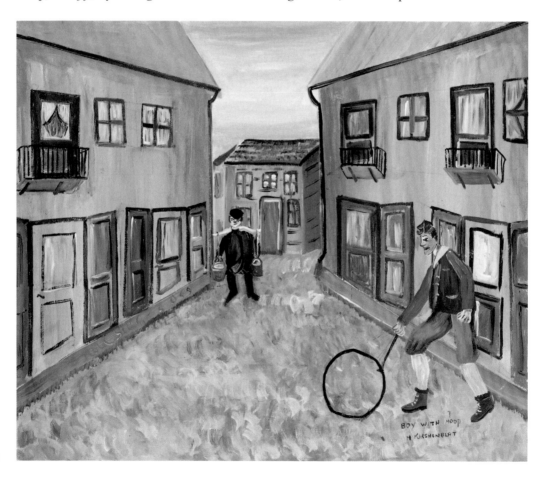

Boy with Hoop

pusher was called a *kierownik*, which means something that you steer with. I bent one end of the wire into a U shape, to guide the hoop, and I bent the other end into a handle. The pusher was about two feet long. My hoop was made from sheet metal. I can't remember where I got it. I once saw a boy put a glass of water on the inside of his hoop. Grasping the hoop with his hand, he turned it quickly in a large circle, as far as his outstretched arm could go. He turned it so quickly that the centrifugal force kept the glass in place, and the water didn't spill. I taught myself that trick. I started by putting a stone on the inside of the hoop and graduated to the glass of water. I wasn't always successful, but most of the time it worked.

I taught myself to ride a bicycle. There was a man who repaired and rented bicycles, and he also tried to make them. He had no welding equipment, but he did brazing, which did not hold too well. He had a special fixed-gear bike for beginners: the pedals always turned, but the bicycle had no brakes. The moment you stopped pedaling, the bicycle would slow down. It was called *ostre koło*. This was the one that I rented when I wanted to learn how to ride a bicycle. I walked it up to the livestock market, at the top of a gentle slope. At the bottom of the slope there were a lot of potholes from the horse and cattle urinating there. Beyond the potholes was the low stone wall of the Jewish cemetery. I mounted the bicycle on top of the slope and wobbled down, out of control, bouncing in and out of the potholes. I hit the low stone barrier, vaulted right over the wall, and landed in tall grass. Had I hit any of the tombstones, I could have killed myself, or at least caused myself serious injury. I was left with a small scar on my eyebrow. This was but one of several close shaves in my life. The next time I didn't go down the slope but rode on a level area. This is how I taught myself to ride a bicycle, and I can still ride one today. The preferred brand, in my childhood, was the Steier bicycle imported from Germany. It was very sturdy. Osa Zinger sold bicycles and Singer sewing machines.

In winter, we went sledding and skating and played in the snow. The days were short and busy, so there wasn't a lot of time to play. My friend Maylekh was lucky enough to have a sled that was professionally made, probably by a wainwright. It had very thin wooden runners with thick steel wires attached to them to make the sled go faster. The sled was natural wood and stood about eight inches off the ground. I could not afford to buy a sled (*shlitn* in Yiddish), so I looked around town for scraps of wood and made one myself. Basically, the sled consisted of a platform sitting on two runners. I braced the runners so that they would stay in place, nailed metal strapping (*bednarke*) to them so they would slide smoothly along the snow, and attached string to the front of the sled so I could pull it.

Our favorite place for sledding was downhill along *Startsove gas,* from the marketplace to Kiliński Street, on the north side of town: this street was wide and steep, indeed, so steep that there was no traffic. We had it all to ourselves. We also liked the hill in back of the district seat and Mandelbaum's building, which were next to each other. This hill was narrow, with a steep drop at the bottom. When you went fast, you took a "flier" through the air before landing on *Ozherover veyg.*

We liked to skate on the pond in the meadow and on the carp millponds on *Ostrovtser veyg* by Goldman's water mill. I also skated along the street in my homemade skates. They consisted of a wood sole and runner. The runner was about half an inch thick, two inches high, and a little longer than my shoe. I tapered the ends of the runner and attached metal strapping to the edge so that the skate would move smoothly along the ice. The strapping came up around the top edge of the runner so no sharp edge would be exposed when the runner was attached to the sole. I also carved out two small indentations along the top of the runner, one at the arch of my foot and one at my toes, so that, after the sole was attached to the runner, there would be two little spaces between the runner and the sole through which to thread straps for fastening the skate to my shoe. Then I nailed the sole to the runner. If you had the money, you got the shoemaker to make two leather straps with buckles for each skate. If not, you tied them on with two pieces of string and tightened the strings with pieces of wood, like a tourniquet. When the strings were tight enough, you tucked the piece of wood under the string. Going downhill was terrific, but on a flat area, you had to shift your weight from skate to skate to make forward progress. These skates were called *lizhve* in Yiddish, from *łyżwy* in Polish.

There were also metal skates that you could buy, if you could afford them. Very few of my friends owned such skates, but hope springs eternal, and all of us got the shoemaker to attach metal plates to the heels of our shoes just in case we got the chance to put on someone else's metal skates. The metal plate was in the shape of a diamond; it had a small hole, also the shape of a diamond, in the middle. To recess this metal plate so that it was flush with the heel, but leave a little space under the hole in the metal plate, the shoemaker carved out a little hole in the middle of the heel; he made the hole in the heel a bit deeper and larger in diameter than the hole in the metal plate. That way the little projection from the heel of the skate would go all the way through the hole in the metal plate and, with one twist, secure the heel of the shoe to the skate. To hold the front of the shoe in the skate, there were two clamps, one on each side of the toes. We would tighten the clamps with a key.

Sledding

Rarest of all was the pair of skates with built-in shoes. These were a real prize. Yankl *kuptsu* had brought such a pair back from Canada after he was deported and forced to return to Poland. Let me explain. This boy was a thief. We went to the same *khayder;* he was a little older than me. He hung out with a gang of Polish no-goods. They used to go around stealing whatever they could lay their hands on, particularly pigeons. At night, when the owners and pigeons were sleeping, they would go into the pigeon loft and steal them. One day, Yankl's mother came to the *khayder* in tears. His father was already in Canada. She begged Moyre Simkhe, "What shall I do with him?" Moyre Simkhe answered, "Tie a millstone around his neck and throw him in the *kanye*." The *kanye* was the deepest place in the Opatówka River. His family had not done well economically in Apt, so his father had immigrated to Canada—to Toronto, to be exact. He became wealthy as a manufacturer of ladies' coats, but he refused to bring his family to Canada or even to send them money. The Jewish community in Apt had to keep them from starving to death.

The Apt *landsmanshaft,* our hometown society in Toronto, went after him, but he still would not bring his family over. Finally, the Apt *landsmanshaft* collected funds and brought the family to Toronto. Among them was Yankl *kuptsu,* Yankl the Thief, from *kupiec* in Polish,

which means businessman, with the added sense of wheeler-dealer. Letting this fellow into Canada is like letting a kid loose in a candy store. In Toronto, all the merchandise was displayed and easily handled. Yankl did a few shoplifting capers. The one that was his downfall was at Eaton's Department Store: it was a small matter for him to open a window on the second floor, overlooking Queen Street, and throw merchandise to an accomplice below. Both of them were apprehended, and Yankl was deported to Opatów. He arrived back a grown man, lean and over six feet tall, with blue eyes—a lady-killer—and took up again with the same old gang. But this time they went for bigger game and got into bigger trouble. As soon as the Germans entered Apt in 1939, they got the local detectives to identify all the thieves and shot them. That is how he perished. They did the same with the Polish intelligentsia, the teachers, lawyers, doctors, and city officials. My friend Maylekh told me.

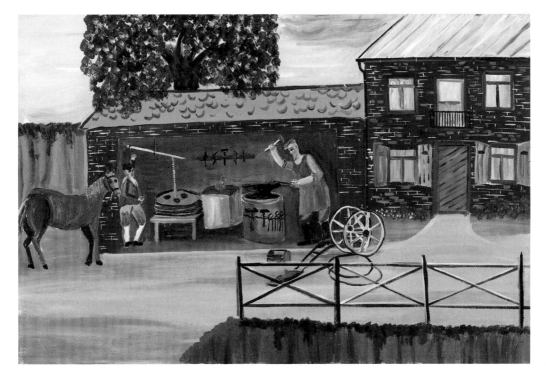

Helping the Blacksmith

Among the things that Yankl brought back to Apt from Canada were the skates with built-in shoes. He sold them to the blacksmith's son. The blacksmith's name was Harshl *koval* (Harshl the Blacksmith). Blacksmithing was a Jewish occupation, and the blacksmith made a very good living at it. Besides shoeing horses (he made his own nails for this purpose), he did all kinds of repairs, even making parts for cars, such as leaf springs. He also repaired

primitive farm implements. I sometimes played hooky from school to watch the blacksmith going about his day. I would help him pump the bellows. His workshop was on *Ivansker veyg* on the outskirts of town.

When we were not making our own fun, we liked to watch traveling performers. There were two spaces for performances near the Jewish cemetery: the *torgeviske* and the *shopa*. Every summer, street entertainers drifted through town. They performed on the *torgeviske* because they needed to moor their equipment into the ground, and this area was not cobblestoned like the streets in the center of town. The most memorable was a motorcycle act. They built a wire mesh cylinder, about twenty feet in diameter and fifteen feet high. The cylinder was wider at the top than at the bottom and, being made of wire mesh, was transparent, so you could see clearly what was going on inside it. A man on a motorcycle would start at the bottom and circle to the top of the structure, where he would go round and round for five minutes or so. After he came down, another man would go up. Now I realize that the centrifugal force kept them from falling. They rode very fast. Before starting their ascent, they would rev up the motor with great noise and fanfare. They were dressed in black. With hat in hand, they worked the crowd for money, before and after their act.

I always looked forward to the arrival of the circus. Its beautiful caravans were gaily painted. The caravans had low wheels, like little trailers, and were drawn by big horses. Men and women walked beside the caravans, which were followed by large platform wagons carrying all their equipment. They immediately headed for the open space at the bottom of a precipice, up the street from the *shopa* at the eastern end of Broad Street. The day after the circus arrived, I played hooky so I could watch them set up the tent and the carousel. When the tent was ready, the circus performers lined up for the parade. The women wore scanty dresses and tights, and the men were all dressed up in top hats and spangles. The circus master was dressed up just like you see in the movies. Some performers were on horseback, some walked, and some rode in carriages. Everyone, young and old, turned out to see the circus parade. That evening, the circus was up and running. I helped feed and water the horses, made myself useful, and got into the circus for free. Sometimes I even snuck in under the canvas tent. There were trapeze artists, midgets who performed as clowns, and animal acts with trained bears and dogs. The equestrians rode big horses, their rumps combed in a checkerboard pattern. The horses pranced around the arena in a circle. Some performers rode bareback. Others stood on the horses' backs at full gallop.

The carousel was not electric. About fifteen local boys were hired to make it go around. On top of the carousel was a big platform and posts. We climbed up there and pushed the posts

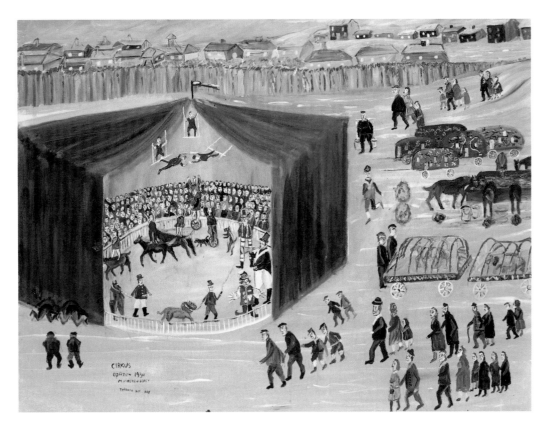

Circus

to make the merry-go-round turn. Boy was it hot up there. It was summer, and the top of the carousel was covered so no one could see us pushing the posts. The carousel went round and round to the accompaniment of a mechanical organ. That thing could go around pretty fast.

Overlooking the open space behind the *shopa* was a dilapidated wooden building, a long one-story structure, which stood precariously on a precipice. A man in this building, a self-taught musician, planned to build a piano. In the hallway stood a piano soundboard. I loved to tinkle the strings. I think he was a *kamashn-makher*. The boards of this dilapidated building had shrunk, and you could see daylight through the cracks.

The *shopa* was the main place for events. The fire brigade stored its equipment in the *shopa* itself and used the open space behind the *shopa* for practicing with equipment and for its annual show. The upper floor of the *shopa* was used by the local Zionist organization for its meetings. The *shopa* was also used by the local theater group for its performances and by traveling troupes of entertainers, who performed theater and reviews. One performance

that particularly struck me was a couple who advertised that they were going to perform on skates—in the middle of the summer, no less. A huge crowd turned up. The hall was darkened. A projector threw up a revolving image of a huge floral design. Out came a hefty, well-endowed woman on roller skates. She started to skate around the stage and was joined by a man in a tuxedo. The crowd, expecting them to skate on ice, started to whistle and yell. The place was bedlam. Eventually the crowd quieted down, and they went on with their performance. Can you imagine? People actually expected them to skate on ice in the middle of the summer.

For such performances, there was a brisk trade in half tickets, so that, with the two tickets we actually paid for, four of us could enter. This is how it worked. When you entered the theater, the usher at the door took your ticket, tore it in half, kept one half, and gave you the other half, which you would save. During the week, you would find someone with a half that matched yours, and you would trade him for it from a stash of half tickets. You would very carefully paste the two pieces together so that you could hardly feel the place where they were joined. Four boys would then go to the theater together, buy two tickets, sandwich two doctored tickets between them, wait until there was a big crowd pressing to get in, and then hand the tickets, in a stack, to the usher, who did not have time to inspect them. Most of the time it worked. If it did not work and you did not run fast enough, you got a cop on the ear.

The *shopa* was on a slope such that the east side of the building had tall doors to accommodate the fire-fighting equipment; the entrance to the theater was on the north side, accessible by six or seven steps. On the west side, at ground level, was a door to the backstage and windows. During performances, the door and windows were locked so that people would not sneak in. We still managed to sneak in. One of us inside would open a window, which was not far off the ground, and we would crawl through it and immediately mix with the crowd. With half a ticket from a previous performance, we could always say we had already paid.

There was no special movie house. Movies were shown in the *shopa*. Movies were not shown regularly, but they were generally well attended. I always went to the movies with my friends, never with my parents. I remember them going to the theater but not to the movies. When I told my grandmother about the movies, about people running around on the screen, she couldn't believe it. There was no point in her going to the movies, in any case, since she couldn't read the Polish subtitles.

Movies were advertised with big placards posted on kiosks in the marketplace and by word of mouth, which traveled pretty fast. There were no movies during the week, only on the weekend, on Saturday nights as I recall. I did not go very often. My mother did not always give me money for tickets. And the doctored tickets did not always work. Not that there were so many films to see, maybe a dozen a year. The first movie I remember seeing was a gangster film. I must have been about nine years old. It was a silent movie. A pianist and a violinist played what I now recognize as Brahms's Hungarian Rhapsody. That was toward the end of the film, when the hero was dying. He leaned on the banister newel post, finally collapsing at the bottom of the steps. I also remember *Zorro*, starring Douglas Fairbanks. He went around with a sword making Z's in the air. He was my hero for a long time. In Radom, I saw my first and only talkie in Poland, *The Champ*, with Polish subtitles. Though not too big, the place could accommodate about 150 people and was more of a movie theater.

One day in Ostrowiec, they opened a night club and we walked there, looked in the window, saw the nice tables and chairs, flowers on the tables, and a little stage—and then walked home again. Mostly, we made our own fun.

Despite the hardships, Jewish youth in Apt had a rich cultural life. During my youth, between the two world wars when Poland was independent and political parties were allowed, there were many political movements and many youth organizations. Zionists were in the majority: they had many factions and the greatest variety of youth groups. The various Zionist youth groups were not that different from each other ideologically—they all wanted to establish a Jewish homeland in Palestine—but there were differences in their orientation. Betar wanted to give the boys military training; they were associated with the Revisionists, led by Vladimir Jabotinsky. Hashomer Hatsair was associated with the Labor Zionists (Poalei Tsion) and attracted the workers. Gordonia was also Labor Zionist. Hashomer Hadati was for the Orthodox, as was Mizrahi, which had the most members. Shomer Leumi was centrist and, like Hanoar Hatsioni, was connected to the General Zionists.

The big appeal of a youth organization was that it gave us a place to belong. The main reason for joining one organization rather than another was social. My friends belonged to Shomer Leumi, so I joined too. Shomer Leumi was sponsored by *di tsienistishe organizatsye*, the General Zionist Organization, which mostly attracted middle-class people. Mikhl Rotsztajn, the leader of the General Zionists, was passionately dedicated to Shomer Leumi. They said he was a very intelligent man. I think he was a bookkeeper by profession. A pale man with eyeglasses, he was a great orator, but when he got onstage and started talking, there was no stopping him. He would drone on and on with his never-ending speeches. He would not stop until everyone had fallen asleep.

As I already mentioned, the General Zionists had two rooms, which they used for services on Friday evenings, Saturdays, and holidays. My father *davened* there. The rest of the week, we were permitted to use the premises for our meetings. For big events, like those where Rotsztajn would give his endless speeches, we gathered at the *shopa*.

Each organization had a room, a *lokal*, where young people could meet. Several people had the key to our meeting room, which was furnished with a few benches, a few shelves, and a few books. We would gather in the evening to socialize. Sometimes we organized a *pgisha*, a big gathering of youth from nearby towns. It was like a festival, with speeches as well as

dancing and music. We often listened to lectures. Our youth group also used to organize performances. I would flirt with the girls, of course.

By about 1931, our youth group moved away from the premises of the General Zionist Organization, and we rented our own room on *Ozherover veyg*, near *Tsozmirer veyg*. One summer evening, I was standing outside when I saw a wagon with a small horse struggling to pull a thirty-foot log. The way they haul such a long log is to take the wagon apart and attach one end of the log to the rear wheels and the other end to the front wheels. There was a slight incline from *Ozherover veyg* to *Tsozmirer veyg*, and the horse could not make it up that hill. It pained me to see the driver beat that horse. I called my friends and said, "Let's give him a hand." With everyone pushing, there was no problem making the hill. The driver was very grateful.

In the summer of 1932, when I was fifteen, Maylekh Katz, Uma Grinsztajn, and I were chosen to participate in a two-week training course, *moshavat menahalim*, to become leaders of a *gdud*, a smaller group within the larger youth movement. When we returned home, we would be qualified to lead a group. It was a big privilege to be elected to participate. The course was to be held in Ruda-Opalin, which was some distance from Apt. I desperately wanted to go, but my mother objected. The moment of departure arrived. My friends left, and I stayed behind. Finally, the next day, I packed my backpack and declared, "I'm leaving." Mother lay down across the threshold to the house and said, "Over my dead body." I stepped over her and I left. She never forgave me for this until the day she died.

Because she objected to my participation, Mother would not give me money for expenses, and I was left to fend for myself. My first task was to get from Apt to Rachów-Annopol, which is on the Vistula River and about twenty-three miles away. This is where the fishmongers got the fish that they sold on the Jewish Street on Friday mornings for the Sabbath. I got a free ride on a horse-drawn wagon with a fishmonger from Apt on Tuesday evening and arrived there on Wednesday morning. From Rachów (Rakhev in Yiddish), I hitched a ride with the postman to Kraśnik. When we got to the Vistula River, the postman had to take the wagon apart, carry it across the bridge in several installments, and lead the horse to the other side. The bridge was old—it had been built by the Austrian army during World War I—and was in disrepair, so they were worried it would collapse from the vibration of traffic, which is why they were so careful.

I hitched a ride with the postman straight to Kraśnik. I arrived Wednesday evening and inquired about the local Shomer Leumi organization. I found my way there, and they made me welcome. The organization had a little room. I unpacked my bedroll and slept on the

floor in a corner. A girl that I knew from Apt—she used to visit her grandmother, who lived in our neighborhood—heard that I was there and came to see me. She brought me a big white roll and a book by Maxim Gorky, *Jestem głodny,* which means "I'm hungry" in Polish translation.

Thursday in Kraśnik was market day, and I was able to get a ride in a truck that was transporting eggs to Łódź. My companions on that trip were thieves and pickpockets who worked the market. We sat in the two feet of space between the tailgate and the egg crates. As I described earlier, the crates were made out of slats, with spaces in between, and the eggs were packed in straw. Using a knife, my companions enlarged the spaces between the slats and took out eggs; we ate raw eggs all night. The truck did not go directly to Lublin, my next destination, but bypassed the city, leaving me off on the outskirts of town late at night. As a result, it took me hours on foot to get to my uncle's place. The family was away on holiday, so the maid let me in. She fed me, and I went to sleep.

When I arose, sometime Friday afternoon, I went to my uncle's shop, and the clerk loaned me some money for the trip to Chełm. Now I could pay a little for a ride, but because I paid so little, I had to sit beside the driver of the *droshke,* not inside with the other passengers. The seat was hard and had no back, but I didn't mind sitting outside, because I could watch the horses. I arrived in Chełm toward evening and went to the *lokal* of Shomer Leumi. They let me bunk on the floor for the night. The Jewish youths in Chełm were very nice: the next morning, someone brought me a bagel for breakfast, and they got me a free ride to Ruda-Opalin. I arrived in the late afternoon. Of course, my friends greeted me with open arms. They did not expect me.

On the outskirts of Ruda-Opalin, about five miles away, was an abandoned glass factory with many dilapidated buildings. We used one for a kitchen and one for a dormitory. Our dormitory, a brick structure, had a roof, two stories, a dirt floor, and no windows or doors. When the wind blew, the dust flew. Despite the austere conditions, the experience was great. There were lectures on how to handle youngsters, how to lead a group of young people, how to keep things interesting, and a little bit of sex education. I took copious notes.

The food was terrible. The main dish was *mamelige,* a coarse cornmeal porridge, with cocoa sprinkled on top. I had never seen corn before: we did not have corn in my region. It took me years in Canada before I acquired a taste for corn. We also received a ration of bread, but not enough for an active fifteen-year-old. When one of us did kitchen duty at night, cleaning up and cutting rations of bread for the next day, he stole a few chunks and handed them to the rest of us through a hole in the wall.

When it came time to go to bed, my friends quickly made a space for me on the floor, evicting a neighbor. Jewish youth from all over Poland had come there. Every evening, they would call out, "Opatów! Śpiewaj!" (Opatów! Sing!). We used to sing three-part harmony. We sang very nicely. The songs were in Hebrew, but we spoke Polish to each other.

After about two weeks, it was time to go home. A wagon came to pick up several guys, and we hitched a ride to Chełm. A *droshke* that was going to Lublin had a few free seats and let me and Uma ride for free. I slept overnight again at my uncle's in Lublin. The next day he got me a night ride to Kraśnik on a freight wagon. The driver had a team of big horses and a wagon loaded to the sky with empty crates. The heap of crates slanted toward the middle of the wagon from both sides to form a V: that way more crates could be stacked than if they were piled up flat. We climbed up on top of the crates and made ourselves as comfortable as possible. When we came to a field of clover, which had been left to dry in small mounds, the driver stopped so we could climb down and snatch a few heaps of clover as a treat for the horses. Sometimes we would trot alongside the wagon for the exercise.

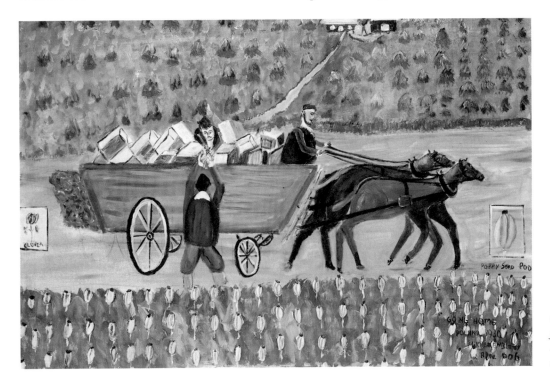

Going Home from the Zionist Training Camp, 1930

The next field we came upon was a poppy field. The poppies were about ready for harvest and practically dry. We scrambled down again and filled up our jacket with heads of poppies. We were hungry, so we ate our fill of poppy seeds, which of course put us to sleep. At

the crack of dawn I woke up. Daylight was just about breaking through. I saw Uma sleeping. He looked dead to me: I believe it was the shadows that made me believe that. I woke him with a whisper, "*Uma, Uma! Leybst nokh? Entfer mir!*" (Uma, Uma! Are you still alive? Answer me!). He awoke. What a relief!

We arrived in Kraśnik and again caught a ride with the postman to Rachów-Annopol. It was Friday. What were we to do? We had to get from there to Ożarów, which was about seven miles away. We had no choice but to walk. We planned to stay overnight at the *hakhshara* (like a kibbutz) in Ożarów, but when we walked in and saw the place—a small room, a table in the center, about ten bunks, and a poor woman washing the floor—I said to Uma, "This is not the place for us." We started walking back to Apt, which was about fifteen miles. We walked all day and all evening until about eleven o'clock at night. I don't know how our friends knew we were arriving, but a whole group of them came to greet us on the outskirts of town.

We came into town and went to my place. My mother, to spite me, took my brothers and went to her sister Mania, who was living in Niekłań, a village some distance away, so we went to Uma's house. We were starved: when Uma and I sat down to eat, we ate up half the food his mother had prepared for the Sabbath. Uma's family was poor, so they had to make do with what was left. Finally, I went home. To get in, I managed to open a window and crawl through. I was exhausted, walking all that way with my heavy backpack: it must have weighed at least twenty or twenty-five pounds. I was so sweaty that the shirt stuck to my back; I had to soak myself to get the shirt off. I undressed, went to bed, and didn't wake up until Sunday morning, more than twenty-four hours later. Once up, I made myself food, bathed, and changed into clean clothes. Then I went to meet my friends and tell them all about my adventure.

It was the custom for anyone who had the desire to go to Palestine to go through *hakhshara:* the word *hakhshara*, which means literally preparation, to get ready, refers to the process and the organization dedicated to preparing Jews to live a communal life and do physical work in the Jewish homeland. The youngsters came from all levels of Jewish society, but very few had much experience doing manual labor. In Palestine, they would be expected to dig ditches, drain marshes, and work the land. *Hakhshara* was also supposed to help them get used to communal life: all for one and one for all. Given these demands, *hakhshara* served as a weeding-out process: those who showed leadership ability and stamina were the first ones to be chosen to immigrate to Palestine. The British distributed a very limited number of permits, so competition for them was stiff.

There was also a *hakhshara* in Apt. It had its own room, with bunk beds and a little kitchen; those going through the *hakhshara* process would actually live there, boys and girls together, in a kibbutz, a collective. I remember that the women cleaned houses, and the men chopped wood; the men also helped with construction and did other kinds of manual labor. When they were too busy to work, a few of us boys undertook the wood-chopping chores. Sometimes we did manual labor in town and donated our earnings to the kibbutz. If there were a communal project in Apt, like our new public school on the edge of town, all the citizens were obliged to give a day's work or a certain amount of time to the project. Many citizens did not want to do hard labor, so they paid someone to go for them. One time we substituted for the father of our *khayder* friend Pinye Czerniakowski, who lived on Shoemaker Street. I have a photograph of Fromek Wajcblum and myself working on such a project. The money we earned went to the kibbutz. Youngsters from far and wide came to the kibbutz in Apt. However, if we wanted to go on *hakhshara*, we had to join a kibbutz in another town: that way, we would not be tempted to go home.

The departure of *khalutsim*, pioneers, for Palestine was a festive occasion. Apt was an assembly point, so people came to Apt from all around. We would escort the *khalutsim* for many miles out of town. After a sad farewell, we walked back to Apt. I remember my

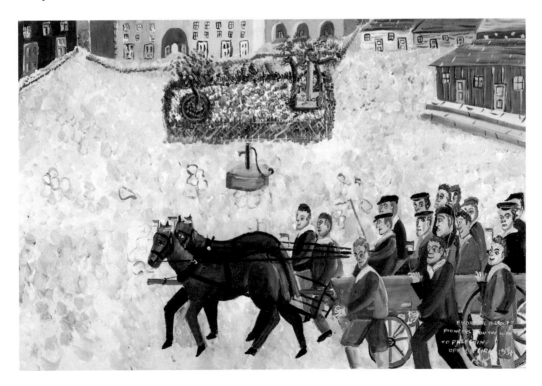

Escorting Pioneers on Their Way to Palestine

mother's brother Eliezer leaving with a group of pioneers in 1930. As I mentioned earlier, four years after arriving in Tel Aviv, Eliezer (we called him Layzer) died in an industrial accident.

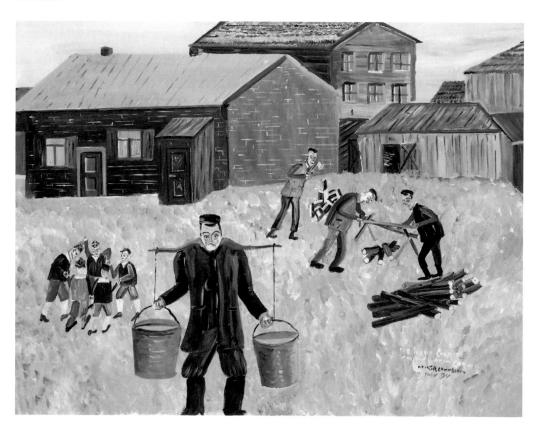

The Woodchoppers and the Water-Carrier

Manual work meant something special to us as young Zionists: it was something we chose to do for idealistic reasons. But other Jews in Apt, like Yosl *poker* and his family, took to chopping wood because they needed to make ends meet. Wood chopping was by and large a Polish occupation. You could see the Polish laborers leaning against a building, sharpening their saws and axes. They would wait early in the morning for the farmers to arrive with loads of pine. There were two teams, with two men to a team. Using a makeshift support and a cross saw, two men could dispatch a load of wood in half an hour, though they did not earn much. Wood was the main fuel for cooking because it caught on fire easily and burned quickly. Coal was best for heating because it burned slowly.

Most of the people I knew were Zionists of one kind or another, but not everyone was in favor of Zionism. Opponents included the Agudah, the Orthodox Jewish party, and the

Bund, the Jewish labor movement, which was not that active in our town. The Bund was left socialist and popular elsewhere; the Bund had a representative in the Sejm, the Polish parliament. There was also an active Communist Party. Because the Communist Party was illegal, its members operated in secret, so it was not possible to tell how many people actually belonged.

If caught, Communists were sentenced to the prison where the most hardened criminals were sent. In the Święty Krzyż penitentiary, political prisoners were not placed with the general prison population: they were separated from the criminals and treated a little better. I heard they tortured Communist prisoners to find out who the other Communists were. The Communists were organized in cells of four or five people, so if one person were caught and revealed the names of the others, not more than four or five people could be caught. One cell didn't know who was in the other cells. The Communist Party was the only political party that the government prosecuted.

The Communist Party focused on teenagers. It would send them out on a mission. One mission was to hang a red flag from the electrical or telephone wires in town; this was the most common act of protest. This is how they did it. They attached a red cloth, about twelve inches by twenty-four inches, to a stick. Tied to the middle of that stick was a string, and to the end of the string they attached a stone. Holding the flag by the stick, they would throw it onto electrical or telephone wires. The stone would wind the string around the wire, and the red flag would hang there. It was very difficult to remove. The police went crazy. We did not have the kind of ladder the fire department has today. To remove the flag from these wires, you had to be careful not to break the wires and electrocute yourself.

Even though it was a secret, I knew who was a Communist. Word got around. I even played around with it myself simply because I knew a bunch of the guys. We used to get together, read pamphlets, sing songs, and go out to the meadow. The path to the meadow led way beyond the Christian cemetery to a clearing up in the hills that was surrounded by rocks. Communism appealed to me very much because I could see no future for me or for Jews in Poland with the government we had: anti-Semitism, hunger, no opportunities. In theory, communism promised a world without discrimination, full employment, and free education; it would solve the Jewish problem. This was a little youthful fling. I liked the idea of belonging to something different; I liked to experiment. I went to a few meetings but quickly lost interest. They were not my kind: they were tailors and shoemakers. I was more interested in Zionism.

Jews were not generally welcome in the many Polish political parties, and I was not aware of Jews joining them. For instance, no Jew would join the Endekes, a Polish right-wing party. Nor did Jewish youth join the Polish Boy Scouts. The Polish Boy Scouts met at the public school because they didn't have a particular *lokal* the way we did. As far as I know, they were not as involved in political parties as the Jewish boys and had fewer activities than we did.

Poland's system of elections was representational. Our main concern was to turn out the vote. There was a 90 percent turnout of the Jewish population thanks to our efforts. We made sure Jews would turn out by hiring a guy with a *droshke* to bring old people who could not walk to the polling station. He gave us a discount. If we could have dug up a few bodies from the cemetery, we would have brought them in as well. Everyone participated.

Jews were a sizable minority in Poland and a majority in Opatów; they succeeded in electing quite a few candidates to the Sejm. Although Jewish delegates in the Polish parliament couldn't accomplish very much—we had only a few Jewish delegates relative to the total number in the Sejm—we tried to get as many votes as possible. There were all kinds of meetings and parades to get people involved, especially at the time of the elections. You cannot imagine the excitement at election time in the city.

May 3 was a government holiday celebrating Poland's constitution. There was a big parade. Members of the fire brigade wore their navy and gold dress uniforms and shiny helmets; their brass instruments were polished. The Polish Boy Scouts carried long staffs on their shoulders and wore khaki uniforms: shirts and shorts, plus knee socks. The uniform for my youth group, Shomer Leumi, which means Guard of the Nation—we were not scouts, but *shomrim*, guards—consisted of a gray shirt, kerchief (worn as a neck scarf), and shorts. Two of my public school teachers, Mr. Wrona and Mr. Krakowski, marched at the head of the parade. Mr. Krakowski was a ranking officer in the Polish army so he carried a sword at the parade; when saluting, he would remove the sword from the scabbard and hold it upright with his right hand, the sharp edge of the sword facing forward. The parade arrived at the garden in the marketplace and gathered in front of the World War I monument to the fallen heroes. After listening to a few patriotic speeches, the crowd dispersed.

Every spring, the Polish government would dispatch two commissions to our town: one commission was a military veterinarian who inspected horses for remounts; the other selected eligible young conscripts. The majority of young men accepted their fate and went into the army without having to be forced. Army life was very difficult, particularly for Jews; there

was a lot of discrimination and anti-Semitism. Young Jewish men were taunted and shamed; they were accused of being cowards and unwilling to fight. They were given menial jobs like cleaning latrines, sweeping barracks, kitchen duties, and the like. A craftsman, however, generally fared better, as he might well wind up in a shop of his own trade.

A small number of men would go to great lengths to avoid enlisting in the army. There were certain people in the town who specialized in disabling people so that they wouldn't be accepted by the draft board. One man's specialty was giving people a hernia; another man would chop off your index finger, the one used for pulling the trigger. Some people had their eardrum perforated. Others drank tea made from tobacco, because nicotine made the heart race or beat irregularly. Little Maylekh's brother drank that tea and had heart problems for the rest of his life; he did not die from heart troubles, however, but disappeared in the Holocaust. Of course, with such disabilities you were not accepted into the army.

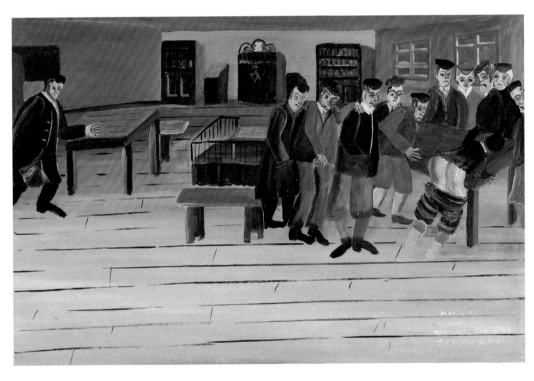

Dupnik: Evading the Draft

Some of the young men chose to torture themselves to lose a lot of weight so they would look emaciated. They deprived themselves of sleep and food and caroused at night. They loved to play pranks when everyone else was sleeping. They turned the signs upside down or changed them around, so, for example, the butcher's sign would be on the barbershop

and the barber's sign on the butcher shop. You can imagine what happened the next morning. One of their favorite games was *dupnik* (from *dupa*, which means backside in Polish). A guy would bend over and someone would give him a good whack. He had to guess who it was. If he was right, the next man would take a turn. If not, he had to go through it again until he guessed right.

One night, being short of pranks, these young men dared one another to go to the Jewish cemetery at midnight. Everyone was scared so no one volunteered. They drew lots. A young man from a religious family was chosen. In order for the group to be able to certify that he

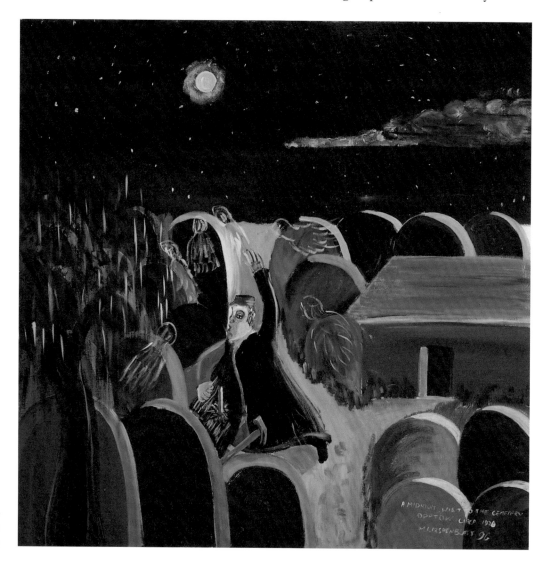

Midnight Visit to the Cemetery

had really been there, it was agreed that he would drive a stake into a grave as proof. When he wanted to leave, he couldn't free himself. He thought the dead man in the grave was holding him back. Apparently, he panicked, and he died. When he did not return, the rest of the group would not dare go to the cemetery while it was still dark to see what happened. The next morning, when they went to investigate, they found him dead, draped over the grave with the stake pinning his coat to the ground. He was wearing a *kapote*, a traditional long coat; it was so dark he couldn't see what he was doing and drove the stake through the corner of his coat by mistake. This was before my time, but I heard about it.

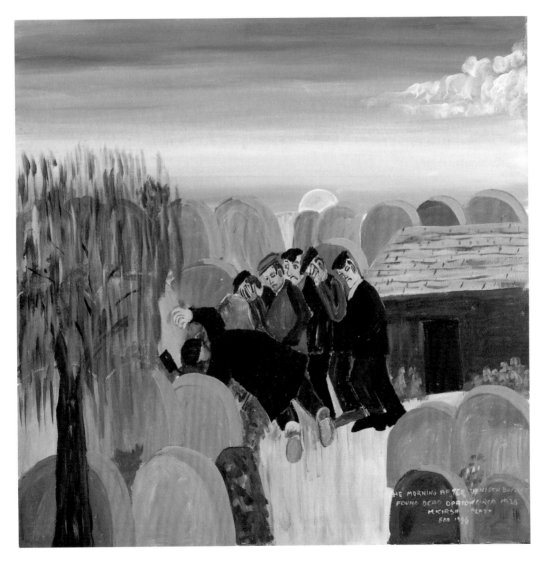

*Next Morning
at the Cemetery*

Most of the Jews in Apt were tradesmen and artisans. They were concentrated in the manufacture of brushes, clothing (suits, dresses, hats, and shoes), and food. Jewish tailors served both Christians and Jews with ready-made and made-to-order clothing. Among the religious Jews in town, men and boys wore the Jewish cap, also known as a *yidish hitl* or *gules-hitl* (diaspora cap), white shirt, long black coat, and black shoes. The only difference was size, big and small; there was one fashion for both, whether adult or child. The more modern Jews and the Poles in town wore fashionable clothes. One of the tailors had a catalogue with very distinguished-looking gentlemen modeling the latest styles. You were shown the catalogue and picked a style. Then you dreamed of how great you were going to look in that outfit. Somehow it never turned out that grand.

We got a new outfit every spring for Passover. Why did we wear dark, drab suits, in dark gray, navy, or brown? First, dark colors were a way to make your clothes more respectable. Second, since we couldn't clean our suits, dark colors were more practical; they didn't show dirt as much. For the same reason, when we went to buy fabric for a suit of clothes, we made sure that it was reversible. After you wore the suit for a year or two, you took it to the tailor and had him take it apart and reverse the fabric. When I outgrew the suit, it was handed down to one of my younger brothers; if it was still serviceable, the tailor would alter it to fit him. Thanks to my father, who sent us parcels of clothes from Canada, I was all decked out in knee socks, fancy shirts and shorts, plus fours, and brown shoes—and, of course, my favorite red ski boots. No one wore such clothes in Apt except me. The only others to wear shorts were the Polish Boy Scouts and the Zionist youth. Orthodox boys wore long pants.

Some people dressed with great flair. *Ciocia* Rozalia, which means Auntie Rose in Polish, was an old maid, a seamstress, who made all her own clothes. She was always bedecked with flowers. She had floral patterns on her dresses and a canopy of artificial flowers on her large hats. She would wear a bouquet of flowers on her right shoulder, another on the front of her dress, and a third on the left side. She was covered from head to toe in flowers. She sure looked grand. She lived on Broad Street next door to my grandfather. Other people were also nicknamed for their appearance: Mordkhe *fatset* (Mordkhe the Dandy) was fastidious

Ciocia Rozalia (left); *Saturday Afternoon Outing*

about grooming and fashion; Tsivye *shmokh* (Tsivye the Slob) and her husband Pinye *shmokh* (Pinye the Slob) got their unfortunate monikers because they were presumed to be slovenly and uncouth.

Once a year, a man came with a huge wagon and bought rags. We had very little to throw out, and everything had a value. He had little tiny toys, whistles, and trinkets: if you had a bunch of *shmates*, rags, he would give you something for them. For a small bundle you would get a toy. For a *tales*, a prayer shawl, he would give us a really big prize, because an old *tales* was the best *shmate:* it was made of pure wool, and wool of any kind was very desirable. Most of our clothes were made of wool; we even used to import English woolens. Linen was grown in Poland, but cotton was imported. We would sneak up on the wagon, snatch a few rags from the back, and take them round to him at the front of the wagon. We would sell them back to him and get a little toy. The rag picker was on the road for a month at a time, collecting a big load of rags. He took the rags to Łódź, where there were machines that tore the rags apart and recycled them into fabric. Łódź was the Manchester of Poland:

it was the center of Poland's textile industry. Can you imagine that man traveling a whole month away from his home, sleeping on the rags in his wagon? He lived on the wagon. He ate there, too.

I recall two of the many tailors in Apt. The first tailor, Yankl Damski, had his premises next door to our house. He and his two sons made ready-to-wear clothing for men: this kind of work was called *tandayt*. The sign on his shop read *"Krawiec Męski, J. Damski,"* which sounds like "Men's Tailor and Ladies' Tailor" but actually means "Men's Tailor, J[ankel] Damski." Everyone found this very amusing. Damski was his family name, but his trade was men's clothing. In his old age, Yankl became shortsighted, so he asked his son Hartske to thread the needle for him. To spare himself the task of constantly threading needles, Hartske would prepare a thread long enough to reach the city hall. He would say, *"Dus iz a fudem farn tatn"* (This is a thread for my father). When my mother asked me to thread a needle for her, she would say, "Don't make me a Yankl length of thread." Damski's daughter Tsirl was my mother's best friend.

The second tailor was known as the American tailor, *der amerikaner shnader*. He did strictly custom work and was considered the best in town. His shop was located opposite our gate

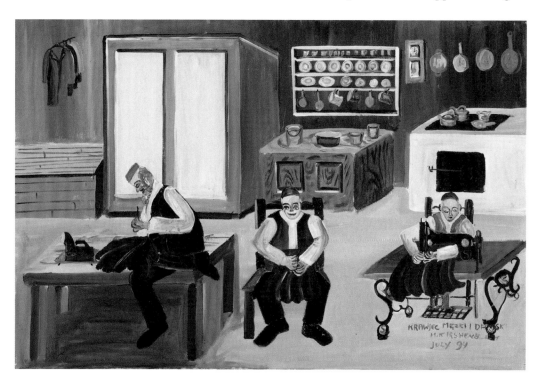

The Tailor: Krawiec Męski, J. Damski

on the north side of Church Street. He lived with his family on ulica Niecała. Why was he called the American tailor? He went to the United States by himself and hoped to be able to bring his family once he established himself. However, he had a daughter, a hunchback, who was terribly disfigured. After a few years, he realized that, to bring his family to the United States, he would have to leave his handicapped daughter behind, so he decided to come back to Apt. Rumor had it that, in order to save himself the fare back, he did something to get himself deported. This was just hearsay. Who knows if it was true? He brought beautiful catalogues from America with all the latest fashions—tall men in three-button suits, lady's suits and coats—and opened up a tailoring establishment that catered to the custom trade.

Even though his daughter was from a very nice family, it was difficult to match her up with somebody. No matter how he tried, he could not marry her off. One day the family noticed that the daughter's stomach was getting bigger, her breasts were becoming larger, but she remained thin. After repeated questioning, she admitted she was pregnant. The father of the child was unwilling to marry her. The family was distraught. It would be terrible for the child to be a *mamzer*, a bastard, for the rest of his life. After all, the child was innocent. He would be excluded from the Jewish community. In Jewish tradition, to be an illegitimate child is a very serious thing, even though the child is not at fault. (Strictly speaking, however, the child would not be a bastard because a *mamzer* is a child resulting from a relationship between a married woman and someone other than her husband.) As a rule, Jews did not avail themselves of municipal courts in civil matters. They convened a *bezdin*, a Jewish court, consisting of the rabbi and two or three prominent citizens. The *bezdin* had no physical power, but it did have moral authority. The court and the family implored the gentleman who did the dastardly deed to marry her, but he adamantly refused.

Her time was fast approaching. The father implored the man one last time, "Is it not enough that God punished the poor girl with such a deformity? Did you have to bring such shame on her?" The father promised the man a dwelling, new garments, and a job in his tailor shop for life, and he enumerated her virtues: she was a good cook, a good housekeeper, and she would make him a very fine home. The man finally relented and agreed to marry her. His name was Avrumele *katolik* (Catholic) Grojskopf, and his mother was a *tikern:* she supervised ritual immersions at the *mikve*.

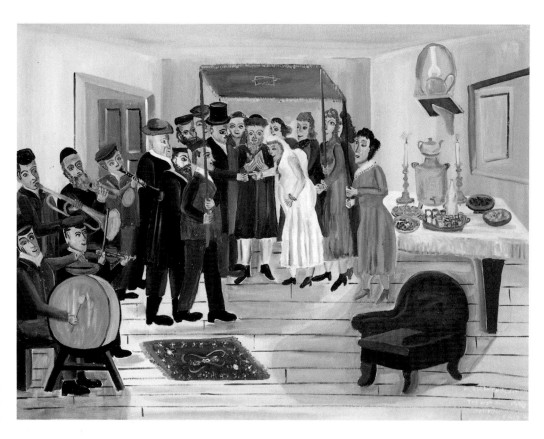

I painted the bride and groom standing under the wedding canopy. The women kept more or less to one side and the men to the other side. There was one top hat in the town: it was called a *tsilinder*. Every groom who wanted to look elegant borrowed that hat. The red chair in the corner is my grandmother's, the one my grandfather got from a nobleman's estate at an auction sale. It was not in the best condition: the springs were popping out. The whole town borrowed it for the *kale-badekns*, the veiling of the bride, so she could be seated as if on a throne as the *badkhn*, a professional master of ceremonies, performed sad rhymes. The origin of the *badekns* is from the story in the Bible about how Laban cheated Jacob of his beloved Rachel by substituting her older sister Leah. Not until the next morning, after the relationship had been consummated, did Jacob see that Leah, not Rachel, had shared his bed; he had to indenture himself another seven years to get Rachel. Since then, to ensure that the groom got the bride he had been promised, she is unveiled to him before they proceed with the wedding ceremony.

After the ceremony, but before the festivities got really under way, the guests would assemble, and the *badkhn* would announce the gifts: "The family of the bride, a pair of silver candle-

sticks. The family of the groom, a Hanukkah lamp. The grandmother of the bride, a feather-bed. The sister of the bride, a feather pillow." Other household items were usually assembled for the bride in her trousseau. After the publishing of the presents, refreshments were served. The favorite drink was *lakritsh*, licorice root boiled in water and sweetened with sugar and lemon to taste. It was served cold on the Sabbath and at weddings. I never liked it and I still don't.

Then the band struck up the music, and the dancing started. At the ceremony, they played traditional wedding music. For the dancing, they played the latest tangos, waltzes, polkas, mazurkas, and sometimes *kolomaykes*. The red carpet in the corner was not just for ornament. As the saying goes, "Whoever pays the piper calls the tune." If you wanted to dance, you had to throw money down. That was a little extra for the musicians.

The room in the painting looks large because all the furniture was taken out for the wedding. Ordinarily, there would be two beds, a table, a couple of benches, maybe a couple of stools in a corner, and a few pieces of wood for the stove. As I mentioned earlier, the clock was the most precious possession, the center of attraction in the house, and often mounted on a piece of wallpaper, which was purchased from my grandmother, who stocked remnants. Wallpaper was so precious that it was sold by the yard. Few people could afford to paper a whole room. After the ceremony, the bride and groom generally retired to an adjoining room. This was the first time they were left alone together.

The wedding I painted was no ordinary wedding. This one took place on a Friday. Usually, weddings were not held on Fridays because, once the Sabbath starts, you cannot play musical instruments. But, since this bride was so close to giving birth, the ceremony could not be delayed. The bride barely managed to say "I do" before she was rushed from the canopy to an adjoining room to deliver a baby boy.

We had a cousin, Khayim Burekh (he was called Kham Burekh), who was a *badkhn*, a jester, a merrymaker, and used to officiate at weddings. Before the wedding ceremony itself, he would tell the bride how difficult a time she was going to have. She'll suffer labor pains. She'll be away from her mother. Life is a struggle. After the ceremony, he would sing and regale the guests with somewhat off-color jokes. When my mother saw Kham Burekh rushing home right after the hunchback's "I do," she asked him, "Kham Burekh, where are you going? Is the wedding already over?" He answered, "I have to go home and change my clothes and come back for the *zukher*." The *zukher* was a little party traditionally given to celebrate the birth of a male on the first Friday after the confinement. For a *zukher*, they would serve boiled *nahit* (chickpeas) and *bobes* (lima beans), candies, cookies, and peanuts,

which were called *erets-yisruel-niselekh* or Land of Israel nuts. The *zukher* was held in the woman's home, and mostly women attended. This young couple lived happily until the war. They were expelled from Apt in 1942, together with all the other Jews, never to return. Only her brother survived.

Kham Burekh was a second-rate *badkhn* who really wanted to be a *khazn*, a cantor, but couldn't realize his dream because he had a very thin voice. A good *bal-tfile*, leader of prayers, he was, but not a *khazn*. I remember that, when he was going to lead the service, before he went to *shil*, he would eat a raw egg. That was supposed to be good for his throat. His family always resented that he was not given the honor of being the city's *khazn*; the Jewish community always imported a *khazn* from out of town. Kham Burekh was handi-capped from birth: his left arm was all but useless. So with his good right arm, he would toss his lifeless left arm to the back, where it kind of rested on the small of his back. Every once in a while, Kham Burekh would take off his *yidish hitl* and *kapote*, don a beige fedora trimmed with a brown band and ribbon, dress up in a proper suit, and disappear. When I asked where Kham Burekh had gone, his son Uma would say that his father went out into the world. To this day I assume he did some begging in other towns. We used to call this kind of person a door-handle polisher.

Kham Burekh was married to my mother's first cousin; the family name was Grinsztajn. Kham Burekh managed to raise a family of five. Three children immigrated to Palestine: Rivke and Moyshe left for Palestine before the war; Mordkhe survived the Holocaust in Rus-sia, returned to Poland, and then immigrated to Israel. Uma survived the concentration camps and immigrated to Canada. Shmiel, the youngest child, did not survive the war. Uma was one of my best friends, and I used to visit him often, so I saw how they lived. It was feast or famine. When they received money from Canada or the lottery numbers came in, it was a feast. Otherwise, which was most of the time, it was famine. Uma's mother would make two scrambled eggs and feed seven people: she would add milk, water, and a little flour, and everybody had scrambled eggs. The same went for ground meat: she would add an egg to hold it together and lots of stale challah and onions. When it was fried, it looked like a ham-burger, what we called a *kotlet*, but it did not taste much like meat. One of the boys used to complain to his mother, "If you're going to give me a piece of meat, no matter how small, give it to me without all the wonderful additives." She used to make potato dumplings, *golkes*, from finely grated raw potatoes, a cheap dish but one that took a lot of work to prepare.

I remember watching them play cards at their place, a game called *oke*, which was similar to draw poker. They played for money, and Kham Burekh would rake off a few cents per

game "to pay for the coal oil" for the lamp, even when they played by day. The players would complain, "Hey! It's still daylight!" To which he responded, "Yes, but it will get dark later on."

Kham Burekh's main business was weddings. A wedding was a very important occasion, and it was not complete without a *badkhn* and *klezmurim*, musicians. The *klezmurim* played not only at the wedding proper but also for the wedding processions. It was customary to escort the bride and the groom down the street to the *khipe*, the wedding canopy. This procession was called *tsi ladn firn*, to escort to sorrow, because before the wedding everything was serious. *Bavaynen di kale* was a ceremony during which the *badkhn* made everyone cry with his mournful rhymes about the end of the bride's carefree youth and the challenges of married life to come. In my painting of escorting the groom, one man in the background is carrying the wedding canopy to the bride's home, where the ceremony would be conducted, while another is transporting the red chair that would be used for the seating and veiling of the bride.

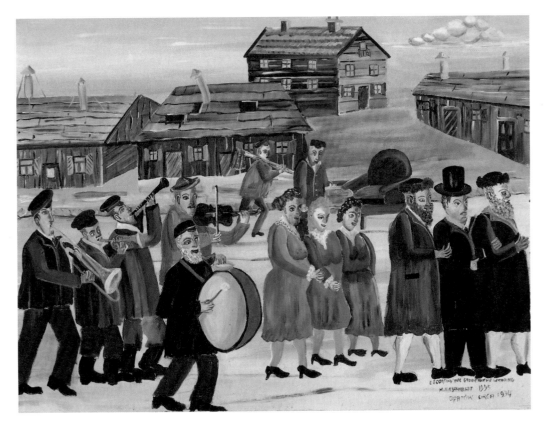

Escorting the Groom to the Wedding

The *klezmurim* also played under some rather unusual circumstances. As recounted in the Apt chronicles, long before my time, the richest man in Sosuv (Sosów in Polish), a town near Apt, was marrying off his daughter. He invited the Apt *klezmurim* to perform. Apt *klezmurim* were considered the best musicians in the region, and they performed in all the surrounding towns. But on the day of the wedding, their holy rabbi, Reb Moyshe Layb, could feel his strength draining away. He knew his end was approaching. He summoned the two families and pleaded with them not to postpone the wedding because of his imminent demise: "Please do not let my death spoil your *simkhe*, your celebration. Be happy and I will be happy." Having uttered these words, he departed this life in happiness. Nothing must interfere with the wedding. When the Apt *klezmurim* arrived, they found the whole town in mourning. They inquired as to the reason for the sadness and were told that the *tsadik*, the holy man, had passed away. The wedding proceeded just as Reb Moyshe Layb had requested.

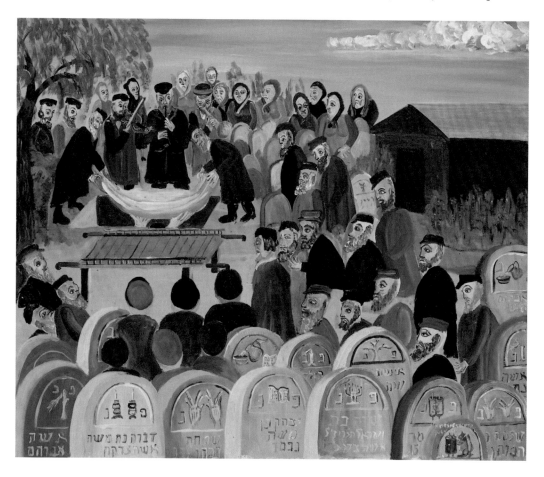

Burying the Rabbi with Music

The Apt *klezmurim* then recalled the time they played at an *ureme khasene*, a wedding for poor people. It was said that there was a table with indentations where Reb Moyshe Layb rested his elbows; any *rebe* visiting that town after his death considered it a great honor to sit in that spot. Reb Moyshe Layb told the Apt *klezmurim* that, when he died, he wanted to be accompanied to the other world by the same melody they had played at the poor wedding. But the Apt *klezmurim* had forgotten the melody long ago. Although Hasidic *rebes* could not read or write music, they composed some wonderful melodies, which they sang to their followers. The people took them home, and before long those melodies spread throughout Poland. All of a sudden, the Apt *klezmurim* recalled the melody.

However, there was a problem: some Jews questioned the legality of the rabbi's request. The community convened a *bezdin* to decide if it were legal to do what the rabbi had requested. The two families that had originally arranged the wedding confirmed that the rabbi had told them the same thing he had told the Apt *klezmurim*. Everyone understood the rabbi's dying wish. The decision was made to honor his request. The Apt *klezmurim* lined up around his grave and played the very same melody they had played at the beggars' wedding long ago. That was how Reb Moyshe Layb was accompanied on his last journey. The whole town recited kaddish, and all the angels replied "Amen." It was a most unusual request. I never heard of music being played at a funeral.

During my time, there were two *klezmer* bands in Apt: Urish Lustig headed up one of the bands, and Luzer *klezmer* headed up the other. Urish Lustig was a renowned clarinetist and fiddler. Five of his eight children became musicians. He and his family lived at the bottom of Broad Street, next door to my granduncle Pinkhes. The family lived on the ground floor, where Urish gave music lessons. You could hear them playing music as you walked past their windows. This part of the street was known as the *Klezmurim-gesl*, or Musicians Street. Other *klezmurim* also lived on this street.

The Apt chronicle reports that Urish learned to play the clarinet in the Russian army. After he returned to Apt in the 1880s, Urish was in high demand for Christian parties, both in town and on the estates of Polish nobility. He was a regular visitor in the home of the church organist, who was a singer and pianist. Later in life, Urish played for traveling theater troupes when they passed through Apt.

The Lewaks, another famous musical dynasty, also lived on this street. Over the years, the Lustigs and the Lewaks intermarried. Most of the Lewaks lived in Warsaw, where they played in high-class coffeehouses. One son made it to the Łódź Philharmonic, and a second son

played in the Warsaw Symphony Orchestra. The Lewaks composed a very beautiful tango that was popular all over Poland; as soon as we heard this tango, we started singing it in Apt. One branch of the Lewak family, Mayer Volf Lewak, the son of the famous Khayimke Lewak, lived with his wife and four children in Apt. All six of them lived in one room a few doors away from Urish Lustig. I once entered Mayer Volf's home and saw him sitting by the light of a candle, plucking his violin and writing music: his son told me he was composing. Mayer Volf was a good violinist. His pièce de resistance was "*der kanarik,*" a famous imitation of a canary. He would play it on request. It became tradition to play it at weddings.

Mayer Volf—his nickname was Mayer Volf *kompot* (compote)—had three sons and two daughters, Rivke and Baltshe. One son, whose name I don't remember, was nicknamed *di matke* (*matka* is mother in Polish), for reasons I don't know. Avrumele was nicknamed *der brayter* (the broad one) because he was short and fat. The oldest son, Yankl, was known as Yankl *żenić,* which means Yankl to Marry in Polish, even though he was single. Not being too bright, he would say nonsensical things like "*Jak się woda ożeni, to będzie czysta,*" which means "If the water would get married, it would become clean." That's how he got the nickname Yankl to Marry. Yankl played a nice fiddle, although he never performed professionally.

In my day, the Lewaks in Apt did not have their own band. They played in Luzer *klezmer*'s band: Mayer Volf on fiddle; Mayer Volf's son Avrumele on trumpet; sometimes Avrum *vlos* (whose real name was Avrum Kuperberg) on fiddle; Avrum *vlos*'s brother also on fiddle; Baynish *poker* (Baynish the Drummer, whose real name was Baynish Moyz) on drum, with a cymbal on top; and Luzer *klezmer* on trombone or bass fiddle. Luzer *klezmer* played a key trombone, not a slide trombone; he also knew how to play violin.

Luzer *klezmer* lived in an apartment in our courtyard. I took violin lessons from him at his place. He would teach some of the other students in their own homes. To supplement his income, he bought and sold violins; I bought my violin from him. He also repaired violins. He had an S-shaped steel tool with a V shape at one end that he used for installing the sound post. He would carve the wooden sound post from a piece of wood, insert it into the V, and then guide it into the violin through one of the S-shaped sound holes. He also replaced the hair on bows.

Mayer Volf was so poor that he gave one of his daughters, Baltshe, to Luzer *klezmer* to raise. As I mentioned earlier, there was no adoption in the Old Country. Everyone had in their

family a poor relative with lots of children. If you were childless, you went to them and proposed that they give you one of their children to raise. The parents were glad to have one less mouth to feed. You made your choice, a boy or a girl, which age, and the like. The mother packed the few rags that the child possessed and off the child went.

One of my maternal grandfather's sisters, *Mime* Rivke, was childless, so she raised two children from her husband's family. My grandfather wanted her to take in her nephew Uma, Kham Burekh's son. Uma, who was my second cousin and one of my best friends—he would have been about six years old at the time—packed his bag and undertook the journey to see her. That was no small sacrifice: she lived in Wierzbnik, between Drildz and Apt, and it took a few hours to get there. My grandfather implored his sister, "You're taking a child from your husband's family, take one from our family too," but to no avail. She had already taken in two children and must have decided that she had enough, but she did agree to take Uma for a few weeks every summer to fatten him up. She had a restaurant, more like an inn, there. I was envious that Uma got to spend the summers in Wierzbnik. I complained to my mother, "Why can't I also go there? I am the same relative as he is!" Mother replied, "You are too small to understand. When you grow older I will explain it to you." She never did. But I got the gist of it by the time I was twelve. If, like Mayer Volf Lewak, you could not afford to raise your children, you tried to place them with another family. We were never reduced to such desperate measures.

In any event, this is how Baltshe came to be raised by Luzer *klezmer*. Avrum *vlos*, the best violinist in town, had a crush on Baltshe, and they had some kind of relationship. She was a very good fiddler in her own right. I often heard them play violin duets; they performed beautifully together. He and his entire family were known by the nickname *vlos; wlos* means strand of hair in Polish. One time, Avrum's brother had a gig at Upper *besmedresh* and asked me to help him; it was a party for men, and we played dance music. Luzer *klezmer* had taught me how to read music, but he never taught me theory, so when Avrum's brother asked me to play a certain chord, I didn't know what he was talking about, and he had to show me what chords to play. I played second fiddle, just oompah, oompah. There were only the two of us: he was the soloist, and I backed him up.

Avrum *vlos* was a handsome rogue and a real ladies' man. I remember the time that I saw Avrum *vlos* with Rivke *di larve* (Rivke the Larva). I was with my friend Makhu: Makhu was a fine boy and wonderful companion. We were both *meshoyrerim* in the *khazn*'s choir. But Makhu's father, Moyshe *khanyok*, was a well-known thief and gangster. His mother also

had a questionable reputation, as did Rivke *di larve*, who kept house for them. Rivke *di larve* was an old whore, wrinkled and ugly. When she could no longer make a living as a prostitute and had no place to go, Makhu's parents gave her room and board in exchange for her housekeeping services.

In the summertime, when we had our two weeks off from *khayder*, Makhu and I would play together. We would wade in a creek and play with the smooth red clay we found there. I suspect it was a piece of old brick that had been submerged in the water for a long time and disintegrated. It was so soft, the consistency of butter, and bright red. We would take an empty matchbox, fill it with red clay, and then dry it in the sun. When the clay was half dry, we would divide it in half to make two bricks. We used these bricks to build a little house and would flatten the clay to make a gable roof.

Makhu's family also had a share in the fish business; his father belonged to a loose association of fishmongers, known as *di fishers*, the fishermen. The fish came from Rachów-Annopol, on the Vistula River. In those days, the Vistula was teeming with fish. The fishmongers would leave Apt for Rachów-Annopol on Thursdays as early as two in the morning and return late in the afternoon or early in the evening, so people could buy live fish on Friday for the Sabbath. A horse pulling a fully loaded wagon would move at about four miles an hour. You could walk alongside the wagon at that speed. It took the better part of the day to get to Rachów-Annopol and back.

The biggest business was before the High Holidays. Everyone wanted live fish for the holidays. To keep the fish alive, the fishmongers would bring them to town in barrels of water. When they were ready to drop the barrels into the river overnight, they would open the trapdoors on either end of the barrel to expose a slatted wood screen. That screen would keep the fish in the barrel while allowing water to flow through. Someone was always there to watch the barrels overnight and ward off thieves. If it were chilly, those guarding the fish would light a fire to keep themselves warm.

One evening when Makhu and I were strolling along the marketplace, he suggested we go down to the river and see how the fish were doing. When we got to the campsite, we saw a wagon. We noticed something moving in the light of the fire. As we came closer, we saw Avrum *vlos* humping Rivke *di larve* on the wagon. Suffice it to say we did not make our presence known and kept the secret to ourselves; we did not want to spoil the relationship between Avrum *vlos* and Baltshe. I heard they eventually got married, but that was after I left. There were other loose women in town. Tania *ryba*, which means cheap fish in Polish, was

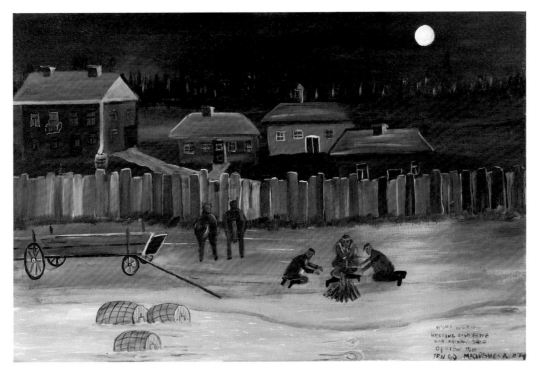

Night Watch

one of Bashe Rayzl's relatives. Tania *ryba* was known as a carpet: it was said she would lie down for everyone—but not for me. I don't know if it were true, but boys like to tell stories, and I heard this from my friends. She was a nice little girl, our age, but I had nothing to do with her. I was too young. Her father was a tailor.

When the fishmongers were ready to bring the fish to market, they would roll the barrels up onto the shore, let the water drain out, place the barrels full of fish in the wagon, close the trapdoor, and partially refill the barrels with water. At the market, they removed the fish from the barrels and placed them in big wooden tubs about five feet across and twelve inches high. They set the tubs on a table that was just a plank resting on wooden horses and sold the fish from there. They weighed the fish on a level scale: it had two trays, one for the weights and one for the fish. A woman would pick out a fish, and the fish would lie on the table. If she protested that it was not alive, the fishmonger would give the head of the fish a whack, and the fish would jump, even though it was dead. "See, it's alive," he would say.

They sold a variety of fish, including carp, tench (*shlayen*), sunfish, perch, and pike (*hekht*). Once, before the High Holidays, someone sold an enormous carp that weighed about fifty pounds. The fishermen and fishmongers brought this huge carp from the Vistula River with

their weekly supply of fish. My mother bought half a head as a delicacy for my father. The fishmongers also brought *kelbikes*, which looked like big minnows; they were about five inches long. Poor people would chop them up, scales, bones, and all, for *gefilte fish*, stuffed fish. Mother made *gefilte fish* from pike and other freshwater fish. She would scale and gut the fish, slice them into steaks, remove the flesh from the spine and ribs, and chop up the flesh. Then she mixed the pike flesh with other fish—I don't recall if that included carp, which makes the fish dark—and added breadcrumbs, an egg, onions, and a little salt, pepper, and sugar. She would use this mixture to fill the space between the skin and the bones as well as the abdominal cavity. She would gently place the stuffed slices of fish into boiling water with an onion and sliced carrot and simmer them slowly. Thanks to the bones and skin, the stock would gel. Mother served the fish cold with its jellied stock and a slice or two of cooked carrot. The portions were perfectly formed to look like fish steaks. If she did not want to go to the trouble of stuffing each fish steak, she just made balls. Sometimes, she made *falshe fish*, or false fish, from chicken breast for the Friday night dinner. I actually preferred *falshe fish*. It was exactly the same as *gefilte fish*, only made with chicken breasts. It was also called *flayshike fish*, or meat fish. She made it by chopping or grinding chicken breasts, adding onion, salt, pepper, a pinch of sugar, and an egg. If the mixture was too loose, she would add a little flour or challah. She would then form the mixture into balls and poach them with carrots and onion in water.

When the time came for me to work, I did not have many options. My father left for Canada in 1928, when I was twelve years old and still in school. When I finished public school three years later at the age of fifteen, I had no intention of going on to yeshiva: I was not religious, and I couldn't see any future for myself sitting all day in a *besmedresh*. Gymnasium was out of the question: I had neither the money nor the ability. I had already failed one year of public school, because I wasn't paying attention in class and because I played hooky. I spent all my time watching the blacksmith, the wainwright, the cooper, and the many other artisans in town. Sure, school would have kept me off the streets, but by the time I graduated I was smoking, I was playing around with girls, I was busy with the Zionist organization. I didn't want to go back to school.

Uma apprenticed to a furrier. Maylekh worked for his father, who salted hides. Avrum Watman helped his father in the brushmaking factory. Harshl Watman worked in his father's hatmaking factory. I went to Lublin to apprentice with my uncle Laybl Rozenberg, who was a licensed electrician and engineer. He's the one in whose home I later slept on the way to the Zionist training camp in Ruda-Opalin. Laybl was married to my father's sister Laye. He

was well-off because, in addition to working as an electrician, he was paid to approve any electrical work that anyone else wanted to do. If an electrician wanted to install an extra outlet, he had to make a blueprint of the whole electrical system and bring it to my uncle, who would review the plan, stamp it, and receive a fee for his services. Then the electrician went to city hall and got a permit, for which he had to pay another fee. Only then could he do the job.

Laybl also had a hardware store. The staple items were cast-iron pots, light bulbs, and locks. The pots, which were black inside and out, were sold by weight. The cast iron was quite thin and somewhat fragile; the better pots had white enamel inside. He also sold electrical supplies, everything needed for making repairs and doing small electrical installations. He sold specialized wires, springs, switches, and the like to hobbyists. I once went with him to one of those customers. The man—he had some kind of hobby that required electrical know-how—lived in a beautiful little brick bungalow on the outskirts of Lublin, with all the modern conveniences. His place wasn't more than eight hundred square feet, on one floor. I was fascinated to see how he lived: he had an indoor toilet, a shower and bath, electric lights, and an electric stove in the kitchen. This would have been around 1931. The only thing we used electricity for in our house in Apt was lights. We had two bulbs.

My uncle Laybl was a funny guy. His coat was one big pocket. He used to carry small tools around in his coat. The pliers, wire cutters, screwdrivers, wire, and tape would fall through the holes in his pockets and fill up the lining of his coat. He walked quickly, taking big strides, and his coat would stick out on each side like wings. With his coat full of tools, he was always ready to do a small job. He was a very nice, intelligent man, but he took advantage of me. He did not pay me a penny for all the work that I did. I worked like a horse. I was there to be exploited. That was the system. That I was a relative didn't matter very much. My mother had to send me a few pennies for spending money, and she couldn't afford even that. He wouldn't put his hand in his pocket and say, "Here's a zloty. Go and spend it on something." About five years before I went to Lublin, Laybl and my father had decided to open a leather store together on Kowalski Street in Old Lublin. After a short time, my mother saw money going in and nothing coming out. She went to Lublin, checked the books, looked at the operation, and said, "That's it." She liquidated the business and came home. She was a very smart woman.

Laybl did provide me with room and board. Their apartment was on the second floor. The interior of the apartment was very nice; it was clean and well furnished. They had three large rooms: Laybl and Laye slept in a huge bedroom, and their two children slept together

in a large crib in the office. I slept on a chaise lounge in the same room as the children. The maid slept in the kitchen. The only convenience was the sink in the hall, where they threw out all the slop. There were no proper bathing facilities, so we would wash our bodies a section at a time. The effluent went directly into the yard, and in the winter the pipes would freeze. The outhouse, with maybe eight holes, was in the center of the yard. There were many apartments around this courtyard.

Mime Laye was short and fat. She was busy working in the store all day, so the maid did the cooking. The maid was a tall woman. I once tried to make out with her. She told me she was not a virgin: she said that she once squatted in the bushes and a twig went inside and broke her hymen. She was the one who fended off my advances by telling me she was wearing black panties. How else was I supposed to know she had her period? She was from a small village.

The period in Lublin was the first time I had lived away from home. Lublin was a big city with a population of about 100,000. It was nothing like Apt or anywhere else I had been. It was my first visit, and I lived there for almost a year. The city made a big impression on me. Laybl's store was on Third of May Street and accessible only from the street; a few steps away, on the opposite side of the courtyard, was our apartment. We did not live in the center of town; we lived near the railway station, where ulica Kolejowa (Railroad Street) met Trzeciego Maja (Third of May Street) and formed a V. At the corner of the V was a store that sold horsemeat: sausage, corned meat, and other horsemeat products. I went once and tasted a sandwich; it was sweetish. They did a big trade.

I didn't have much of a social life. When I was not out doing electrical jobs, I was helping out in the store. I was hoping to learn something. I had no friends except Laybl's daughter. I used to supervise Laybl's children at the ice-skating rink not far away: his daughter Rushke was about thirteen and the son was about five. I could not afford to go home for the holidays. Besides, I didn't especially want to go home: the best part of being in Lublin was being away from home and more or less on my own. I loved to explore the city. I went for long walks. I liked to go to the railway station to watch people come and go and to see the locomotives come into the station. No train came through Apt. The nearest railway station to Apt was in Ostrovtse. Right around the corner from our apartment were city buses and a theater that showed movies and vaudeville.

There was a huge meadow between ulica Kolejowa and the Old City; instead of taking a bus that went around this area, I would walk across it to the Old City. It was two-thirds of

a mile. Sometimes when Laybl went from the store to the Old City, I would go with him. He walked so fast, with his coat full of tools flying out to the sides, that I had to trot to keep up. The Old City was fascinating, with its narrow streets, tall buildings, and hustle and bustle. There were many religious people in their black coats. There was a big yeshiva there too. I explored every nook and cranny.

Next door to my uncle's store was a courtyard that you entered from the street. Up and down walked a woman wearing a nice coat with a fur collar and red slippers with white pompoms. I knew who she was and what she was: prostitution in Poland was legal. One day she asked me, "What are you looking at?" So I said, "You know what I'm looking at. But I have no money." The fee was one zloty. That was a lot of money, considering that a laborer earned one and a half zlotys a day. She replied, "Wait for me in the front of the store on Thursday afternoon, because in the morning I go for my medical. I have one client, he's eighty years old, who always wants to be the first one after the examination. Fuck him! What's he trying to do? Live to be a hundred?" Faithfully I waited for her. She took me to a tiny little room in the courtyard. The room was divided with a curtain, and behind the curtain was a narrow cot. An old woman came over to wash my penis. She said, "Don't bother. He's not a paying customer." Before I even got to her I was finished. She encouraged me, and this time I did it. I was sixteen years old. That was the first time I had sex. What did I know about sex? What did I know about contraception? I knew what people did but I didn't know the mechanics. When I was fourteen years old, we had gone to a little store in Apt, a *galenterye*, which sold sewing supplies as well as condoms. With my hard-earned savings I had bought one just to look at the picture of a naked lady and play with the condom itself.

At five feet, two inches tall and weighing less than a hundred pounds, I was always slight of stature and trying to assert my masculinity. No job was too difficult for me. Sometimes we had to install electricity in a house in the Old City. The walls were three feet thick: they had been built in medieval times, not from brick but from huge boulders. Even the inside partition walls were built to last hundreds of years, and they did. It was my job to drill holes from one room to another with a *Schlagbohr*. This is a German word, and it is the word we used for this tool in Yiddish and Polish: *schlag* (German) and *shlug* (Yiddish) mean to strike. A *Schlagbohr* is a short length of pipe with small V-shaped teeth carved into the edge of one end. The pipe, which was about eighteen inches long and one inch in diameter, was heated to an orange glow and immersed in water to harden the metal. Then you would hold the *Schlagbohr* against the wall with your left hand and, with a maul or hammer in your right hand, you would strike the bore, turning the bore a little to the right or the left

each time you hit it. The dust would come through the hollow of the pipe. Every so often, you had to sharpen the teeth. I remember hitting a very hard rock with such force that I dislodged a huge stone on the other side of the wall: it fell to the ground. All in all, I didn't learn much, and I wasn't getting anywhere: I worked so hard and didn't have a penny to show for it. Finally, I had enough. I told my mother I wanted to come home. Maybe I was just homesick.

On my return to Apt from Lublin, I approached the only electrician in town, a greaseball drunk, a Pole, but an excellent craftsman. I worked for him for one week that summer. We wired the home of the church organist. The church organist had a gorgeous home, maybe ten rooms on two floors. The Polish electrician showed me what to do. When we came to the house, he marked where I should make holes through the walls for leading the wires from one room to another. Every evening, he would come to inspect what I did. After a few days, when I had finished making the holes, the lead pipes and connectors would arrive. We had three kinds of connectors: straight ones, T-shaped connectors, and forty-five-degree ones for corners. The pipe was easy to cut because the lead was very soft; it was about half an inch in diameter and lined with tarpaper insulation. He could adjust the angle of the connectors with a crimping tool to make the pipe fit the exact shape of the wall. He was so skilled that, in no time at all, he had cut the pipes to the right lengths and laid them on the floor according to where they were to go on the wall. When this was done, he left for the bar. It was my job to fasten the pipes to each other and to the walls, exactly as he instructed. This took me two or three days. He returned every evening to inspect my work. After I had installed all the pipes, he brought rolls of wire. In a matter of hours, he wired the whole place: he would feed the wires into the tubes and make them go to the right places. All the on and off switches and all the pipes and fitting were on the surface of the wall, not embedded. Finally, he would install the fixtures and switches and hook the system up to the main feed. What I know today about electricity, I learned from him.

It was a hard job, but the hardest job of all was to find him at the end of the day and get my wages, one zloty. I had to search for him in all the taverns in Apt and beg him for the money. It was demeaning. He would dig around in his greasy pockets and pay me in small change. The first greeting he offered when he saw me coming was, "Oh, it's you again." He never washed. He must have slept off his drunken stupor in a corridor somewhere. I never could find out where he lived. He spent all day in the tavern; he would only come at the end of the day to check what I did and to give me orders for the next day. Then he would take off again. I only did this one job for him as he did not have any more work for me that sum-

mer. But I did not want to continue working for him in any case because I hated begging for my money. I did do one small job on my own: I installed electric lights over the bench where the *antsiers* were sitting in *Feter* Sukher's brush factory.

At sixteen, I realized I had no future whatsoever in Apt. Of course, you could always go through the four years' apprenticeship for tailoring or shoemaking, which was very unpleasant, but even after such an apprenticeship, there was little work in Apt. Most of the time, young people drifted into the big cities to work in sweatshops. They lived with six to eight other workers in a room under terrible conditions. They would eat catch as catch can, skimp and save every penny, and bring the money back to their families when the season was over or when they came home for the High Holidays. They would stay in Apt for about a month, and then leave again.

We were always discussing when and how to leave Poland. The preferred place to immigrate was Palestine, but the British Mandate authority issued few permits. There were many applicants. Few were chosen. One also had to find the money for the fare. Understandably, since my friends and I were raised in the Zionist movement, we were all inspired to become pioneers. It was the patriotic thing for Jews to do. Also, once you had a permit and the fare, it was easier to go to Palestine than to the United States or Canada because you did not need a sponsor. To immigrate to the United States or Canada, you needed not only a permit but also a blood relative who would help you financially. My father's family had started immigrating to Canada around 1905. Immigration to the United States virtually closed in the 1920s, although Canada and South America were still open; a lot of people were immigrating to Argentina, Mexico, Uruguay, and Paraguay.

I decided that, since everyone else was going, I might as well go too. I told my mother that I was going to apply to leave. By 1933, my father had been in Canada almost five years. He had left for Canada at the height of the Depression and was having a very hard time. My mother wrote to my father that he must do something to bring us all to Canada because if I, the oldest son, left, his other three sons would probably follow. She told him, "Remember! The family will disperse and we will have nothing. We will have no family left."

My father wrote back that I should apprentice to a *kamashn-makher* and learn the trade. A cousin of my father's was a foreman in a shoe factory in Toronto; he told my father that if I learned this trade, he would give me a job the moment I arrived in Canada. His name was Shmiel Hirszenhorn. He was my father's first cousin: Shmiel's mother, Maryem, and my paternal grandfather, Yukl, were brother and sister. He had a high-pitched voice, like his fa-

ther. A *kamashn-makher*, who made the upper part of the shoe, was a profession in Poland one step higher than a cobbler, which wasn't very high.

Following the instructions in my father's letter, my mother started to ask around. Sure enough, there was a *kamashn-makher* who required an apprentice. His workshop was in a room on the second floor of a building just up from the pharmacy on the marketplace. Apprenticeships usually lasted four years. I didn't expect to learn the whole trade, because we anticipated immigrating to Canada at any moment; I just hoped he would teach me to use the machines and give me an idea what the whole business was about. I was shocked by what I encountered. Upon my arrival early in the morning, the man had just finished urinating in the slop basin. He gave the high sign: I was expected to empty the basin through a window. Walking carefully so as not to spill the contents along the way, I had to check that there was nobody below before I whooshed the slop out the window. By that time the household had come to life. Two experienced employees arrived and sat at their sewing machines.

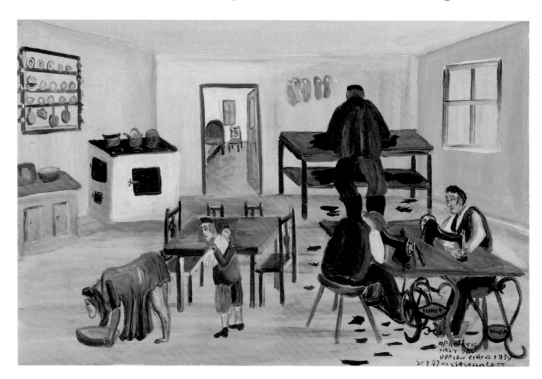

Apprenticing to the Kamashn-Makher

Then the lady of the house came out carrying a baby. The dwelling had two rooms: you entered the kitchen, which served as both the living area and workshop, and from the kitchen you went into a nursery bedroom, where they stored leather. The owner would cut the

leather, and the two workers would stitch the uppers on sewing machines. The lady was not so much fat as she was big: she had broad shoulders, wide hips, and enormous breasts. Of course, she was breastfeeding. With her size, she could have suckled a platoon. She wore a dress that reached below the knees in the front and just below the buttocks at the back. Since she didn't wear underwear, every time she bent over you got a full view of the whole landscape. She had vaginal lips the size of cabbage leaves. I had never seen anything like it. At home we were four boys, and my mother was very careful.

The lady gave me the baby to hold. When the man of the house needed me, I handed the baby back to her. He sent me out to do different chores, deliver finished goods, pick up some supplies, and sometimes shop for groceries. After work I had to sweep the place, clean up, and chop some kindling wood for the next day. I worked twelve hours a day. After a few days, I got tired of playing with the baby, so every time the lady gave me the baby, I would pinch it and the poor baby would cry. She came and grabbed the baby, exclaiming, "I don't understand how come every time you hold the baby, the baby cries." I replied, "The truth is the baby doesn't like me, and I don't like the baby." After one week, I told my mother that I would quit because I wasn't learning anything except being a nursemaid, and we would probably leave for Canada soon anyway. One day, I decided enough is enough, and I just quit. I was never paid a penny.

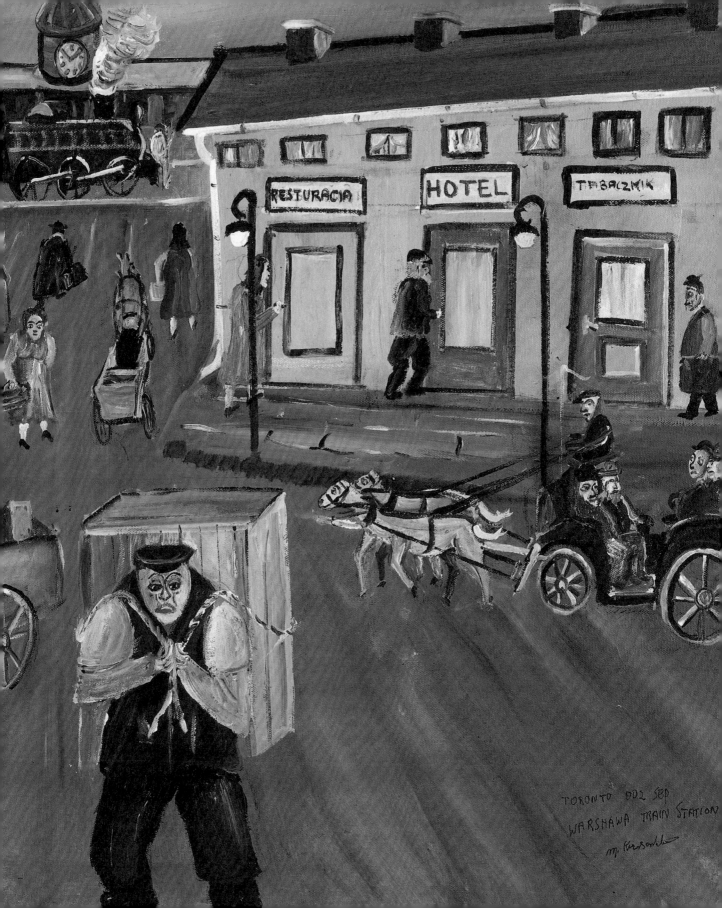

A COLD AND STORMY CROSSING

The first to leave Poland, around 1905, was *Mime* Ester, my paternal grandfather's sister. She brought two sisters, Maryem and Libe, to Canada. They in turn brought over my father's brother Shmiel, who brought his brother Arn Yosef. The others— a married brother, Harshl; two single brothers, Duvid and Sruel; and three single sisters, Rivke, Royze, and Shayndl—were reluctant to leave. They made emigration papers for my uncle Duvid three times. Each time he refused. Eventually, my father took advantage of his brother's reluctance to emigrate, assumed his brother's name, and immigrated to Canada on his papers. My father left Opatów in 1928.

There was a lot of unemployment at the time, and Jews were discriminated against. I always considered myself a Pole, but when people called me a Polish Jew, I objected. I am a Jewish Pole. To the government, however, I was *Żyd*, I was a Jew, and basically to me *Żyd* has a horrible sound. It grates on my ears. The Polish government did not consider me a Pole, even though I was a Polish citizen, went to a Polish public school, and was steeped in Polish literature and history. I had read the great Polish literary works by the time I was fifteen. I could recite verses from Mickiewicz's *Pan Tadeusz*. I read everything that Henryk Sienkiewicz wrote. So of course I was a Polish patriot, and the reason I left Poland was basically economic.

When I went to city hall to get my passport, I saw my friend Kazimierz Kucharski working there. We had gone to the Polish public school together and sat on the same bench—there were four students to a bench. We were friendly. If we met on the street, we would stop and chat for half an hour or so. When Kucharski saw me applying for a passport, he said, "Mayer, why are you leaving your homeland?" I replied, "Because you are sitting behind the desk and I am standing in front of the desk. That's why. Could I get a job here? I am just as good as you. This is the reason I am leaving."

I just could not see any future in Poland. When some of my friends got married, I said to myself, "Why do these people want to get married? To have someone to sleep with?" They were only a few years older than I was. By the time they were eighteen or twenty years old, they were married and started having babies right away, one after the other. They struggled to make a living. They started aging before their time. The conditions were appalling. They lived in a tiny room on nothing. Life was such a struggle.

Why didn't other people leave? The reason was this. Those who had enough money to leave didn't want to leave. Those people who wanted to leave didn't have the money to leave. Mostly, though, everyone who could leave left. My future in a small town was nil. When I got to be seventeen, I wrote to my father and told him, "Look, I have no future here, I'm leaving. I have two aunts in Belgium. I'm going to them." As I explained earlier, entry to the United States and Canada was already closed. You had to have special permits and somebody, a relative, to sponsor you. But South America was open. Uruguay, Paraguay, Chile, Venezuela, Brazil, and Argentina were open. A lot of my friends went there. With help, they succeeded. So I said that whatever they do, I will do, too.

Then my mother wrote to my father and said, "Listen! You had better see what you can do. Mayer is the oldest. If he leaves, the other ones will grow up and want to leave too. Your family will scatter all over the world and you will have nothing. You have got to do something. You have to bring us to Canada." So my father went and he hocked himself up to here. We were paying out a dollar a week for the ship tickets. There were five of us—the four boys and my mother.

There were many months of preparation. We had to be checked out by the eye doctor and the physician. We needed statements from the police and city hall. We had to be in perfect

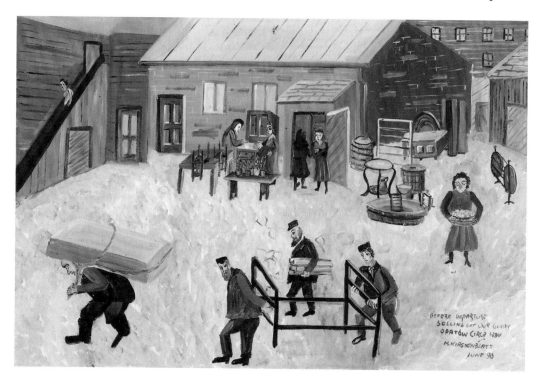

Selling Our Goods before Leaving

health and of perfect character. Finally, the happy day arrived. We were ready to leave. Most of our things were already spoken for. They were promised to my maternal grandmother, Mother's sister in Niekłań, and one of Mother's first cousins in Apt who was also named after my great-grandmother, Rivke. Rivke's family was really poor. We put everything that had not already been spoken for, particularly the bedbugs, outside. Fortunately, it was a warm day. People started shlepping away beds, chairs, and other household effects. We gave away the potted plants, and were promised that they would be looked after. Whatever was left, my grandfather sold or gave away. Everything had a value.

The wagon was waiting. We piled our luggage on the wagon, including the featherbeds, the brass mortar and pestle, the pair of silver candlesticks that Mother used for lighting the candles for the Sabbath and other holidays, and the beautiful Hanukkah lamp that I inherited after my mother passed away a few years ago. We climbed into the wagon not with sadness but with great anticipation of our new life to come. Everyone turned out to wave good-bye. We had already taken our leave from Father's family in Drildz several weeks before. We were on our way at last.

We went by horse and wagon from Opatów, through Łagów, to Kielce, the provincial seat, where we took care of some papers. From Kielce, we took a train to Warsaw, where we

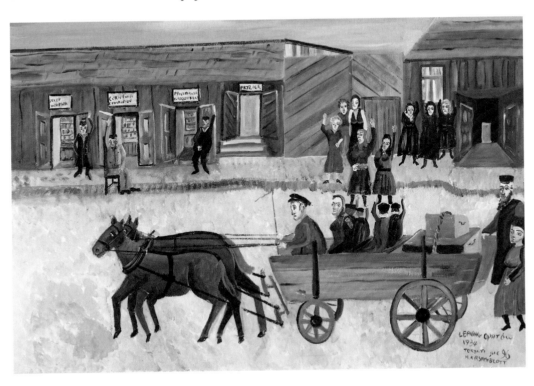

Leaving Apt

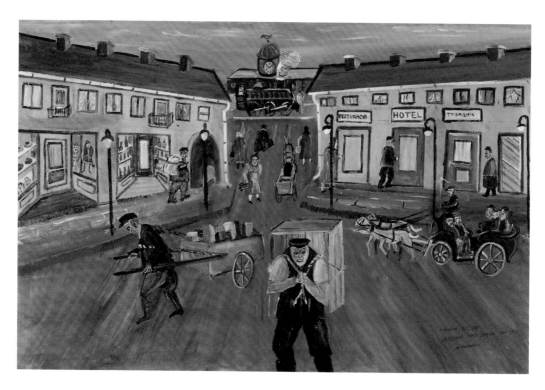

Warsaw Train Station

stayed for a few nights. Warsaw was an assembly point. This is where I first encountered a flush toilet. I spent half the night pulling the chain, marveling at the flushing water. From Warsaw, we traveled by train to Hamburg, where we stayed several nights in a huge compound that belonged to the Hamburg American Steamship Company. I couldn't stand being confined to this area and wanted to explore the city, so I went to the office and got permission to go into town. What impressed me in this office was the huge picture of Hitler on the wall. I also saw Germans wearing armbands with swastikas and greeting each other with *"Heil Hitler!"* although we did not personally experience any anti-Semitism. In Hamburg, we met with the Canadian consul and were again examined for health and hygiene. A man was covered with hair like an ape. They shaved him clean.

The first thing I saw when I went out the gate in Hamburg was a fruit stand piled high with oranges. Oranges were so precious in Apt that the whole family would share a single orange. I had never seen so many oranges at one time. I asked, in what I thought was German, *"Bitte Pomerantsn?"* (I had studied German in the Polish public school. We learned to read and write in the Gothic script.) She corrected me, *"Das sind Apfelsinen."* I thought that *Apfelsinen,* the German word for oranges, literally meant sun apples, but I am told that it means apples from China. *Pomerantsn* is the Yiddish word for oranges, from the Polish

Exit Hamburg,
1934

pomarańacza. I also saw three of the biggest horses pulling a flatbed wagon. What impressed me most were the horses' hooves. They were as big as platters. The wagon was loaded with bags of grain. To ease the load they were pulling, the horses just leaned into the harness.

From Hamburg, we traveled to Copenhagen by train and ferry. We were chaperoned by a German official; I assume that he worked for the shipping company. On the way to Copenhagen, the train boarded a ferry. I pretended to be a representative from a Jewish agency. When our chaperone found out I was fooling, he was furious and tried to find me. Somebody had tipped him off, and I had to hide for fear of punishment, at least until we crossed the Danish border. We had a wonderful Danish breakfast. I can still taste it: warm small buns, delicious butter and cheese, and coffee like I have never tasted before or after—the coffee at home was mostly chicory. The waiter was tall and very gentle, and he spoke German. Of everything I experienced in Copenhagen, what amazed me most were the thousands of bicycles and the clean streets.

In Copenhagen, we boarded a small boat that took us to the big ship moored mid-channel, the *Kościuszko*, which would bring us to Canada. (I later found out that this ship was built in 1915; as it passed from one company to another, the ship's name changed from *Czaritza* to *Lituania* to *Kościuszko* in 1930, when the Gdynia America line of Poland bought the vessel.)

It was a very cold and stormy crossing. It was to be a thirteen-day journey, so we had lots of time. I mostly hung out in the ship's lounge or explored the ship. I made friends with two boys my age, and we spent many hours running back and forth from bow to stern. We would watch the stern rise up with every large wave; sometimes we could even see the tips of the propellers and hear them thrashing when they were out of the water. We loved to watch distant ships fighting to mount a big wave; it looked like they were climbing up a mountain. The first night onboard, we were sailing what I now know was the English Channel. The whole third-class complement, about five hundred people, turned out to dine. The dining room was huge. The next morning, when we sailed into the open sea, there was hardly a soul at breakfast. They were too seasick to get out of bed. The rest of the journey, we three guys and the *mazhgiekh*, the man who oversaw the ritual purity of the kosher food, had the entire dining room to ourselves. The breakfasts were great, and the service was exceptional; each of us had our very own waiter. They gave us oranges, which were huge with a thick peel, but inside there was very little orange and, what little there was, was dried out.

I slept on a bench in the lounge. My mother and brothers stayed below deck in steerage. I did go down to visit. The stench from vomit was vile. They were just too weak and sick to come up on deck. I gave them each a little water and tried to make them feel better. My

mother never forgave me for not staying with them below. Years later, she would throw this incident back at me.

I begged one of the crew to take me down to the boiler room. The place was huge. Although I never did see the machinery, I did get to watch the huge shafts that drove the propellers. The boilers were fired with coal. There were six boilers and three firemen to feed the fires, each man stoking two boilers. When a fireman had finished stoking one boiler and closed the fire door, he immediately started on the second one. They never stopped feeding the boilers. To me, the coal bins looked sixty feet high. I also got to see the steering cabin on the deck. There were two double steering wheels, with big heavy hawsers around them, which moved back and forth automatically. Spokes protruded from the wheels so that, in case of an emergency, two or three men could operate the steering wheels manually.

As we approached Canadian shores, we encountered ice fields as far as the eye could see.

Ice Fields: Arriving in Canadian Waters, February 1934

Huge chunks of ice, more than three feet thick, accumulated on the bow of the ship and slid down the deck as the vessel pushed forward. The crew came out with iron bars, stood on the bow, and pushed chunks of ice off the prow. Within a day, we were in Halifax and boarded a train for Montreal. I remember being welcomed by the Salvation Army, who gave the chil-

dren toys and treats. My father was awaiting us in Montreal. When I stepped off the train, I was amazed to see the train completely covered in ice. After a happy reunion with our father, we were off to Toronto.

Since we arrived in Canada six years after my father, he had a difficult time explaining to government officials how, having come to Canada as a single man, he had acquired a wife and four children in Poland during the intervening years. My father explained that he was in love with the woman, who already had children, before he left Poland, implying perhaps that she was a widow. With manipulation and *protektsye*, influence, he managed to acquire the necessary documents to bring us over. We bought the ship tickets largely on credit. We also bought the furniture for our flat on credit. Eventually we paid it all off, a little each week, every last penny.

In preparation for our arrival, Father had rented a flat next to his father's sister Maryem. He hoped that, being next door, she would help us. He also bought a new bedroom set, which included a double bed, a highboy, and a dresser with a mirror. When he invited his aunt to see it, she was aghast. "You mean you're going to sleep in the same bed with your wife, with four young boys around?" Father quickly phoned the furniture store to exchange the double bed for two singles. About six months after we arrived, we moved from this flat to a house and used the downstairs living room for a bedroom. After a few months, my father put an advertisement in the newspaper to sell the beds: "Two single beds, one slightly used."

The first six months were very difficult. The year we arrived, 1934, was the second-coldest winter in the history of Canada. Not long after we arrived, I wrote to a girlfriend in Apt that we were literally going hungry. "Just the same," I wrote, "if I am to die of hunger, I would rather die on the sidewalks of Toronto than Opatów." With the arrival of spring, things got better. Later, in 1937, we were able to open our own paint and wallpaper store.

Today, I am comfortably retired and, after trying various things to occupy myself—refinishing and repairing furniture, collecting antique clocks, buying and selling old dining room sets—I found my calling. I did not like being a housepainter, and my store was not a great source of satisfaction, even though my customers, who knew me as Mike Kirsh, were very loyal. I raised three daughters, all with university educations and good professions, which is a great source of satisfaction. I was very happy to be accepted as a good sailor and to be sought after as a companion on camping trips into the bush way up north: I know how to survive in the wilderness, how to handle a canoe, how to set up camp and cook, and how to make an eight-hundred-yard portage with a thirty-five-pound backpack,

which is no mean feat considering that I am only five feet, two inches tall and, when I was younger, weighed just under a hundred pounds myself.

It is with my paintings that I have found the greatest acceptance of all. How satisfying, particularly at my age, to have found my calling. I feel that my paintings expose a whole new world that nobody knows except me, the friends of my youth (most of whom have passed away), and people from my town who survived the Holocaust. They know all about this world, so maybe it's not as important to them, especially after all they've been through. What I'm trying to say is "Hey! There was a big world out there before the Holocaust." There was a rich cultural life in Poland as I knew it at the time. That's why I feel I'm doing something very important by showing what that life was like. It's in my head: I will be gone, but the book will be here. They didn't call me Crazy Mayer for nothing.

T
he first time my daughter went back to Poland to visit my town, she asked me to come with her, but I adamantly refused. That was around 1981. A few years later, I changed my mind and asked her to take me back. We finally made the trip around 1990 and again in 1995. I looked forward with great anticipation to visiting my birthplace. My heart was pounding as we approached the town. On entering Apt, the first place I wanted to see was the place where I used to live. It was gone. Most of the block had recently been demolished. As I remember, ours was the only brick house on a block of dilapidated wooden houses. New houses were in the process of being built. I went to a few places. The visit made me very sad, literally ill. After five hundred years of Jewish habitation in Apt, there was not a single sign that Jews had ever lived there. I wanted to leave immediately. My daughter remarked, "All your life you dreamed of coming here and now you want to leave so soon?" I replied with a heavy heart, "Get me out of this sad place."

When I was a boy, there were horses all over the place, but no more. The population changed, the situation changed. In the town we had industry; now I could see no industry whatsoever. Opatów had become a sleepy bedroom community for people who worked elsewhere. That would have been unthinkable in the old days, when you had to go half a day to get anywhere. Everything was so far away by horse and wagon. I don't know if the mills were still operating, but the soap factory was gone, as were all the Jewish trades. There was no sign of the shoemaker or tailor. When I was a boy, they were all over the place.

On my second visit to Poland a few years later, I felt a longing to see the area again. As I was looking around, I approached a young man. In the course of our conversation, he asked, "Did you live at the Słupowskis?" I still speak fluent Polish. I replied, "Yes." He asked me to return in about an hour. His mother had always dreamed that some of the old people who used to live here would return. We waited and were invited to enter their humble home. The remarkable thing was that their place did not show any holy picture or icon. When I lived in Apt, every Christian home had such pictures. Instead, on the wall hung a huge red flag, with a picture of Lenin and the hammer and sickle. Someone had pinned a gold star to Lenin's earlobe. I asked them how they were doing financially. They answered, "Those who bought the houses and household effects of Jews became rich. We did not buy anything, so

we are not rich." They invited the man who bought Harshl *kishke*'s house to join us. He did not look very prosperous to me. He asked me, "Did you leave anything in Apt?" I answered, "Yes, poverty!" I went to visit Harshl *kishke*'s house. There had been two entrances to a courtyard where the well was: one entrance was from *Ivansker veyg* and the other was from Narrow Street. Now they were both locked from the street with padlocks, so I assumed the property was no longer occupied.

The young man that I met on the street escorted me to the Jewish cemetery. The townspeople had removed tombstones spanning the past five hundred years and used them to make floors for pigsties and stables. I was told the following story. About fifty Apt survivors in Israel—there were about a hundred of them there in all—decided to make a pilgrimage to Apt on the fiftieth anniversary of the expulsion of the Jews from the town. Mayer Lustman, a prominent citizen in Israel and a veteran officer of the Israeli army, is actively involved in Apt affairs. He wrote to the mayor of Opatów to inform him that the old Apt citizens would like to visit. The mayor replied that they would be welcome. However, the mayor was in a dilemma. There was not a single sign of Jewish life in Apt to show. During the war, the Germans had used the synagogue as a stable; after their retreat, some of the people living in Apt used it as a woodworking shop. When I first visited Apt in 1990, I was dismayed to learn from someone I met that the synagogue, having survived the war and the Communist regime, was dismantled by local residents, particularly farmers, who recycled the stone, bricks, and timber. However, the eastern wall of the synagogue did not completely vanish because it was attached to another building. You can still see traces of the circular window with a Star of David that used to be part of the eastern wall of the synagogue. It's hard to fathom how a masonry building like that could be destroyed. There is now a little park with a few small trees where the synagogue once stood.

The powers that be decided to make twelve monuments in the cemetery. They retrieved fragments of old tombstones from the *kanye*, where they had been dumped. They embedded these fragments, with their inscriptions, in concrete. However, since they could not read the Hebrew inscriptions, many fragments were placed upside down, and they had to redo the markers. When the pilgrims arrived, they were greeted by the mayor, the organist and priest, nuns from the local convent, city officials, and some citizens. The pilgrims said kaddish for the dead. City officials made a few speeches. After some singing and some congratulations, the pilgrims went to visit what remained, if anything, of their humble homes.

I was escorted to the cemetery by the people we got to know. It was now a park, with many trees and benches. There was hardly a sign that this area had ever been a cemetery, let alone

a Jewish cemetery. I was amazed at how huge the place was. Finally we arrived at the spot where they had erected the twelve monuments. The place was in disarray. Some of the markers had fallen down. Some were leaning. They were overgrown with weeds. I asked, "Was it not possible to maintain even these few signs of five hundred years of Jewish habitation in Apt?" My companion assured me that he would bring the matter to the attention of city hall and that it would be looked after.

Two of the people we met gave me a book about the seven-hundred-year history of Opatów. The young man showed a special interest in talking with us, especially when I showed him snapshots of my paintings of Jewish life before the war. He was eager to keep a few photographs, so I gave them to him. His family offered us the use of their apartment in Sandomierz, if we ever wanted to stay for a while. We kept in touch. The young man wrote to me that people in the town had found a few more original gravestones after the river flooded. They had been used to protect the riverbanks from erosion. They kept them in a basement to dry out and want to restore them. This young man got married and came with his wife to visit me in Toronto in 1999. How he got here was thanks to another Apter living in Toronto who visited Apt and stayed in their Sandomierz apartment. She later arranged an inexpensive ticket for the young newlyweds to visit Toronto. When I saw him in Toronto, he told me that everything we discussed when I was in Apt about the tombstones had been taken care of.

After I visited familiar places—the public school, the Jewish streets that I remembered, the buildings where my family had our shops, the place where Mandelbaum's factory once stood, the Opatówka River—we left for Drildz, my father's birthplace, by way of Ostrovtse. We stopped briefly at a hat shop. The merchant sold me something similar to a sailor's hat. When I asked for a bag for the hat, he said, "To this level of technology, we have not yet risen." He could wrap it for me in a daily or in a weekly newspaper.

Drildz has not changed much. The mountain is still there, as are the ruins of the ancient castle. At the base of the mountain my grandfather's house, built right into the mountain, still stands. The doors were yellow—I had never seen them yellow. The courtyard is now built up so there is no longer access up the incline to the stable and outhouse. I asked permission from an old woman to enter the house and look into the kitchen. It was a lot smaller than I remembered, perhaps because it was so cluttered. I asked the woman if she ever heard of the Kirszenblats. "Yes," she said, "I saw the name on documents I had to sign." She said, "I bought this secondhand," which means that she was not the one who took it after the war.

I told her, "The man had no right to sell you something that was not his." It is not hers. I have no intention of dispossessing her, but it will never be hers. She did all the talking. Her husband sat quietly. By the end, he started to shake. I didn't even bother going to the cemetery, which I was told is still there. The store that belonged to my grandmother burned down. The lot was empty, but you could see on the wall of the adjoining house the outline of the gable of the roof of my grandmother's store. We left Drildz with a heavy heart. I never returned to Apt again.

A DAUGHTER'S AFTERWORD

Dus epele falt nisht vat fin baymele.
The apple falls not far from the tree.

—YIDDISH PROVERB

I began interviewing my father in 1967. Is this the way to talk to a parent? If interviewing is "listening with love," I have been listening with love for four decades.[1] Of course, I was listening even before I began interviewing. As a child I listened to detailed explanations of everything from combustion engines to where babies come from. "The womb is a pear-shaped object," my father would begin. "Do you know how a car works?" he would ask. "What about the stock market?" And so it would go, especially during the drive from his paint and wallpaper store in downtown Toronto to our home in the suburbs. I still listen to my father's explanations. While driving across the Brooklyn Bridge during a recent visit to New York, he launched into an excursus on the engineering of suspension bridges.

Something happened in 1967, however, that was to change the course of our conversations forever. That November, during the Thanksgiving break, I came home with Y. M. Sokolov's *Russian Folklore*, which I was reading for a course. Sitting at the kitchen table, I read aloud from the chapter on funeral ceremonies: "In order to protect themselves from the return of the dead man, they would lay him out on a table or bench . . . invariably with his feet toward the outer door. . . . In the window, water was placed in some kind of vessel, and a towel was hung up, so that the soul of the dead man might wipe itself."[2] "Jews did that too," my parents remarked. Thus began the interviews that I was to conduct, with both my parents, for the rest of our lives.

My parents were born during World War I. My father grew up in Opatów (Apt in Yiddish), a provincial city near Kielce, and my mother, Doris (Dvoyre) Shushanoff, lived in the city of Brest-Litovsk (Brisk in Yiddish, Brześć nad Bugiem in Polish, and Brest in Belarus today).[3] Doris immigrated to Toronto with her family in 1929, and Mayer arrived in 1934. They met in Toronto and married in 1940. I was born two years later, during World War II, during which my father served in the Canadian army in the engineer corps. He was stationed in the Northwest Territories.

*Self-Portrait with
Mother, Father, and
Three Brothers*

Restrictive quotas enacted during the 1920s severely limited immigration to the United States, so Jews leaving Eastern Europe after that point settled elsewhere, many of them in Canada. Jews from my father's region concentrated in Toronto, where they formed hometown societies, or *landsmanshaftn*, and bought cemetery plots so they could be buried together. The immigrant neighborhood in downtown Toronto, even as late as the 1950s, was reminiscent of New York's Lower East Side decades earlier.

That was where we lived from 1947 to 1955, amid a host of Jewish institutions. Immediately across the street from our home on the corner of Cecil and Ross Streets were the *moyshev-zekaynim* (old folks' home) and the *folksfarayn*, a charitable organization that received and resettled recently arrived "displaced persons," as survivors of the Holocaust were known then. Their kids—I remember one little boy in a brown velvet outfit, with white ribbed stockings, his long curls not yet shorn—spoke only Yiddish, and that was the language in which we played. Up and down the street were *shtiblekh*, little prayer houses, in the converted ground-floor flats of brick houses. At either end of Cecil Street were grand synagogues: the *Ostrovtser shil* and the Henry Street *shil*. A few blocks away was the Kensington Market, with its Jewish bakeries, dairy stores, kosher butchers, fishmongers, and produce stalls.

Down the block from our house were Jewish schools, among them the *Farband-shule* (Labor Zionist) and the *Perets-shule*, a secular Yiddish school named for the great Yiddish writer Y. L. Peretz. A few blocks away was the D'Arcy Street Talmud Torah, a modern Orthodox school that admitted both boys and girls—and still inflicted corporal punishment.[4] These schools met five days a week: Monday through Thursday from four to six o'clock in the afternoon, and Sunday from ten o'clock in the morning until noon. I moved from one to the other and was not happy in any of them. The best part of Orde Street Public School, also a short walk from home, was night school, which my father and I attended together; while I learned to sew pleated skirts and reversible vests, he took a landscape painting class.

As I approached adolescence, my parents thought it best to move "up north" to Downsview, a brand-new suburb. Our house was still under construction when we first visited it, and the streets were still unpaved. This was another world altogether, too quiet and remote for my liking. The moment I could, which was during my second year at the University of Toronto, where I was an English major by default, I moved right back downtown and rented a room within a block of where we had lived when I was a child. A decade later, I made my home on New York's Lower East Side, just as such legendary institutions as *The Forward*, the Garden Cafeteria, Metro Music, and the Hebrew Publishing Company were closing or moving elsewhere.

A year after I married Max Gimblett in 1964, he decided to study at the San Francisco Art Institute, and I transferred to the University of California, Berkeley. It was there, in 1965, that I found my calling. This occurred quite by accident, when, as a senior, I enrolled in Introduction to Folklore, taught by the legendary Alan Dundes, to fulfill a breadth requirement in the social sciences. Here, at long last, was a discipline that would let me bring all my interests together. Here was a field that valued what was extraordinary in "ordinary" people, celebrated the oldest members of a community, and appreciated their accumulated wisdom, deep memory, and creative capacities late in life. This is how I discovered my own family and came to prepare for their aging.

That day at a suburban kitchen table reading passages from *Russian Folklore* led to a survey of Yiddish folklore in Toronto for the Canadian Centre for Folk Culture Studies at the National Museum of Canada (now the Canadian Museum of Civilization) and a doctoral dissertation on traditional storytelling in the Toronto Jewish community directed by Richard M. Dorson at Indiana University's Folklore Institute. As I learned more about the history of my chosen field, I found myself staring into an abyss. An entire generation of Yiddish folklorists had perished in the Holocaust. I decided to dedicate myself to bridging that chasm through my research and teaching.

During those years, the late 1960s, my mother was more responsive to my questions than my father, who was busy running a business, six days a week, ten hours a day. He was younger then than I am now, and he had precious little time to pursue his own interests—bushwhacking and sailing—let alone answer my questions. He was generally exhausted by the time I got to him at the end of the day and proved an unenthusiastic, though not uncooperative, "informant." Besides, I was competing for his attention with my two younger sisters, Elaine and Anne.

In 1975, Mayer suffered a serious illness that was to change the course of his life. He was only fifty-nine years old. Fearful of the responsibilities that would land on my mother's shoulders were he to fall ill again, he sold the business and retired early. He was now at loose ends. He collected clocks; we said he was hoarding time. He repaired and refinished antique furniture. He and my mother bought dining room sets at auctions; Mayer fixed them up and Doris resold them. Nonetheless, Mayer sank into a deep depression, which was unusual for him. This one lasted three years. We were very worried. I continued to interview him.

I also started encouraging (and then imploring) him to paint what he could remember of his childhood in Poland. But, despite my pleas and those of my mother and Max, he refused.

When I first started interviewing Mayer, not only was he busy but also, he insisted, Poland was a bad memory, so much so that he would not join me when I made my first trip to Poland in 1981. A few years later, he had a change of heart and we returned to Poland together. As we approached Apt, toward the middle of our itinerary, it became clear that Mayer was apprehensive. He had planned on one roll of film for the entire trip and had allowed fifteen minutes for Apt. During my first visit, his house had still been standing, though I never drummed up the courage to enter the courtyard. This time, however, we were too late: his childhood dwelling had been demolished, and a new building was under construction.

For the next several years, the campaign continued. Max supplied Mayer with paper, pastels, brushes, paint, canvas, and easel. These were his birthday and Father's Day gifts for almost ten years. But to no avail. The supplies accumulated in a closet, untouched. My mother was unrelenting. In desperation, she signed Mayer up for art classes at the local community center. When he protested, she told him flatly that, since she had already paid for the classes and the fees were not refundable, he had no option. He attended the first few classes but was unhappy: the nude model in the drawing class changed poses too quickly, and the still-life class was dull. His sketchbook is filled with charcoal drawings of onions and green peppers and the occasional sketch by the instructor, the sort of thing one might find in "how to draw" books. The results were disappointing, and he was frustrated.

I continued to urge him simply to paint from memory without worrying about "technique." I knew that he could do it. I knew, not only from the interviews but also from my childhood, that he was endowed with an unusual visual intelligence. When words failed, he instinctively turned to pencil and paper. With a quick diagram, he would clarify a spoken explanation. I also knew that he was artistic. There were the two little landscape paintings from that night class he took in the 1950s at my public school. There were his interior decorating skills: he knew how to stencil walls and make any surface look like the wood of your choice—I once watched him grain enormous church doors. The beautiful bedroom that I shared with Elaine was the result of his handiwork: he painted the walls a deep royal blue and sewed the bright yellow curtains and matching bedspreads (the quilted tops had a circus pattern and the flounces were the same fabric as the curtains). When my mother envied the gathered curtains—they're called Austrian shades—that her brother had, my father made some for her. He was just plain good at making things, and we were the beneficiaries. He made me wooden educational toys. He showed me how to stencil Valentines and how to use toothpicks to make a scale model of an Iroquois village for a class project. But when it came to painting from memory, he was filled with doubt.

The turning point came in 1990. We had been touring New Zealand in a rented car, Max driving, me beside him, Mayer and Doris in the back. Max is a New Zealander, and we had always dreamed of taking my parents around the country. While driving in torrential rain through a gorge, with the road falling away, our hearts racing and our knuckles white, I overheard Doris murmur: "Mayer, why don't you paint the kitchen? Do it for Barbara. She'll use it in her work." Doris knew that, of all the scenes Mayer had described to me over the years, my favorite was the kitchen. Little did we suspect that for the rest of the trip through New Zealand's alps and fiords and temperate rain forests, without saying a word to anyone, he was imagining, in his mind's eye, exactly how he would paint the kitchen of his childhood.

As soon as we returned home, Mayer made a pencil drawing of the kitchen, then a watercolor, and finally an acrylic painting on canvas board. A few weeks later, Elaine and I catered a party for our parents' fiftieth wedding anniversary in her home. Mayer brought his easel and propped up the watercolor. Buoyed by the many compliments and his own amazement at what he had done, he began painting in earnest. He converted a room in his split-level bungalow into a studio. The moment he completed a painting, he brought it into the living

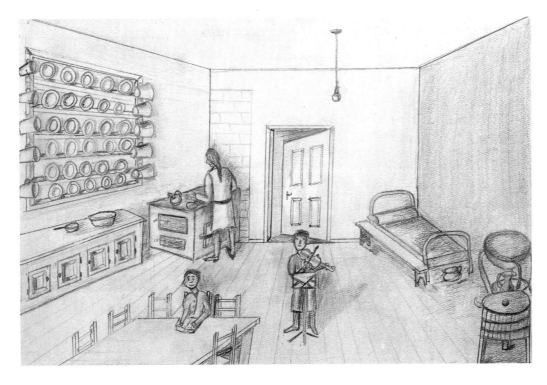

Kitchen, the Very First Drawing

room and looked at it for several days. Gradually, he covered almost every wall of the house with paintings. As the artwork accumulated, he converted another room into a storage area and Elaine's husband, Marvin, built racks to hold it. The bedrooms that Anne, Elaine, and I had once occupied were now full of paintings.

Doris encouraged friends and family to come to the house to see Mayer's paintings. She would serve tea, coffee, and cookies she had baked, and Mayer would take the guests from room to room and narrate the paintings. These little salons were her way of building Mayer's confidence, she explained. In short order, Mayer was exhibiting his work and giving slide lectures for schools, synagogues, community centers, hospitals, nursing homes, and senior centers as well as for university classes and Yiddish cultural programs.

People started asking to buy paintings. Mayer was heartened by the interest, and Max stressed the professional satisfaction that would come with sales. I insisted that the collection had to stay together forever, and, to prevail, I proposed that Mayer make limited-edition prints that he could sell. Max made arrangements at the Printmaking Workshop in Manhattan, estab-

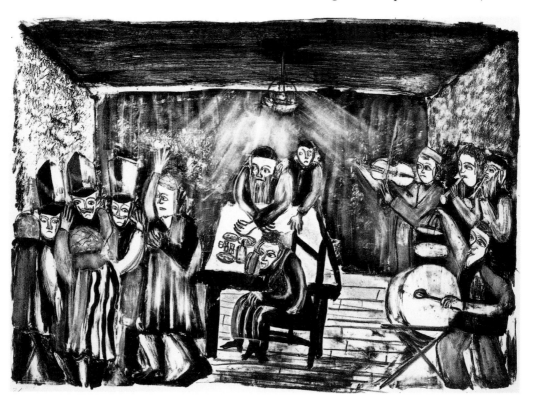

Purim

lished in 1948 by the visionary African American artist and master printmaker Robert Blackburn. Mayer came to New York for a week and, with a minimum of technical advice, made lithographs on stone and metal plates on his favorite themes: Purim, shaving the corpse, the water-carrier, the porter, and even a pair of lovers under a tree. He would later hand-color some of the prints. He was intrigued by the printmaking technologies, just as he had been fascinated by the goldsmith and the watchmaker in Apt.

As Mayer continued to paint and print—he later made engravings on his own in Toronto—and as we continued to talk, our way of working started to change. Not only had he become more receptive to being interviewed, but what had started out as my project was finally becoming his project. I soon realized that most of our interviews had been recorded before Mayer started painting, and I began taping his slide lectures—in English, Yiddish, and Polish. Then, in 1995, when we were in Kraków together for five weeks, we embarked on a new set of interviews. This time, with snapshots of the paintings before us, we talked about each and every painting that he had done.

Mayer had also started writing. In 1994, when he exhibited his work in a solo exhibition at the Koffler Gallery at the Bathurst Jewish Community Center in Toronto, we needed to prepare captions quickly. It was impractical to do this from New York, because I needed to interview him in front of the paintings. He soundly rejected the proposal that he just talk into a tape recorder to himself. Elaine, who was helping him with the exhibition, had the inspired idea of asking him to write the captions himself, which he promptly did. These little written versions of his stories had a charm of their own, and, from that point on, I encouraged Mayer to write down what he could, however brief, even on topics we had already covered in interviews.

I would take a stack of paper, twenty or thirty sheets at a time, write a keyword on each sheet—railroad, electricity, poppy seeds, goose feathers, laundry, radio, cars, clocks, water, shoes—and ask Mayer to free-associate and write down what came to mind. These concise texts often contained a little diagram or sketch—the flag that the Communists used to throw so it would wrap itself around the electrical and telephone wires, the little trough in which the goldsmith melted metal, or the belt with which his *khayder* teacher Moyre Simkhe beat one of his schoolmates mercilessly. So memorable was this beating (it left blue welts on the boy's back) that Mayer included a little drawing to show precisely how the leather was attached to the brass ring that made the welts.

THE COMINIST PARTY

THE ONLY POLYTAL PARTY THAT WAS
PROSOCUTED WAS THE COMUNIST PARTY
THEY OPARATED IN GROUPS OF. OF 5. SO IF THE
GOVERNMENT COUGHT ONE AND SEVERY
INTEROGATED. HE COUL ONLY INFORS ONLY. SENTECES
WERE HARSY. THE COMUNIST WERE SENTENSED
TO ŚWIĘTY KRZYL. WHERE THE MOST HARDENED
CRIMINALS WERE SENTENCETO TO.
BUT I BELEIVE THAT POLITICAL PRIZONERS
WER SEGREGATEY
THE MOST COMMON ACT OF PROTEST. WAS
TO HANG A RED FLAG. THE FLAG WAS
ABOUT 12"X24 WITH A STICK INSERTO ON
THE 12" SIDA ATTACHED A STRING ABOOT
24" LONG WIT A STONE AT THE END
TROW IT ON ELECTRIC OR TELEPHONE WIRES
TIT STONE WOULD WRAC ITSELF AROUND THE
WIRE ANO IT WOULD HANG. AND WOUL BE
VERY DIFFICULT TO REMOVE

*Communist
Flag*

Water in the winter

AS I MENTIONED BEFORE THERE WASNT MUCH TIME PLAY
SO WE TOOK EVERY OPPORTUNITY
THIS HAPPENED ON A HOT SATURDAY AFTERNOON, NOT EVEN SATURDAY
WAS FREE COMPLETELY FREE. I HAD TO RETURN TKHEIDER. AT 3 AM
TO LEANRN AND RECITE PERKEY AJOT PARIK FOR SHORT.
THAT SATURDAY AFTERNOON WE DECIDET TO GO TO TE TORGOVISGO
THE LIVESTOCK MARKE AREA AND PLAY SOCCER
WE GOT SO ENGROSSED IN THE PLAY WATCHES WE DIDN'T HAVE
THAT WE FORGOT ABOUT KHEIDER. THE TWO TEACHERS MOIRE BERMAN
AND MOIRE SYMKHA WERE WAITING WITH PRACTICALY EMPTY
CLASSROOMS. THE GOT TOGETHER FOR A CONFERENCE. AND CAME TO
THE CONCLUSION. WIHERE WE ARE. THERE WERE TWO ENTRANCES TO
THE GROUNDS ONE TEACHER TOOK ONE ENTRANCE. EACH.
WE SAW MOIRE SYMCHA FIRST A HEW AND CRY WENT UP EVERYBODY
RUSHED FOR HIS BUNDLE OF CLOTHES FOR WE WERE STRIPPED TO THE
WAIST IT WAS A HOT DAY. WE ALL RUSHED TO THE UPPER EXIT.
WHERE WE ENCOUNTERER MOIRE BERMAN. WE WERE TRAPPED
WE WERE MARCHED BACK TO OUR RE RESPETIVE KHEIDERS
USUALY AFTER THE LECTURE THE TEACHER USE TO TELL US A STORY
BUT THIS TIME NOT STORY WE WERE SUMMERILY DISMISSED WE WENT
HOME WORRIED WHAT FAITH AWAITS US
NEXT MOANING WE WENT FOR PRAYERS. USUALY AFTER PRAYERS ON SUNDAY
WE WENT HOME FOR BREAFAST. THIS TIME WE WERE FORBIDDEN
WE WAITED AROUND UNTIL NOON. AND THE YOUNSTERS LEFT
THAT AFTERNOON RATHER THAT TEACHING. IT WAS EXAM TIME. WE WERE
LEARNING THE THE TALMUD BABA BEIA. THE FIRST BOY TO START
TO RECITE THE PORTION WAS PINKHAS CZERNIKOWSKI, HE WAS A VERY
STUBBORN BOY. HE PUT HIS ELBOW ON THE DESK HIS HEAD RESTING
ON HIS PALM AND REFUSED THE ORDER THIS INFURATED THE TEACHER
HE TOOK OFF HIS BELT WHICH WAS CONNECTED IN THE CENTRE BY
A STEEL RING ⊏━━━━◻━━━━⊐ HE KEPT HITTING HIM ON THE ARM
EACH TIME LEVING A RING MARK ON THE BOYS ARM. HE THE BOY DID NOT
GIVE IN HE GOT SO ANGRY MAD THA HE STARTED HITTING EVERYBODY
AT RANDOM AL GREEN MAILECK KATZ AND I SET ON THE SAME BENCH

p. 44 C:\WPDOCS\ESSAYS\MK\NEWTOPIC May 5, 1996

I WAS SITTING THE FIRST ISE SEAT AT THE PASSAGE I TRIED TO HIDE
BEHIND THE DESK EXPOSING MY BACK. HE HIT ME THREE TIMES
AND HAD THREE BLUE MARKE 6" TO 8" LONG ON MY BACK. I GOT THO WORST.
OF IT OVER

Beating

As I began to compile the manuscript from the transcribed interviews and Mayer's pithy writings, I decided that the text for *They Called Me Mayer July* would be entirely in Mayer's voice and that its structure would arise from an internal logic, yet to be discovered, in the tangled network of stories and images that he had created. What resulted is more picaresque than bildungsroman. *They Called Me Mayer July* is episodic: it is made up of spare anecdotes told in the "realm of living speech," digressions into the practical workings of the world, and loose associative links. It is through their "chaste compactness" that these stories achieve their amplitude. This is Walter Benjamin's art of the storyteller: "the man who could let the wick of his life be consumed completely by the gentle flame of his story."[5]

Once the manuscript was organized, I asked Mayer to read it and to mark whatever needed fixing. We then sat at the dining room table, day after day, going through the text page by page. Mayer would fill in gaps, puzzle over inconsistencies, clarify points, or elaborate descriptions. Sometimes he would dictate and I would take down his words; other times he would write a paragraph that I would incorporate and read back to him. Or we would simply do another interview. When Mayer was uncertain, he would telephone his Apt friends in Toronto and New York, especially his childhood buddy Maylekh Katz. Sometimes they would come by the house and reminisce together. This was a process that we would repeat each time the entire text had been revised. Watching Mayer absorbed in reading the manuscript as we worked together, I would ask him, "How is it?" Looking up for a moment with obvious delight, he would say, "It reads like a novel."

When I say that *They Called Me Mayer July* is entirely in Mayer's voice, I mean to distinguish this book from such works as Art Spiegelman's rightly celebrated *Maus*, which is structured around "the story of the story"—that is, around the process of creating the work. *Maus* shows both parties to the collaboration in conversation, overtly representing their relationship and way of working together. Indeed, for Spiegelman, "the story of the story" is the story.[6] This is decidedly not the case in *They Called Me Mayer July:* here, the story is the story. Nonetheless, to say that *They Called Me Mayer July* is "entirely in Mayer's voice" is not the whole story because the text is anything but a monologue. Quite the contrary: it is profoundly dialogic, but without our forty-year conversation appearing as such in the text.[7]

In *They Called Me Mayer July*, the voice of the text is the voice of our collaboration. There were many other ways we could have composed this text. I could have told Mayer's story in the third person.[8] I could have written in my first-person voice and quoted him.[9] I could have preserved the form of the interview.[10] Or, in the manner of Charlotte Salomon, we

could have matched a sequence of images to a sequence of discrete texts.[11] We chose instead what anthropologist Barbara Myerhoff calls the "third voice," which she explains as follows: something new, a "third person," is created "when two points of view are engaged in examining one life."[12] That voice can be heard in the text's orientation to the listener: "the authorial word enters the other's utterance from the lived subject position of the listener, that is, as if it were a gift of loving attention."[13] For Myerhoff, who developed these ideas while working on *Number Our Days,* a book and film about elderly Jews living in Venice, California, listening is an ethical stance; it is essential to what she calls "growing a soul."[14] The third voice that emerges from the listening relationship is realized textually through an approach to editing that she calls "soulwork." [15] To be present in the text as a listener is not an act of self-effacement but one of intense attentiveness.

Mayer is from the "tribe of storytellers" who stayed at home.[16] His stories are about everyday life in the place where he lived as a boy. But, with emigration, the Holocaust, and the passage of time, home became a remote place, and he joined the tribe of storytellers who bring news from afar. Not everything that Mayer remembered from that other world became a painting. He started with the kitchen because that was the room I was most interested in and, initially, he painted it for me. "After doing the kitchen," he explains, "I painted other scenes from inside my house and then I painted what happened outside my house with other people." He moved from there to the courtyard, the street, the marketplace, the river, the countryside, and other towns—such as Iłża (Drildz), his father's birthplace, and Ostrowiec (Ostrovtse), the nearest train station. The geography of his painted world expanded to include school outings to historic sites in the environs—the twelfth-century Benedictine abbey at the top of Święty Krzyż mountain, and the imposing ruin of Krzyżtopór, a seventeenth-century castle—and a famous porcelain factory in Ćmielów.

Mayer also worked in series. After doing the shoemaker, he went on to all the other trades; he did the same for the holidays and life-cycle events. Or he organized his subjects in sequences. Having shown Jadwiga washing the laundry in a wooden tub, he painted each subsequent step: rinsing the laundry in the stream, stealing the laundry, redeeming the laundry from the local mafia, and pressing the linens with a mangle. He painted episodes within a story: one painting showed a young man driving a stake into a grave in the cemetery at midnight on a dare, and a second one showed him dead, slumped over the grave, the next morning.

As Mayer exhausted the memories that first came to mind, his search for new subjects took him to the orchard, where teenagers would gather on a Sabbath afternoon in nice weather, and to intimacies that fathers do not generally share with their daughters. But I was now older than he was when I first started interviewing him in 1967, and no subject was off-limits, neither in his paintings—whores appear in several market scenes—nor in his accounts of adultery, promiscuity, and his own early sexual experiences.

New topics for paintings and interviews continue to arise. A severe Toronto winter prompted us to note that the eternal season of Mayer's Apt is spring and summer. We needed some winter paintings for the winter stories in the book. The result, in late 2004, was a series of lyrical winter scenes: skating on a frozen pond, sledding down a steep street, and riding in a horse-drawn sleigh. Soon after, in 2005, Mayer completed a painting of the annual arrival of a gypsy caravan in Apt, another of Buchiński's inn, where gypsy musicians used to play, and still others: the Polish Boy Scouts marching down the street; Tisha b'Av, a day of mourning when Jews visit the graves of their relatives and mischievous boys throw burrs at the girls; the circus that used to come to town; his granduncle's corpse lying on the wooden washing board as it is being cleansed for burial; and the ship's passage to Canada, among others. As this book was going to press, Mayer painted his summers at Planta and Niekłań, where his family was in the forestry and timber business. He recently made his very first paintings set in Canada, all of them nature scenes from his army days in the Northwest Territories and his fishing expeditions in northern Ontario.

It is to Apt, however, that he always returns. Thanks to the paintings, the Apt of memory was acquiring scale and light and, above all, that intangible quality of lived space. Until Mayer's paintings, all my images of Jewish life in Poland were black and white because all of them were from photographs. I had the privilege of working with the collection of 15,000 photographs of prewar Polish Jewish life at the YIVO Institute for Jewish Research during the 1970s, when I collaborated with the late and beloved Lucjan Dobroszycki on *Image before My Eyes: A Photographic History of Jewish Life in Poland, 1864–1939*. That world, thanks to Mayer's paintings, was now emerging in vibrant color.

For Mayer, Apt had become a memory palace. On an imaginary walk through the streets of Apt, Mayer would call forth the memories attached to each of the city's topographical features: the old city gate, the church bell, the World War I monument, the marketplace, the military latrine, the synagogue, his father's leather store, his grandmother's grocery, the cemetery. As he literally filled in the picture, painting after painting, I started to feel myself

inside the town, walking down its streets and entering its rooms. I needed to orient myself as a walker in the city and to ensure that the reader would be able to do the same. Mayer drew maps and took me through each street, house by house. He brought me into the courtyards, and together we moved from one apartment to another, precisely locating people and events.

There was another map at work as well, a map that children improvised when they ran around town with their hoops, floated paper boats in the gutter after a rain, and sledded down an icy street. In the absence of playgrounds and toys, besides the ones he made for himself, the entire town and its environs were there for the playful taking. Mayer's account of the Opatówka River, which runs around three sides of Apt, includes not only the water mill and the shallow area where women rinsed the laundry but also the *shlizhe*, where boys slithered down a mossy wood slide along a steep drop in the riverbed, the *kanye*, a deep pool in the bend of the river where they swam, and the opening to the carp millpond, where they used to catch minnows.

Above all, Mayer's maps are about where things were done. Although he had elaborated on the "doing" in our interviews, it was not until he began painting that the "where" emerged in all of its dimensionality. The stories now occupied space in a way they never had before. What had been locations indexed in a kind of shorthand—the cemetery, the military latrine, the *khayder*, the market, the inn—were now spaces, and they were filled with objects and people and activities and information, much of which had never made it into the spoken stories.

In this way, we built a scaffold that became the conditioning context for remembering. The paintings became our compass, putting things in relation to one another in space better than spoken descriptions could. When someone's name came up, Mayer could now say, "You know, the kleptomaniac, they lived near the mill," as if I too had grown up in Apt.

How did Mayer come to know so much about his town and everything that went on there? How was it that he could describe in exquisite detail how to bridle a horse, press bed linen with a mangle, or make a brush, a barrel, or rope? How did he learn all about tanning leather, inflating cow bladders, extracting oil from rapeseeds, or harvesting carp? Not until I noticed a discrepancy between the seven grades of school he completed and his age at graduation—he was one year older than he should have been—did I understand. With a little prodding, Mayer confessed that he had failed a year of school. Though an avid reader, proud of his command of Polish, and obviously intelligent, he had never considered him-

How to Bridle a Horse

self a particularly good student. "You failed a year of school?" I exclaimed in disbelief. "Yes," he retorted. "How do you think I got to know about everything in Apt? I played hooky! That's how I know all about the blacksmith, the chimney sweep, and the mason. That's how I know how they bred livestock, put out fires, and paved roads."

Mayer has a way of knowing the world that is breathtaking. He is my Diderot, Melville, and Rabelais. Roland Barthes, writing about Diderot's great eighteenth-century *Encyclopédie*, remarked that the optimism of this prodigious work—the idea that everything about the world could be known and contained within its seventeen volumes of text and nine volumes of illustrations—derived at least in part from the transparency of an artisanal and mechanical universe about to be transformed by the industrial revolution.[17] One could actually see how things worked. The same could be said of Mayer's town—a small world intensively observed—except that it was not industrialization, but the Holocaust, that ultimately transformed Apt. Today, Opatów is a quiet bedroom community of commuters whose occupations are to be found no longer in the workshops, small factories, and once bustling marketplace but in nearby cities and the countryside. The economy of the region continues to depend on agriculture, industry, and small and medium-sized businesses, while rural occupations and traditional handicrafts are now the focus of heritage tourism initiatives intended to revive the local economy. In 2000, an environmental partnership launched what it hoped would be an Opatów Fair featuring local products and specialties from along the "Amber Trail." This effort to reinvigorate a historical trading route is imagined as a return to Opatów's more vibrant economic past: "So let Opatów's Warsaw Gate welcome visitors, merchants, traders, farmers from far and wide and let Opatów once again be known for its famous Fairs."[18]

Apt's markets are vividly remembered in Mayer's paintings, as are the techniques for making many of the things that were sold there. Like the plates of the *Encyclopédie*, Mayer's paintings offer a tableau of the total scene, whether the workshop of the tailor or the smithy, and, like the step-by-step illustrations in the *Encyclopédie*, Mayer's drawings show each stage

in making a shoe or casting a lead *dreydl*. Just as the *Encyclopédie* enumerates the many trades, so too does Mayer in his descriptions, drawings, diagrams, and paintings of how to make cabinets, harnesses, barrels, bricks, and wigs. He learned some of these things in school: how to bind a book; how to draw perspective; how to make a coat hanger. He learned other things through apprenticeship, such as how to install electricity. Most things he learned from close observation of craftsmen at work: the cobbler who lived next door; his school chum Maylekh, who inflated cow bladders and stretched animal skins; the Trojsters, who uphol-stered furniture and repaired saddles in their front yard when the weather was nice. When his father ordered a bedroom set, Mayer watched the carpenter at each stage of the process. Delight in how things work—"in the pleasure taken in observing process"—is what Neil Harris calls the operational aesthetic.[19]

"It is perhaps in the artisan that one must seek the most admirable evidences of the sagac-ity, the patience, and the resources of the mind," writes Jean Le Rond d'Alembert in his "Preliminary Discourse to the Encyclopedia of Diderot," which appeared in 1751.[20] This too was Mayer's philosophy. With the town as his classroom, Mayer pursued a self-designed curriculum of gestural knowledge, embodied intelligence, and know-how connected to tools,

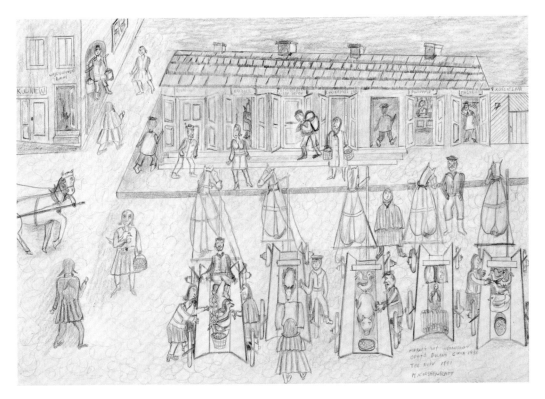

Market Day outside My Home on 7 Kościelna Street

materials, processes, and workspaces.[21] Such informal learning is in the best tradition of soft mastery, which proceeds by watching and doing, trial and error. Soft mastery is the opposite of knowledge abstracted into textbooks and transmitted in the classroom through systematic instruction.[22] Yet, when this inquisitive boy appears in the paintings, as he often does, it is always in his blue "uniform," a reminder of the hard mastery of the school classroom— even when he is playing hooky. Today, in the unique world created by his paintings, the boy in blue who helps the smithy with the bellows or watches the brushmakers through a window has also become a child witness to a remembered world.

Above all, what Mayer knows, he knows in relation to people. What he presents are not simple facts. They are *felt* facts. The tailor is no generic tailor but *der amerikaner shnader,* the American tailor, because he spent some time in America and brought the latest fashions back to Apt. But that is not all. He had a hunchbacked daughter whose wedding, moments before she was about to give birth, is another story and another painting. The cobbler is no typical cobbler. All his sons died at birth except the last one, who was dressed in white pajamas—until the day the Nazis took him to his death—because his parents hoped that the Angel of Death would be fooled by the white clothing, which looks like a burial shroud, think he was dead, and overlook him. The brushmaker had a callus the size of a silver dollar on his chest from a lifetime of pressing his body against the boring machine. And, while Mayer remembers in detail how the watchmaker repaired timepieces, what he recalls most vividly is his phobia of cats. This is a world not only to be known but also to be felt. It is the affective charge that gives to memory its luminosity.

Unlike the *Encyclopédie,* Mayer has not taken the world apart at its joints to create an inventory and alphabetical catalog. True, he has made drawings of objects—a tin whistle, a willow *shoyfer*—in stages, from start to finish. More often, tools and processes and things are embedded in a densely textured social world, one that he remembers associatively and that opens up like a flower with each telling. Thus, *Boy with a Herring,* a self-portrait, occasions an anatomical description of each element of Mayer's public school "uniform," starting with the hat, proceeding to the collar, the plus fours, and finally to the red ski boots with their brass eyelets and yellow laces and the two pairs of socks, one pair rolled down. But the boy in this uniform is also carrying a herring, which prompts an equally detailed account of everything from the preciousness of newspaper to licking the dripping brine and recipes for making a piquant sauce from the herring's sperm. But that is not all. It was in this outfit that Mayer, on his first day in Toronto, chased a fire engine. He gave up after about a mile, when it dawned on him that Toronto must be bigger than Apt.

Jennifer Romaine, a wonderful theater artist who has collaborated with Mayer on a toy theater, *The White Pajamas*, based on his stories and paintings, commented that Mayer's minutely detailed descriptions—how, after the kitchen floor was scrubbed so many times with a special cleanser, it acquired the sheen of burnished ivory—reminded her of Moby Dick. There was nothing about the great whale that did not fascinate Ishmael (and Melville), and there is nothing about Apt that does not fascinate Mayer, whether it be how to make mortar or cure hides. The first chapter of *Moby Dick* opens with Ishmael instructing the reader to "circumambulate of a dreamy Sabbath afternoon" the island of Lower "Manhattoes," precisely the place where I am writing these words. What will the reader find? "Mortal men fixed in ocean reveries." Mayer, who for many years used compass navigation to sail the Great Lakes, crosses an ocean of time. The reveries of his childhood world also include a whale, the Leviathan of the Messianic banquet, which is the subject of several of his paintings.

Mayer's capacity to describe in detail is matched by my own fascination with the fine grain of his memory. I am my father's daughter. As a teenager, I spent months teaching myself the intricacies of the card loom, ancient precursor of the Jacquard loom and the computer. I spent an entire summer learning complicated Inuit, Bella Coola, and Torres Strait Islands string figures. Until my very last year of high school, I contemplated a career in home economics—to the patient consternation of my father—because I thought, mistakenly, that I would be spending my days cooking and sewing, not doing food chemistry in a laboratory. Knowing how things work—and knowing how to make them work—is a joy that I share with Mayer, and some of the fine detail in *They Called Me Mayer July* has more to do with my obsessions, food being one, than his. But to take pleasure in *explaining* how things work, you need a partner. I am that partner. Together, we explored all the parts of the whale that is Apt.

"I always go to sea as a sailor," writes Ishmael. This could be said to be Mayer's philosophy. He has often said of himself that he is a doer, not a watcher; he likes to be a participant and active observer, not a voyeur. He says he has no imagination, by which he means that he is more interested in the "made" than in the "made up," although he has painted angels, ghosts, and mythical beasts. He describes himself architecturally as a "storehouse of memories," and while he says he can only paint what he remembers, his idea of memory is capacious enough to include legends that he heard as a child or read in the Apt memorial book about the Jewish consort of King Kazimierz the Great, the monk who encountered a

stag in the forest with a fragment of the cross caught in its antlers, and the shaving of the corpse. He has also painted events he never witnessed but only heard about, notably the execution of his parents' families by the Nazis, a subject he was only able to tackle after seeing Goya's *The Shootings of the Third of May, 1808*, at the Prado. After standing in front of that painting for almost an hour, Mayer turned to Max and said, "I know now how to paint what happened to my father's family."

Mayer's disclaimer notwithstanding, memory and imagination go together. His capacity to find the extraordinary in the ordinary is the form that his imagination takes. We might call this kind of imagination extrospective because it is more concerned with the palpable world than with interiority. In this respect, *They Called Me Mayer July* is an instance of what Paul John Eakin calls the referential aesthetic.[23]

What makes Mayer's stories memorable is precisely that they do not force "the psychological connection of the events" on the reader (or the listener); this is a hallmark of the art of the storyteller as Benjamin understands it.[24] When Mayer says, "What I am trying to do basically is not to glorify myself but to portray life as it was," he points to what makes *They Called Me Mayer July* an extrospective autobiography. It is a prime example of the "dependence of the self for wholeness on its surroundings," in John Dewey's words.[25]

Mayer's account differs from the autobiographies that the YIVO Institute for Jewish Research had hoped to solicit from Jewish youth in Poland during the 1930s through a series of autobiography contests.[26] What YIVO wanted were autobiographies that would yield insights of psychoanalytic value, the better to understand a generation that in many cases saw little hope for a future in Poland. The more introspective, the better. Mayer could easily have been a contestant; he was in Poland at the time and the right age to enter the contest. But would he have won a prize?

And is *They Called Me Mayer July* an autobiography, strictly speaking? If, as Elizabeth Bruss states, "There is no intrinsically autobiographical form," what kind of autobiography is *They Called Me Mayer July*, particularly when Mayer asserts, as he often does, that his project is about Apt, not about himself, and that all such towns were pretty much the same?[27] This kind of autobiography, which gives precedence to the world in which Mayer lived, is what I am calling extrospective; others have called it autoethnographic because of its strong documentary impulse and focus on daily life. Although many examples of such autobiographies can be cited, to mention only those of Henry Louis Gates, Jr., and Zora Neale Hurston,[28] Jewish autobiography has been characterized not only as a late flowering within the history

of autobiography more generally but also as decidedly not in the confessional mold of St. Augustine and Jean-Jacques Rousseau, which have traditionally defined the genre. It follows, some have argued, that many Jewish autobiographies are therefore not autobiographical because their focus is "not upon the self of the author but upon the community, the first-person singular of the autobiographical narrator being, in effect, a trope for the first-person plural of the collective."[29] Given that all autobiographies are relational and that they can take any form, *They Called Me Mayer July* may not look like Rousseau's *Confessions*, but that does not make it any less autobiographical.

Moreover, the distinction between extrospective and introspective, while useful, quickly dissolves, for the material world as lived has a way of exceeding its concreteness: "A house that has been experienced is not an inert box,"[30] as Gaston Bachelard writes. The experienced house, however extrospectively described, has the capacity to "become the topography of our intimate being." Notice the doorways and windows in Mayer's paintings, which often open to mysterious spaces rather than to precisely defined locations in Apt, suggesting a psychic topography yet to be charted, in an affective territory that is at once oneiric

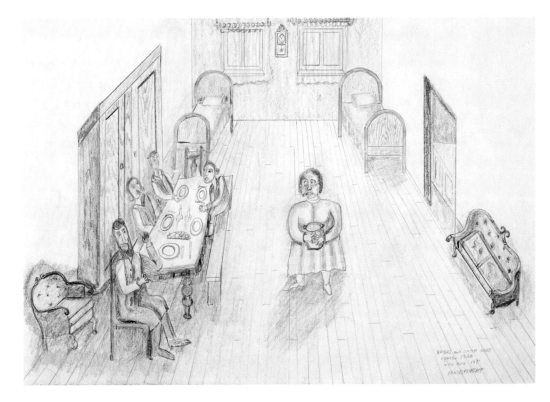

Saturday Dinner at Grandmother Shoshe's

and foreboding. For all its discomforts—damp walls, frigid winter nights, the outhouse, no running water—the house in which Mayer grew up is described in fine detail in painting after painting and story after story: the stenciling of the walls, construction of the oven, repair of the ceiling, and working of shutters and locks. By day and by night, whether viewed from the front door or from the opposite direction, Mayer's home is a vital space intensely inhabited. In Bachelard's words, "by remembering 'houses' and 'rooms,' we learn to 'abide' within ourselves."[31]

Mayer's way of knowing the world may account in part for his ability to remember, for there is something intrinsically mnemonic about his bodily engagement with an intelligent material universe. Its relational logic makes it memorable, whether the articulation of parts, the workings of a mechanism, the entailment of steps in a process, the arrangement of things in space, or the connection of a thing, process, or space to a vivid person. There is also something intrinsically mnemonic in his ability to see the potential for a good story in the vicissitudes of daily life and idiosyncrasies of those around him and to organize experience into crisp vignettes. Even his descriptions of things, tools, and machines are narratives, and they too are endowed with a poetics of their own—if we agree with Barthes, writing about the images in Diderot's *Encyclopédie*, "to define Poetics as the sphere of the infinite vibrations of meaning, at the center of which is placed the literal object."[32]

I had heard many of Mayer's stories many times. When you talk for forty years about the same subject, vast as it might be, "repetition" is inevitable. Children and folklorists prize repeated tellings. Trained to value all the versions and variants equally, I accumulated many tellings during our conversations over the years. When Mayer painted the same subjects several times, it was either to "replace" a painting that he had given to a family member or to "improve" on a previous version, contrary to the received wisdom that the work of self-taught artists does not change over time.[33] But, when he told the stories over again, he was neither improving them nor simply repeating them. He was performing them, each time in different circumstances. Such variations might disconcert the historian but they delight the folklorist, for the "truth" that I was after was the truth of Mayer's way of knowing the world, his way of giving shape to his experiences in words and images.

I have always felt myself blessed to have been raised in an environment—the immigrant neighborhood of my childhood, my family, their friends—suffused with an East European Jewish sensibility and fed by a spring so close to the source. During the early years of my research, I interviewed not only my father but, above all, my mother, whose repertoire of

parables and proverbs, learned from her mother and deployed with stunning psychological insight, were a testament to her social grace.[34] She was a treasure trove of traditional wisdom, and I recorded everything she could remember. I interviewed her younger brother, Motl, the best raconteur of all by acclamation. I interviewed my grandmother Rivke, Mayer's mother. And, quite by chance, when Sylvia, my mother's oldest sister, asked Mariam Nirenberg, a cousin, to sing her favorite songs from the Old Country, I discovered an extraordinary traditional singer right in my own family and recorded all her songs.[35] Although Mariam has passed away, her voice still fills my parents' kitchen, thanks to these recordings. My mother, who has lost most of her vision and much of her memory, finds it hard to follow a conversation, movie, or television program. But when she hears Mariam's voice, as she does most mornings at the kitchen table, she remembers all the songs and sings along, never tiring of the repetition.

At family gatherings, my father and uncles, many of them expert raconteurs, would regale one another with hilarious stories and jokes, many of them not in the best of taste. I had learned from Mikhail Bakhtin and Gershon Legman to prize the Rabelaisian for its imaginative energy and rebelliousness, for the world upside down. Even as a young girl, I was not sent out of the room when my father and his brothers told risqué stories. I heard everything. The spirit was down-to-earth and never prudish, though not all members of my family approved of the ribaldry. A constant stream of new anecdotes reached us from the salesmen and customers who came into my father's store and from my uncles, who heard the latest jokes while on the road selling furniture or women's fashions. Then there were the "classics," largely stories about the immigrant experience that had stood the test of time and whose creative elaboration made each retelling an event unto itself.

In her 1993 Nobel lecture, Toni Morrison implores the blind old woman: "Think of our lives and tell us your particularized world. Make up a story. Narrative is radical, creating us at the very moment it is being created."[36] Whereas Morrison beseeches the blind woman to "speak the language that tells us what only language can: how to see without pictures," Mayer's stories unfold in words *and* images, sometimes in parallel, sometimes complementing each other, sometimes independently. He shows us how to see *with* pictures—they are not self-evident in any case—as well as with words. Together, his visual and verbal narratives chart the porous boundaries between himself and the world and, at times, his imaginative fusion with the town of his youth.

Whatever their relation, the paintings and stories treat time differently. The Mayer of the paintings is almost always of the same indeterminate age, rarely younger or older, always a school boy in blue. True, Mayer appears as a baby in a cradle in the scene of his mother after she gave birth to his brother, but this is exceptional. Many of the paintings are inscribed "Opatów, 1934," including scenes that occurred repeatedly over the course of many years, as if to say that the clock stopped in 1934, the point beyond which there would be nothing to remember. Virtually all of Mayer's seventeen years in Poland seem to be compressed into the year of his departure; even a domestic scene that includes his father, who left Poland in 1928, is dated 1934.

Mayer's paintings of historical subjects, especially legends, occupy a deep undated past, and his holiday paintings mark recurring moments in the circle of liturgical time. It is when he speaks, however, that time has not only duration and recurrence but also passage. The time of the spoken narratives is marked above all by the inevitability of leaving Poland for a better future elsewhere, and in that inevitability and the fate that he escaped is the ultimate significance of the year 1934. His approach to time is one of the ways that Mayer expresses who he was then in relation to what he hoped to become and became (and is still becoming). Those relations, implicit in the paintings, are elaborated in the spoken accounts.

Never self-sufficient, Mayer's paintings are quite literally conversation pieces. Mayer does not intend the paintings to stand alone. They are, each and every one, an occasion for a conversation between the artist and the viewer. Mayer comes to know himself—and we come to know him—through the stories he tells in conversation. It took considerable work to connect these luminous dots in what was, for me, still a dark landscape. Only as I was assembling the manuscript did I realize that seemingly unconnected cameos were about the same person or about people related to one another or that different events took place in the same location. It was as if Apt were in pieces and the pieces scattered randomly across the uncharted terrain of Mayer's memory. Romaine encouraged us to think of those pieces as "vibrants" of a world alive in memory, rather than as remnants of a lost one.

It has been said that all portraiture is self-portraiture, and *They Called Me Mayer July* is no exception. It is at once the portrait of a town, its inhabitants, a boy who delighted in their idiosyncrasies, and the man he became, and perhaps even the daughter with whom he collaborated. Many of Mayer's paintings are closer to what Richard Brilliant calls "ethnographic portraits," because they exhibit a "narrow range of physiognomic variation" but considerable detail of other kinds, like the rope around the water-carrier's waist, the red kerchief in his pocket, and the corners of his coat tucked under his belt so they are out of his way.[37]

Although the water-carrier in Mayer's painting is unnamed and it is not strictly speaking a portrait—for an image to be a portrait in the technical sense, it must portray an actual individual—the image occasions spoken portraits of named water-carriers such as Ludwik. To compete with this tall Polish man, who ordered extra-large buckets from the tinsmith, all the other water-carriers were forced to carry oversized buckets, even though buckets of the shortest ones, like Duvid *vaser-treyger* (David Water-Carrier), almost dragged on the ground. When Ludwik does appear, Mayer has written his name on his shirt to distinguish him from the other water-carriers in the scene, as if to say that Ludwik is who he is by virtue of his relationship to them. Once individualized, a type becomes a character, if not in the painting itself, then in conversation.

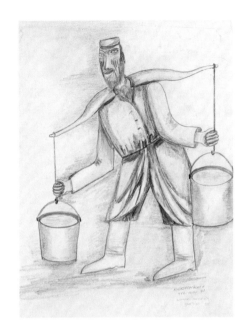

Ludwik the Water-Carrier

Apt was a treasure trove of local characters with memorable peculiarities. *Ciocia* Rozalia was a fashion plate who loved bold floral prints and big hats and is shown in all her finery. Malkele *drek* (Malkele Shit), a lovely woman, acquired this unfortunate moniker (and her problems finding a husband) when she accidentally fell into the military latrine. In her portrait, Mayer escorts her home after a visit to his mother. The key to the portrait of Laybl *tule*, a flour-porter weighted down with a heavy sack, is the little boy in blue a few steps behind him: the story occasioned by this portrait is about what Mayer's mother did to stop him from following Laybl *tule* around. With the exception of one engraving—a self-portrait that includes his parents and three brothers—Mayer's portraits are never heads or busts but always full figures, almost always standing, often front and center. The one formal portrait he painted is actually a painting of a portrait: it shows *klezmurim* sitting for their photograph in front of a painted backdrop in the photographer's studio.

That words are necessary is a mark not of the image's insufficiency but of Mayer's distinctive way of distributing the story across the many occasions of its telling, both spoken and painted. These portraits, like all of Mayer's paintings, not only *tell* but also ask to be *told*. Like the itinerant patuas of Bengal, who unroll their painted scrolls and perform the stories visualized on them, Mayer narrates his images, whether they are hanging on the walls of his home, projected on a screen, or captured in snapshots that can be passed from hand to hand. The paintings are not illustrations and the stories are not captions. They are not versions of

one another. Rather, different parts of the story are told in different ways in different media to form a whole that is greater than could be achieved in words or images alone.

In a letter dated June 6, 1982, Mayer wrote to tell me that he had carefully packed the porcupine he made from an intact eggshell and toothpicks, and that he hoped this time it would arrive in one piece. He included a few Yiddish children's rhymes in the letter and a P.S.: "This should make your day a happy day for you." Indeed, it did. This book is the culmination of many such happy days.

Barbara Kirshenblatt-Gimblett
Manhattan, August 2006

NOTES

1. David Isay, the brilliant radio documentarian and founder of Sound Portraits and StoryCorps, defined interviewing as "listening with love" when talking with my students at New York University about his work on May 5, 2003.

2. Y. M. Sokolov, *Russian Folklore*, trans. Ruth Smith (Hatboro, Pa.: Folklore Associates, 1966), 225. *Russian Folklore* first appeared in Russian in 1941, the year that Sokolov died, and the English translation first appeared in 1950.

3. On Apt, see Zvi Yasheev, ed., *Apt (Opatov): Sefer zikaron le-'ir ve-em be-Yisra'el asher hayetah ve-enenah 'od—Yizker-bukh tsum ondenk fun undzer geburts-shtot in Poyln velkhe iz mer nishto / Apt: A Town Which Does Not Exist Anymore / Sefer Apta* (Tel Aviv: Yots'e Apt be-Yisra'el, Ar. ha-B, Kanadah, Brazil, 1966), and Gershon David Hundert, *The Jews in a Polish Private Town: The Case of Opatów in the Eighteenth Century* (Baltimore: Johns Hopkins University Press, 1992).

4. The D'Arcy Street school was also called Eitz Haim, which means tree of life.

5. Walter Benjamin, "The Storyteller: Reflections on the Works of Nikolai Leskov," in *Illuminations*, ed. with an introduction by Hannah Arendt, trans. Harry Zohn (New York: Harcourt, Brace & World, 1968), 108–9.

6. For comments on the relational nature of autobiography, even those authored by one person, see Paul John Eakin, *How Our Lives Become Stories: Making Selves* (Ithaca, N.Y.: Cornell University

Press, 1999). Eakin discusses four examples of "the story of the story" approach, including Art Spiegelman, *Maus: A Survivor's Tale: My Father Bleeds History* (New York: Pantheon, 1986) and *Maus II: A Survivor's Tale: And Here My Troubles Began* (New York: Pantheon, 1991). When asked in a 1991 radio interview about the prominence in *Maus* of eliciting the story from his father—"how important to you is that dimension of the entire story?"—Spiegelman replied, "Oh, I think it's the actual story" (quoted in Eakin, *How Our Lives Become Stories*, 60).

7. This is to be distinguished from the "as told to" genre. See, e.g., Norman Salsitz, *A Jewish Boyhood in Poland: Remembering Kolbuszowa*, as told to Richard Skolnik (Syracuse, N.Y.: Syracuse University Press, 1992), although this fine book is the closest to *They Called Me Mayer July*. Skolnik, a historian, interviewed Salsitz and reviewed the manuscript with him, but he understood the process and the result differently; as he explains, "What follows is my writing," which tries, among other things, to capture Salsitz's unique style. On dialogism, see Michael Holquist, *Dialogism: Bakhtin and His World*, 2nd ed. (London: Routledge, 2002).

8. Yaffa Eliach, *There Once Was a World: A Nine-Hundred-Year Chronicle of the Shtetl of Eishyshok* (Boston: Little, Brown, 1998). Most of this almost-900-page account of 900 years of Jewish life in Eishyshok is devoted to the first half of the twentieth century and is based in large measure on interviews.

9. See, e.g., Theo Richmond, *Konin: A Quest* (New York: Pantheon, 1995). See also Diane Armstrong, *Mosaic: A Chronicle of Five Generations* (Sydney, Australia: Random House, 1998), which is narrated largely in the third person, with brief moments of quoted dialogue; it does contain some narration in the first person when the author tells the story of the story or when the story to be told is her own. The subtitles of these two books, which combine biography with autobiography in varying degrees, capture the difference in their approach.

10. See, e.g., Shlomo Noble and Jonathan Boyarin, *A Storyteller's Worlds: The Education of Shlomo Noble in Europe and America* (New York: Holmes and Meier, 1994).

11. Charlotte Salomon, *Life? or Theatre?*, trans. Leila Vennewitz (Zwolle, Netherlands: Waanders, 1998). Johannes Fabian, *Remembering the Present: Painting and Popular History in Zaire* (Berkeley: University of California Press, 1996), matches the image sequence to the artist's narrative and adds a short dialogue between artist and anthropologist as well as additional information in a separate note by the anthropologist; the three kinds of text appear in three different typefaces.

12. See Marc Kaminsky, "Myerhoff's 'Third Voice': Ideology and Genre in Ethnographic Narrative," *Social Text* 33 (1992): 130. Parts of this essay were incorporated into his introduction to Barbara G. Myerhoff, *Remembered Lives: The Work of Ritual, Storytelling, and Growing Older*, ed. Marc Kaminsky (Ann Arbor: University of Michigan Press, 1992), 1–97.

13. Kaminsky, "Myerhoff's 'Third Voice,'" 138.

14. Ibid., 133, is quoting Myerhoff in conversation. Barbara G. Myerhoff, *Number Our Days* (New York: Dutton, 1978).

15. Kaminsky, "Myerhoff's 'Third Voice,'" 126.

16. Benjamin, "The Storyteller," 85.

17. Roland Barthes, "The Plates of the Encyclopedia," in his *New Critical Essays*, trans. Richard Howard (New York: Hill and Wang, 1980), 25–26.

18. "Opatow Fair: Local and Ecological Products from the Amber Trail," http://free.art.pl/jarmarkopatowski/new_1.htm, accessed Mar. 17, 2006.

19. Neil Harris, *Humbug: The Art of P. T. Barnum* (Boston: Little, Brown, 1973), 81.

20. Jean Le Rond d'Alembert, *Preliminary Discourse to the Encyclopedia of Diderot*, trans. Richard N. Schwab (Chicago: University of Chicago Press, 1995), 42. See also John R. Pannabecker, "Diderot, the Mechanical Arts, and the *Encyclopédie:* In Search of the Heritage of Technology Education," *Journal of Technology Education* 6, no. 1 (1994), http://scholar.lib.vt.edu/ejournals/JTE/v6n1/pdf/pannabecker.pdf, accessed Mar. 17, 2006.

21. See H. Otto Sibum, "Working Experiments: A History of Gestural Knowledge," *Cambridge Review* 116, no. 2325 (1995): 25–37.

22. On styles of mastery, see Sherry Turkle, *The Second Self: Computers and the Human Spirit* (New York: Simon and Schuster, 1984), and Sherry Turkle, *Life on the Screen: Identity in the Age of the Internet* (New York: Simon and Schuster, 1995).

23. Eakin, *How Our Lives Become Stories*, 4.

24. Benjamin, "The Storyteller," 89.

25. John Dewey, *Art as Experience* (New York: Perigee, 1934), 59. See also Elinor Ochs and Lisa Capps, "Narrating the Self," *Annual Review of Anthropology* 25 (1996): 19–43.

26. Jeffrey Shandler, ed., *Awakening Lives: Autobiographies of Jewish Youth in Poland before the Holocaust* (New Haven, Conn.: Yale University Press, 2002).

27. Elizabeth W. Bruss, *Autobiographical Acts: The Changing Situation of a Literary Genre* (Baltimore: Johns Hopkins University Press, 1976), 10, quoted in Eakin, *How Our Lives Become Stories*, 74.

28. Henry Louis Gates, Jr., *Colored People: A Memoir* (New York: Knopf, 1994); Zora Neale Hurston, *Dust Tracks on a Road: An Autobiography* (Philadelphia: Lippincott, 1942).

29. Marcus Moseley, *Being for Myself Alone: Origins of Jewish Autobiography* (Stanford: Stanford University Press, 2006), 73. Moseley is characterizing (and takes issue with) the classic view of the history of Jewish autobiography espoused by Jacob Shatzky, David Roskies, Leo Schwarz, and others. Of special interest here is David Roskies, *Against the Apocalypse: Responses to Catastrophe in Modern Jewish Culture* (Cambridge, Mass.: Harvard University Press, 1984).

30. Gaston Bachelard, *The Poetics of Space*, trans. Maria Jolas (Boston: Beacon Press, 1994), vii.

31. Ibid., xxxvii.

32. Barthes, "Plates of the Encyclopedia," 34–35.

33. Angela Levine, "A Century of Naïve Art in Israel," *Ariel: The Israel Review of Arts and Letters* 110 (1999): 55–70. Levine writes: "Naïve painters are nearly always self-taught; they work alone and do not belong to any group or school. Their approach is instinctive and their style, once formed, does

not undergo any progression or change. Many naïve painters take up their brushes seriously for the first time quite late in life, often on retirement" (55).

34. Barbara Kirshenblatt-Gimblett, "A Parable in Context: A Social Interactional Analysis of Story-telling Performance," in *Folklore: Performance and Communication*, ed. Dan Ben-Amos and Kenneth S. Goldstein (The Hague: Mouton, 1975), 105–30.

35. Barbara Kirshenblatt-Gimblett, Chana Mlotek, and Mark Slobin, *Folksongs in the East European Tradition from the Repertoire of Mariam Nirenberg* (New York: YIVO Institute for Jewish Research and Global Village, 1986), LP recording.

36. Toni Morrison, presentation speech for the Nobel Prize in Literature 1993, delivered Dec. 7, 1993, http://nobelprize.org/literature/laureates/1993/morrison-lecture.html, accessed Mar. 17, 2006.

37. Richard Brilliant, *Portraiture* (Cambridge, Mass.: Harvard University Press, 1991), 107.

NOTE ON LANGUAGE AND LOCATIONS

The romanization of Yiddish in this book, while guided by the standards of the YIVO Institute for Jewish Research, preserves the basic dialectical features of Mayer's Polish Yiddish (e.g., *khayder*, not *kheyder*). The romanization of Hebrew follows Polish Yiddish pronunciation and YIVO conventions. Hebrew and Yiddish words common in English follow conventional English spellings, based on the *Merriam-Webster's Collegiate Dictionary, 11th ed.*, and the *Oxford English Dictionary*, with a preference for older forms.

The spelling of Jewish personal names reflects Mayer's pronunciation while following YIVO romanization conventions. Family names are generally rendered according to the way they were spelled in Poland during the interwar years, based on Polish business directories of the period and databases of Holocaust victims.

Locations are identified by both their Polish and their Yiddish place names. When talking about his hometown as a municipality, Mayer refers to it by its Polish name (Opatów); when talking about everyday life, he tends to refer to it by its Yiddish name (Apt). Similarly, some streets were known by several names and in more than one language, and Mayer alternates among the names, some of which are translated into English, although Mayer never refers to them by their translated name. Thus, the street where the ancient city wall once stood is ulica Starowałowa in Polish; *di alte valove, di valove,* and *di vul* in Yiddish; and Old Rampart Street in English translation. The main street in town, *di yidishe gas* (the Jewish Street), is also ulica Szeroka in Polish and *di brayte gas* in Yiddish (Broad Street), and ulica Berka Joselewicza in Polish and *di gas fin Berek Yoselevitsh* in Yiddish (Berek Joselewicz Street).

Whereas Poland uses the metric system (as does Canada, since 1970), Mayer tends to remember dimensions in inches and feet, though he recalls distance in kilometers and weight in kilos. In this book, all weights and measures are rendered according to the U.S. customary system of measurement.

Because not all of Mayer's paintings are formally titled, the titles provided here are based on what he has written on some of them and on how he refers to them when speaking; they follow standard English spelling and romanization consistent with his Yiddish dialect. Mayer's inscriptions, when they do appear on a painting, may be a title or caption; they use his unique English and Polish spelling and romanization of Yiddish.

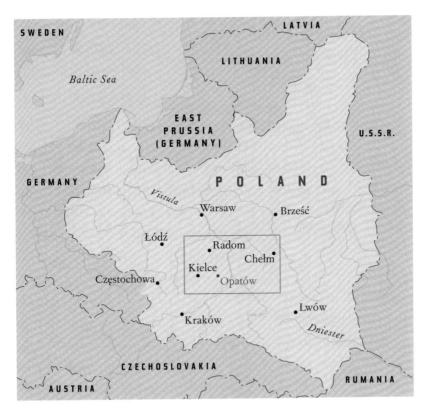

SWEDEN

Baltic Sea

LATVIA

LITHUANIA

EAST
PRUSSIA
(GERMANY)

U.S.S.R.

GERMANY

P O L A N D

Vistula

Warsaw
Brześć

Łódź

Radom
Chełm

Kielce

Częstochowa
Opatów

Lwów

Kraków

Dniester

CZECHOSLOVAKIA

RUMANIA

AUSTRIA

*The Second
Polish Republic
(1921–1939)*

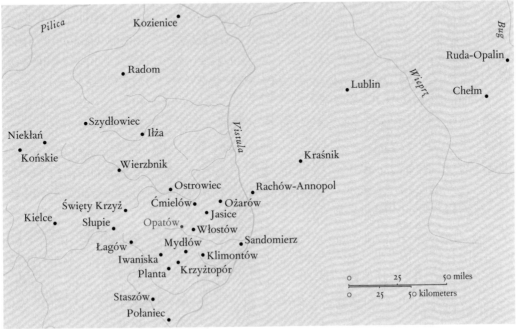

Pilica

Kozienice

Bug

Ruda-Opalin

Radom

Lublin

Wieprz

Chełm

Szydłowiec

Iłża

Niekłań

Vistula

Końskie

Wierzbnik

Kraśnik

Ostrowiec

Rachów-Annopol

Święty Krzyż

Ćmielów

Ożarów

Kielce

Jasice

Słupie

Opatów

Włostów

Łagów

Mydłów

Sandomierz

Iwaniska

Klimontów

Planta

Krzyżtopór

Staszów

Połaniec

0 25 50 miles

0 25 50 kilometers

During the past forty years, many people played a vital role in making this book possible. If not for the late Jerome Mintz (Indiana University), Barbara would never have started interviewing her family in Toronto, and without Robert Klymasz (Canadian Centre for Folk Culture Studies, National Museum of Canada), she would never have made Toronto's Jewish community the focus of her first major research effort. It was Marvin I. Herzog (Columbia University) who launched her on the path of Yiddish Studies, and for that she is eternally grateful.

Over the years many people have afforded Mayer opportunities to present his work to the public. Mary Hufford, Marjorie Hunt, and Steven Zeitlin were the very first to include Mayer's paintings in an exhibition just months after he began painting (*The Grand Generation*, organized by the Smithsonian Institution, 1990). Joan Eleanor Tooke, a staunch supporter of Mayer's work, was the first to give him major solo exhibitions, first at the Koffler Gallery (Toronto) in 1994 and, with the assistance of Dale Barrett, at the John B. Aird Gallery (Toronto) in 1999. Thanks go as well to Ashkenaz: A Festival of New Yiddish Culture in Toronto and the BloorJCC in Toronto for hosting a solo exhibition of Mayer's work in 1997. The Jewish Museum (New York) included Mayer in their 2005 exhibition of self-taught artists. For organizing the traveling exhibition that accompanies this book, we express our gratitude to Alla Efimova, Chief Curator at the Judah L. Magnes Museum (Berkeley), and for their generous support of the project, we thank the Taube Foundation for Jewish Life and Culture. Warmest thanks to Stuart Schear for drawing attention to this project.

Henry Sapoznik (KlezKamp), Hy and Jacqueline Goldman (KlezKanada), Emily Socolov and Itzik Gottesman, Jan Gross, Joachim Russek (Center for Jewish Culture, Kraków), and Norman Frisch have encouraged Mayer by providing opportunities for him to present illustrated talks. We are gratified by the success of the Samberg Family History Program at the Center for Jewish History in using *They Called Me Mayer July* as a model for intergenerational oral history projects and thank Shiri Cohen, Robert Friedman, and Jane Rothstein for their efforts. Barbara expresses her appreciation to David Ruderman, who invited her to present this project during her residency at the Center for Advanced Judaic Studies, University of Pennsylvania.

During a residency at the Institute for Advanced Studies at the Hebrew University in 1996, we began the process of assembling the manuscript. We thank Richard I. Cohen and Ezra Mendelsohn for this opportunity and the Institute staff for their support. For their encouragement and warm hospitality during that period, we are grateful to Harvey and Judy Goldberg, Galit Hasan-Rokem and Freddie Rokem, Brenda Danet, and Tamar and Jacob Katriel.

We deeply value the specialized linguistic and historical expertise provided by Paul Glasser and Marek Web (YIVO Institute for Jewish Research), Natalia Aleksiun, Ulrike Kiefer (Language and Culture Atlas of Ashkenazic Jewry), Andrzej Rataj (Muzeum Etnograficzne, Kraków), Jarosław Czub (Municipality of Opatów), Samuel Kassow, Zachary Baker, David Assaf, and Robert Rothstein.

New York University provided generous support. We thank Matthew Zimmerman (Humanities Computing Group), ably assisted by Rachel Eunjoon Un and Jonathan M. Verbanets, for creating our image database; the Faculty Technology Center, especially Tal Halpern and Vincent Doogan, for their ongoing support; and Joseph Hargitai for his help at an early stage of the project. To the Department of Performance Studies we express appreciation for our capable research assistants: Elizabeth Kurkjian and Sarah Curran scanned slides; Anurima Banerji read the manuscript and made valuable suggestions; and Brigitte Sion dedicated long hours and her formidable talents to the preparation of the final manuscript and index. We also thank Masi Asare and Patty Jang for their technical assistance. Barbara's colleagues at New York University have offered their support on many occasions: we thank Diana Taylor and Eric Mannheimer, Richard Schechner and Carol Martin, Faye Ginsburg and Fred Myers, and Martha Hodes, Nancy Regalado, and Evelyn Birge Vitz.

Robert Kissen photographed Mayer's work over the years. Excellent color transparencies for the book were made in Toronto by Rafael Goldchain, assisted by John Jones and Tami McInnis, and in New York by Tom Warren, with the expert help of Anthony Fodero, who coordinated the work. To Frédéric Brenner we are grateful for the author photograph and his boundless generosity. We thank the Toronto Jewish Arts Council of the UJA Federation of Greater Toronto and the Humanities Council, New York University, for generously supporting the photography. We are especially grateful to Jack Kuper for producing *Shtetl*, a documentary film about Mayer and his work, in 1995.

For their expert advice as we were developing the concept for *They Called Me Mayer July* and seeking ways to publish the book, heartfelt thanks go to Bill Anton, Dan Ben-Amos, Roger Bennett, Nancy Berman, Sara Bershtel, Julia Bloomfield, Frédéric Brenner, Walter Cahn, Dalia Carmel, Joost Elfers, Estelle Ellis, Neil Harris, Marianne Hirsch, Shelley Hornstein, Jenna

Weissman Joselit, Barbro Klein, Jack Kugelmass, Krzysztof Machocki, Bruce Mau, Donald Preziosi, Isabelle Rozenbaumas, Edward Serotta, Andrea Raab Sherman, Amy Shuman, Martha Wilson, and Wendy Wolf. For their efforts to help us find the resources and institutional support to exhibit the paintings, we offer our deep appreciation to Ilana Abramovitch, Ruth Beesch, Hetty Berg, Joël Cahen, Clifford Chanin, Anna R. Cohen, Annie Cohen-Solal, Teri Edelstein, Grace Cohen Grossman, Elaine Heumann Gurian, Jerzy Halberstadt, Macy Hart, Anna Hudson, Gershon Hundert, Felicitas Jellenik, Ewa Junczyk-Ziomecka, Joanne Marks Kauvar, the late Hans-Christian Kirsch, Norman Kleeblatt, Laura Kruger, Deborah Lipstadt, Hooley McLaughlin, Shana Penn, Sheldon I. Posen, Sigmund Rolat, Rhoda Rosen, Joan Rosenbaum, Eleanor Shapiro, Catherine Soussloff, Peter L. Stein, Bernice Steinhardt, Harold Troper, Jill Vexler, Aviva Weintraub, Chava Weissler, Connie Wolf, and Carole Zawatsky.

A singular highlight in Mayer's career has been the opportunity to work with Jennifer Romaine on a toy theater, *The White Pajamas*, based on his work. Special thanks to Alain Lecucq for commissioning this work for the Rencontres internationales de théâtre de papier (Troyes, 2004); to the French Ministry of Culture and National Foundation for Jewish Culture for their generous support of this production; and to Great Small Works (John Bell, Trudi Cohen, Stephen Kaplin, Jennifer Romaine, Roberto Rossi, Mark Sussman) for featuring *The White Pajamas* at the 7th International Toy Theater Festival (New York, 2005).

For careful reading of the manuscript, we thank Olga Litvak and Carol Zemel. Our abiding gratitude to Jeffrey Shandler for his generous and imaginative responses. To our able proofreaders, Elaine, Lisa, and Shawna Silver, we are grateful. Warm appreciation to Stanley Holwitz, our editor at University of California Press, for his faith in this book, and his team: Rose Vekony, Dore Brown, and Julia Zafferano for their care in preparing the manuscript; Nola Burger for her inspired design; John Cronin and Janet Villanueva for their production expertise; and Amy-Lynn Fischer, Julie Christianson, and Alex Dahne for bringing the book to its readers.

Warmest thanks to Mayer's friends from Apt, the late Maylekh Katz, Harshl Weiss, and Saul Marmurek, who shared their memories and were always ready to answer our questions. Mayer also thanks Joanna and Dariusz Sobczyk for their support.

Above all, it is to our families that we owe the deepest debt of gratitude: Doris for her unwavering commitment to Mayer's mission; Max Gimblett, who has always encouraged Mayer to blossom as an artist; Elaine and Marvin Silver for their devotion and tireless efforts day to day; Shawna Silver, Lisa Silver and Corey Brozovsky, and Noam and Doron Berlin for the love they shower on their grandparents; Daniel Berlin, for his ongoing support; and Annie, who would have been overjoyed to see this book appear.

LIST OF ILLUSTRATIONS

All works are by Mayer Kirshenblatt and, unless otherwise noted, were created in Toronto, are acrylic on canvas, and are in his collection. Dimensions are in inches, height before width. If no photographer is named, the works were photographed by Rafael Goldchain, with the assistance of John Jones and Tami McInnis.

This book is published in conjunction with an exhibition at the Judah L. Magnes Museum.

Judah L. Magnes Museum, Berkeley, September 9, 2007–January 13, 2008
The William Bremen Jewish Heritage Museum, Atlanta, Spring 2009
The Jewish Museum, New York, May–September, 2009
Joods Historisch Museum, Amsterdam, 2009
Museum of the History of Polish Jews, Warsaw, 2011

Additional information about the book can be found at www.mayerjuly.com.

University of California Press, one of the most distinguished university presses in the United States, enriches lives around the world by advancing scholarship in the humanities, social sciences, and natural sciences. Its activities are supported by the UC Press Foundation and by philanthropic contributions from individuals and institutions. For more information, visit www.ucpress.edu.

University of California Press
Berkeley and Los Angeles, California

University of California Press, Ltd.
London, England

Text: 12/15.75 Fournier
Display: Tasse
Designer: Nola Burger
Compositor: Integrated Composition Systems
Cartographer: Ben Pease
Printer/Binder: Friesens Corporation

Library of Congress Cataloging-in-Publication Data

Kirshenblatt, Mayer, 1916–.
 They called me Mayer July : painted memories of a Jewish childhood in Poland before the Holocaust / Mayer Kirshenblatt, Barbara Kirshenblatt-Gimblett.
 p. cm.
 Includes bibliographical references and index.
 ISBN-13: 978-0-520-24961-5 (cloth : alk. paper)
 1. Jews—Poland—Opatów—History. 2. Jews—Poland—Opatów—Social life and customs. 3. Jews—Poland—Opatów—Biography. 4. Kirshenblatt, Mayer, 1916–. 5. Opatów (Poland)—Biography. I. Kirshenblatt-Gimblett, Barbara. II. Title.

DS135.P620595 2007
943.8'45—dc22 2006036182

Manufactured in Canada

16 15 14 13 12 11 10 09 08 07
10 9 8 7 6 5 4 3 2 1